PALGRAVE STUDIES IN THEATRE AND PERFORMANCE HISTORY is a series devoted to the best of theatre/performance scholarship currently available, accessible, and free of jargon. It strives to include a wide range of topics, from the more traditional to those performance forms that in recent years have helped broaden the understanding of what theatre as a category might include (from variety forms as diverse as the circus and burlesque to street buskers, stage magic, and musical theatre, among many others). Although historical, critical, or analytical studies are of special interest, more theoretical projects, if not the dominant thrust of a study, but utilized as important underpinning or as a historiographical or analytical method of exploration, are also of interest. Textual studies of drama or other types of less traditional performance texts are also germane to the series if placed in their cultural, historical, social, or political and economic context. There is no geographical focus for this series and works of excellence of a diverse and international nature, including comparative studies, are sought.

The editor of the series is Don B. Wilmeth (EMERITUS, Brown University), Ph.D., University of Illinois, who brings to the series over a dozen years as editor of a book series on American theatre and drama, in addition to his own extensive experience as an editor of books and journals. He is the author of several award-winning books and has received numerous career achievement awards, including one for sustained excellence in editing from the Association for Theatre in Higher Education.

Also in the series:

The Drama of Marriage

Gay Playwrights/Straight Unions from Oscar Wilde to the Present

John M. Clum

First published in 2012 by
PALGRAVE MACMILLAN®
in the United States—a division of St. Martin's Press LLC,
175 Fifth Avenue, New York, NY 10010.

Where this book is distributed in the UK, Europe and the rest of the world,
this is by Palgrave Macmillan, a division of Macmillan Publishers Limited,
registered in England, company number 785998, of Houndmills,
Basingstoke, Hampshire RG21 6XS.

Palgrave Macmillan is the global academic imprint of the above companies
and has companies and representatives throughout the world.

Palgrave® and Macmillan® are registered trademarks in the United States,
the United Kingdom, Europe and other countries.

ISBN: 978–0–230–33840–1

Library of Congress Cataloging-in-Publication Data

Clum, John M.
 The drama of marriage : gay playwrights—straight unions from
Oscar Wilde to the present / John M. Clum.
 p. cm.—(Palgrave studies in theatre and performance history series)
 Includes bibliographical references.
 ISBN 978–0–230-33840–1 (alk. paper)
 1. English drama—Male authors—History and criticism. 2. American
drama—Male authors—History and criticism. 3. Marriage in literature.
4. Gay men's writings, American—History and criticism. 5. Gay men's
writings, English—History and criticism. 6. Popular literature—Great
Britain—History and criticism. 7. Popular literature—United States—
History and criticism. I. Title.

PR635.H65C58 2012
822'.91093543—dc23 2011024734

A catalogue record of the book is available from the British Library.

Design by Newgen Imaging Systems (P) Ltd., Chennai, India.

First edition: January 2012

10 9 8 7 6 5 4 3 2 1

Printed in the United States of America.

For Walter Simon Melion
My partner, my spouse, my muse.

Contents ✑

Illustrations ❧

Following page 112

1. Rose Coghlan and Maurice Barrymore in the climactic confrontation between Mrs. Arbuthnot and Lord Illingworth in the 1893 American production of Oscar Wilde's *A Woman of No Importance*. Photo courtesy of Lebrecht Music and Arts.

2. Noël Coward and Gertrude Lawrence as Elyot and Amanda in the original production of Coward's *Private Lives*. Photo courtesy of Lebrecht Music and Arts.

3. Iain Glen and Gina McKee as John and Anne in the 2010 Chichester Festival Theatre revival of Terence Rattigan's *Separate Tables*. Photo courtesy Lebrecht Music and Arts.

4. Aidan Gillett and Saskia Wickham as Will Trenting and his very understanding wife in the 2011 Finborough Theatre revival of Emlyn Williams's *Accolade*. Photo by Helen Warner.

5. Christy McIntosh and Jeff Pucillo as Becky and Tom Warder in a moment of intimacy in the 2006 Metropolitan Playhouse, New York City, revival of Clyde Fitch's *The Truth*. Photo by Mary Rose Devine.

6. Zoë Wanamaker and Darrell D'Silva as Serafina and Alvaro in the 2006 Royal National Theatre revival of Tennessee Williams's *The Rose Tattoo*. Photo courtesy Lebrecht Music and Arts.

7. Bill Paterson and Sheila Gish as the battling Jack and Jill in the 2001 Royal National Theatre production of Edward Albee's *Marriage Play*. Photo by John Haynes, courtesy Lebrecht Music and Arts.

8. Doyle Reynolds and Steven Emanuelson as Carl and Bernie on Fire Island in the Actor's Express, Atlanta, production of Terrence McNally's *Some Men*. Photo by Chris Ozment.

Acknowledgments

Heartfelt thanks to the following:

First of all, Samantha Hasey at Palgrave Macmillan for being such a helpful collaborator and Don Wilmeth for his helpful, meticulous reading of the text.

Duke University, particularly former dean of the faculty of arts and sciences, George McLendon, for giving me the time to research and write this volume.

Katherine Freisenbruch at the V&A Archives, Eleanor McKeown at Lebrecht Music and Arts, and Suzanne Dolan at the National Theatre Archives for their help with illustrations.

Freddie Ashley at the invaluable Actor's Express (Atlanta), Neil McPherson at the Finborough Theatre (London), and Alex Roe at the Metropolitan Playhouse (New York City) for their assistance.

My colleagues in the Theater Studies and English Departments at Duke University, who have provided such support and inspiration over the past decades, particularly Sarah Beckwith and Jeff Storer, and special thanks to my colleagues, mentors, and counselors, Dale and Phyllis Randall.

And finally, thanks galore to the friends who kept me sane during this book's long gestation process: Bob West, Fred Oliphant, Pedro Patterson, Eric Thornton, Marcia Cohen, sister Jean Wotowicz, and of course, scholar and partner extraordinaire, Walter Melion.

London, June 2011.

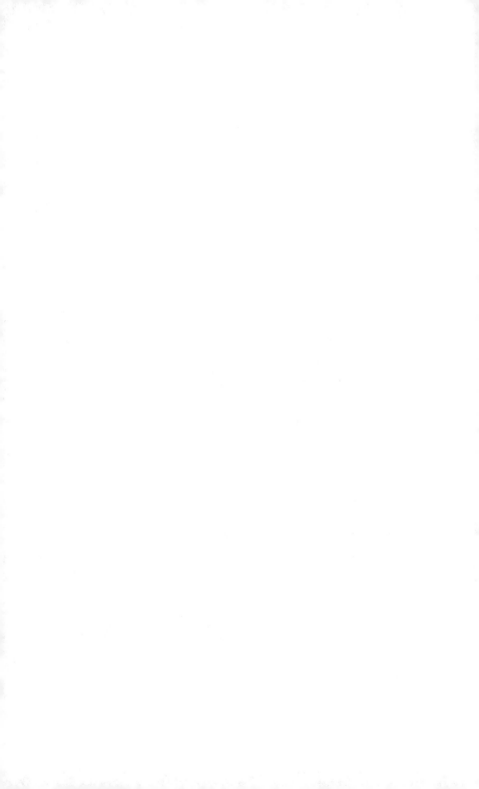

Introduction ✌

*T*he *Drama of Marriage* is a study of performances of marriage in modern and contemporary British and American drama. While for the most part, it examines works that are about heterosexual relationships, it is written from the point of view of a gay male individual and will focus on depictions of marriage by gay playwrights. Of course, marriage has always been a central theme of drama, from the troubled, usually fatal, marriages of Greek kings and queens (no divorce necessary in classical Athenian tragedy!) to the turbulent marriages in the plays of Edward Albee with their ritual sacrificial deaths; from the shrewish wives and henpecked husbands of classical farce to the clever wives and outwitted husbands of television sitcoms and commercials. In British and American drama of the past century and a half, marriage has been presented as an ideal, an impossibility, and a measure of the morality and limitations of the parties involved. Do marriages fail because couples fail or because the ideal of marriage is impossible to realize? Is true understanding between two people possible? Is monogamy unrealistic? These are some of the questions asked in the plays I shall discuss in these pages.

In this study, I am interested in the paradox that, during the twentieth century, many of the most commercially and artistically successful plays written in Britain and the United States about heterosexual marriage were written by homosexual men (many of them had a very different understanding of the word "gay") despite the fact that, during much of this period, homosexuals were under constant threat of arrest or blackmail. Despite draconian sanctions, many of these playwrights also tried in their private lives to negotiate some sort of same-sex partnership. The writers I discuss have become as much a part of gay history as theater history. The relationship between the ways these men tried to find ways to live and love outside the law and the plays they wrote about heterosexual marriage is an important aspect of this study.

The book begins with Oscar Wilde and focuses on some of the most successful British and American playwrights of the past century: Somerset

Maugham, Noël Coward, Terence Rattigan, and Emlyn Williams in England, and Clyde Fitch, George Kelly, Tennessee Williams, William Inge, and Edward Albee in the United States. We shall see how the popular depictions of marriage in the plays of these men tend to critique the premises of marriage in their time or to show the institution's basic instability.

I was drawn to this subject by the current controversy over gay marriage in the United States, which is as much a controversy about the very nature of marriage as it is about the limits on the place lesbians and gay men are allowed to hold in contemporary American society. The issues that circle around the gay marriage debate are the same as those seen in dramatic depictions of heterosexual marriages: the perennial issue of "who's on top," the question of the possibility of lifetime fidelity and everlasting love, and the concomitant matter of divorce. What we shall see in these pages is that, for the playwrights I discuss and for their audiences, marriage may be a state to which most aspire, but it is always a problem and a process toward an unattainable ideal.

"I LOVE TO CRY AT WEDDINGS"

There is a song in Cy Coleman and Dorothy Field's score for the 1966 musical *Sweet Charity* in which an observer at the heroine's least-disastrous attempt to get to the altar celebrates the tears he sheds at weddings. Why is crying at weddings such a popular cliché? Why should a wedding elicit the same emotional response as a funeral? I assume that tears are a sentimental response to the culmination of a romance and the realization of a social ideal. Marriages ensure the future of the family and the race. Ideally, they celebrate the beginning of a lifelong loving relationship. I cried at my wedding—tears of anxiety at my ability to renounce what I had renounced and tears of joy at, for once, being seen as "normal." At the same time, I knew that this was a yet another performance of normality. Is that not what a wedding is for many people—an affirmation of one's place in one's social group? The ring and the framed picture of one's spouse and children on the desk are tokens that one belongs.

A wedding—the first and most public performance of marriage—is a complex event, both real and symbolic. There was a time in the not too far distant past when all it took to be married was the simple statement by a couple that they were married. No church or state sanction was necessary. Many contemporary couples function successfully without the sanction of church or state, but they are not married, and in the United States, much more than in England, these relationships are considered to

be unsanctioned and provisional. Marriage is still the norm and is still seen as a sign of maturity. A wedding is also, like the first communion or bar mitzvah, a coming-of-age ceremony, a sign of the maturity of the husband and wife. The attendants at a wedding are not merely an audience. They are, in some sense, participants. A marriage ceremony is, after all, a performance of a contract between the couple and the community represented by those who witness the contract. A nuptial ceremony always needs witnesses, whether it takes place in a municipal office or in a church. The vows are public. This is a major difference between the spoken and unspoken, written and unwritten, contracts made by a couple who lives together out of wedlock and the marriage vows, which are both religious and secular. The couple pledges to each other, to their God (if it is a religious wedding), and to the community.

It is impossible to say what a wedding ceremony means to most people who participate in it. For some, it is a crucial ritual binding the couple to their families past and future, to their religion, and to the community, a mixture of feeling and social obligation in varying proportions. To others, it is a commitment made because a couple wants children or a certain position in respectable society. For many of those invited, it is a giant party. In all cases, even if the couple is truly in love, the wedding usually is more a performance than a religious ritual. In an eloquent defense of gay marriage, David Brooks celebrates the ideal of a marriage in which two people come to a full understanding in love: "They may eventually come to the point when they can say to each other, 'Love you? I *am* you.'"[1] That understanding, if it comes at all, takes years. It is not there on the wedding day, but the wedding is a commitment to work toward the ideal Brooks describes. Over the years, the wedding has become less of a commitment ceremony and more of an elaborate theatrical event. As novelist David Leavitt observes, "Rarely is an event in ordinary life so heavily orchestrated, so overdetermined, as a wedding. It is the closest most of us get (who are not actors) to being on stage."[2] Mark Jordan adds, "At most church weddings, the chief ritual specialist is not the pastor or priest, but the wedding planner, followed closely by the photographer, the florist and the caterer."[3] Sometimes it seems easier to get out of a marriage than to get out of a wedding. If it were not, perhaps there would be fewer marriages—and divorces.

I cried again at the civil union ceremony I shared with my partner of twenty-three years. The ceremony has neither changed our relationship in any way, nor has it given us any rights and privileges we did not have before. What brought tears to my eyes was the idea that, finally in some

enlightened states like the one in which I was born, our loving relationship could be recognized in the same way—except for one word—as heterosexual relationships and that people I loved could be official witness to Walter and my devotion to each other. Since the federal government accords no rights to same-sex unions, the event was largely symbolic but nonetheless significant for us.

My generation of gay men often got married to women if they wanted stability, companionship, and a semblance of normality. It seemed to be the only alternative to loneliness, particularly for those of us who had to move out of an urban environment to places like, say, Durham, North Carolina, as it was in the mid-1960s. The marriages often did not last because the husbands eventually saw at least the possibility of a different affective life. Many of my gay friends who were once married to women now see themselves, even if their government does not, as happily married to men. The last chapter in this volume will focus on dramatizations of this pattern.

I do not think gay men who married women were or are the only men who feel a sense of a divided self when they put on a wedding ring. American literature, drama, and film are filled with men who feel that their primary bond is a nonerotic one with another man. They probably do not end up having sex with their buddies on Brokeback Mountain, but there is an attraction to the drinking, the game, or the hunting or fishing trip with the buddies. Men can feel the need to combine the homosocial love of buddies with the erotic love of a woman, with its attendant commitments and duties. I also know heterosexual men for whom women may be for sex and a kind of intimacy not available with men (though their male friends also offer a kind of intimacy not available with women), but monogamous commitment, much less marriage, seems unrealistic.

MARRIAGE AND THE GENDER ORDER

For many conservatives, the battle to preserve marriage as a purely heterosexual institution is in great part a battle to maintain the traditional gender order. As George Chauncey points out, "The [anti-gay marriage] movement's opposition to 'homosexual marriage' was inspired in good part by its fear that allowing two people of the same sex to marry would ratify the transformation of marriage over the past thirty years into an institution of legal equality and gender neutrality, in which most people expect and are expected to negotiate the terms of their own relationships free of legally or divinely mandated gender roles."[4] Many straight men, if they thought

about gay sex at all, have seen it as a question of "who's on top" because they see their heterosexual liaisons that way. Who is screwing whom, literally and figuratively. What happens to marriage when it is built on equality? This is the specter raised by gay marriage. As Christian conservative Jerry Falwell puts it, "We would not be having the present moral crisis regarding the homosexual movement if men and women accepted their proper roles as designated by God."[5]

The view of marriage espoused by the conservatives goes back to St. Paul and the early church fathers. In 401 A.D., St. Augustine wrote his "Of the Good of Marriage," a work that still informs much of the contemporary discourse on marriage, even among non-Catholics. What may be surprising to some is that St. Augustine's work focuses on sex, for only marriage can justify pleasures of the flesh. For St. Augustine, marriage is a contract between a man and a woman for companionship, love, and the rearing of children. It is also a legitimate channel for "carnal concupiscence." If one had to sin—and sex was a sin—better to sin within a marriage, which allows "a mutual service of sustaining one another's weakness, in order to shun unlawful intercourse."[6] All sex outside of marriage was adultery. For St. Augustine, marriage is necessary but inferior to celibacy.

St. Augustine also saw marriage as a hierarchy in which the wife loves, honors, and obeys: "This is where domestic peace starts, the ordered harmony about giving and obeying orders among those who live in the same house. For the orders are given by those who are concerned for the interests of others; thus the husband gives orders to the wife, parents to children, masters to servants. While those who are the objects of this concern obey orders, for example wives obey husbands, the children obey their parents, the servants their masters."[7]

Some aspects of St. Augustine's thinking still pertain for the staunchest defenders of traditional marriage. This is why groups like the Southern Baptist Convention have reinstated a more vertical concept of marriage requiring a wife's obedience to her husband. Actually the "18th Article of Baptist Faith and Message," passed by the convention in 1998, is an interesting balancing act between a modern notion of gender equality and a biblical notion of wifely obedience:

> The husband and wife are of equal worth before God, since both are created in God's image. The marriage relationship models the way God relates to his people. A husband is to love his wife as Christ loved the church. He has the God-given responsibility to provide for, to protect, and to lead his family. A wife is to submit herself graciously to the servant-leadership of her husband even as the church willingly submits to the headship of Christ. She, being in

the image of God as is her husband and thus equal to him, has the God-given responsibility to respect her husband and to serve as his helper in managing the household and nurturing the next generation.[8]

So a wife is equal but must choose to be subservient. She is equal but assigned only the role of "helper" to her husband. Needless to say, there is no room in the Baptist definition of marriage for same-sex unions. Nor would most same-sex couples choose to be in such a hierarchical relationship.

The late nineteenth- and early twentieth-century critiques of marriage written by reformers like Edward Carpenter lay the problems of marriage at the feet of the prevailing gender order reflected in these Christian doctrines. We see in the critiques of marriage written by gay playwrights either an acceptance of or critique of the gender order that underlies traditional marriage. Many of the wittiest epigrams in Oscar Wilde's plays literally put women in their place, while many of the plays of his successors attempt to present a woman's point of view toward the prevailing gender order. If wives are shrewish in the plays of Somerset Maugham and George Kelly, it is because they are smarter or more able than their husbands but can only exercise their power in the domestic sphere. Later writers were interested in whether gender parity and marriage could be happily combined.

If the hierarchical order espoused by St. Augustine and modern Christian conservatives (to say nothing of other orthodox faiths) seems archaic and unjust to women, gender parity poses its own problems for marriage. Marriage is now in crisis, David Brooks writes, "because marriage, which relies on a culture of fidelity, is asked to survive in a culture of contingency."[9] One cannot ignore the irony embedded in the fact that the Defense of Marriage Act was written by thrice-married Robert Barr and signed by one of the most famous adulterers of our time, Bill Clinton. What is contemporary marriage? Andrew Sullivan observes,

> Marriage itself has changed. Far from being an institution governed by men, it has been placed on a radically egalitarian footing. From being a contract for life, it has developed into a bond that is celebrated twice in many an American's lifetime. From being a means to bringing up children, it has become primarily a way in which two adults affirm their emotional commitment to one another. From being an institution that buttresses certain previous bonds—family, race, religion, class, it has become for many a deep expression of the modern individual's ability to transcend all of those ties in an exercise of radical autonomy.[10]

Dan Savage has a more wry interpretation: "The institution of marriage, as currently practiced, is terrifically hard to define. Marriage is whatever two

straight people say it is. Kids? Optional. Honor? Let's hope so. Till death do us part? There's a 50/50 chance of that. Obey? Only if you're a female Southern Baptist."[11] So marriage has moved from an economic and social contract, often negotiated by parties other than the marrying couple, to a lifelong commitment, to an attachment based on love, honor, and obedience, to a commitment with no real contract and no clear end date.

Andrew Sullivan notes, "When we talk about the same-sex marriage debate, then, we are also talking about the marriage debate."[12] Conservatives are trying to hold on to a traditional, stable notion of marriage at a time not only when is it estimated that 50% of marriages will end in divorce (some surveys claim that the divorce rate is higher for conservative Christians than any other religious group, by the way) but also when fewer couples are getting married. Individuals are waiting longer to get married, if they get married at all. With such statistics, it is surprising that so many lesbians and gay men demand the right to marry and even more surprising that there is such virulent resistance to a group still committed to the idea of marriage. Sullivan observes that, however amorphous marriage has become, "the symbolic power of marriage, it turns out, is even deeper than that of citizenship, even starker than that of military glory, even clearer than that of public space. It is the institution where public citizenship most dramatically intersects with private self-definition. It is where people have historically drawn the line."[13] No wonder arguments against gay marriage are circular: "Marriage is between a man and a woman because, well, marriage is between a man and a woman." These arguments tend to be extremely emotional on both sides, and because they concern symbolism and prejudice more than substance, they are not easily resolved.

Given the contingency of contemporary marriage and the hostility to same-sex unions, why do many gay people care so much about marriage equality? In one sense, it is a demand that what is forbidden to gay men and women be granted by the primary institutions of our society, namely the government and the church. George Chauncey writes that many lesbian and gay couples "wanted to be recognized as fully equal. The fierce resistance to same-sex marriage had impressed upon people the power of marriage to symbolize that equality."[14] I bridle at the notion that my twenty-five-plus-year union with another man is not seen as equal, if not superior, to my three-year marriage to a woman. How can it possibly be just that our relationship is denied legitimacy?

In a civil sense, marriage offers legal protections we do not have without obtaining multiple contracts (e.g. power of attorney, health care power of attorney, etc.), which still do not give us full rights. As I look toward

retirement, I know that my partner of over two decades is not entitled to the same access to the retirement funds I have built up that my widow will have. Of course, all these matters could be taken care of with laws that claim equal legal protection for all domestic partners. However, the very laws that are being put through in many states to ban same-sex couples from marrying are also taking away many of the domestic partnership agreements we now have and further banning such agreements.

So the cry for the performance of marriage is a cry for a performance of parity with straight America, even if true parity means that gay divorces are likely to become almost as common as heterosexual ones. In this battle, we have already lost some of what we have slowly gained in recent years as the red states become more tied to Christian fundamentalism, itself a bastion against a larger culture, seemingly without a moral compass. For these people, lesbians and gay men are the worst examples of contemporary society's loss of values. We are ipso facto immoral, though the biblical ammunition they unleash to prove this is not convincing to anyone with a sense of biblical history.

If the issue of gay marriage divides heterosexuals, it also splits the fictional demographic known as "the gay community" into the groups wanting the right to share in all the institutions of American society (assimilationists) and those who want lesbians and gay men to be "queer," outside of and resistant toward such normative institutions as marriage. The argument voiced by Paula L. Ettelbrick is a typical queer critique: "Marriage runs contrary to two of the primary goals of the lesbian and gay movement: the affirmation of gay identity and culture and the validation of many forms of relationships."[15] For those of us in what I call the "gay center," there are a number of problems with Ettelbrick's assertion. It assumes a fixed gay identity that would be threatened by assimilation into the mainstream. What is a gay identity beyond a desire for persons of the same sex? Does "gay identity" not depend on a number of cultural variables? Is my "gay identity" the same as Ettelbrick's or that of the affluent nineteen year olds I teach or that of a working-class homosexual from West Virginia, much less that of a Chinese or Iranian gay person? And what is "gay culture"? I have written in the past about certain historical manifestations of gay culture, but I am aware that many lesbians and gay men have different senses of the term. To me, it may mean opera and show tunes; to another, it may mean Lady Gaga and club music. Others who feel desire for their own sex may not be invested in anything traditionally known as "gay culture." However, what Ettelbrick means by "gay identity and culture" are the cultural and political investments and personal style of one group of educated lesbians

and gay men. Her assertion is as problematic as the unexamined, unargued assertion that "marriage is between a man and a woman." The final season of Showtime's gay soap opera *Queer as Folk* centers on aging club boy Brian's resistance to the gay marriage of his best friend, Michael, and the desire for a committed relationship of his on-again, off-again boyfriend, Justin. The more domesticated Michael becomes, the more obnoxiously resistant Brian becomes to his best friend's new identity as a "Stepford Fag." Michael, his partner, Ben, and their adoptive gay son move into a settled gay community where same-sex couples talk about mortgages, decorating, and children. The more Justin sees of that world, the more he wants it for himself. However, Brian's world is Babylon, a gay nightclub with an orgiastic back room. For most of its five seasons, the show presents the split in the queer community between settled, some-times fraught coupledom and Babylon. The more settled, coupled lesbians and gay men are the ones who engage in political protests and campaigns. To Brian, Babylon is politics. It is the gay identity he is willing to fight for even if it means losing friends and lovers. When Babylon closes, he buys and reopens it. Are coupledom and Babylon conflicting segments of a community, opposing versions of "gay culture," or chronological stages in the lives of gay men? Should thirty-five-year-old Brian outgrow Babylon as Michael and Ben have? Should he leave it to the younger hunks and twinks? Ultimately, the series says yes. Coupledom and marriage for gay men (and, perhaps, for their straight counterparts) may be a particularly attractive option when one can no longer be part of the young crowd at Babylon. David Leavitt reflects on the horror with which "we regard the elderly queen who still devotes his life to the pursuit (usually in exchange for cash) of frequent and varied sex! 'That's the wonderful thing about us,' a particularly grotesque exemplar of the genre said to me a few years ago in Florence. 'We never grow up.' Better—more dignified—to be part of a dapper, elderly couple. 'Imagine! Two men together that long! What's your secret?'"[16]

Gay men are the first to note that age can wither. In Babylon, we become invisible once we no longer look young. Better to marry, though that is hardly a solid political argument for gay marriage. Ageism is not an exclusive property of the "gay community," but we offer a slightly exaggerated version of American popular culture's ridiculous emphasis on youth when most of the population is middle-aged or older.

The conflict played out in most of *Queer as Folk* reflects the one played out in the equally fictive "heterosexual community." Is the sexual market-place not the norm for many of those under thirty who will delay settling

down until they have had their fun, if at all? Should not all those conservatives fighting same-sex unions be happy someone, even if it is a homosexual, cares deeply about the institution of marriage?

"MARRY ME A LITTLE"

If weddings are performances, so is much of marriage, and gay playwrights may be more sensitive to the performances of married couples, not only the public performances of married coupledom but also the performances of the roles of husband and wife in the domestic sphere. Some past homophobic critics have maintained that gay playwrights cannot possibly understand marriage because they live outside it. However, they were raised by heterosexual parents, though the marriages of the parents of many of these writers were often unconventional and turbulent. Biographers point out that characters in the plays of Terence Rattigan, Edward Albee, and Tennessee Williams were based on their parents. In dramatizing marriage, gay playwrights exploited a popular topic of twentieth-century, middle-class drama, but their outsider status may have allowed them more distance. Writing on marriage may also have been a smokescreen for them at a time when expression of their own sexuality onstage or in their lives was proscribed.

Do gay playwrights treat marriage differently than their straight counterparts? Certainly, their plays were popular with heterosexual audiences. As necessarily closeted gay men, these writers knew what aspects of their own lives would be acceptable to the people around them and gauged their public behavior accordingly (Wilde may be the glaring exception here). It is commonplace now to speak of the homosexuality of these writers when discussing their work, but that was certainly not true in their own time. Perhaps, this necessary secrecy made them more sensitive to what audiences would accept and applaud. Success in the theatrical marketplace and affluence were important to all of them. One aspect of this study will be the tensions and compromises involved in writing popular drama.

I do not deal with musicals elsewhere in this book,[17] but a vivid example of the sort of compromise I am talking about can be found in the 1970 Stephen Sondheim-George Furth musical *Company*, written just after the Stonewall riots but before the legalization of homosexual acts in the United States and a very public gay presence. The subject of *Company* is marriage. Its central character, Bobby, is a bachelor with commitment issues who is about to celebrate his thirty-fifth birthday. Bobby cannot settle on one woman with whom to share his life (he admits to male lovers, but the musical does not deal with them). His ideal is a combination of the attributes of

the single women he beds and the married women who treat him like their kid brother. His visits to his married friends demonstrate the compromises married couples make to stay together. At best, as the song "Sorry, Grateful" puts it, Bobby witnesses the ways marriage elicits profoundly mixed feelings from the couples. The sort of marriage that Bobby can envision really is not a marriage at all. "Marry Me a Little," he sings at the end of the first act, offering a marriage that makes few demands on either party.[18]

The script and score of *Company* offer one of the most acerbic critiques of marriage the Broadway theater has seen, comparable to Edward Albee's work but with the upbeat ending required of a musical. In his powerful final song, "Being Alive," Bobby realizes that, like his married friends, to fully live he needs someone to hold him too close and need him too much. Bobby has his conversion on his thirty-fifth birthday. Marriage is again depicted as part of growing up.

In the 2011 London revival directed by Joe Fredericks, the most intelligent production of the musical that I have seen, Rupert Young presented Bobby as an unhappy, increasingly anxious man haunted by dreams. The action takes place entirely in Bobby's head as he ponders his future. Like his gay creators, Bobby is a detached observer in his married friends' homes, but his detachment is not satisfactory for him. The only way to have a real place in his society is to be married. At the same time, the ending of *Company* leaves some questions unanswered. In the final scene of the musical, Bobby imagines his friends gathering to give him a surprise birthday party, which he does not attend. If he has gone off to find a suitable partner, why does he have to reject his married friends? This ambiguous ending is one of the reasons why, despite Furth's and Sondheim's insistence that it is not what they intended, gay fans of the musical find it easy to read the ending as Bobby's coming out.

Company is an example of gay men creating a vision of contemporary heterosexual marriage. It is not only an ironic critique but also an affirmation that will satisfy all the married couples in the audience. Sondheim and Furth were, after all, wooing a large, primarily heterosexual audience. The many revivals of *Company* attest to its continuing relevance. The writers who are the subjects of this book perform the same balancing act as Sondheim and Furth. They too wrote successfully for an imagined heterosexual audience, though drama does not have to make the same compromises as a musical.

What one can say is that the writers I discuss here were particularly good at sympathetic depictions of women unsatisfied by the prevailing gender order and economy of marriage. Compare, for instance, the

sympathetic depictions of unfulfilled married women in the work of George Kelly, William Inge, and Tennessee Williams with Arthur Miller's obedient wives and Eugene O'Neill's female symbols that are often "the problem" in his plays. I do not want to make some essentialist statement about gay playwrights' unique sympathy for their female characters, but the playwrights who appear in this volume created the most fully rounded parts for actresses in the theater of their time.

THE OPEN SECRET AND PROTECTIVE CIRCLES

What was the position of the gay playwright in the first half of the twentieth century? Certainly, the men I discuss in this book were commercially successful and often the best the age had to offer. Personally, for the most part, they may have been "out" to their friends and many of their colleagues but were protected by fictions of heterosexuality and respectable bachelorhood. They lived within the open secret. With the exception of Noël Coward and George Kelly, they were born into the upper middle class, but all of them came to live in a sophisticated, affluent environment that to some extent supported and protected them. Indeed, Coward and Rattigan were attacked for their supposed celebration of upper-middle-class values. In the United States, Edward Albee, Tennessee Williams. and William Inge were attacked in the press for their sexuality, which supposedly made it impossible for them to create convincing heterosexual characters.

As I began research on the book, I became aware that the playwrights I discuss were all connected, often in intimate ways. One aspect of gay culture in the era of Draconian prohibition, sanctioned prejudice, and the ensuing closet was the creation of protective circles of men who offered professional support, even if there was also some fierce rivalry. British theater in the first half of the twentieth century offers a fascinating example of a social and professional circle that remained unbroken despite competition and feuds. Oscar Wilde had an affair with successful American playwright Clyde Fitch. Somerset Maugham knew and slept with writer Beverley Nichols, who later published a scathing attack on the novelist-playwright. Maugham was also close friends with Noël Coward, who wrote a play loosely based on Maugham's long-term relationship with Gerald Haxton. Maugham's nephew, Robin, became a respected writer whose novel, *The Servant,* became a film classic. Playwright-actor Emlyn Williams met the young Terrence Rattigan, fresh from Oxford, at John Gielgud's flat, and socialized with Coward, actor-director Charles Laughton, and actor-dancer

Robert Helpmann. The most successful West End producer of the period, Hugh "Binkie" Beaumont, whose homosexuality and casting couch were open secrets, produced much of the work of these men. After all, Coward and Rattigan were the most successful playwrights of the 1930s and 1940s, just as Maugham had been the toast of the West End and Broadway during the previous two decades. All three men are known through classic film versions of their work. In the United States, Tennessee Williams was mentor to and probably lover of William Inge, and for a time, Edward Albee and Terrence McNally, American's premier playwright of gay men, were lovers.

In his book *Straight Acting,* Sean O'Connor defines the work of Maugham, Coward, and Rattigan as "popular gay drama."[19] Popular drama it certainly was. The playwrights I discuss aspired to commercial success: they were drawn to the theater because playwriting was a lucrative profession. Some of the plays I discuss in the book have not stood the test of time. They were meant to be crowd pleasers, and the tastes of the crowd change, but their success in their own time speaks to the ways in which their creators, whose sexuality placed them outside of the mainstream (and the law), were able to write versions of marriage their audiences enjoyed. Their plays have not been the subject of serious analysis for decades, so for many readers, this book will be an introduction to their work and to some twentieth-century popular drama.

If one sees all drama written by homosexuals as "gay drama," then the term is appropriate for the works discussed in this volume. The crucial point is that the work of these successful dramatists was also the straight drama of the time, and these artists' portrayals of heterosexuality were the most powerful and amusing on the British and American stage during the last century. For the contemporary reader, there is a subversive quality to the best works that gives them continued interest.

THE PERSISTENCE OF DOMESTIC REALISM

During a recent spate of London theatergoing, a fellow drama scholar was surprised to find that the mode of presentation of British drama, whether revivals of work from half a century ago or plays by new, young playwrights, was much the same as it was in the late nineteenth century. It is indeed true that many contemporary authors—and their audiences—still favor domestic realism, the dominant mode of representation for British and American drama since the middle of the nineteenth century, when the box set was developed. In Oscar Wilde's time, the curtain rose on a

convincingly realistic, scenic representation of a domestic interior inside which actors created detailed performances. Costumes were to be opulent and fashionable, mirroring the apparel of the occupants of the best seats in the house. Playwrights like Oscar Wilde and Clyde Fitch, who also directed his own work, obsessed over details of costume and decor. Audiences at West End and Broadway theaters wanted to see an opulent environment and fashions to mirror their own taste. While later, serious modern playwrights were more interested in the experience of the economically oppressed, their dramas were presented with the same realistic detail—the kitchen sinks on the set had running water. What was considered to be realistic acting within these settings changed over the years. In Oscar Wilde's time, stars were expected both to act according to the class of their characters and to give star turns. By the time Rattigan and Williams began writing, realistic acting had become more nuanced, more psychological. Williams was less comfortable with the conventions of theatrical realism than his British counterparts, but he was dependent on the dominant acting style of the day, which was based on the version of Stanislavski's techniques advocated by veterans of the Group Theatre who had become the major directors and acting teachers in the United States.

Most of the plays in this volume are examples of domestic realism. They are written to be performed in convincing representations of living rooms or other domestic social spaces. Most of them depict aristocratic or upper-middle-class characters. What one saw on the stage was shaped in part by the taste of the audience members who could buy the most expensive seats. Within this visual mode of representation, we shall see a variety of writing styles from the elegant wit of Wilde, Maugham, and Coward to the more mundane but no less eloquent style of Kelly, Inge, and Williams, to the understatement of Rattigan, to the theatricality of Albee's speech. Domestic realism allows a variety of verbal styles. Marriage raises even more questions for contemporary society than it did in Wilde's time, so it is not surprising that domestic realism continues to thrive as a dramatic style.

The Drama of Marriage begins with Oscar Wilde and ends with some contemporary plays about gay marriage. In chapter 1, I look at two seminal British gay figures of the 1890s: Edward Carpenter, whose writings on marriage and homosexuality were to have an enormous impact on both sides of the Atlantic, and Oscar Wilde, whose comedies of marriage were cheered until his life as a gay man eclipsed his work. These men offer contrasting versions of homosexuality and marriage in their time. As we shall see, in many ways, Wilde's dramatic pronouncements on the gender order

and on marriage were often quite conservative. It is interesting to note that a constant theme in his work is the education of a straight-laced wife on the moral ambiguities of masculine behavior.

Chapter 2 is devoted to Somerset Maugham, one of the most successful writers of the twentieth century. Though remembered primarily as a writer of fiction, for over twenty years from 1907 until 1933, Maugham was the writer of some of the most acclaimed and profitable social comedies and melodramas produced in London and New York. The chapter focuses on the ways in which Maugham's work mirrors his own turbulent life and offers an acerbic view of the role of the upper-middle-class wife.

Noël Coward's final London play and acting performance was a fictional portrayal of Somerset Maugham. Coward replaced Maugham as the master of stage comedy, and his most celebrated works reject conventional marriage as irrelevant to the experience of his witty narcissists. Terence Rattigan's richest plays examine the conflict between sexual desire and social convention that makes marriage difficult, if not impossible. For decades, Coward and Rattigan were the most popular playwrights on the British stage. Chapter 3 focuses on their work.

Chapter 4 centers on actor, playwright, and memoirist Emlyn Williams, whose autobiographical volumes offer a conventional narrative of the "development" of a self-absorbed young man from intense homosexual relationships to heterosexual marriage. His play *Accolade* can be read as a coded presentation of his own double life.

American playwrights Clyde Fitch and George Kelly are the focus of chapter 5. Fitch was the most prolific and financially successful American playwright before World War I. Now Fitch, possibly a former lover of Oscar Wilde, is seen more as a footnote to gay history. Like Wilde and Maugham, accounts of and speculation about his private life have almost overshadowed his work. In the 1920s and 1930s, George Kelly's work offered a more substantial and more eccentric view of American domestic life. Like Fitch, Kelly has become the subject of gay scholarship, though his plays deserve more critical attention than they have received.

By the 1950s, playwrights were queering middle-class marriage and the sex/gender system underlying it in complex ways. William Inge's highly successful work presents a sad view of marriage as entrapment. Tennessee Williams's comedies *The Rose Tattoo* and *Period of Adjustment* present bittersweet views of the eroticisms and gender politics of marriage. The work of these men will be discussed in chapter 6.

No British or American playwright has been as devoted to dissecting the ambiguities and complexities of marriage as Edward Albee, who is the

subject of chapter 7. From his early one-acts to his more recent work, like *The Goat,* Albee's setting of choice is an upper-middle-class living room peopled by a husband and wife whose relationship has become a complex series of negotiations, compromises, and battles.

In chapter 8, "Gay Playwrights, Gay Husbands, Gay History," I discuss how contemporary gay playwrights use the narrative of the gay husband unhappily trapped in a heterosexual marriage as a means of creating a theatrical picture of gay history of the past half-century.

The question addressed by the works discussed in this book is "Is marriage possible?" To those of us who believe in committed relationships, whether or not we are allowed to marry, real and metaphorical marriage is a process and a challenge, an ideal sought but never truly attained. At best, what we see in depictions of marriage is just that process. At worst, what we see is failure that reveals the flaws in the couple involved and the flaws in the institution of marriage. As many of us fight for the right to marry, we must also understand the contingency and variety of forms represented by the word "marriage." The works discussed in these pages see it as an unattainable ideal that we mortals continually fail to achieve, yet an ideal we also continually strive for.

1. Edward Carpenter and Oscar Wilde: Ideal and Real Marriage ᧞

As long as man is only half-grown and woman is a serf or a parasite, it can hardly be expected that Marriage should be particularly successful.

Edward Carpenter, *Love's Coming-of-Age*

Between men and women there is no friendship possible. There is passion, enmity, worship, love, but no friendship.

Lord Darlington in Wilde's *Lady Windermere's Fan*

Any study of the relationship of gay writers to the discourse on heterosexual marriage in modern drama must begin with Oscar Wilde (1854–1900), but while Wilde was basking in his all-too-brief success as a West End playwright, Edward Carpenter (1844–1929) was writing one of the works that would make him both a canonical gay writer and a champion of marriage reform. Both Oscar Wilde and Edward Carpenter were born of privilege and became distinguished university graduates, but they took opposite paths. Carpenter imported the muscularity, homoeroticism, and democratic spirit of American poet Walt Whitman to Britain while Wilde famously tried to export his aestheticism to America. Carpenter spent his life speaking and writing in support of socialism; Wilde wrote essays in favor of socialism but was too much of an individualist to be part of any movement. He was sympathetic to Carpenter's writings on socialism but found them too solemn. Both, in very different ways, became gay icons: Wilde as martyr, Carpenter as champion of homosexual rights. While Wilde became a symbol of excess and depravity for his time and place, Carpenter was seen by many radicals and homosexuals of the

late nineteenth and early twentieth centuries as the visionary who would lead to a more enlightened attitude toward homosexuality. Wilde symbolized an effete, urban homosexual who lived outside of conventional morality; Carpenter lived a rural life—a kind of British counterpart to the experience of Henry David Thoreau at Walden Pond half a century before. Wilde's indiscreet liaisons with teenage, working-class rent boys led to his imprisonment. Carpenter believed in comradeship and love between the classes outside of capitalist structures and, despite the law and the hysteria stirred up by the Wilde scandal, had a long-term, though nonmonogamous, partnership with an uneducated, working-class man. The Wilde scandal made Carpenter's project of decriminalization of homosexual acts all the more challenging.

THE RESPECTABLE HOMOSEXUAL

For progressives in England and the United States in the late nineteenth and early twentieth centuries, particularly for those interested in sex reform, women's rights, and civil treatment of homosexuals, no figure is more central than Edward Carpenter, the Cambridge cleric who moved to the country for a simple life and became a key figure in a number of reform movements. Carpenter was a socialist, environmentalist, and advocate of prison reform. He is most remembered now as the most important figure in early twentieth-century gay politics. Historian Matt Houlbrook points out that "between the wars, Edward Carpenter's work was particularly important in framing a respectable 'homosexual' selfhood, predicated upon his exaltation of the moral and spiritual worth of love between men."[1] Matt Cook notes, "Carpenter looked on homosexuality as part of a wider vision of social renewal, and positioned it clearly on his broad socialist and democratic agenda."[2] Carpenter's writings on homosexuality were part of a larger general desire to reform all sexual and affective behavior and the laws governing them. As Sheila Rowbotham points out, "Carpenter not only asserted that same-sex desire was congenital, he insisted that private behavior was beyond the province of the law."[3] Carpenter protested the removal of Oscar Wilde's name from the playbills of *The Importance of Being Earnest* after the playwright was convicted because he believed that the law should not be involved in sexual matters and that Wilde's use of rent boys was morally no different from the common heterosexual male's use of female prostitutes.

This pioneer for gay politics also authored of one of the major works on marriage reform. In 1894, Carpenter wrote a series of pamphlets on

marriage that were published two years later in book form under the title *Love's Coming-of-Age,* a work that was reprinted many times over the next few decades. *Love's Coming-of-Age* was supposed to include another essay published in pamphlet form in 1894 (the year Wilde's *The Importance of Being Earnest* was written), "Homogenic Love," that equated male-male love and sexuality with heterosexual love, but the reverberations from the Oscar Wilde scandal made its inclusion in the first edition of *Love's Coming-of-Age* impossible (it was included in the 1906 edition), and Carpenter's major book on homosexuality, *The Intermediate Sex,* was not published until 1918.

Love's Coming-of-Age, written by a man who had never been married and whose primary relationship was with a man, became a central work of marriage reform that was, for Carpenter, the cornerstone of his larger agenda for social reform. Carpenter met George Merril in 1891 (the same year Wilde met Lord Alfred Douglas), and they remained partners until Merril's death in 1928. Carpenter was 47 years old when he met the 25-year-old Merril. They were also separated by class and education, but this difference was seen by many of Carpenter's disciples as a model for relationships that would break down Britain's rigid class system. Carpenter, who above all believed in an organic, unified life, had to make his sexuality part of his political program. Love embraced all possibilities.

IDEAL MARRIAGE

When Carpenter's pamphlets were compiled in book form under the title *Love's Coming-of-Age,* he ordered his topics in a way that would be shocking to some Victorian sensibilities. The book begins with a chapter on what Carpenter calls "The Sex-Passion," which centers on the relationship between sex and spiritual love. While the 1890s was a decade in which sex was beginning to be the subject of important scientific writings, there was still a disinclination to make sex the basis for a discussion of marriage, and Carpenter balanced his radical approach with an assertion of the importance of self-control and the primacy of the spirit over the flesh. Like American writers Henry David Thoreau and Walt Whitman, Carpenter combined a Western sensibility with a fascination for the integration of body and spirit he found in Eastern religions. Sex and love were part of a mystical pattern:

> Sex is the allegory of love in the physical world. It is from this fact that it derives its immense power. The aim of love is non-differentiation—absolute union of

being; but absolute union can only be found at the center of existence. Therefore who has truly found another has not only found that other himself, but has also found a third—who dwells at the center and holds the plastic material of the universe in the palm of his hand, and is a creator of sensible forms.

Similarly the aim of sex is union and non-differentiation—but on the physical plane—and in the moment when this union is accomplished creation takes place.[4]

Erasing difference and gender inequality is the foundation of Carpenter's vision of social reform. He also sought a balance between sexual expression and Victorian morality: sex is crucial to the union of two people and no marriage can exist without it, but like all pleasures, it should be enjoyed but not seen as an end in itself. Nor should it be considered dirty and repressed. This balance distanced Carpenter from libertines like Oscar Wilde and from the common Victorian tendency to make sex shameful. It had to be integrated with love and kept under control: "It is not perhaps until the great current of sexual love is checked and brought into conflict with the other parts of his being that the whole nature of the man, sexual and moral, under the tremendous stress rises into consciousness and reveals in fire its god-like quality" (11).

From sex, Carpenter moves on to the Victorian notions of gender that make true marriage impossible. The chapters after "The Sex-Passion" outline the current place of "Man" and "Woman." Men are crippled by their education, which teaches them to dominate but does not teach them self-consciousness or spiritual development: "They really have never come of age in any adequate sense" (33–4). Men create society in their image: "In consequence of which we naturally have a society made after his pattern—a society advanced in mechanical and intellectual invention, with huge passional [sic] and emotional elements, but all involved in whirling confusion and strife—a society ungrown, which on its material side may approve itself a great success, but on its human and affectional side seems at times an utter failure" (31–2). Part of the male-created capitalist order, built on his "craze for property and individual ownership" (44), is the enslavement of women. As a result, there are only three roles for women: the upper-middle-class lady who is basically an ornament, the lower-middle-class household drudge who is free domestic labor, and the prostitute. The limited roles women are allowed lead them to develop guile in order to have any power over their lives. As we shall see, Oscar Wilde had a more conservative sense of gender roles. For him, the limited moral education of the upper-middle-class and aristocratic wives made it impossible for them to understand their

husbands. Far more interesting was the scheming "fallen woman" who is capable of manipulating men. Somerset Maugham would make this type of woman the central character in his plays. Yet these playwrights are indifferent to Carpenter's social critique of the causes of their characters' behavior. What can marriage be in such a society, and what should marriage be? Idealistic in all things, Carpenter envisioned marriage as a "permanent and life-long union... founded on some deep elements of attachment and congruity in character" (93). This union is based on a selfless love for the partner:

> That there should exist one other person in the world towards whom all openness of interchange should establish itself, from whom there should be no concealment; whose body should be as dear to one, in every part, as one's own; with whom there should be no sense of Mine or Thine, in property or possession; into whose mind one's thoughts should naturally flow, as it were to know themselves and to receive a new illumination; and between whom and oneself there should be a spontaneous rebound of sympathy in all the joys and sorrows and experiences of life. (93–4)

Carpenter saw that his vision of ideal marriage was impossible within the prevailing sex/gender system and that "actual marriage, in its squalid perversity" was the union of a half-grown man and a woman who was "a serf or a parasite" (74): "The monetary dependence of the woman, the mere sex-needs of the man, the fear of public opinion, all form motives, and motives of the meanest kind, for maintaining the seeming tie; and the relation of the two hardens down into a dull neutrality, in which lives and characters are narrowed and blunted, and deceit becomes the common weapon which guards divided interests" (76).

To move the real marriage closer to the ideal, Carpenter proposed a reform of the institution. First, women must have economic equality and freedom, which Carpenter thought more likely in a noncapitalistic society. Second, sex education was necessary to ensure sexual fulfillment for both men and women without which there could be no real marriage. Third, women had to have free movement outside the home and social relations with friends and institutions outside of the marriage. Marriage was a balance of freedom and commitment, and Carpenter believed that monogamy was essential for a successful marriage and that social norms were necessary to protect the institution:

> While we cannot help seeing that the marriage-relation—in order to become the indwelling-place of Love—must be made far more free than it is at present,

we may also recognize that a certain amount of external pressure (as things are at least) is not without its uses; that, for instance, it tends on the whole to concentrate affectional experience and romance on one object, and that though this may mean a loss at times in breadth it means a gain in depth and intensity. (91–2).

Carpenter could not advocate for married couples the kind of sexual freedom he claimed for himself within a loving relationship. The changes he called for were radical enough for their time, and while the language of *Love's Coming-of-Age* may seem prudish to us, his insistence on sexual satisfaction for both parties as a crucial basis for a successful marriage was ahead of its time.

Carpenter realized that the kind of marriage he called for would not be possible for everybody because not everyone was capable of the "loving surrender to another" that is the basis of marriage (110).

For the twenty-first century, many of Carpenter's ideas are hopelessly dated. While one can admire his ideas about gender equality, Carpenter had very conventional notions of gender behavior (e.g., male strength, female sensitivity). The same ideas underpin Carpenter's idea of homosexuality. If capitalism is an expression of unbridled masculinity, then reform will come from those not totally masculine; that is, women and "the intermediate sex," homosexuals who ideally combine qualities of both sexes: "We find a man who, while possessing thoroughly masculine powers of mind and body, combines with them the tenderer and more emotional soul-nature of the woman."[5] Carpenter cites examples from history and literature to demonstrate that such men are capable of great and lasting love. He is perhaps overly cautious or simply wrongheaded about the place of sex among homosexuals. He goes so far as to claim that "their love-feeling…is gentler, more sympathetic, more considerate, more a matter of heart and less one of physical satisfaction than that of ordinary men" (128). Despite the laws proscribing homosexual acts, homosexual unions "are remarkably permanent. Instead of the wild 'general post' which so many good people seem to expect in the event of law being relaxed, one finds (except of course in a few individual cases) that common sense and fidelity and a strong tendency to permanence prevail" (125). Many of Carpenter's claims were rebuttals to the prevailing prejudices about homosexuality and homosexual behavior that were reinforced by the public exposure of Oscar Wilde's promiscuity.

When Carpenter wrote his pamphlet *Homogenic Love* in the 1890s, it could be seen in the context of other radical writings on homosexuality,

particularly the work of Carpenter's friends John Addington Symonds and Havelock Ellis. Despite the stringent prohibitions on homosexual behavior, this group of intellectuals, inspired by Walt Whitman and German writing on sexuality, supported each other in the campaign for the reform of thinking and laws on sexuality in general and homosexuality in particular. Symonds died in 1893, but Ellis's *Sexual Inversion* was published in German (medical work at the time was often published in German) in 1896 and in English in 1897. Ellis's work was considered scientific, but Carpenter's pamphlet on homosexual love was perceived as political. It was circulated privately but not published until 1906. It would be a long time before anyone would produce a play or publish a novel that reflected Carpenter's arguments for homosexual rights and the sanctity of homosexual unions. The most important novel directly influenced by Carpenter was E. M. Forster's *Maurice,* written in 1913 but only circulated privately in the author's lifetime and not published until 1971 (and turned into a superb film by the gay Merchant Ivory team in 1987).[6] Eventually, Carpenter's works were widely read and important to homosexuals of the period. For decades after its publication, *Love's Coming-of-Age* was equally important. It became one of Carpenter's most widely read works in England, the United States, and, through translation, many European countries. As we shall see, his views on marriage are echoed in the works of Maugham and other writers of the period.

REAL MARRIAGE

Carpenter's championing of the intermediate sex and male-male love became crucial to men trying to carve out a positive identity, particularly after the Oscar Wilde trials did so much to reinforce a negative view of homosexuality. Carpenter's ideas on homosexuality were widely published in a series of pamphlets; Wilde's most famous utterance on the Greek ideal of male-male love was delivered from the prisoner's dock in a Bow Street courtroom. At the time of publication of Carpenter's pamphlets on marriage and homosexuality, Oscar Wilde, poet, critic, novelist, and former editor of *Woman's World* magazine, was basking in his success as a West End playwright. His five hit plays were written and produced as his life was about to spin out of control. He had virtually left his wife and sons and, like his Jack Worthing in *The Importance of Being Earnest,* was living for "pleasure, pleasure"[7] while basking in his newfound theatrical success. Carpenter was an advocate of what one may call the authentic life. Wilde saw life as a series of performances. Certainly, his view of

marriage was that it was greatly a performance. Indeed, Oscar Wilde's views on gender and marriage reflect just the sort of crippling notions of gender Carpenter attacks. Wilde saw himself as something of a feminist, but in his plays, women are either ladies or refined courtesans.

When I read Wilde's plays, I think first not of their author but of Constance, his wife, who tried her best to be a loving, devoted wife and mother even after her husband spurned her, humiliated her, and dragged her into his scandal. I think of the woman who, from all reports, remained loyal to her husband until it became clear that, even after prison and the reflection and penance of *De Profundis,* he was incapable of freeing himself from his self-destructive tendencies and his addiction to the mad, bad Bosie. In many ways, Constance Wilde resembles the young wives in her husband's dramas, thrown into a morally complex situation their education has not prepared them for, except that Wilde's young heroines escape scandal and do not die a painful, early death. Constance had to deal with the implications for her and her children of the greatest scandal of her age. If it had been put on stage, Constance Wilde's story would have been considered "sordid" by her husband and certainly by his audience.

Wilde's marriage to Constance resembles the marriages Carpenter decries. A man educated in an all-male environment chooses a wife he sees as an ornament for a marriage that will be a performance of marriage. Constance was anything but a vapid ornament. Compared to many women of the time with a limited formal education, she was quite cultured. She had traveled in Europe, was fluent in French and Italian, and was seriously interested in art and the aesthetic movement. After her marriage to Oscar, she wrote intelligent theater reviews for women's magazines and was such an advocate for sensible dress for women and children that she edited the *Rational Dress Society Gazette* for two years. Later, she became interested in photography. Biographer Joyce Bentley describes Constance as a "cultured, beautiful and well-read" woman who had "her quiet independence, her own views on art and morality, which opposed some of his [Oscar's]."[8] She had her own circle of friends and interests. Her at-homes were as glittering as those depicted in Wilde's plays. If she had any flaw, it was, as Franny Moyle notes, that "Constance was by nature a fanatic who would throw herself wholeheartedly into one fad or craze before moving on to another. After her profound commitment to occult mysticism in the late 1880s, in the '90s Constance moved on from 'Rosacrucianism and fairies' to the booth presided over by the socialist clergymen."[9] Wilde wrote of his marriage to Constance, "There is one thing infinitely more pathetic than to have lost the woman one is in love with, and that is to

have won her and found out how shallow she is."[10] "She could not understand me," Wilde wrote, "and I was bored to death with the married life." Neil McKenna opines that part of that boredom came with Constance's "frequently expressed sense of conventional morality" (88). Certainly, her morality was sorely tested by her husband's open violation of his marriage and association with male prostitutes. His scandal also placed her in an untenable position: "I am obliged to live abroad and the boys will be forced to make their own way in life heavily handicapped by their father's madness for I can consider it nothing else."[11] Nonetheless, she tried to be the loyal wife. Though in ill health from a spinal condition that was never properly diagnosed from which she became increasingly, painfully crippled throughout the rest of her life, Constance traveled from Genoa to Reading Gaol to inform her estranged husband of his mother's death (Constance had been a good friend and caregiver to Wilde's mother). That is not the act of a woman crippled with conventional morality. After his release from prison, she wrote: "I have again had pressure put upon me to persuade me to go back to Oscar, but I am sure you will agree that it is impossible. I am told that I would save a human soul, but I have no influence upon Oscar. I have had none, and though I think he is affectionate, I see no reason for believing that I should be able now to perform miracles, and I must look after my boys and not risk their future."[12] Her only influence was financial, cutting off Wilde's income when he reunited with Bosie. Wilde mocked even that attempt at influence: "How can she really imagine that she can influence or control my life? She might just as well try to influence and control my art. I could not live such an absurd life—it makes one laugh."[13] Constance died in 1898, two years before her husband.[14] Wilde claimed to be grief stricken at Constance's death, but an account of his visit to her tomb was more in the line of self-justification: "I was deeply affected—with a sense, also, of the uselessness of all regret. Nothing could have been otherwise, and Life is a very terrible thing."[15] Here is Wilde in his role as tragic figure, a victim of fate—a role that allowed him to avoid responsibility for his actions.

It is interesting to note that *De Profundis,* the long letter Wilde wrote to Bosie from Reading Gaol in 1897, is greatly an attack on Bosie for his shallowness, yet Wilde could never fully cut himself off from Bosie as he did from his wife and the mother of his sons. In need of infinite variety, Wilde found the routine of marriage repellent. Bosie never asked for fidelity or routine: he wanted only money, constant company, and diversion. Add to this Wilde's revulsion for the female body and his discovery of and growing addiction to pederasty, and the marriage was bound to collapse.

I raise the issue of Bosie in this discussion of Wilde and marriage because Wilde's relationship with the young lord was far more intense than his relationship with Constance, perhaps because Wilde could see it as tragic. In one sense, Wilde saw Bosie as the Greek ideal, the willing disciple, an aspiring poet who seemed eternally youthful. On the other hand, Wilde seemed aware that Bosie was also something of an evil genius, keeping him away from his work and leading him into sexual addiction. We may see it now as a horrible codependency, but Wilde saw it as tragic love. Conventional marriage, as he so brilliantly depicted it in his plays, was comic with a spicing of melodrama. Fortunately, he did not live to see Bosie turn into a version of his father, an irrational, litigious bully who, ironically, spent six months in jail for libel.

I find one of the most telling insights into Wilde's view of marriage in his magnificent, if terrifying, novel, *The Picture of Dorian Gray* (serial, 1890; book, 1891). Dorian sees a lovely young actress on stage playing Shakespeare's heroines. The theater in which she performs may be tawdry, but Dorian finds Sibyl Vane radiant: "Ordinary women never appeal to one's imagination. They are limited to their century. No glamour ever transfigures them. One knows their minds as easily as one knows their bonnets. One can always find them. There is no mystery in any of them...But an actress! How different an actress is!"[16] Dorian is enthralled with the roles Sibyl plays. When the aesthete Lord Henry Wooten asks Dorian, "When is she Sibyl Vane?" Dorian responds, "Never" (66). Dorian has no interest in the offstage working-class girl he has idealized. Unfortunately, Sibyl Vane's love for Dorian destroys her ability to enter fully into the fantasy of the theater: "You taught me what reality really is. To-night, for the first time in my life, I saw through the hollowness, the sham, the silliness of the empty pageant in which I had always played" (75). Sybil's experience of real emotions hinders her ability to act out a fantasy onstage, and Dorian witnesses a poor performance. He is not interested in the real Sibyl Vane and her protestations of love. He wants the actress and the illusion: "You have killed my love," he cries as he abandons her (75). Dorian wants a woman to have mystery, but that mystery involves having no personality of her own and having no sexuality. Wilde, too, may have felt this. Neil McKenna writes of Wilde's feelings about his wife, Constance: "Oscar had married the Madonna Mia of his poetic imagination. With her slender, boyish figure and tremulous flower-like beauty, Constance was the embodiment of sexual innocence: unsullied, untouched, and untainted by any overt manifestation of sexuality. Oscar worshipped her purity, her freshness."[17] He claimed to have fallen out of love when he was confronted

with the physical reality of Constance's pregnancy: "When I married, my wife was a beautiful girl, white and slim as a lily, with dancing eyes and gay, rippling laughter like music. In a year or so the flowerlike grace had all vanished; she became heavy, shapeless, deformed."[18] Constance was no longer a girl, but Oscar, like Dorian, was obsessed with youth and ideal beauty. His wife was supposed to remain a girl, as boys, not men, would be an irresistible attraction.

It is not surprising that the only truly erotic play Wilde wrote is about a teenage girl whose sexuality was destructive. Salome is a sexual magnet. Narraboth, captain of the guard, kills himself out of jealous passion, and her stepfather, Herod, desires her. Salome dies overwhelmed with desire for the man she cannot have. If Salome cannot have Jokanaan's body, she will have his head. For that, she will reveal her own body to her stepfather and his court. She gets her way by playing on her stepfather's desire for her. At the end, she kisses the lips of the man she has had killed: "I am athirst for thy beauty. I am hungry for thy body; and neither wine nor fruits can appease my desire. What shall I do now, Jokanaan?" (741). Joseph Donohue notes that "desire does indeed lie at the very centre of the play, multivalent, chaotic and ungovernable."[19] I would add that in the play desire is both insatiable and proscribed. It is everywhere, yet must be kept within limits. The play is a chronicle of sexual frustration. A decade later, it would be brilliantly complemented by Richard Strauss's sinuous chromatic orchestration. Wilde's *Salome* demands music. Above all in *Salome* (1893), female sexuality is omnivorous and dangerous. Frank Harris, not the most reliable of biographers, claims that Wilde told him that "a woman's passion is degrading. She is constantly tempting you. She wants your desire as a satisfaction for her vanity more than anything else, and her vanity is insatiable if her desire is weak, and so she continually tempts you to excess, and then blames you for the physical satiety and disgust which she herself has created."[20] Salome is an extreme representation of the destructive female sexual appetite. Goaded by a monstrous mother and sybaritic stepfather, she is the alluring but horrifying manifestation of a court run amok.

There are times when Wilde seems as sensitive as Carpenter to the position of women in his society. The title character of his poetic drama *The Duchess of Padua* (1883) claims:

We are their chattels, and their common slaves,
Less dear than the poor hound that licks their hand,
Less fondled than the hawk upon their wrist.
Woo, did I say? Bought rather, sold and bartered,

Our very bodies being merchandise.
I know it is the general lot of women,
Each miserably mated to some man
Wrecks her own life upon his selfishness:
That it is general makes it not less bitter. (594)

Lady Markby voices the same sentiment as a witty epigram in *A Woman of No Importance:* "Mine [my husband] is the general rule, and nothing ages a woman so rapidly as having married the general rule" (518).

There is neither the unbridled desire of *Salome* nor the bitterness of his duchess in Wilde's hit plays, but these drawing room classics offer an interesting double view of Victorian morality and marriage. On one hand, the plays are melodrama built on the conventions of the well-made play and not terribly different from the social melodramas of Arthur Wing Pinero and Henry Arthur Jones, but on the other, Wilde's genius combined this melodrama with witty social satire. While they seem to uphold conventional standards of morality and celebrate marriage, they are constantly questioning those standards and satirizing those who unthinkingly hold conventional ideals.

LEARNING RELATIVITY

While Wilde was deserting his role as husband and father, he was having enormous success in the theater. Marriage was a favorite subject of audiences in the 1890s, and Wilde had found a way to write popular, lucrative plays on the subject.

One common narrative in Oscar Wilde's plays is that of a young woman filled with the sort of moral certainty we identify with Victorian England who learns that love means accepting moral frailty (the title character in *Lady Windermere's Fan,* Lady Chiltern in *An Ideal Husband*). Another is the fate of the "fallen woman" who may be too accepting of moral ambiguity to be admirable (Mrs. Erlynne in *Lady Windermere's Fan,* Mrs. Chevely in *An Ideal Husband*), but who is more fun than the virtuous, young wives. These two characters merge in the moralistic single mother, Mrs. Arbuthnot in *A Woman of No Importance,* a self-proclaimed fallen woman who is still a paragon of moral rectitude. The men in these plays come in shades of gray: from the good, if misunderstood, husband of *Lady Windermere's Fan* to the devoted husband with a sordid political past in *An Ideal Husband,* to the well-meaning bachelors, Lord Goring and Lord

Darlington, and the outright cad, Lord Illingworth in *A Woman of No Importance.*

The women in these plays are defined by their relation to men. Pragmatic women want men to do something for them; "good women" demand that their husbands are also good. "The Ideal Man," says one of the society women in *A Woman of No Importance,* "should talk to us as if we were goddesses and treat us as if we were children" (447). These people have never read or seen Ibsen's *A Doll's House.* Wilde's fallen women, who have learned the sort of guile Edward Carpenter described, are not destroyed as they are in much Victorian melodrama, but his good women, like the heroines of *Lady Windermere's Fan* and *An Ideal Husband,* must learn that moral absolutes can destroy a marriage.

In *Lady Windermere's Fan* (1892), the comments about marriage are expressed more in the play's serious moments than in witty epigrams. There is less social satire than in the later plays, yet the play is fascinating in that nothing is as it seems and illusions are never totally dispelled. Margaret—Lady Windermere—the central character, is about to celebrate her twenty-first birthday, symbolically her coming of age. Though Lady Windermere is a major figure in London society, her own parentage, like that of so many of Wilde's characters, is questionable. After her mother ran off with another man and her father died of a broken heart, young Margaret was raised by an aunt, a paragon of rectitude who maintained the myth that the girl's mother was dead: "My mother died when I was a mere child. I lived always with Lady Julia, my father's elder sister, you know. She was stern to me, but she taught me what the world is forgetting, the difference between what is right and what is wrong. She allowed no compromise" (387). Nor does Lady Windermere when she suspects that her husband is having an affair with the notorious Mrs. Erlynne.

The glittering society surrounding Lady Windermere is cynical about marriage. Her friend, Lord Darlington, calls it a game:

> *Lord Darlington*: It is a curious thing, Duchess, about the game of marriage—a game, by the way, that is going out of fashion—the wives hold all the honors and invariably lose the odd trick.
> *Duchess of Berwick*: The odd trick? Is that the husband, Lord Darlington?
> *Lord Darlington*: It would be rather a good name for the modern husband. (389–90)

In this somewhat forced card metaphor, the wives win, but lose their husbands in the process. Honor is a term in a card game.

To the ladies, marriage is a performance. Lady Plymdale comments, "It's most dangerous nowadays for a husband to pay any attention to his wife in public. It always makes people think he beats her when they're alone. The world has grown so suspicious of anything that looks like a happy married couple" (400). Or marriage is a realistic, decidedly unromantic transaction, as it is for Mrs. Erlynne, who is in need of the income that comes with a husband: "And I dare say I'll make him an admirable wife, as wives go. And there is a great deal of good in Lord Augustus. Fortunately it is all on the surface" (407). At the heart of "the world's" suspicion is the deep-seated cynicism about marriage Wilde projects onto the world of his play. When Lady Windermere says, "I can't believe my husband is untrue to me," the Duchess of Berwick responds, "Pretty child! I was like that once. Now I know that all men are monsters" (392). Typical of Wilde's society ladies, the women around Lady Windermere articulate a negative view of men in general and of their spouses in particular. This cynicism is yet another performance, but Lady Windermere, like other "good women" in Wilde's plays, is not adept at distinguishing between candor and artfulness. When she suspects her husband, Lady Windermere joins the army of disenchanted women: "London is full of women who trust their husbands. One can always recognize them. They look so thoroughly unhappy. I am not going to be one of them" (400). But what is the alternative to such unhappiness?

As is often the case in Wilde's plays, the unmarried man philosophizes the most about the gender order underlying marriage. Lord Darlington states that "between men and women there is no friendship possible. There is passion, enmity, worship, love, but no friendship" (404). If this is so, then a lasting, happy marriage between a man and a woman is impossible. One thing that makes friendship impossible is the difference between moral standards for men and for women. Lady Windermere has contradictory views on this. On one hand, she believes that there should be the same laws for men as for women. This does not mean that moral strictures should be loosened for women but rather that they should be tightened for men. When offered the chance for the same sort of infidelity she thinks her husband is practicing, she asks, "because the husband is vile—should the wife be vile also?" (388).

The central irony in *Lady Windermere's Fan* is that the only transgressive action we see in the play is performed by the puritanical Lady Windermere herself. It is she, the self-proclaimed "Puritan," who is willing to follow her

mother's footsteps and leave her husband for another man. By the end of act 2, Lady Windermere's love has switched objects: "Tonight a man who loves me has offered me his whole life. I refused it. It was foolish of me. I will offer him mine now. I will give him mine" (407–8). She can conceive of leaving her husband, whom she wrongly believes to be unfaithful, but only if she can establish a relationship with another man. Ibsen's Nora may have been able to conceive of a life outside a male-dominated society, but Wilde's women cannot. Lady Windermere is saved by the fallen woman who will sacrifice her own chance at an advantageous marriage to protect her daughter's reputation. Ultimately, she learns not to judge others by her old, absolute standards: "I don't think now that the world can be divided into the good and the bad as if they were two separate races or creations" (421). She cannot judge Mrs. Erlynne harshly because she too was tempted.

At the end, marriage is upheld, but so are the lies. The Windermeres' marriage is secure, and Lord Augustus accepts Mrs. Erlynne. Neither marriage is any more idealistic than the other society marriages we see. Margaret never discovers the true identity of Mrs. Erlynne, and Lord Windermere never discovers how close he came to being a cuckold. Virtue may be upheld, but marriage is protected by lies.

Wilde is far more interested in his cynical satire than he is in his melodrama. The pragmatic Mrs. Erlynne's banter with Lord Windermere is far more interesting than the penitent Magdalen she plays with her daughter. If anything, Wilde shows that marriages built on romantic love are fragile. The disillusioned Lady Windermere says to the Duchess of Berwick, "Windermere and I married for love," to which the duchess responds, "Yes, we begin like that" (392). What does "marrying for love" mean? Sex and sexual attraction dare not speak their names in these plays, but that seems to be what love means in this context, not the sacramental love Wilde idealizes in so many works, particularly *De Profundis*.

Wilde would like to be on the side of the women, but it is the women who are not to be trusted in *Lady Windermere's Fan;* they are capable of betrayal. Yet they are also the mouthpieces of morality. Young women may be idealists, but as they grow older, they become pragmatists, if not cynics. With this view of women, how can marriage prevail? Wilde was no Henry James, who was always on the side of the good woman even if the corrupt one was more interesting. He found both to be dramatically interesting and equally untrustworthy. What wins is moral relativism. But the authority of the man is reasserted as Lady Windermere vows to trust her husband "absolutely" (429). The institution of marriage, however equivocal, remains the bedrock of the society he depicts.

A Woman of No Importance (1893) is one of Wilde's most complex and interesting plays because it makes us see its central characters both through the pathetic view of melodrama, which admits no irony, and through satire, which depends on irony. The central conflict is between characters who see their experience in melodramatic terms (Mrs. Arbuthnot, her son Gerald, and the American heiress, Hester Worsely) and the rest of the characters, who see their experience in comic terms. This clash of genres and views of experience mirrors differences in class. Hester may be rich, but she is not an aristocrat. In some ways, *A Woman of No Importance* seems more similar to the conventional fallen-woman play of the time than Wilde's other plays, but he is toying with and perverting the audience's expectations. At the heart of the narrative is another disclosure of parentage. Like Mrs. Erlynne, Mrs. Arbuthnot is a fallen woman, but she could not otherwise be more different. Mrs. Arbuthnot has no sense of humor and no sense of irony. She sees her life as a penance for her wrongdoing. Mrs. Arbuthnot may be a woman with a past, but to her friends in society, she seems a model of rectitude. Her name itself is a fiction. Rachel (Mrs. Arbuthnot) poses as a widow so that her son is seen to be legitimate. Rachel sees herself as a disgraced, fallen woman, but she is accepted into the finest country house as a good friend to the mistress of the house, Lady Hunstanton. Though her son, Gerald, is a mere bank clerk, he is invited to social events. Pasts are easy to hide in the drawing rooms of proper society. Gerald comes to the attention of Lord Illingworth, who is presented as a "man of the world"—rich, powerful, charming, and eternally single. He is also Gerald's father.

Men like Lord Illingworth are expected to have a past while women must find a way to hide theirs or disappear. Like Hester Prynne, Hawthorne's repentant adulteress in *The Scarlet Letter,* Rachel allows her disgrace to become her identity. She spends all her time doing good deeds and going to church. Above all, she lives for her son: "For, though day after day, at morn or evensong, I have knelt in God's house, I have never repented of my sin. How could I repent of my sin when you, my love, were its fruit" (475). She has reared her son to fit into the social world she has renounced. Rachel has gone through all the motions of the repentant sinner. Given that the father of her child, Lord Illingworth, seems to be a total cad, the audience is on her side.

The play opens by introducing its two most rich and powerful characters, a wealthy young American, Hester Worsely (another reminder of Hawthorne's Hester Prynne), and the "man of high distinction," Lord Illingworth. Hester is Wilde's caricature of the chauvinistic and moralistic American. The jaded sophisticates, Lord Illingworth and his friend Mrs.

Allonby, fire an arsenal of anti-American gibes when they are not debating the differences between the sexes. Hester immediately admires Gerald Arbuthnot for his simplicity and sincerity and has a strong aversion to the wittier characters, whose jokes are always at someone else's expense. But in a play in which the display of brilliant wit has the highest entertainment value, Hester comes off as something of a prig.

We don't see Lord Illingworth right away, but we are told in the first few lines that "it is a privilege to meet him" (431). Yet we are informed a few minutes later that "the world says that Lord Illingworth is very, very wicked" (435). Lord Illingworth's great wealth and high rank have conferred on him a distinction that allows him to get away with his wickedness. He will be accepted into what Lady Stutfield calls "the world" no matter what he does. That is the difference between the expectations of a man and a woman. Later, Hester describes an equally notorious Lord: "Lord Henry Weston! I remember him, Lady Hunstanton. A man with a hideous smile and a hideous past. He is asked everywhere. No dinner party is complete without him. What of those whose ruin is due to him? They are outcasts. They are nameless. If you met them in the street you would turn your head away. I don't complain of their punishment. Let all women who have sinned be punished" (449). The story of Lord Henry Weston is the story of Lord Illingworth and Rachel, who lives in shame for being "ruined" by him. Yet Lord Illingworth is the only character in Wilde's successful social comedies who expresses a powerful sexual desire that seems to be omnisexual. In the course of the play, he makes a pass at prim Hester, the least likely person to respond to his advances (the lure of the unattainable), and is clearly attracted to Gerald Arbuthnot, who he later discovers is his illegitimate son. Wilde told Herbert Beerbohm Tree, who played Lord Illingworth at the premiere, "He is certainly not natural. He is a figure of art. Indeed, if you can bear the truth, he is MYSELF."[21] Wilde was ostensibly referring to Illingworth as a man of wit, a social performer whose mask slips only once in the play, in a private moment away from the country house that is his customary stage. However, he may also have identified with the secret sexual life of his creation.

If the relationship of Mrs. Erlynne to her daughter in *Lady Windermere's Fan* is the stuff of sentimental melodrama—a mother preventing her daughter from making the same mistakes she has made—there is something perverse about the relationship between Lord Illingworth and his illegitimate son. This "wicked man" has taken "quite a fancy" to young Gerald and offers him a position as his private secretary. He tells Gerald, "It is because I like you so much that I want to have you with me" (441).

Is this an unconscious love for his son or sexual attraction to a young man of a different social class? It is hinted that Lord Illingworth's influence on Gerald will be corrupting. Otherwise, why all the fuss? Alan Sinfield pointed out how an earlier draft of the play codes Illingworth's true feelings for Gerald:

> *Mrs. Allonby*: How you delight in your disciples. What is their charm?
> *Lord Illingworth*: It is always pleasant to have a slave whisper in one's ear that one is, after all, immortal. But young Arbuthnot is not a disciple... as yet. He is simply one of the most delightful young men I have ever met."[22]

Since "disciple" was a code word for the boys Oscar and his friends had sex with, Illingworth's desire can be seen as predatory. In a 1907 letter, Lytton Strachey offered a tongue-in-cheek synopsis of the play that exaggerated the possible homosexual subtext: "A wicked Lord, staying in a country house, has made up his mind to bugger one of the other guests—a handsome young man of twenty. The handsome young man is delighted; when his mother enters, sees his Lordship and recognizes him as having copulated with her twenty years before, the result of which was—the handsome young man. She appeals to Lord Tree [*sic*] not to bugger his own son. He replies that that is an additional reason for doing it (oh! He's a *very* wicked Lord!)."[23] Strachey's synopsis is not to be taken totally seriously, but the play's homosexual subtext is clear.

The discovery that Gerald is his son changes Illingworth's motivations but increases his desire to control Gerald's future. Though Gerald comes to despise his father when Lord Illingworth, on a dare, makes a pass at the virtuous Hester, he still wants a marriage between his father and mother on moral grounds: "The wrong that has been done you must be repaired. Atonement must be made" (473). If his mother constantly echoes Victorian attitudes toward the fallen woman, Gerald is the proponent of the ultimate Victorian value: "You must marry him. It is your duty" (475). Marriage, the primary duty for ladies and gentlemen, is the glue that holds society together. It has little, if anything, to do with love or happiness. Women need it for social and economic reasons, and men need it for respectability and lineage. Lord Illingworth has another interpretation: "Men marry because they are tired; women because they are curious. Both are disappointed" (460). Rachel, the penitent, sees marriage as a promise made before God, a figure otherwise absent in this social world. Rachel is a woman of feeling in a room full of cynics. Her grand, sentimental statements are almost extreme enough

to be funny. She sounds like Racine's Phèdre trapped in a Victorian draw-ing room: "All love is terrible. All love is tragic" (480). Who would want to marry someone who sounds like that? She is out of place in a comic world. Lord Illingworth's proposal of marriage is proper, though far from any ideal of marriage: "I don't admit it is any duty of mine to marry you. I deny it entirely. But to get my son back I am ready—yes, I am ready to marry you, Rachel—and to treat you always with the deference and respect due to my wife" (479). In the cynical social world of the play, Lord Illingworth's offer is a fine one that comes with wealth and security. Isn't that what marriage is about for a woman? Rachel would live well, and her beloved son would be set for life. Were it not for the presence of Hester, the wealthy American heiress, the "Puritan in white muslin" as Illingworth calls her (above all, Illingworth wants to see to it that his son does not "take the side of the Puritans" [478]), the proposal would be very difficult to refuse. However, there is a fairy-tale element to Wilde's play, and Hester is the Jamesean *dea ex machina* who will take Gerald and his mother away to America, where their absolute values will be respected. Rachel can refuse Illingworth because her son has a better offer: "I hate my riches. They are a burden. Let him share them with me" (476). Wilde must have had his tongue firmly planted in his cheek when he wrote Hester's lines. Like young Lady Windermere and Lady Chiltern (*An Ideal Husband*), Hester has learned that her morality is too inflexible, but her mercy only extends to those who share her earnestness.

Sending solemn Hester, Rachel, and Gerald off to America, a repeat of the Puritan migration of 1630, is a resolution that is both melodramatic and comic. The wronged and good are rewarded, but society goes on as usual. Illingworth's final line is a both nasty and appropriate rejoinder to a person who does not know her place in the world he dominates: "It has been an amusing experience to have met amongst people of one's own rank, and treated quite seriously too, one's mistress and one's— " (480). Rachel may be right in her melodramatic action of striking him with his glove, but with her gone, his world can get back to high comedy where nothing, including love and marriage, is taken very seriously.

One can read *A Woman of No Importance* as an assertion of morality; however, the most interesting characters are the amoral ones, and Lord Illingworth sounds too much like Oscar Wilde himself, even in seeming to revel in his own notoriety. The play might have been more interesting if Hester had not been there to shower her largesse on Rachel and her son and if they both had a hard economic choice to make.

In *A Woman of No Importance,* marriage is determined by the difference in genders. Lord Kelvil says that "women are always on the side of morality,

public and private" (435) and that it is the strong moral sense that defines Hester and Mrs. Arbuthnot. The cynical Mrs. Allonby turns that notion around: "We [women] have a much better time than they [men] have. There are far more things forbidden to us than are forbidden to them" (434). Later Lord Illingworth tells Rachel Arbuthnot, "You women live by your emotions and for them. You have no philosophy of life" (479). Rachel agrees, as she tends masochistically to agree with all societally based negative judgments of her. Though Rachel speaks of her shame and degradation, she seems to be accepted into polite society.

The discussion of gender difference extends to views on marriage. Mrs. Allonby asserts, "Men always want to be a woman's first love. That is their clumsy vanity. We women have a more subtle instinct about things. What we like to be is a man's last romance" (446). Only then, perhaps, is marriage safe.

Given Wilde's love of ironic titles, one comes to *An Ideal Husband* (1895) knowing that such a concept is and should be impossible. Wilde thought *An Ideal Husband* his best play. It is the play that comments most directly on his situation at the time and on his views of marriage. According to Franny Moyle, "the title of the play was like a red rag to a bull for the hordes of so-called 'New' or 'Advanced Women' emerging by the mid-1890s, a group of proto-feminists in whose cultivation women such as [Wilde's wife] Constance and magazines such as *The Young Woman* [to which Constance contributed] played their part."[24] If Wilde's play posits that there is no such thing as an ideal husband, it certainly ratifies the ideal of the submissive wife.

Sir Robert Chiltern is, we are told, "a genius." Unlike most of the aristocrats we see in Wilde's plays, Chiltern is extremely ambitious. He lives to have power over others and, in the past, was willing to commit a crime to get the money he needed to achieve the power he desired. Chiltern is very much a man of the world. His wife is another of Wilde's moral absolutists. Like Constance Wilde, she is a member of the Liberal Society and is involved in charitable work. Her husband must be above reproach: "He is not like other men. He cannot afford to do what other men do" (510). Lady Chiltern's conditional love for her husband depends on his living up to her ideal of goodness: "We women worship when we love and when we lose our worship we lose everything" (501). Enter Mrs. Cheveley, the fallen woman of the piece, who is willing to blackmail Robert Chiltern for her own gain. Mrs. Cheveley is a pragmatist who wants to win in a man's world without the protective veneer of moral cant: "Of course I have not talked morality to you. You must admit in fairness that I have spared you that" (496).

Lady Chiltern's idealization of her husband—the conditional love built on her own unrealistic view of him—cannot survive the revelation of his past crime. Sir Robert responds, "Why do you place us on monstrous pedestals? We have all feet of clay, women as well as man; but when we men love women we love them knowing their weaknesses, their follies, their imperfections, love them all the more, it may be, for that reason. It is not the perfect, but the imperfect, who have need of love" (521).

Sir Robert, Lady Chiltern, and Mrs. Cheveley are characters in a melodrama of marriage and blackmail that was not atypical of 1890s West End drama, but as Richard Allen Cave points out, "Melodrama is crucial to Wilde's strategy: it underpins all his plays to intimate how slender a hold the society he depicts has on its professed stability and decorum."[25] However, a comedy of courtship runs parallel to the melodrama, and its central character, the effete dandy Lord Goring, is the play's moral compass. Goring can judge Sir Robert's mendacity but remain sympathetic. He can tell Lady Chiltern: "Life cannot be understood without much charity, cannot be lived without much charity" (511). Only Lord Goring, whose morality is not built on abstract ideals, can foil the scheme of his former lover, Mrs. Cheveley, and convince the Chilterns to reconcile. Yet his solution involves a moral compromise. If she truly loves her husband, Lady Chiltern must allow him to continue his public life and must understand her secondary role: "A man's life is of more value than a woman's. It has larger issues, wider scope, greater ambitions. A woman's life revolves in curves of emotions. It is upon lines of intellect that a man's life progresses...A woman who can keep a man's love, and love him in return, has done all the world wants of women, or should want of them" (548). Goring espouses a view of the woman's role that was already seen as reactionary by some in 1895. Yet Lady Chiltern echoes his words at the end of the play. In other words, as Kerry Powell puts it, "A cover-up, not the 'moralization of politics,' is what is wanted. Instead of meddling in the man's world of dirty politics, Lady Chiltern learns simply to leave it alone."[26] Here, Wilde espouses the traditional gender order. The comedy of courtship that is a counterpoint to the marriage melodrama offers a different point of view.

When Mrs. Cheveley proposes marriage to Lord Goring as the price for her silence regarding Sir Robert's corruption, his response is not only clever, but also witheringly candid:

Mrs. Cheveley: What do you know about my married life?
Lord Goring: Nothing. But I can read it like a book.

Mrs. Cheveley: What book?
Lord Goring: The Book of Numbers. (532)

Goring expects more of a marriage than a financial negotiation. This elegantly structured play begins with Sir Robert's younger sister, Mabel, discussing Lord Goring and ends with her happily engaged to him. In the midst of all the play's social artifice, Wilde describes Mabel in natural imagery: "She has the fragrance and freedom of a flower. There is ripple after ripple of sunlight in her hair" (483). Mabel is something of a wit who has no ambition beyond being a good wife to the right man. She tells her sister-in-law, Lady Chiltern, "You married a man with a future, didn't you! But then Robert was a genius, and you have a noble, self-sacrificing character. You can stand geniuses. I have no character at all, and Robert is the only genius I could ever bear" (513). Lord Goring is equally self-deprecating when he proposes to Mabel:

Lord Goring: Of course I'm not nearly good enough for you, Mabel.
Mabel: I'm so glad, darling. I was afraid you were. (542)

Mabel's response intimates the banter of Wilde's next play, *The Importance of Being Earnest*, a comedy that does away entirely with the melodrama of marriage. For all her wit, Mabel is serious about her love for Goring. Mabel doesn't want an ideal husband, nor does she aspire to be an ideal wife: "He can be what he chooses. All I want is to be…to be…oh! A real wife to him. (551). Mabel's somewhat inarticulate response is a sharp contrast to the other characters' hyperarticulate pronouncements on the ideals and pitfalls of marriage, one that underscores the depth and sincerity of her feelings. The banter between Mabel and Goring echoes that of witty lovers in Restoration comedies of manners. Like Restoration wits, Mabel and Goring negotiate an honest relationship based on mutual respect.

In the background, the society ladies in *An Ideal Husband* lament their husbands' virtues and domesticity:

Mrs Marchmont: My Reginald is quite hopelessly faultless. He is really unendurably so at times! There is not the smallest amount of excitement in knowing him. (490)

Imperfect husbands like Chiltern and Lord Goring are to be preferred to "perfect husbands" who offer their wives no excitement.

The mix of genres makes *An Ideal Husband* fascinating and explains its continuing hold on audiences. The melodrama is presented effectively

even if its gender politics are beyond the pale. Wilde himself explodes the earnestness of the Chilterns through the play of wit of his other characters. Earnestness and seriousness are not the same thing, and for all the characters' poses, the play sanctifies sincerity. There is a lot of celebration of love in *An Ideal Husband,* but it is not clear what Wilde means by love beyond another ideal. There is precious little sexual attraction, and what seem to be of paramount importance are understanding and compassion.

In *An Ideal Husband,* as in Wilde's other marriage plays, melodrama and farce play out in a grand, opulent world. The visual aspects of Wilde's society plays were a crucial element in their success. According to Joel Kaplan, Wilde "intruded himself into every aspect of performance from minute details of *mise-en-scène* to the seasonal lines of [producer George] Alexander's dressmakers."[27] The stage had to be a mirror of the elegance and taste of the aristocratic world Wilde both idealized and satirized.

An Ideal Husband is the least cynical of Wilde's marriage plays. The marriage of Lord Goring and Mabel Chiltern reflects Edward Carpenter's idealistic view of marriage as an expression of love:

> Practically, I do not doubt that the more people think about these matters, and the more experience they have, the more they must ever come to feel that there is such a thing as a permanent and life-long union—perhaps a many life-long union—founded on some deep elements of attachment and congruity in character; and the more they must come to prize the constancy and loyalty which rivets such unions, in comparison with the fickle passion which tends to dissipate them.[28]

Wilde was able in his plays simultaneously to endorse and mock this ideal.

2. Somerset Maugham's Inconstant Spouses ❧

There are no happy marriages. But there are some that are tolerable.

Somerset Maugham, *Home and Beauty*

Though he became better known as the author of novels like *Of Human Bondage* and *The Razor's Edge* and is praised now mostly for his short stories, W. Somerset Maugham was, with Sir Noël Coward and Sir Terence Rattigan, one member of the triumvirate of gay dramatists who dominated the British stage in the first half of the twentieth century and had major success on Broadway as well.[1] He is also the only English playwright to rival Oscar Wilde and Noël Coward in terms of box office success. If Wilde had three plays running concurrently in the mid-1890s, Maugham topped him by having four plays running fourteen years later. By the time Maugham gave up playwriting (1933), Coward was the reigning British theatrical figure who, like Maugham, was a success in New York as well as London. Terence Rattigan's career would begin a few years later. If playwriting was a lucrative occupation in the Edwardian era in which Maugham thrived as a playwright, film later became even more of a cash cow, and Maugham became even better known for the film versions of his novels and plays.

Maugham achieved a position that would be virtually impossible in our culture—he was a celebrity who managed to keep his private life out of the public eye. Ironically, the only time he was the subject of scandal was when he was named as corespondent in the divorce of Syrie Barnardo Wellcome. This heterosexual scandal may have helped to hide his homosexual activities, but it also was a cause of his miserably unhappy marriage to Syrie. Indeed, Maugham's life demonstrates how complex the concept of the closet can be. The closet depends on a contract of discretion on the part of those in one's social circle. All his life, Maugham relied on on a conspiracy of silence that was violated the minute he died. At that point,

the man who had done everything in his power to keep biographers at bay, who had tried to destroy all the evidence of his private life, became public property. As his literary reputation waned, his role as a gay man waxed.

The subject of Maugham's most successful plays is marriage. Most of them were written while he led a double life—embroiled in an unhappy marriage but spending most of his time with his lover, Gerald Haxton.

One of the most telling anecdotes about Somerset Maugham is recounted by his nephew, Robin, in his memoir, *Escape from the Shadows*. On his first stay at the Maughams' Riviera mansion, Villa Mauresque, with his uncle's blessing, Gerald Haxton took Robin to a brothel to have his first sexual experience with a woman and, shortly afterward, took him onto his yacht where a beautiful young boy, Laurent, was waiting. Robin had sex with Laurent and fell madly in love with him. When Robin told "Uncle Willie" that he was in love with Laurent, the author responded

> "Balls!" Willie said. "You've just got a simple lech on him, that's all. You want his body and you enjoy having him. Be honest with yourself. Rid yourself of cant…He lets you have him because each time he goes with you, I pay him his standard tariff—which, in fact, is almost the equivalent of three pounds."
>
> Willie put down his glass and clasped and unclasped his hands. "The boy's nothing more than an accomplished little prostitute," he said. "The fact that he has persuaded you to believe that he's in love with you has annoyed me quite considerably. I refuse to allow you to make a complete fool of yourself while you're staying under my roof."
>
> I looked at Willie. He was shaking with anger. I turned away from him.
>
> "I've sent Gerald down to the yacht to pay Laurent for tonight," he continued. "Gerald will make sure that you never see the boy again."[2]

"Rid yourself of cant," Somerset Maugham advised his nephew. The "cant" consisted of using the word "love" to describe what is, in fact, a business transaction and simple sex. Maugham wanted his nephew to learn that all primary relationships were business transactions. Adolescent romanticism was anathema to the author, yet he saw the caddish Gerald Haxton as his great love. Maugham's most interesting dramatic characters are as clear-eyed as he wanted to be.

KING OF THE WEST END

Somerset Maugham's highly successful playwriting career began in the first decade of the twentieth century, a very rich time for British drama. There

had been a building boom of theaters in the West End in the late nineteenth and early twentieth centuries, and audiences flocked to the theater as popular entertainment. George Bernard Shaw, Harley Granville-Barker, John Galsworthy, and Sir Arthur Wing Pinero were at the height of their careers. This was the era of upper-middle-class, realistic drama filled with moral dilemmas in opulent drawing rooms. Maugham had not yet fully made his mark as a novelist and was attracted to the theater as a source of money and public recognition: "I wanted to write plays that would be seen not only by a handful of people. I wanted money and I wanted fame."[3] He was not interested in the critical respect accorded "serious" modern playwrights like Ibsen and Granville-Barker: "I was not satisfied with the appreciation of a small band of intellectuals. I wanted no such audience as this but the great public."[4] He found his niche in a crowded market by writing social comedy: "I reflected on the qualities which the managers demanded in a play: evidently a comedy, for the public wanted to laugh; with as much drama as it would carry, for the public liked a thrill; with a little sentiment, for the public liked to feel good; and a happy ending" (ix). For all his later claims that playwriting is easy, it took Maugham years to become established in the London theater, but once his first social comedy, *Lady Frederick,* finally saw the light of day in 1907 after five years of being rejected by a number of producers, Maugham was much in demand. And by all reports, he was a shrewd businessman. In his biography of legendary British producer Hugh "Binkie" Beaumont, Richard Huggett notes, "Maugham was the most astute businessman Binkie had ever met and he watched over his theatrical empire with a jealous and possessive vigilance."[5]

Biographer Jeffrey Meyers claims that Somerset Maugham is "the dramatic link between Wilde and Coward."[6] This is true in terms of the history of the English comedy of manners. John Russell Taylor also links Maugham to Wilde: "Wilde had finally, after toying with the well-made drama in three plays, summoned up the courage to write the first British masterpiece of artificial comedy for nearly 200 years; Maugham followed in his footsteps and at once became the licensed jester-in-chief of the London stage."[7] Like Wilde, Maugham's greatest theatrical success was achieved with a series of comedies that satirize the mores and hypocrisies of the moneyed classes. In the limited social world of Maugham's highly successful comedies set in the world of the very rich and powerful, the subject is marriage, or rather, how to evade the duties of marriage while keeping the privileges. What does marriage become if there is no love between the parties or if evanescent love dies, leaving only the marriage bond? Can there be a happy marriage if women do not have the same financial position in the partnership as men?

Maugham's most successful social comedies, produced between 1907 (*Lady Frederick*) and 1927 (*The Constant Wife*), were quite daring in their presentation of marriage and sexual mores. One can only conjecture whether audiences agreed with Maugham's rather acid view of heterosexual relations or whether they enjoyed the plays as witty, rather outrageous entertainments. Maugham was always careful to downplay the serious aspects of his comedies. He claimed that a comedy "is not a work of edification, though it should be a work of art, and if it castigates the follies of the moment that is by the way and only so far as this laudable process occasions laughter" (2; ix). Nonetheless, there is a consistent, serious element to his work and, as we shall see, clear links to his own experience. Later in his playwriting career, Maugham moved into drawing-room melodrama, but love and marriage, or rather love versus marriage, remained his focus.

THE INCONSTANT HUSBAND

While Maugham's better plays can stand perfectly well on their own without the additional interest of biographical details, his most acerbic dramatic depictions of marriage (*The Circle, Our Betters, The Constant Wife*) were written in the midst of a turbulent period in his own life, namely while he was married to Syrie and in love with and, for a great deal of the time, living with his lover, Gerald Haxton. In fact, the last of his commercially successful plays, *The Sacred Flame* (1929), opened shortly after his divorce.

Maugham's relationship with Haxton is a problematic chapter in the history of gay partnerships. Indeed, Wilde and Maugham offer parallel versions of gay marriage. Both men were married to women and were fathers. Both deserted their wives for men who were seen by many as malignant influences. Both saw their male partners as muses, essential to their art and their life. Wilde sacrificed his career and his life in a foolish attempt to abet the petulant Bosie (Lord Alfred Douglas) in his hatred of his father. Maugham courted scandal and became an exile to be with Haxton. Neither relationship was monogamous. Wilde was convicted, not for his sexual relationship with Lord Alfred Douglas, though that was the catalyst, but for his many liaisons with working-class rent boys, a habit he and Douglas shared. The Maugham-Haxton relationship was far from monogamous, and like Wilde, Maugham's sexual activities often involved young rent boys. Maugham, however, was far more discreet than Wilde and kept much of his sex life outside the boundaries of his native land.

It is interesting to note that Maugham, who advocated wives' financial and sexual independence in his plays, had a series of primary homosexual relationships that followed the traditional economy of marriage. Maugham biographer Selina Hastings notes, "There is a visible pattern that runs through these relationships, beginning with a sexual affair which then evolves into an intimate friendship, with the one-time lover becoming part secretary, part companion and facilitator."[8] Gerald Haxton was not only his partner and sometime lover, but was also financially dependent on Maugham. Haxton was supported by Maugham, as was, from 1928, Alan Searle, another young lover who became Maugham's companion after Haxton's death, and who had a salary and a London home thanks to the author's support. As we shall see, this sort of employer-employee relationship was not unique to Maugham and his lovers. It may have been a way to legitimize a relationship that was illegal and would become the subject of scandal. In exchange for Maugham's support, Haxton was responsible for managing their domestic life. Robin Maugham remembers, "It took me some time to realize that it was Gerald Haxton who was largely responsible for the atmosphere of happiness and comfort in which I was now living" at the Villa Mauresque.[9] That atmosphere was decidedly and daringly gay. Jeffrey Meyers observes that "the unbuttoned, carnivalesque atmosphere [at the Villa Mauresque], a striking contrast to Maugham's often forbidding formality, shocked both liberated women and straight men."[10]

In addition to master of ceremonies and manager of the home, Haxton was a professional assistant, editor, and sometimes translator (like Paris-born Maugham, Haxton was fluent in French). Indeed, Robin Maugham supports Haxton's claims that "when the two men traveled around the world together, it was Gerald who made the contacts that Willie needed for his stories."[11] According to Haxton, his essential role in Maugham's creative process was the most important thing he brought to their relationship and his part of the bargain they struck shortly after they met in France during World War I: "'You see, what I want is fun and games,' I told him, 'but I've not got a cent. So I want someone to look after me and give me clothes and parties. And the odd thing is that I reckon I could give you what you are after as well if I were your friend. If you took me on your travels I'd be the one who picked up the interesting character in a bar and got a story for you.'"[12] If this was true, it was in no way acknowledged by Maugham in his work, but Haxton was not particularly interested in Maugham's literary output: "Gerald had little interest in literature; he was mainly interested in Willie's books and plays because they brought in money."[13] It is true, as Bryan Connon claims, that Maugham's "best work was produced while

Haxton was with him: the most successful plays, nearly all the short stories and novels, from *The Moon and Sixpence* to *The Razor's Edge,* all show the importance of his influence."[14] After Haxton's death, Maugham was more the literary éminence grise than an active, successful author.

Like many wives, on and offstage, Haxton often complained about and rebelled against his subordinate position to the writer known as "The Master." Yet they were essential to each other. The gregarious Haxton complemented the shy, stuttering Maugham just as the disciplined Maugham complemented the self-destructive, alcoholic Haxton, who gambled away a fair amount of Maugham's royalties. Maugham was aware of Haxton's problems. He observes to his nephew, "You know, I'm perfectly aware that Gerald is both a drunkard and a gambler. I don't think of him as an angel, but he does have great qualities."[15] Some of those "qualities" did not fit the image of respectability that Maugham tried to maintain. Robin Maugham wrote openly about Haxton's attempt to seduce him when he was a teenager and his function as procurer: "Willie...depended on Gerald to produce young boys who could creep into the Mauresque by the back door and sleep with him. Gerald was Willie's pander; Willie was rich enough to keep him."[16] Meyers calls Haxton "Maugham's evil genius."[17] Writer Beverley Nichols observes, "He stank. He had about him an aura of corruption."[18] As Haxton's alcoholism grew worse, bitter fights erupted between the two men. Maugham depended on a stable routine to enable his work, and the increasingly unreliable Haxton became less of an asset. By the beginning of World War II, they had separated.

Though on the surface it looked like Haxton was dependent upon Maugham, the author's friends were often shocked by Haxton's surly behavior toward him. There was clearly a shifting power dynamic between them. Certainly, Maugham was devoted to Haxton. Nichols observes, "For Gerald, Mr. Maugham would have been prepared to sacrifice all the glittering prizes in the world."[19] Haxton was arrested in 1916 on six counts of gross indecency and, as a result, was banned from entering Britain.[20] Maugham, the most successful English writer of his time, then spent most of his time living outside his native country. This was motivated both by his desire to be with Haxton and by the awareness he shared with many well-heeled Englishmen that it was safer for a gay man to live in France than in England. There his private life could be separated from his celebrity, and he would not live in fear of Britain's draconian sodomy laws. After Haxton died in 1944, Maugham grieved for the rest of his long life. He wrote Noël Coward, "Since Gerald died, I have been very far from well...For thirty years, he had been my chief care, my pleasure and my

anxiety and without him I am lost and lonely and helpless."[21] Yet he was not alone. Shortly after Haxton's death, Maugham summoned Alan Searle, who had met and had an affair with Maugham beginning in 1928 and who had been Maugham's secretary and assistant in England ever since, to be his companion and assistant, a task Searle maintained faithfully for thirty years until the author's death. There was a dark side to Searle as well, which emerged as he abetted a vicious feud between Maugham and his daughter. Indeed, Maugham attempted unsuccessfully to adopt Searle in 1961 while he was in a series of legal battles with his daughter. More than Haxton had, Searle devoted his life to Maugham, even after the author suffered bouts of dementia and became sometimes violently cantankerous. Most of Maugham's close friends thought Searle to be a saint.

Maugham's devotion to Haxton and Searle was a contrast to his cavalier treatment of his wife, Syrie. Like Maugham, Syrie came from a distinguished family, though one without the social pedigree of the Maughams. Syrie's father was the philanthropist Thomas John Barnardo. She married millionaire Henry Wellcome and was the mistress of department store magnate Gordon Selfridge. Her affair with Maugham, which produced a daughter, Liza, required her cheating on both her estranged husband and her lover. Much to Maugham's chagrin, Wellcome initiated divorce proceedings with Maugham as corespondent. Wellcome had tolerated Syrie's affair with Selfridge, but now there was an illegitimate child who might be in line for part of the Selfridge fortune. By the time Maugham married Syrie, he was already in love with Haxton. During the marriage, Maugham spent much of his time away from Syrie, whom he had come to despise. While she developed an extremely successful career as an interior decorator for the rich and famous, she maintained the vain hope that she could win her husband back from Haxton. After the divorce, Maugham never stopped resenting the alimony settlement. In his mad last years, he even claimed that he was not the father of Liza.

Why did Maugham marry Syrie? Late in life, he explained, "You see, I was a quarter normal and three-quarters queer, but I tried to persuade myself it was the other way round. That was my greatest mistake. It flattered me that Syrie should throw herself at my feet. She told me that she cared for me more than anything else in the world. And she wanted to bear my child. I was so vain and stupid I believed her...But she ruined my life. She made my life utter hell. You may laugh, but it's true. But it was all my own fault—because if I hadn't been vain and stupid, I'd never have listened to what she said."[22] Glenway Wescott believed that it was supposed to be a marriage of convenience: "Willie knew all about her

past and her lovers, and Syrie knew about his homosexuality. She wanted a father for her child and a man who was at the height of his fame as a playwright. He wanted a hostess, who knew the *tout-Londres* and would give him as much rope as he needed."[23] Others believed Syrie blackmailed Maugham into marriage through threats of exposing his relationship with Haxton. Maugham may have felt duty bound to marry her after the scandal of being named corespondent in her divorce. Whatever the motivation, had it worked out, marriage to Syrie would have enabled Maugham to lead a respectable—well, somewhat respectable, given Syrie's reputation—straight life. Syrie was well connected socially and Maugham was known to love being with the good and the great. However, the marriage was doomed from the start. Syrie found she loved him too much to put up with Gerald Haxton, and he quickly came to despise her jealousy of his work and of Haxton and her need to be the most important thing in his life. His response was absence and, on some occasions, cruelty. Various aspects of Syrie, particularly her highly successful career as an interior decorator, emerged in the plays (Constance in *The Constant Wife* becomes a successful interior decorator), and Maugham's cynical view of marriage sprang from his own experience.

For the most part, Maugham kept homosexuality out of his work. Even when it was overt, as it is in the 1932 novel, *The Narrow Corner*, which Maugham supposedly referred to as his "queer novel,"[24] male-male desire and love are part of a series of narratives of women's betrayal. The novel's center of consciousness is Dr. Saunders, an opium-smoking cynic who has been struck off the doctor's list because of some scandal in his past (i.e., homosexuality). Saunders's memories of London before World War I echo the experiences of gay men of the time: "There was the part that in his day they called The Front, the street on the north side [of Piccadilly Circus] that led from Shaftesbury Avenue to the Charing Cross Road, where from eleven to twelve people walked up and down in a serried throng. That was before the war. There was a sense of adventure in the air. Eyes met and then . . . "[25] Saunders is hiding out in China, attended by his young servant, Ah Kay: "He was a slim, comely youth with large black eyes and skin as smooth as a girl's . . . he had a langorous elegance that was strangely touching . . . Dr. Saunders sometimes flattered himself with the thought that Ah Kay regarded him with affection" (40). While Saunders is attracted to Ah Kay, he "was not as a rule captivated by feminine beauty; he could not but think the manner in which a woman's frame was made for obvious physiological purposes detracted from his aesthetic appeal" (136). There is no question, however, of the doctor's attraction to Fred Blake, an "astonishingly handsome" (118) man: "There was something appealing in his beauty

so that Dr. Saunders, who had thought him a rather dull young man, felt on a sudden kindly disposed to him" (113). Fred Blake, like Saunders, has a mysterious past. In a typical Maugham narrative of female treachery, he has had an affair with an unhappily married woman who then used him to set up the murder of her husband. Saunders and Blake become traveling companions, and on a South Sea island, Blake becomes involved in another triangle. He becomes "much taken" with a young Dane, Erik Christessen, who awakes in Fred spiritual feelings he has never known before: "At that moment the rather ordinary, handsome boy was conscious of something he had never imagined, spiritual beauty" (129). If Erik represents spiritual beauty, his fiancée, Louisa, represents carnal desire. She is secretly engaged to Erik but feels no desire for him and is aware that his devotion to her is tied to his devotion to her dead mother. Erik kills himself after discovering that Fred and Louise are sleeping together. Fred's response to Erik's death shows that a spiritual male bond is of far more value than anything a woman can offer:

> I'm so miserable. I thought nothing worse could happen to me than what has. But this...She meant nothing to me really. If I'd only known I wouldn't have thought of fooling about with her. He was the best pal a chap ever had. I wouldn't have hurt him for anything in the world. What a beast he must have thought me! He'd been so awfully decent to me.
>
> Tears filled his eyes and flowed slowly down his cheeks. He cried bitterly. (196–7)

Though it seems clear that Dr. Saunders is physically attracted to men, sexual relations between men is not the subject of *The Narrow Corner.* Maugham knew that was a taboo subject. If Maugham had been more explicit, the book would never have been published. This was still a time in which gay fiction was privately circulated. *The Narrow Corner* focuses on spiritual love between men in the tradition of Herman Melville. Women are, for the most part, agents of betrayal and destruction of men and are narrated by men rather than allowed to act directly. The murderous Mrs. Hudson, who implicates Fred in murder, only appears through Fred's words, and Louise's affair with Fred is presented through the observations of Erik's and Fred's narration. In her original review of the novel in the London *Saturday Review,* Anne Armstrong observes, "Somerset Maugham does not understand women. He realizes that man is a complex animal, part good and part bad; but women to him are all of a piece—100 per cent uninteresting angels (off stage) or passionate and consuming vamps in the spot light."[26] *The Narrow Corner* shows how he could idealize

and romanticize men, particularly beautiful young men. Nonetheless, Maugham was delighted that "nobody's seen" the novel's seemingly overt homoeroticism.

The Narrow Corner was the first novel Maugham published after he announced that he was giving up playwriting and focusing on his fiction. It is interesting to observe that he had, at least temporarily, moved from a female-dominated genre—at least as he saw it[27]—to a male-dominated work in which all women are versions of Eve, temptress and betrayer. They not only are agents of unhappiness in marriage but also destroy male bonds.

LEADING LADIES, SUPPORTING MEN

Maugham had a complex relationship to the social world he satirized in his plays. All his biographers comment on his desire to be accepted into the world of the rich and powerful. It was the world of his family. His brother Frederic was a celebrated jurist who became lord chancellor, his nephew Robin, Frederic's son, inherited his father's peerage, and his daughter married a member of the British nobility. To some extent, his celebrity placed him in the society he sought to join, but he actually spent most of his social life in the society of artistic gay men. Both Maugham's social awkwardness (i.e., shyness and a terrible stutter) and sexual orientation created a complex relationship with the world into which he was born and to which he aspired. Biographers differ in the extent to which Maugham's homosexuality was known to the elite, but it is this complex relationship to the upper class that allowed Maugham to create such fascinating satires of the wealthy.

Maugham's strategy as a commercial playwright was the same as that of his predecessors Henry Arthur Jones, Arthur Wing Pinero, and even Oscar Wilde—to create roles that would entice leading actresses: "it seemed to me that if I could devise a part that an actress very much wanted to play, it was probable that she would get a manager to let her" (1; ix). Like so much fiction of the time, London drama centered on female characters and the stars who played them. Where Ibsen's women were often trapped in overstuffed, claustrophobic bourgeois homes and small town society, the leading ladies of British drama dressed magnificently and performed in opulent settings. London audiences wanted to see the glittering world of the rich. Even more than Wilde, Maugham was particularly fascinated with the performative aspects of the lives of his grande dames. The drawing room or country house is a stage for his leading ladies. More than

Wilde, Maugham focused on the characters who, in the 1890s, were considered "fallen women." He was fascinated by the ways women eluded the social and financial traps set for them.

In 1937, four years after he gave up playwriting, Maugham wrote *Theatre,* which is about the kind of actress for whom he wrote his plays.[28] Therein, he rehearses the vision of love and marriage that is so central to his earlier plays. *Theatre* is a good starting point for a discussion of gender, love, and marriage as it appears in Maugham's plays. The novel is the history of an extramarital affair told without melodrama or sentimentality. Julia Lambert is a celebrated actress at the height of her career. She falls out of love with her husband, Michael Gosselyn, who is also her producer, and loses her heart to an unworthy young man. This is no *Madame Bovary* or *Anna Karenina.* There is no scandal, no great heartbreak, no tragic death. Julia has her affair and moves on. She still has her career, which is more important to her than anything or anyone else. In one sense, *Theatre* is a novel about the various ways in which a woman can be empowered. Julia, after all, has the most important form of empowerment, economic independence. Her husband may run her career, but actually, he depends on her talent more than she does his business acumen. Yet it is not so much the money that Julia loves about her work: "It was the power she felt in herself, her mastery over the medium, that thrilled her."[29]

There are other subtle but equally important forms of empowerment. Julia, like many of Maugham's women, is married to a man she no longer loves. Marriage may offer companionship, but it is no longer romance. For Julia, this realization, which came some years before the action of the novel begins, is another step toward her independence: "Her heart sank because she knew that she had lost something that was infinitely precious to her, and pitying herself she was inclined to cry; but at the same time she was filled with a sense of triumph, it seemed a revenge that she enjoyed for the unhappiness he had caused her; she was free of the bondage in which her senses had held her to him and she exulted. Now she could deal with him on equal terms" (50). Love brings weakness, for love gives the object of love power over the lover. What Maugham means by love is sexual passion, which marriage always outlives in his world. It is not that Julia feels nothing for her husband. They are professional colleagues, housemates, and friends who have settled into an amiable routine. This is fine for Michael, who like many of Maugham's men, lacks a strong libido: "He was not a man to whom sex was important, and he was relieved when he discovered that Julia no longer made any demands on him" (58). To the outside world, Julia and Michael's marriage looks ideal, but "it seemed to her that no one

but she knew what it was to live with a man who was such a monster of vanity" (63). Julia, in her late forties, begins an affair with Tom Fennell, a young accountant who works in her husband's office. Julia enjoys the affair but does not lose her head over Tom: "For Julia was shrewd, and she knew very well that Tom was not in love with her. To have an affair with her flattered his vanity. He was a highly-sexed young man and enjoyed sexual exercise" (98). Nonetheless, "she left nothing undone to bind him to her" (99). Money puts her in control. She provides a flat for their trysts, appropriate clothing for their dinners out, and money to help the young man with his debts. After all, being the one to dispense largesse put her in the dominant position, and that "excited in her a surprising passion" (102). Nonetheless, Julia goes through the emotional roller coaster that is part of any affair. She even becomes jealous of her own son when he and her lover become friends. Tom comes to resent his financial dependence on Julia and takes up with an aspiring actress closer to his own age. Julia triumphs over Tom's vapid new girlfriend on stage and wins back his ardent affections, but she is no longer interested: "When she came to the conclusion, quite definitely now, that she no longer cared two straws for him she could not help feeling a great pity for him" (229). Preparing for what will be another triumphant opening night, she realizes that "love isn't worth all the fuss they make about it" (230). At the end, she is happily dining alone and relishing her success: "She had a wonderful sense of freedom from all earthly ties, and it was such an ecstasy that nothing in comparison with it had any value" (242). Julia triumphs over her vain, clueless husband, her dull, self-absorbed lover, her lesser rivals, and her adoring audience.

Love in this work is powerful but transitory, and strong women know to keep their wits about them. Love is enjoyable but not essential. Marriage offers companionship but little more. The crucial thing is independence, and Julia has that.

Like some of his forbears, Maugham presents his novel solely from Julia's point of view. But what is the author's point of view? He clearly admires Julia's independence and her devotion to her art. However, Julia has chosen an unworthy object for her love. Even her eighteen-year-old son realizes that Tom is a dull chap and "a poor little snob" (219). There is a crucial scene toward the end of the novel in which Julia has something of a heart-to-heart talk with her son, Roger, who chides her because there is nothing under her surface: "If one stripped you of your exhibitionism, if one took your technique away from you, if one peeled you as one peels an onion of skin after skin of pretence and insincerity, of tags of old parts and shreds of faked emotions, would one come upon a soul at last?" (217). Julia's reaction in the

scene is typical of her: "What he had said had not really penetrated to her understanding, his words were lines and the important thing was not what they meant, but whether they 'got over', but she was sensitive to the emotion she felt in him" (218). Is Maugham satirizing people like Julia who can only see human behavior in terms of theater, or does he believe that performance is all that Julia or anyone is? I find that this question niggles at me as I experience Maugham's plays. Oscar Wilde's sense of human performance and of the aesthetics of behavior being more interesting than morality is a consistent stance, which means that the characters who think they are acting from sincerity or conviction, the earnest Lady Windermeres and Mrs. Arbuthnots, are either deluded or tiresome. Maugham seems to be writing satire, but what is he satirizing? *Theatre* is typical of his work in that there are no fully sympathetic characters. We may be fascinated with Julia, but she is totally self-absorbed, as is everyone else in the novel. This objectivity is one reason Maugham was more successful at comedy than at serious drama. We are always at some distance from characters in comedy.

What we observe in *Theatre* are ways in which a woman can hold power without any sense of losing her femininity. This is the view of women that dominates Maugham's plays. His leading ladies learn to function in a society in which men are vain and obtuse. There is no battle between the sexes in Maugham's plays. Men and women seldom care enough about each other to battle. If they do spar, the ladies win in great part because they see life as a series of performances. The women have a sense of irony that the men lack.

"ACTING"

In a superb coup de théâtre in the final act of his first successful play (written 1902, premiered 1907), the title character, the glamorous but down-on-her-luck Lady Frederick, invites her much younger lover to her dressing room before she has put on her makeup. She wants to scare him off by showing him the effort it takes to cover the ravages of age. She knows that her life is an act, and this performance of her toilette is one of her grandest: "You don't for a moment suppose I should have let you into these horrible mysteries of my toilette if I had any intention of marrying you" (1; 76). This was a very daring scene for its day, demanding that a mature actress appear in harsh light without her makeup. The scene underscores the equation between the boudoir of a lady of a certain age and an actress's dressing room. Lady Frederick insists on bright sunlight so that the signs of her age

are shown in the harshest possible light. When her rejected lover is about to make his dejected exit, Lady Frederick jokes, "I'd like to imprint a chaste kiss on your forehead, only I'm afraid it would leave a mark" (79). Unlike the scenes of noble sacrifice that fallen women enact in so many popular nineteenth-century melodramas from Dumas onward, Lady Frederick plays her moment for its comic effect, even emphasizing her Irish brogue.

The marriage into which the slippery Captain Montgomerie tries to blackmail her would also be a performance devoid even of the pretense of love: "I only ask you to perform such of the duties of a wife as are required by Society. They are few enough in all conscience. I should wish you to entertain largely and receive my guests, be polite to me at least in public, and go with me to the various places people go to. Otherwise I leave you entire freedom. You will find me generous and heedful to all your wishes" (51). Montgomerie wants a social ornament, not a partner or lover. Like most of Maugham's men, he lacks the irony and the joy of playing the game of life and love that characterize Maugham's women. However, love is not the goal of Maugham's mature women. As Lady Frederick tells her old friend Paradine Mereton, "there's only one thing worse than being in love...having someone in love with you" (80). To marry the ardent young Charles would be "to commit suicide by sheer boredom" (79). It is Charles's money that she craves more than his youthful, ardent devotion, which she finds too high a price to pay for material security. Lady Frederick prefers a man who would accept rather than idealize or use her: "Don't you think I might find a man who loved me though he knew me through and through? I'd rather that he saw my faults and forgave them than he thought me perfect" (80). At the final curtain, Lady Frederick gets her wish. Maugham calls her a "clever manager who twists all and sundry round her little finger" (ix). As we shall see, this description fits all of Maugham's theatrical heroines.

While Maugham's comedies are often compared to those of Wilde, Restoration comedy is the model for the complex pattern of misalliances and obstacles to true love that we find in *Lady Frederick,* but the focus here is more on money than it is on sex. The economic position of women is always in the spotlight in Maugham's plays. Marriage, like theater, is a commercial enterprise.

In *Our Betters* (1917, the year of Maugham's marriage), Pearl, the leader of a circle of wealthy American heiresses who have through marriage bought English and European titles, knows that her place in British society depends on, as she puts it, paying the piper. Like a theatrical producer, to keep the right people coming to her house, she needs to provide the

best entertainment: "If a dancer is the rage, they'll see her at my house. If a fiddler is in vogue, they'll hear him at my concert. I give them balls. I give them dinners. I've made myself the fashion. I've got power, I've got influence. But everything I've got—my success, my reputation, my notoriety—I've bought it, bought it, bought it" (2; 110–11). Pearl's husband is invisible, her lover an elderly American vulgarian (based, supposedly, on Syrie's ex-lover, Gordon Selfridge) who provides an income for her. In the third act of the play, after Pearl has been caught having sex in the teahouse with the young lover of one of her best friends ("I find no man so desirable as one that a friend of mine is in love with" [97]), she manages to regain control through a series of performances. She regains the devotion and money of her lover by playing "the dear little thing racket" (101) superbly. She avoids humiliation and keeps her guests for the weekend by bringing in the fey dancing master to whom they are devoted. Success is knowing how to manipulate the weaknesses of everyone around you. At the final curtain, her friends are literally dancing to her tune.

The ironically named Constance in *The Constant Wife* (1927) spends half of the play feigning ignorance of her husband's affair with her best friend: "I've spent the last six months in a desperate effort to prevent my friends and relations from telling me your ghastly secret. It's been very difficult sometimes" (2; 144). Like Maugham's other leading ladies, Constance is very rational about her position. She comes to understand her social and economic position and finds that she must change the terms of her marriage to convert it from a performance to an honest relationship.

In the farce *Home and Beauty* (1920), Victoria spurns the heroic men who have been her husbands for a wealthy man she can manipulate—to her, the ideal man is like a unicorn: "a shy and somewhat timid animal, and it is impossible to catch him with the snares of the hunter. But he is strangely impressionable to the charms of the fair sex. When he hears the frou-frou of a silk petticoat he forgets his native caution. In short, a pretty woman can lead him by the nose" (2; 292). Of course, the "charms" of the fair sex are a series of performances. Like most of Maugham's women, Victoria is a materialist. In a world in which women are supposed to be kept by men, in or out of marriage, a woman has to look out for the best opportunity. "Now I want to marry a Rolls-Royce," Victoria proclaims (291). She is marrying the things a man can buy more than she is marrying the man.

Maugham's comedies focus on the point of view of the women. Men hold the reins of power in the world outside the home and, because of the prevailing sex/gender system, have the economic advantage; however,

it is just this assumption—or illusion—of masculine strength that gives women the advantage. In Maugham's world, it is usually men who are sentimental and therefore easily manipulated by women who understand them better than they understand themselves. Indeed, much of his comedy is built on a reversal of conventional gender expectations. In his plays, the women are rational and the men emotional and impulsive. Again and again in Maugham's plays, women comment on the weaknesses of men. Pearl's comment in *Our Betters* is typical: "Men are very trivial, foolish creatures. But their heads. Oh, dear, oh, dear, it's lamentable. And they're so vain, poor dears, they're so vain" (2; 107). Constance, our not so constant wife, notes, "They're like little boys, men. Sometimes of course they're rather naughty and you have to pretend to be angry with them. They attach so much importance to entirely unimportant things that it's really touching. And they're so helpless" (108).

Helpless, and often sexless, in Maugham's work it is often the men who are frigid. At the end of *The Circle*, young Elizabeth leaves her husband and runs off with a more passionate man. Arnold, her husband, admits to her, "After all, a man marries to have a home, but also because he doesn't want to be bothered with sex and all that sort of thing" (2; 57). Arnold's mother had done exactly the same thing thirty years earlier. At the end of *Home and Beauty,* Victoria's ex-husbands, happily rid of her, set up house-keeping together. Some critics have found hints of homosexuality in these situations. I think sex of any kind is the one thing these men are escaping. While men do feel passionately about women, women seldom act out of sentiment. One of the most clearheaded of Maugham's women is Lois in *For Services Rendered* (1932). A twenty-six-year-old beauty, Lois finds herself pursued by two married men, the wealthy, sentimental, elderly Wilfred Cedar and her loutish, drunk brother-in-law, Howard Bartlett. A woman of conventional morality would avoid a sexual entanglement with either of these men, but Lois finds herself torn between sexual desire for Howard and pragmatism. When Howard crudely offers her an affair, she responds

> *Lois*: Isn't human nature funny? I know with my mind you're a rotter. And I despise you. Isn't it lucky that you can't see into my heart?
> *Howard*: Why, what should I find there?
> *Lois*: Desire. (3; 163)

Sex with Howard is tempting even though Lois would be betraying her own sister. But Lois knows that there is no real love between her sister and Howard, only the recollection of a lost passion: "Romance doesn't last.

When it's dead what is left but dust and ashes?" (139). Lois runs off with Wilfred in part to avoid Howard, but Wilfred also offers to settle twenty thousand pounds on Lois if she will run off with him. She has no qualms about Wilfred's marriage. She knows he despises his wife and that it will be "I or another" (177). She will earn financial independence and a sense of power: "Has it never occurred to you what power it gives a woman when a man is madly in love with her and she doesn't care a row of pins for him?" (ibid.). Of all the characters in *For Services Rendered,* Lois is the survivor because she is unencumbered by sentiment or morality. Unlike most of the other characters, she refuses to be a victim. Her mother says of her, "She's hard and selfish. I don't think she's stupid. She can take care of herself" (3; 179). Lois represents a new breed of tough, amoral people who can survive. The old, humanistic values of Edwardian England and the Edwardian drama of playwrights like Harley Granville-Barker and John Galsworthy have been lost even if the same country house stage set remains, a vestige of an era about which one can feel nostalgia. Mrs. Ardley, soon to die of cancer, says, "I'm not at home in this world of today. I'm pre-war. Everything's so changed now. I don't understand the new ways" (ibid.). The play ends with her husband, a representative of Edwardian prewar optimism, proclaiming, "This old England of ours isn't done yet, and I for one believe in it and all it stands for"(181)—a prelude to Lois's sister Eva's demented singing of "God Save the King," that brings down the curtain. It is lack of a man that has maddened Eva, but we do not see much of a sign that a man would do her any good. The three Ardley sisters offer three different alternatives, unhappy marriage, hysterical spinsterhood, or cynical exploitation of a feckless man.

Maugham wanted his audience to see *For Services Rendered* as his commentary on the psychic and spiritual damage caused by World War I, which was a central subject for playwrights in the 1920s. R. C. Sherriff's *Journey's End* (1928) brilliantly places the horrors of life in the trenches on stage. J. R. Ackerley's *The Prisoner of War* (1925) dramatizes the psychic damage on one soldier. Arthur Wing Pinero's more optimistic dramatic fable, *The Enchanted Cottage* (1921), centers on the spiritual healing of two wounded veterans who learn that love can conquer all. Yet the war and its aftermath are not central in Maugham's play. It is background to another chapter in Maugham's study of how a tough woman negotiates the prevailing sex/gender system.

The only man in Maugham's plays who seems to maintain any power over the woman who loves him is the one in the economic position usually held by women, the kept man Anthony Paxton in *Our Betters.* (Some

say Anthony is modeled on Gerald Haxton.) Tony is a pretty, young boy toy who bristles against the possessiveness of the middle-aged duchess (American-born Minnie) who keeps him, but Minnie is totally and foolishly smitten with him even though she is aware of his faults: "He's a gambler, an idler, a spendthrift, but in his way he is fond of me" (2; 22). After Tony asserts some independence by having sex with Pearl in the teahouse, he manages to manipulate his older lover into giving him an income and marriage. The resolution of their affair is ominous for Minnie:

> *Duchesse*: Oh, Tony, I do love you so.
> *Tony*: That's right. (85)

Minnie has made a fatal mistake that her friends are smart enough to avoid—she has let love get in the way of clear thinking. Tony's situation, like that of many of Maugham's wives, is economic subservience: "He had to be dependent on me, and that's partly why he always wanted to marry me" (99). Most of the women in *Our Betters* have the money, and therefore the freedom and power, but many of Maugham's wives need a husband for economic reasons.

Two of Maugham's later plays, *The Letter* (1927) and *The Sacred Flame* (1929), are murder mysteries in which a woman commits a murder and then coolly behaves as if she is innocent until confessing just before the final curtain. Both women are praised for their self-control. The investigator in *The Letter* praises Leslie Crosbie, "Her self-control is absolutely amazing. She must have a nerve of iron."[30] She is steely enough to have put six bullets into her lover then behave as if it were self-defense: "He tried to rape me and I shot him" (92). Actually, she shot him because he told her he was not interested in her any more. Leslie is not punished for her crime in the usual fashion. She is innocent in the eyes of the law but must live the rest of her life with a husband she does not love and feel guilt and grief for killing the man she still loves. A lifetime in a loveless marriage is the worst punishment Maugham can conceive of for his protagonists. In *The Sacred Flame,* a mother poisons her paraplegic son so that his wife can marry her husband's brother, the man she truly loves and whose child she is carrying. Mrs. Tabret realizes that Stella, her son Maurice's wife, is in a sexless, loveless marriage and that she deserves something more. Her crippled son has developed for his wife "a hungry, clinging, dependent love" (3; 295) that was the only thing that sustained him: "It was an illusion that sustained poor Maurice in his sufferings, and if he lost it he lost everything. Stella had done as much for him as even I, his mother, could ask of her. I was not

so selfish as to demand from her the sacrifice of all that makes a woman's life worthwhile " (3; 317).

So Mrs. Tabret kills her son to free his wife when maintaining his illusion of her devotion becomes impossible. Like Leslie in *The Letter,* she is free of the law at the end of the play but must live with the loss of her son. However, there is nothing in Maugham's work to suggest that Stella and Colin's love for each other will last. Love never lasts in Maugham's marriages. Sometimes an accommodation can be made that allows husband and wife to have a pleasant life, but romance comes from an affair outside the marriage. Nor do children provide much of a lasting bond, if they exist at all, and they seldom do in Maugham's world. In *Our Betters,* Pearl resents the fact that her husband wants her to "have a baby every five minutes" (2; 27). If she has them, they are invisible to her social circle and to her audience. If Maugham were a conventional moralist, one could opine that the lack of children is precisely the problem in his marriages, but he simply is uninterested in that crucial aspect of marriage. So are, for that matter, Wilde and Coward.

LOVE AND/OR MARRIAGE

Late in life, Maugham told one interviewer, "A marriage, at best, is the most abnormal of relationships between man and woman. I refuse to believe that it was ever intended for man and woman to be bound together by a legal contract under one roof. It constitutes an invasion of privacy, an encroachment on individuality, the shattering of peace-of-mind, the interruption of independent thought and action, and the engulfement of an innocent human being in a bog of boredom."[31] It is interesting to observe that Maugham sees only one member of the couple engulfed in boredom. Though Maugham saw himself entrapped by his marriage to Syrie, in his plays it is the woman who finds ways of manipulating the restrictions of marriage to her own advantage while the men are forced to adapt.

The key questions in Maugham's plays are, what is marriage? and, what is the relationship between love and marriage? Maugham presents these questions from different points of view and in different circumstances. The American heiresses in *Our Betters* have money but want husbands for social positions. Young Bessie has come to England for just this purpose but returns to America at the end of the play because she is horrified by the emptiness of the lives of her older compatriots. In *The Constant Wife,* Constance understands all too well what a middle-class wife is—"a parasite," "a prostitute who doesn't deliver the goods" (2; 160,157). Constance

knows that "it all comes down to the economic situation" for women (162). The only solution is financial freedom, and Constance finds that through her successful career as an interior decorator. Once she can repay her husband what he has spent for her upkeep, their marriage can be an honest one. Constance does not want to leave her husband. Though she no longer has any romantic feelings for him, she finds him a good companion. He gets his passion elsewhere, and now, financially independent, she can as well: "You could never bring yourself to divorce me for doing no more than you did yourself" (198).

In Maugham's world, a good marriage is an honest companionship between intellectual and financial equals. It cannot be lifelong passion or romance because they do not last. For a woman, the reward of passion is less the sexual pleasure, though that is present, and more the feeling of importance gained from a man's attention. When Constance decides to go off on a six-week affair with an admirer, she tells her husband, "Once more before it's too late I want to feel about me the arms of a man who adores the ground I walk on" (195). She knows the affair will be temporary and sees no reason why it should threaten her marriage. Monogamy is not upheld as a virtue here or elsewhere in Maugham's plays.

In Maugham's farce, *Home and Beauty*, Victoria loves marriage more than any particular husband: "I should never survive it if anything happened to my present husband, but if anything did—touch wood—you know, I couldn't help myself, I'd just have to marry again, and I know I'd love my third husband just as much as I loved the other two" (2; 230). There is a delicious contradiction here between the sweet sentimentality of the first clause and the emotional promiscuity of the rest of the speech. She later tells her manicurist, "I don't want to be understood. I want to be loved" (231), preferably by a very rich man.

Victoria is in an extremely awkward situation. When her husband, William, died in the war, she married his best friend, Frederick. Victoria understands too late that this is a mistake: "You pretended you loved me. I would never have married you if it hadn't been for Bill. You were his greatest friend. You made me love you because you spoke so beautifully of him" (244). Marriage for both Victoria and Frederick is a way of maintaining William's memory. The strong bond between these men is evident in the naming of their firstborn children: William and Victoria's son is named Frederick, and Frederick and Victoria's son is named William. When William turns out to be very much alive and returns home to find his wife married to his best friend, the two men, instead of fighting over who will be Victoria's husband, fight to see who can escape from the marriage. At

one point in the ensuing confusion, Victoria tells William, "What a pity it is you were ever my husband. I'm sure you'd make a charming lover," to which he responds, "I have often thought that is the better part" (300). Lovers enjoy romance and sex with no other obligation. Marriage means constant companionship. At the end, Victoria runs off with a wealthy admirer, leaving William and Frederick to toast her departure from their lives. The two friends seem happier with each other away from the demands of a wife. At the final curtain, the two men toast Victoria's third marriage and their freedom.

There are no overt hints of homosexuality in the relationship between William and Frederick—there simply could not be on the English stage in 1917—but it is difficult to read this play without seeing the resolution as the "marriage" of William and Frederick, whose feelings for each other are far stronger than their feelings for Victoria, who rightfully complains, "There are two men in the house, and neither of you pay the least attention" (298). No wonder she runs off with someone else. The attitude toward marriage expressed in *Home and Beauty* reveals Maugham's own attitude, and the situation offers a funhouse mirror reflection of his life as he escapes his marriage to be in a primary relationship with a man. "The aim of comedy," Maugham wrote, "is not to represent life, but amusingly to comment on it" (3; xxiii). The absurd trappings of farce allow Maugham to reveal more of his true feelings than a more realistic work would.

Maugham gave up writing plays in 1933. His later plays, which moved away from the format of elegant drawing room comedy, did not fare well. Nearing sixty years old, he saw theater as a young man's profession, particularly as he had little interest in the actual production of his plays. He wrote Noël Coward in 1933:

> I have done with playwriting. I know now that I made a mistake in writing plays then washing my hands of them. But it is too late to regret that I did not do something that I disliked and probably should not have done any better than the people in whose hands I left it. I cannot tell you how much I loathe the theatre...After one has got over the glamour of the stage and the excitement, I do not myself think the theatre has much to offer the writer compared with other mediums in which he has complete independence and need consider no one.[32]

Theater had given Maugham his first financial success and, a decade later, a series of star-studded hit revivals produced by Binkie Beaumont (five Maugham productions in 1946 alone) offered Maugham continued remuneration.

THE AUTHOR AS SUBJECT

Maugham tried to combine literary celebrity with secrecy about his personal life, a feat easier to accomplish in his lifetime than now. He asked correspondents to destroy his letters, and he himself destroyed documents that would have aided potential biographers. In his memoir, *Remembering Mr. Maugham,* Garson Kanin describes Maugham's bonfire nights:

> 1958 *St. Jean-Cap Ferrat.* He and Alan tell us, with a certain macabre glee, about their bonfire nights.
>
> They sit before the fire in the sitting room evening after evening, with cartons and boxes full of old papers, notes, letters, documents, fragments. First acts, unsent letters—and so on.
>
> WSM examines each item and nine times out of ten hands it over to Alan who puts it on the fire...
>
> I ask if some of the material he is so systematically destroying might not be of value to an eventual biographer.
>
> He says that's just it. There is to be no biographer and no biography. Ever? Ever.[33]

Revealing intimate details of Maugham's sexual proclivities is a betrayal of the author's wishes. Born in the nineteenth century, a young man during the Oscar Wilde scandals, Maugham was "deeply affected by Wilde's fate."[34] Given the draconian British laws against homosexual activity, Maugham had to balance the closet with a gay life. Like most closeted celebrities of his era, he was only partially successful at maintaining cover. His biographers report that, in the 1930s, he was warned that Scotland Yard was watching his activities in England and that he needed to use more discretion. Nonetheless, Maugham had no sympathy for the victims of the antigay witch hunts of the 1950s. His only public statements about homosexuality, contained in an essay on the painter El Greco, mirror the stereotypical, negative view of homosexuality prevalent in England in his time:

> It cannot be denied that the homosexual has a narrower outlook on the world than the normal man. In certain respects the natural responses of the species are denied him. A distinctive trait of the homosexual is a lack of deep seriousness over certain things that normal men take seriously. This ranges from an inane flippancy to a sardonic humour. He stands on the bank, aloof and ironical, and watches the river of life flow on. He is persuaded that opinion is no more than prejudice.[35]

Like many contemporary commentators on homosexuality, Maugham did not see that the flippancy he noticed was not an effect of homosexuality, but rather a response to the prevailing homophobia in which the homosexual had to live. As time went on, Maugham seemed to be more concerned about the exposure of his homosexuality. In his 1962 memoir, "Looking Back,"[36] he went to great pains to paint himself as a heterosexual and womanizer, attacked Syrie for serial infidelities, and reduced Gerald Haxton to the role of a secretary. "Looking Back" is more fiction than fact, the self-portrait Maugham wanted the world to see. To those who knew him, it was scurrilous. Excerpts of the memoir appeared in the *Sunday Express,* but Maugham's publisher refused to issue it in book form. While there is no excuse for Maugham's cruel depictions of Syrie and his daughter, one can understand why a man born in the 1870s was not inclined to make his sexuality a public matter, particularly when it would affect his literary reputation and his legal status in England. The memoir caused a great deal of anger among Syrie's friends and hurt for Maugham's daughter, who was the most innocent party in all that had transpired over the years.

For all his attempts to falsify the truth, Maugham's private life became public immediately after his death in 1965. Maugham became the subject, rather than the masterful author, of books by those closest to him. His obituary in the *New York Times* mentioned his homosexuality as if it were common knowledge. In 1966, erstwhile friend and ex-lover Beverley Nichols published *A Case of Human Bondage,* outing him and presenting a sensational, if biased, depiction of Maugham's marriage and relationship with Gerald Haxton. Nichols is an interesting character, a minor novelist and composer of a few songs who is best known for a series of garden books. He wrote a few plays, which he collected into a volume aptly named *Failures.* Nichols was a precursor of what is now a common phenomenon—a "celebrity" of limited talent but with an endless appetite for being with the right people and attracting publicity. He had regular columns in a women's magazine and a tabloid newspaper and wrote volumes of memoirs that were evidence of his talent for changing facts to make better stories. He claims in one volume, *The Unforgiving Minute,*[37] to have attempted to murder his father three times. One would think this confession to be legally dangerous. According to his biographer, Bryan Connon, Nichols was openly gay and into rough trade: "A BBC producer remembers Beverley hobbling into his office one afternoon. 'I was practically ripped apart last night,' he said cheerfully. 'I've been sitting in a cold bath all morning to reduce the swelling.' Arthur Diamond said that some

of the situations he got into were extremely dangerous: 'he paid for sex and goaded rough trade into violent assault."[38] Despite his proclivities, he had a lifelong relationship with actor Cyril Butcher and hobnobbed with royalty and powerful figures like Winston Churchill as well as with fellow gay artists like Maugham and Coward. In the 1930s, he was both an outspoken antiwar campaigner and a Mosleyite fascist, but this did not seem to threaten his social status.

Connon's biography of Nichols indicates that, despite his being openly gay, he and Butcher were invited into the homes of members of the social A-list of his time, which indicates that if one was charming and wealthy enough, homosexuality was not grounds for being a social outcast in the 1930s and 1940s. Nichols's own memoirs are accounts of his interactions with the rich and famous. He was less cautious than Coward and Maugham, but he had less to lose. He was not a major literary or theatrical figure—which he resented—and did not have the same sort of public image to protect.

Nichols was friends with both Somerset and Syrie Maugham throughout their lives, traveling in both their circles (Syrie's was the more fashionable). He claims to have written *A Case of Human Bondage* to defend her from her ex-husband's malicious depiction of their marriage in "Looking Back." Nichols claims that his book, dedicated "To the Memory of Syrie Somerset Maugham with Love," is "not an attack on a dead man, rather it is the refutation of libel upon a dead woman."[39] However, it is not clear why Nichols felt that he needed to enter the fray three years after "Looking Back" was published. Because the work was never circulated in book form, it had only reached a limited audience. Why the need to open old wounds? Or, had Nichols written the book years before and waited for Maugham's death to publish it? At the beginning of *A Case of Human Bondage,* Nichols claims that the book "tells the true story of one aspect of Somerset Maugham's life which hitherto has never been even vaguely suggested to the general public" (9). In other words, the book is the first to "out" Maugham, at least in terms of his relationship with Gerald Haxton and the failure of his marriage. Nichols's narrative is of a malignant home wrecker and pernicious influence (i.e., Haxton) tempting Maugham away from his wonderful, long-suffering wife. Nichols describes Maugham's relationship with Haxton as an "ensnarement" (140). The book also claims that Haxton was the person responsible for Maugham's eventual attempt to disown his daughter, although that sad chapter of Maugham's life was a decade and a half after Haxton's death when Maugham was living with Alan Searle.

Nichols is honest enough to claim self-interest as a motivation for befriending Maugham: "he had it in his power to be useful to me or to any other young writer" (70). Later, Nichols describes his relationship with Maugham in the 1920s:

> In one's early twenties, struggling to make a living from letters, one would be a fool to ignore the kindly attentions of the literary lions, particularly if they happen also to be rich and not unamusing. Willie's attentions were very kindly indeed. He dined me, wined me, sent me seats for his first nights, and gave me all the interviews I asked for at a time when he was not too accessible to the Press. It was largely through Willie that I had my first best-seller—a little book called *Twenty-Five,* which swung to success after his glowing review of it in the *Sunday Times.* (101)

Everything in Maugham's biography suggests that such generosity was a sexual quid pro quo. Moreover, Nichols claimed to friends that he had sex with Maugham and Coward, among others. Nichols was a regular guest at Maugham's home until the publication of "Looking Back," after which he and others who were also close to Syrie felt they had to distance themselves from her vituperative ex-husband.

The story Nichols tells in *A Case of Human Bondage* would make a great play. In 1926, Syrie buys a house near her estranged husband's in the south of France and decorates it beautifully—by this time, she is celebrated for her interior decoration. She invites Maugham, Haxton, and other guests (e.g., Noël Coward and his partner, Jack Wilson, and Beverley Nichols, among others) for the weekend in the vain hope of effecting reconciliation with Maugham and winning him away from Haxton. After almost a decade of separation, this seems a rather odd and potentially humiliating endeavor but, according to Nichols, "she loved the man. It was not the dramatist who held her, nor his money, nor his fame—it was the man, the whole man, with his stumpy little body, his trembling lips, and his shimmering, contorted brain. She loved him, warts and all" (72–3). Of course, the weekend was a disaster. When Maugham arrives, Syrie comes "toward him, arts outstretched. 'Darling' He turns away" (72).

Nichols claims that late Saturday night, he had walked into a room and found "Gerald on the floor, stark naked, *covered* with thousand franc notes. Never seen so much money in my life. On the bed, over his legs, practically in his hair. Gerald trying to be sick and sometimes succeeding. What does one do in such circumstances? Gerald looks about to die. Stand there, feeling very inadequate, when suddenly noise behind me. Turn. Willie in a bright green dressing gown and looking like the wrath of 49,000 Chinese

gods" (28). Nichols later admitted that it was not Maugham who had appeared in a silk dressing gown looking like the wrath of Chinese gods, but Noël Coward, after Jack Wilson had come into Nichols's room and made a pass at him. Coward accused Nichols of inviting Wilson to his room. After this confrontation, Nichols had to leave. "It is a very strange story and I have an uncanny feeling that it clouded my relations with Noël for the rest of our lives. At any rate, he never forgot it, nor did I—though my conscience is as clean as a newly polished whistle."[40] Such rearranging of the truth is not uncommon in Nichols's memoirs.

On Sunday, according to Nichols, Syrie left her own house party and, with him as her companion, returned to London. In the dining car of the train to London, Syrie loudly announced her feelings about the wreckage of her marriage. It did not matter whether the cause of the breakup of her marriage was a man or a woman, but Gerald Haxton was too much to bear: "What distresses me, what really does make the whole thing intolerable, is the fact that Gerald is a LIAR, and a FORGER and a CHEAT" (138). For Syrie, and for Nichols, Haxton was indeed a pernicious influence who did all he could to break up the marriage. Throughout the book, Nichols demonizes Haxton and, by association, Maugham. He attacks Maugham not only for cruelty toward Syrie but also for hypocrisy in his work: this homosexual would not write about homosexuals in his work or support homosexuals in his life. Other than Syrie and Nichols himself, the only person to come out of *A Case of Human Bondage* unscathed is Alan Searle, who is depicted as "something of a saint" (31).

Nichols thought that his book was a noble act that would have the support of Syrie's daughter, now Lady Glendevon, and Robin, now Viscount Maugham. They did not stop the publication of the book, but they did not praise it either. Nor did they defend Nichols from the attacks he received when *A Case of Human Bondage* was published. Nichols was bitter for the rest of his life at the hostile reaction he received for attacking a celebrated writer who had been his friend and supporter.

OVERSHADOWED

No one was as ardent an outer of Maugham as Robin Maugham. Richard Huggett claims that Robin "had always adopted a curiously jealous and possessive attitude towards his Uncle Willie whom he clearly regarded as his own personal property."[41] While Beverley Nichols wrote one book "outing" Maugham, Robin almost made a career out of publishing details of

his uncle's private life. Robin was the son of Maugham's brother, Frederic, who was a distinguished barrister and was, for a brief period in the 1930s, lord chancellor. Like Nichols, Robin painted a very black picture of his uncle in his memoirs. At the beginning of *Escape from the Shadows,* he says of himself, "Overshadowed, queer and alcoholic, I should have been a complete failure."[42] He felt overshadowed by his dour, strict, and distinguished father and by his celebrated uncle. He tried to follow his father's footsteps but found the law tedious, so he turned to his uncle's profession, but "Uncle Willie" was too possessive of his own position to appreciate a literary relation and resented it when Robin's novels were compared to his. Nonetheless, Robin had some success as a writer. His novella *The Servant* (1948) was turned into a classic film. *The Wrong People* (1967) is considered an important early work of gay fiction

In a series of memoirs, *Conversations with Willie, Somerset and All the Maughams,* and *Escape from the Shadows,* Robin offers just the sort of intimate details about his uncle's private life that the great author assiduously tried to prevent in his lifetime and afterward. One can only wonder what sort of resentment fueled Robin's motivation. He had expected a generous bequest from his uncle but was not mentioned in the will (just about everything was left to Alan Searle).

So, in the years after Maugham's death, more was written about the details of his personal life as a gay man than about his work as a writer. Maugham's literary reputation has waned. He always resented being considered a second-rate commercial writer while critical praise went to the more experimental modernists, but as a writer, Maugham was shaped by the style of the century in which he was raised and educated. He is, in some ways, a Victorian writer. His plays were influenced by the drama that thrived in his twenties when Wilde was, briefly, the darling of English theater. Now, when I tell friends that I am writing about Maugham, they tell me they know the short stories, which are his most lasting legacy. Given all that has been written about his life in the past half century, he is in the anomalous position of being considered a gay author who did not write gay literature and who is therefore of only marginal interest to queer studies. The plays do, however, show how a writer can be exceedingly popular while defying conventional morality and traditional gender roles.

3. Love or Marriage: Sir Noël Coward and Sir Terence Rattigan ❧

I love Otto deeply, and I respect him as a person and as an artist. To be tied legally to him would be repellent to me and to him, too.

Noël Coward, *Design for Living*

Oh, I'm not denying you married for love—for your idea of love. And so did I—for my idea of love. The trouble seems to be they weren't the same ideas.

Terence Rattigan, *The Deep Blue Sea*

In 1972, at a celebration honoring the knighthood of Terence Rattigan, a photographer took a picture of Noël Coward, knighted three years before, warmly embracing the playwright: "'For God's sake, Noël,' said Rattigan, 'everyone will think we're having an affair.' 'Why not,' he [Coward] asked, 'It's perfectly legal, very suitable and, considering our combined ages, extremely unlikely.'"[1] By this time, the two playwrights, friends and rivals, had been the lions of British commercial theater for decades. In 1931, Rattigan, then a stringer for an Oxford paper, *Cherwell*, wrote a negative review of Coward's recent play *Cavalcade*. Rattigan attacked Coward, whose early work was more daring, for selling out in order to gain commercial success. Later, Rattigan was accused of the same thing. Both men craved fame, fortune, and the lavish lifestyle they allowed. When Rattigan's first hit, *French without Tears,* was produced in 1937, he was hailed as the new Coward. However, the old Coward did not give up the spotlight easily. Later, the work of both men was produced by Binkie Beaumont, which placed them in the gay theatrical mafia that seemed to dominate the West End.

While Coward's dramatic output varied, his comedies from the early years of his career are the works that are most often revived. His reputation is as a master of light entertainment, with clever farces, witty songs, and droll performances of his own work. When I was a student, Coward's television appearances and record albums were considered the epitome of British wit and sophistication. Although Rattigan's first success is a farce, he continues to be celebrated as the premier serious dramatist of the pre-Pinter period of the twentieth century and as a master craftsman who could uncover the anguish underneath British reserve. Much of his best work is about heartbreak and the violence that follows lost love.

Marriage was a central subject for both men. Coward's best work dismisses it as a social custom that is beneath his brilliant, rebellious characters. Rattigan's most powerful work dramatizes marriages gone wrong.

"THE MASTERS"

One of the people most virulent in his criticism of Beverley Nichols's diatribe against Somerset Maugham, *A Case of Human Bondage,* Noël Coward wrote in his diary, "Beverley Nichols has written a ghastly book purporting to defend Syrie's memory. He has been rightly crucified for it. It is vulgar, tasteless and inaccurate."[2] In another entry, he refers to the book as an "essay in bitchiness."[3] Syrie had been a friend of Coward's. Indeed, she seems to have been a central figure in the sophisticated gay set of the 1920s. Richard Huggett, Binkie Beaumont's biographer, contends that the high-camp argot of the circle was influenced by Syrie's patter as well as her all-white interior decoration. Quoting Tallulah Bankhead, a favorite of gay men at the time, Huggett repeats, "'Oh, daahling, isn't it sheer and utter blissikins,' an expression Bankhead had picked up from Syrie Maugham."[4] Later, he says Syrie's "special high camp slang which she invented...was copied by everybody in fashionable London."[5] No wonder gay socialites like Beverley Nichols were so protective of her.

In his last play and last star turn, *A Song at Twilight,* produced the same year that Nichols's attack was published, Coward created a critical, fictional version of Somerset Maugham. Coward's play is cited as the one work of his in which homosexuality is candidly presented and gay rights are advocated. Some critics claim that it is autobiographical, but in performance, Coward made himself up to resemble Maugham as much as possible, and clearly, the play is more about Maugham than Coward

and is another response to Maugham's covering up of his sexuality in his memoirs.

Coward and Maugham were friends, colleagues, and, to some extent, rivals. Barry Day observes that "the greatest influence on the early Coward was undoubtedly W. Somerset Maugham... For a while Coward and Maugham were professional contemporaries, then—when Maugham literally quit the stage—they remained wary friends, pacing around each other, as someone described it, like a couple of panthers."[6] They were both respectfully, though sometimes mockingly, referred to as "The Master." Coward exploded onto the West End in the mid-1920s as Maugham's career as a playwright was winding down. It is to Coward that Maugham confessed his hatred of playwriting: "I cannot tell you how I loathe the theatre. It is all very well for you, you are author, actor and producer [director]. What you give an audience is all your own; the rest of us have to content ourselves with at the best an approximation of what we see in the mind's eye."[7] While Coward was fully a man of the theater whose stardom was important to him, shy Maugham preferred the control and distance of the novelist. Theater had given him his first taste of fame and fortune, but he did not need it anymore. Maugham recognized Coward's ascendance by writing a glowing preface to his first collection of three plays, and the two authors read each other's manuscripts. Coward acknowledged Maugham's influence on his short fiction as well as his drama. Yet Coward had little patience with Maugham's misanthropy. In 1966, the same year as the publication of Nichols's book and Coward's *A Song at Twilight,* he provided a preface to a new memoir of Maugham by the playwright-screenwriter Garson Kanin:

> The old truism that a writer's character is usually reflected in his work in particularly applicable when discussing Willie Maugham. He was a complex man and his view of his fellow creatures was jaundiced to say the least. He of course had his friends and his loves, and I myself am indebted to him for nearly fifty years of kindness and hospitality, but I cannot truthfully say that I really knew him intimately. He believed, rather proudly I think, that he had no illusions about people but in fact he had one major one and that was that they were no good.[8]

Nonetheless, Coward remained friends with Maugham but later called him an "unadmirable character"[9] and dubbed him "The Lizard of Oz." Coward did go to the Villa Mauresque to see Maugham a couple of months before his death: "He was living out his last days in a desperate nightmare,

poor beast. He barely made sense and of course his mind was gone. Poor, miserable old man. Not very sadly mourned, I fear."[10]

In 1934, Coward wrote one of his least successful works, *Point Valaine,* as a vehicle for his friends Alfred Lunt and Lynne Fontanne, with whom he had appeared in *Design for Living* (1931). He served as director of the Broadway production of *Point Valaine,* but neither his direction nor the the couple's star power could save the play. Coward dedicated the play to Maugham, and one of its characters, the detached novelist Mortimer Quinn, is somewhat based on Maugham. One of the problems with *Point Valaine* is that Coward seems to have tried to write a work in Maugham's style and imbued with the older author's cynicism. The setting is a tropical hotel on a Caribbean island where it rains most of the time, an echo of Maugham's short story "Rain," which had been turned into a hit stage vehicle for Tallulah Bankhead and several movies. The island hotel is run by a forty-something woman who seems to attract desperate men and destroy them. By the end of the play, one has destroyed himself and the other is in despair. Quinn is a misogynist:

> *Linda*: Woman hater?
> *Quinn*: With reservations.
> *Linda*: What is it you hate about women?
> *Quinn*: I think I despise their lack of emotional balance.[11]

Later, Quinn describes himself to the distraught young man who has fallen in love with the passionate but feckless Linda: "You see, I also affect to despise human nature. My role in life is so clearly marked" (149). There are many similarities between Quinn and Maugham and many of Maugham's characters. Quinn is "cynical, detached, unscrupulous, an ironic observer and a recorder of other people's passions. It is a nice façade to sit behind but a trifle bleak. Perhaps I am misunderstood. I often toy with that idea" (150). He hates "the dreary capacity of the human race for putting the right labels on the wrong boxes" (150) and insists that the people around him do not romanticize or try to dress up desire as love: "Don't romanticize unduly. Look at the truth...Don't try to smear your desire with luminous paint" (151–2). Moreover, like some of Maugham's dispassionate observers (e.g., in *The Narrow Corner*), Quinn does not seem to have any emotional life of his own. Maugham, for all his cynicism and misanthropy, had a complex emotional life centered, like that of many of his characters, on an unworthy object. Quinn's insistence on honesty echoes Maugham's but is also typical of Coward's characters, who often advocate candor and rejection of conventional morality.

There is little of vintage Coward in *Point Valaine*. It is as if he is unsuccessfully trying to channel his older mentor and failing. Coward is very much Coward in his second, more withering, portrait of Maugham in his last play, *A Song at Twilight,* the most successful of the three plays Coward wrote under the sobriquet *Suite in Three Keys* (1966). As a 2009 British revival demonstrated[12], it is still a powerful work. Here in Coward's last work, we have his only direct discussion of homosexuality as part of a depiction of a passionless but practical heterosexual marriage. Set in a hotel in Switzerland, it focuses on the aging, celebrated author Hugo Latymer. Though renowned for his work, Hugo is cut off from the outside world. He has alienated most of his friends. For twenty years, Hugo has been in a loveless marriage of convenience with his secretary, Hilde, who manages many aspects of Hugo's career and knows more about him than he would ever admit. Hugo has recently written a memoir that a reader has called a "superlative example of sustained camouflage."[13] As Maugham did in his specious memoir, "Looking Back," Hugo presents himself as a heterosexual and makes negative comments about the women in his life, but Hugo is not "very nice about anybody" in his memoir, which is the expression of "a profound cynic" (438).

On the night the play takes place, Hugo is visited by a former lover, Carlotta, whom he has not seen in decades. Carlotta claims to have come to this particular Swiss hotel for anti-aging injections (Maugham himself went to Switzerland for "rejuvenating" injections from the fetuses of sheep, which were meant to prolong life and sexual prowess). Actually, Carlotta has come to discuss two sets of letters she possesses. She first asks Hugo for permission to publish in her forthcoming memoir letters he had written her when they were lovers: "They *are* love letters of course up to a point and brilliantly written. The more ardent passages are exquisitely phrased although they do give the impression that they were commissioned by your head rather than dictated by your heart" (401). True to form, Hugo, who hates the idea of biography, refuses Carlotta's request. Carlotta offers to give him the love letters he wrote her, but at the first act curtain, she reveals that she now possesses another set of letters Hugo wrote Perry Sheldon, "the only true love of [Hugo's] life" (402). There are two groups of letters:

> Love letters, most of them. They are less meticulously lyrical than the ones you
> wrote to me, but there is more genuine feeling in them. They were written in
> your earlier years, remember, before your mind had been corrupted by fame
> and your heart by caution. The last ones were written in the last years of his
> life. There are three of them. All refusals to help him when he was in desperate

straits. They also are fascinating in their way, masterpieces of veiled invective. Pure gold for your future biographer. (406)

Carlotta is deciding whether to give the letters to an Oxford professor who wants to write Hugo's biography or to give them back to Hugo. She would like him to see the extent of his "complacent cruelty and moral cowardice" in not acknowledging honestly who he is:

> But why the constant implications of heterosexual ardor? Why those self-conscious, almost lascivious references to laughing-eyed damsels with scarlet lips and pointed breasts? And, above all, why that contemptuous betrayal of Perry Sheldon…He loved you, looked after you and waited on you hand and foot. For years he travelled the wide world with you. And yet in your book you dismiss him in a few lines as an "adequate secretary." (419)

Carlotta observes of Hugo, "He has never taken into account the value of kindness and the importance of compassion. He has never had the courage or the humility to face the fact that it is not whom he loved that really mattered but his own capacity for loving" (438). The echoes of Maugham's personality and his memoirs here are anything but subtle. Neither are the descriptions of Perry as an alcoholic and "a weak and feckless character" that echo descriptions of Gerald Haxton. Hilde calls him "a creature of little merit; foolish, conceited, dishonest and self-indulgent" (440). Coward gives Hugo a redeeming moment at the final curtain as he sits reading Perry's letters to him: "*It is apparent from his expression that he is deeply moved. He starts to read the letter again and then, with a sigh, covers his face with his hand*" (441). This highly theatrical ending gives Hugo more heart than Maugham seems to have had. John Russell Taylor observes that "the question remains of whether he [Hugo] does not have something to be said in his favour that cannot be said of either of the women in the play—that he has felt real passion at least once in his life and has suffered because of it, while both the women seem to be theorizing in a vacuum."[14] Carlotta is a bit too self-righteous, and it is not clear exactly why at this particular point in their lives she needs a confession from Hugo. John Lahr, who reads everything of Coward's as a self-portrait, filtered through Lahr's particular brand of heterosexism, delineates the play's weaknesses: "Coward was too much of a stranger to his intimate feelings to make his vulnerability articulate. Even his language foreshadowed a hardening of his theatrical arteries."[15] Though Coward obviously felt the need to explain why he and Maugham created public heterosexual personae, Hugo Latymer is not merely a self-portrait any more than he is completely a portrait of

Maugham. After all, neither playwright denied himself a love life. Coward had a number of intense long-term relationships, and neither man sought the lifelong "cover" of marriage.

According to Huggett, Beaumont and Coward were concerned enough about these references to Maugham to show the play to Robin Maugham: "He didn't dislike the play, but he was alarmed that people might think it was a portrait of Somerset Maugham and upset that Coward had trespassed on what he thought of as *his* territory. He tried to persuade Coward and Binkie to cancel the production... He further warned them that Maugham might consider himself libeled since his homosexuality, though known to his family and close friends, had not been made public... and the dead male love in the play, Perry Sheldon, obviously referred to... Gerald Haxton."[16] Beaumont and Coward were not dissuaded by Robin's threats. Fortunately for them, Maugham died a few months before the scheduled opening, and one cannot be accused of libeling a dead man.

A Song at Twilight was a critical and commercial success. A number of the critics caught the allusions to Maugham, whose secret life was never as secret as the author thought it was. Coward, of course, had been cagey about his private life, a censored version of which he had already presented in his many volumes of memoirs. He knew, as did his creation, Hugo Latymer, that homosexuality was a criminal offense. To some extent, the neutral version of homosexuality that he presents in *A Song at Twilight* is something of a self-outing as well as an outing of Maugham.

Though the play's dramatic revelations spotlight Hugo's romance with Perry Sheldon, the central relationship is the passionless marriage of Hugo and Hilde. A German Jew, Hilde escaped from Nazi Germany in 1940. She had left behind the man she loved, who later was killed in a concentration camp. Hugo hired her as his secretary in 1945 and married her two months later. For twenty years, she had been his companion and his assistant, but never the object of his passionate love. She tells Carlotta, "I recognized his need for a 'façade' and was quite content to supply it. I thought that it was a most realistic and sensible arrangement and, what is more, I think so still. I am not pretending that our married life has been twenty years of undiluted happiness. He is frequently sarcastic and disagreeable to me and I have often been unhappy and lonely. But then, so has he" (439). But Hilde knows that the aging, infirm Hugo needs her, "and that, with my sentimental, Teutonic mentality, is the reward I have been waiting for" (439). This is marriage as compromise, something quite different from the love Hilde once had for her German lover or Hugo had for Perry Sheldon. But love and marriage in Coward's works were always separate, the one a

natural feeling that may or may not be connected to sexual passion, the other a repressive social institution.

LOVE OR MARRIAGE

In Coward's most successful comedies, for which he was author, director, and star, marriage is an irrelevant bourgeois institution that characters move in and out of freely with no concern for the repressive divorce laws of the day. After all, Coward's leading characters are all self-obsessed, eternal adolescents who thumb their noses at respectable society. The butt of his jokes and the laughter of his gay (in the original sense of the word he so loved to use) characters are the spokespeople for bourgeois morality. In *Private Lives* (1930), Coward's most revived play, Elyot and Amanda cannot live with each other, but also cannot live without each other. After a turbulent marriage and divorce, they remarry their opposites, a proper English man and woman who are too well behaved to offer them the theatrics they so crave. Life should be a grand, flamboyant performance, and Elyot and Amanda's new spouses, Sybil and Victor, can only sit in the audience and judge. So, at the end of act 1 after a witty reunion, Elyot and Amanda run off, leaving their spouses to chase after them. In act 2, we see a performance of their relationship from romance to fisticuffs. Elyot and Amanda relish the roles of *divo* and diva: they are both stars of and audience to their theatrics. When Victor and Sybil catch up with them, Elyot and Amanda can only make them figures of fun to leave again at the end. Coward's leading characters are incapable of living by the rules of conventional society, and marriage is a set of rules. In *Hay Fever* (1925), a middle-aged husband and wife both invite young admirers and would-be lovers to their country home for the weekend. The heroine of *Design for Living* gives up a lover at the ends of acts 1 and 2 and leaves her husband at the end of act 3 to be reunited with the two men she loves, who also love each other. It is difficult for us now to appreciate how transgressive these plays were in their time, when divorces were not so easily acquired and divorced women were seen as tainted and dangerous. Coward's fallen women relish their status.

Though it is far from his best play, in part because Coward does not present the material in his usual comic manner, *Easy Virtue* (1926)[17] offers one of the playwright's most interesting meditations on marriage. Coward saw *Easy Virtue* as his version of nineteenth-century melodramas of "fallen women" such as Arthur Wing Pinero's *The Second Mrs. Tanqueray*, but

Coward's heroine feels no need to commit suicide as an act of atonement for past sins. She is more like the "fallen women" of Oscar Wilde and Somerset Maugham who manage to survive and even triumph at the final curtain. Coward wanted to show that Larita is more vibrant and interesting than the family into which she has married.

The setting is the elegant country house of Colonel Whittaker and his wife and family. The marriage of the Colonel and his wife is far from happy. She has suffered nobly, if audibly, through his affairs with other women, caused in no small part by her frigidity, but has chosen to stay married because that is what wives should do. She and her older daughter, Marion, are high priestesses of social convention. Coward writes of Mrs. Whittaker, "The stern repression of any sex emotions all her life has brought her to middle age with a faulty digestion which doesn't so much sour her temper as spread it."[18] Her older daughter, Marion, wears "mannish" clothes and is a paragon of Christian virtue. The younger daughter, Hilda, has "a deficient sense of humor," the worst possible failing for a character in a Coward play. Colonel Whittaker tries valiantly to maintain high spirits and a sense of humor around the dispiriting women in his household:

> *Marion*: People think too much of all that sort of tosh nowadays, anyhow. After all, there are other things in life.
> *Colonel*: You mean higher things, don't you, Marion?—much higher?
> *Marion*: I certainly do—and I'm not afraid to admit it.
> *Colonel*: You mustn't be truculent just because you've affiliated yourself with the Almighty. (228)

When the play opens, the Whittakers are expecting the arrival of their son, John, and his beautiful, elegant new wife, Larita, who already is the object of scorn among the Whittaker women. John met Larita at a French casino and quickly fell in love with and married her. Larita is, horror of horrors, a gay divorcée. Worse yet, her first husband (the marriage was arranged by her mother) divorced her after she ran away. She first describes this aspect of her past with the shame that proper people would expect from her: "I was very young and silly—I should have waited, shouldn't I? and borne it stoically. It would have been braver" (209). Larita's courage, however, is of a different sort—the courage of her own convictions, which are quite different from those of her husband's family. She soon speaks her own mind instead of what the Whittakers expect her to say.

After three months at the Whittaker home, Larita is bored and frustrated. She also knows that John sees clearly that his wife does not fit into

his social world. When he expresses some regret to Sarah, the woman his family had wanted him to marry, she responds:

> *Sarah*: You took your opportunity and married for love, John
> and I respect you for it. If we'd married, it would have been for
> friendship and convenience.
> *John*: Would it?
> *Sarah (firmly)*: Yes—we knew one another far too well.
> *John*: Do you think that's a disadvantage?
> *Sarah*: In married life, certainly.
> *John*: I don't.
> *Sarah*: It would have been so dull and ordinary—no excitement at all.
> *John*: I don't want excitement. (233)

Alas, Larita does, and she knows that John's enthusiasm for life and his love of her have been "slowly crushed out of [him] by the uplifting atmosphere of [his] home and family" (240).

When the family discovers more lurid details of Larita's past, their judgments become even more harsh, but Larita bravely speaks her mind: "I have a perfect right to say what I like and live how I choose...and I don't intend to be browbeaten" (256). She tells Marion that she has discovered that he "is charming and weak and inadequate and he's brought me down to the dust" (257). Larita sees marriage as a "hideously intimate" relationship, particularly when a man and a woman no longer love each other. She knows now that marrying John "was the most cowardly thing I ever did" (275).

The issue in *Easy Virtue,* as it so often is in Coward's plays, is the difference between love and marriage and between love and sexual desire. Love is irrational, "utterly inexplicable": "I can look round with a nice clear brain and see absolutely no reason why I should love John. He falls short of every ideal I've ever had" (275). But Larita does love him, even if marriage to him is unbearable. They should have had a passionate affair in France and then called it quits, but marrying John has tied her to all the baggage that comes with him, particularly his priggish family. When someone suggests that the only explanation for Larita's love is sexual, she counters, "If my love were entirely physical it would, but it isn't physical at all" (276). So what is the basis for her love for John? Was she just trying to escape an unhappy life that had gotten too chaotic for her, or does she have maternal feelings for the younger man?

Unfortunately, Larita becomes as judgmental and preachy as Mrs. Whittaker and Marion, constantly delivering diatribes against their rigid

values throughout the second half of the play. Coward's "gay" characters are fun as long as they keep their sense of humor. Larita becomes humorless, and what should be the stuff of comedy turns tedious. Finally, Larita makes her inevitable exit after asking John's ex-fiancée to get back together with him:

> *Larita*: You're fond of him—you ought to have married him, by rights. He needs you so much more than me. He's frightfully weak, and a complete damn fool over most things, but he has got qualities—somewhere—worth bringing out. I'm going to arrange for him to divorce me without any fuss.
> *Sarah*: I don't love him nearly as well as you do.
> *Larita*: All the better. Women of my type are so tiresome in love. We hammer at it tooth and nail, until it's all bent and misshapen. (278)

Larita exits and returns to the Ritz in Paris, her natural milieu, and life at the country house goes on as before. There is no parting scene between John and Larita. He is off dancing with someone else when she leaves. Echoing the fallen women in nineteenth century drama, Larita leaves the society that cannot accept her. However, she does not die like earlier heroines but moves back to the social world in which she belongs. Nor does she apologize for her past or in any way accept the moral judgments of the society into which she has married. She tells the shocked Whittaker women, "I've never had an affair with a man I wasn't fond of" (258). Other than her marriages, she has lived by her principles, which are not those of the Whittakers. As she tells puritanical Marion, "You've played physical purity too high and mental purity not high enough" (258). Mental purity entails having the courage of one's own convictions.

In *Easy Virtue,* Coward takes the conflict of his comedies—the glittering egotists against the conventionally virtuous—and places it in the language of the Victorian problem play. The result is too sententious. What fun is a Noël Coward play when none of the characters have a sense of humor?

In essence, Larita's self-regard and sense of superiority is the same as that of the ménage à trois in *Design for Living*, a play Coward took more seriously than some of his audience did: "With the fall of the curtain after Act One, Noël stormed off the stage in a blind rage. It was a serious comedy. The oafs had laughed all through the first act, he'd be damned if he'd go on with the play."[19] *Design for Living* cuts closer to the bone than Coward

plays have in the past. For one thing, the playwright was dealing openly and positively with homosexuality and celebrating a high-camp sensibility. He was also justifying living outside of conventional morality. Leo, the successful playwright and Coward's alter ego, proclaims to Ernest, the representative of conventional values, "We have our own decencies. We have our own ethics. Our lives are a different shape from yours."[20] Here, as in *Easy Virtue,* the rebels are quite preachy about their alternative value system. Their life may be "degrading; according to a certain code, the whole situation's degrading and always has been" (49). However, "we're not doing any harm to anyone else" (50).

Gilda offers her view on marriage, which is representative of that of many Coward characters: "The only reason for me to marry would be these: To have children; to have a home; to have a background for social activities, and to be provided for. Well, I don't like children; I don't wish for a home; I can't bear social activities, and I have a small but adequate income of my own" (8). Why then does Gilda marry the aptly named Ernest? She thinks she wants to escape the turbulent life of yo-yoing back and forth between Otto and Leo, who love her but in their fame and fortune do not really need her. Ernest will offer her the calm, comfortable life she thinks she wants and needs. She does not yet see that the solution to her problem is not a passionless marriage with Ernest, but a passionate nonmarital ménage with *both* Otto and Leo.[21] In *Private Lives,* the solution to Elyot and Amanda's turbulent romance that does not work within the bounds of marriage is to stay together out of wedlock. In Coward's most-performed comedies, the rules, particularly the rules of marriage, simply do not apply to his sophisticated, successful characters. Coward's most successful comedies end with the characters escaping conventional marriage. Even *Blithe Spirit* ends with Charles escaping the tyranny of the ghosts of his two wives. Freedom, alone or with one or two loved ones, exists only outside marriage. John Lahr, always eager to invent a homophobic reading of Coward's work, says that *Blithe Spirit* "acts out Coward's fantasy of homosexual torment and triumph."[22] Such a bizarre, simplistic reading does not explain the enormous success of the plays with heterosexual audiences (over eleven hundred performances of *Blithe Spirit* in war-torn London). Coward gives his audience a fantasy world of ultrasophisticated people who are above the rules of conventional society. Coward's sexual orientation is not as central as his narcissism. His characters are too self-centered to conform. They are certainly too self-centered to see marriage as anything but a performance doomed to a run too long to be palatable.

PROPER ROMANCE

Of the many film adaptations of Coward's work, the successful film is the sentimental romance *Brief Encounter* (1945, directed by David Lean), an adaptation of his one-act play *Still Life* that was produced as part of *Tonight at 8:30* (1936). In both play and film, two respectable middle-class people, content in their marriages, deal with romantic feelings that take them out of their usual comfort zones. The setting of the play (opened out somewhat for the film) is the waiting room and café of a midlands train station. There we see the flirtations of the staff, led by Myrtle Bagon, "a buxom and domineering widow."[23] Myrtle, now the object of the attentions of the ticket collector, is not a fan of marriage: "It's all very faine [*sic*], I said, expecting me to do this that and the other, but what do I get out of it? You can't expect me to be a cook-housekeeper and char rolled into one during the day, and a loving wife in the evening just because you feel like it. Oh, dear no. There are just as good fish in the sea, I said, as ever came out of it, and I packed my boxes then and there and left him" (270). A flirtation seems to be enough for her. Housewife Laura Jesson is in the waiting room drinking a cup of tea before her train arrives. Comfortably married to a man who is "kindly, unemotional" (274), Laura is returning from an afternoon in town, her Thursday routine. When she gets a cinder in her eye from a passing train, Dr. Alec Harvey comes to her aid. When we next see them three months later, Laura and Alec have met incidentally in town and spent the afternoon together at lunch and then the cinema: "An accidental meeting—then another accidental meeting—then a little lunch—then the movies—what could be more ordinary? More natural?" (273). Of course, in England in the 1930s, married women did not have lunch or movie dates with married men. A relationship has begun that will take them both out of their usual spheres. Three months later, after weekly meetings, Alec is trying to convince Laura to join him for sex at a friend's flat. However much Laura loves Alec, her sense of morality is too strong to make a sexual affair an easy matter for her: "It's so furtive to love like that—so cheap—much better not to love at all" (281). Here, Coward deals with the confusion regarding "love." Alec and Laura are lovers in the sense that they have acknowledged their feelings of love toward one another, but they have not "made love"—turned their romance into a sexual affair. Laura sees great courage in not taking that step and in not making sex important. That way they do not move irrevocably outside of the values of their world: "It would be far braver to say good-bye and never see each other again" (281). Alec's response is typical of Coward's characters. What

they are feeling is more beautiful than anything they have felt before and takes them beyond social convention. It is "something lovely and strange and desperately difficult. We can't measure it along with the values of our everyday lives" (281). Unlike Laura, who sees everything in moral terms and therefore sees their romance as "dreadfully wrong," Alec is a doctor who sees phenomena like their love outside of moral judgments: "I can see what's true—whether it's wrong or right" (280). Alec sees their love not as a set of choices but as something outside their control. Ultimately, it can be kept pure and noble if they can manage to keep it secret, "untouched by anybody else's knowledge or even suspicions—something of our own for ever—to be remembered" (286). Only the knowledge and judgment of other people can tarnish it, but other people keep intervening. Their sexual tryst is interrupted by an unexpected visit from the owner of the flat Alec is borrowing. Three months later, they realize the relationship must end. Laura believes too strongly that "self-respect matters, and decency" (289), and Alec knows that he too must get away. He nobly accepts a position in South Africa where he will move with his family. He and Laura will have the memory of their love as they continue with the lives they had before they met. Dolly, a garrulous friend of Laura's interrupts their final parting with the real world of middle-class chatter. As Alec leaves, Dolly assails Laura with news of the divorce of mutual friends, a fate Alec and Laura have nobly avoided. In *Still Life,* this romance is carried on against the background of the employees of the railroad station and their comic inter-actions. Middle-class love and angst is set against working-class flirtation.

Coward's screenplay for *Brief Encounter* (Anthony Havelock-Allan and Ronald Neame created the scenario from Coward's play, but Coward provided all the dialogue) makes four major changes to *Still Life.* Of necessity, it "opens out the script." We see Laura and Alec at lunch, in the cinema, boating, and walking and driving in the countryside. Picturesque backgrounds intensify the romance. Second, it presents the relationship of Laura and Alec in flashback. We first see Dolly's intrusion into their farewell. The rest of the romance is presented as Laura, sitting in her living room across from her husband, imagines how she would tell him of what has happened to her. This change places the focus on Laura much more than on Alec. Her memories and experience control the action. In doing so, Coward and his collaborators show us Laura's home life and, most important, her devoted, if dull, crossword-puzzle-loving husband. Laura is not carrying on a romance with Alec because of a miserable home life. That would be too rational an explanation for what has happened to Laura and Alec. Husband Fred may be a bit clueless—when Laura tells him, "I

had lunch with a strange man today and he took me to the movies," he responds, "Good for you!"—but he is also understanding and kind. At the end, he says to her, "You've been a long way away. Thank you for coming back to me."[24]

Brief Encounter is considered a film classic. Released as World War II was ending, it was a kind of celebration of middle-class British decency and restraint. It is romantic but not melodramatic. Laura has no reason to be unhappy in her marriage and in her return to the self-respect and decency she cherishes. Alec will continue to be a dedicated doctor and a good husband. Order is restored. There is a moment in which Laura's husband turns down the swirling, passionate Rachmaninoff that is on the radio and that provides the background to his wife's romance with Alec—it is too emotional for him. The film, too, keeps emotions restrained. And it does not glamorize its stars. Trevor Howard (in his early thirties at the time but looking much older) is a fine actor but is far from a conventionally handsome film star, and neither is the doe-eyed Celia Johnson. Recently, a lovely stage adaptation had a successful run in London. The production took place in an old West End cinema much like the one in which Laura and Alec have their trysts.

In this play, Coward, who became during World War II a kind of British patriotic institution, celebrates the values he mocks in so much of his early work. Instead of self-indulgent, if charming, eternal adolescents who scoff at respectability, we have eminently respectable individuals who give up their relationship so they can continue to be "nice people," which means being good married people. They may go to see *Flames of Passion* at the cinema, but their reality is quite tame.

FINAL THOUGHTS

A Song at Twilight, Coward's picture of Somerset Maugham and, to some extent, himself, is one of a trilogy of plays that were Coward's farewell to the stage as playwright and star. Though only sixty-seven years old, he had difficulty remembering his lines even though he had written them. The trilogy comprises *A Song at Twilight,* which was performed alone on one evening, alternating with the double bill of *Shadows of the Evening* and *Come into the Garden Maud.* All three plays are set in lavish hotel suites in Switzerland, and all three featured Coward with two leading actresses, Lilli Palmer and Irene Worth. So at the end of his career, Coward went back to the variations on a trio that had served him well

in *Design for Living* and *Blithe Spirit*. Here, all three plays offer rumina-tions on love, sexual desire, and mortality. As we have seen, in *A Song at Twilight*, an aging writer living in a passionless marriage is forced by a former mistress to confront his feelings about the male lover he rejected. It is a play about regret and compromise. It is as if narcissistic Leo, the successful writer in *Design for Living,* gives up Otto and Gilda for the kind of compromised marriage Gilda has with Ernest. Leo, for all his attach-ment to public adoration, is capable of love. Hugo leaves the people who passionately love him and settles for a wife who is more an employee than beloved partner.

The worst crime in *A Song at Twilight* is the inability, or refusal, to break through ego and love another human being. Carlotta says of Hugo, "He has never taken into account the value of kindness and the importance of compassion. He has never had the courage or the humility to face the fact that it was not whom he loved in his life that really mattered, but his own capacity for loving."[25] George Hilgay, the central character of *Shadows of the Evening,* shares Hugo's misanthropy: "Human beings are intrinsically cruel, it is part of their inheritance" (487). George has just been informed that he has only months to live. Linda, his mistress with whom he has lived for the past seven years, has summoned his wife, Anne, to offer her support at the end. Anne has refused to grant a divorce to George and has continued to love him as he has continued to love her. George may be a misanthrope, but he has the capacity to love two women at once. In *Blithe Spirit,* Charles's proper wife, Ruth, is the opposite of his free-spirited ex-wife, Elvira, who has rematerialized after a séance. In *Shadows of the Evening,* "compulsive amoureuse" Linda, whose "heart yearns for passion-ate love" (486), contrasts with Anne, who admits that she has "never been a particularly passionate woman": "I was not in love with you when you 'upped and left me'. Perhaps I was never in love with you the way that you mean. But I cared for you deeply. There are so many different degrees of loving. How can one tell? One loves as much as one can" (468). George will share his last months with the two women he loves. Like so many of Coward's leading figures, George believes that "courage and honesty and humour" are the cardinal virtues (483). The play ends with the three set-ting off for an evening at the casino.

Because Anne has refused to give George a divorce, he has maintained a loving relationship with his wife and children as well as a romance with his mistress. Anne and Linda may resent each other's role in George's life, but they agree to play out their roles to the end. One can love in a passionate, sexual way, but one can also love in a more rational way, as Anne does. If

one cannot find these qualities in the same person, one can, as George has, find two complementary women with whom to share his final days. Vernon Conklin, the wealthy American businessman in *Come into the Garden Maud,* the final play of the trilogy, is not as lucky as George and leaves his unhappy marriage for a mid-life romance with Maud Carnagni, a broke Italian princess, now shopkeeper, with a shady past. Like so many "fallen women" in British drama, she is beautiful, elegant, witty, and far more interesting than George's wife. Up to this time, George's love life has not been particularly happy. The girl he had loved and married ran off with someone else when he was drafted into the Navy after Pearl Harbor. When he had returned from the war, his current wife, Anna-Mary, was waiting to snatch him up. Any love left after the honeymoon had faded when the extremely vain Anna-Mary had an abortion without telling Vernon: "She was scared I guess. Also she didn't want to spoil her figure" (533). Since that time, Anna-Mary's primary occupation has been living the role of the wealthy American and trying to break into European society. While Anna-Mary is hosting a dinner for a bankrupt prince in the hotel dining room, Vernon and Maud plan to run off together. Maud does not offer "till death do us part": "This isn't a business deal. Come and live with me and be my love for just so long as it works, for just so long as it makes us both happy…Don't let any sense of moral responsibility rub the gilt off our gingerbread" (534–5). Love trumps marriage, and Vernon already knows that love and marriage are not the same thing. Neither is guaranteed to last. The worst misery is a loveless marriage.

The plays in *Suite in Three Keys* lack the playful wit of Coward's early work and are as tendentious as *Design for Living.* The prevailing mood is melancholy; the issue is what one does with the time left. It is too late for Hugo but not for Vernon. And George will make the most of his remaining months. What redeems the time for a playwright who is not in the least religious is love in or out of marriage or, perhaps, in *and* out of marriage.

RATTIGAN: UNEQUAL LOVE

As with Somerset Maugham, Noël Coward had a long friendship with Terence Rattigan but was critical of the man, if admiring of his work. Coward wrote in his diary after a visit from Rattigan to his Jamaica home: "Terry is a most curious mixture. His appearance and ordinary dialogue are deceptive. He is light, sweet, ready to giggle, incredibly silly over his emotional life, weak and stubborn at the same time—they usually go

together—and yet capable of writing *The Deep Blue Sea, Separate Tables, The Browning Version,* etc., plays so richly impregnated with human understanding and compassion."[26] The mixture of superficiality and depth Coward found in Rattigan can also be found in Rattigan's characters, who often make foolish choices even though they understand themselves quite well.

Like Noël Coward, Terrence Rattigan's reputation went through a number of reversals in his lifetime. His first West End play, the farce *French without Tears* (1936), was a huge hit, but his next work, the more serious *After the Dance* (1939), though cheered on its opening night, closed after only sixty performances. A highly acclaimed 2010 revival at the Royal National Theatre in London confirmed its position as one of Rattigan's finest works and one of the best British plays of the last century. After service in World War II, he wrote three fine plays—*The Winslow Boy* (1946), *The Browning Version* (1948), and *The Deep Blue Sea* (1952)—and many less fine but often commercially successful works that became a target of scorn from the younger generation of Royal Court playwrights and their champions in the press. To them, he and his usual producer, Binkie Beaumont, represented the effete, upper-middle-class drawing room dramas they hoped to replace. Rattigan, Coward, and Beaumont were all known to be part of the gay ruling clique of British drama that was to be supplanted by more "masculine" writers like John Osborne and Arnold Wesker, who represented the new Britain. As the "French window"[27] plays were replaced by "kitchen sink" dramas, Rattigan drew more fire than necessary through his attacks on the new drama, as if the plays of Osborne and Wesker posed a personal threat. In a series of articles and prefaces, Rattigan invented the typical British theatergoer, "Aunt Edna," whose tastes had to be catered to. What did "Aunt Edna" expect of a play?

> First, that it excite her to laugh or cry or to wonder what is going to happen next; and second, that she can suspend her disbelief willingly and without effort. It's only Aunt Edna's *emotions* that a playwright can hope to excite, because we know for sure that she does bring them to the theatre. But we can't hope to excite her intellect because, if she has one at all, which is unlikely, she will almost certainly left it behind in her rooms, or forgotten it on the bus, or checked it in the theatre cloakroom...Laughter, tears, excitement. That is all she demands...Her greatest joy is still and always will be for a good strong meaty plot told by good strong meaty characters.[28]

In other words, Aunt Edna would have no interest in the plays of the younger generation of British writers or in the nonrealistic works by

Samuel Beckett or the absurdists: "She is bored by propaganda, enraged at being 'alienated', loathes placards coming down and telling her what is going to happen next, hates a lot of philosophical talk on the stage with nothing happening at all, enjoys poetry only when it is dramatic and fine prose only when there is action to go with it" (15). In the 1960s, Rattigan did praise the work of Joe Orton, the most irreverent of the younger generation of British playwrights. It was probably no coincidence that Orton was also the only openly gay playwright of the group. Though his editor rightfully thought Aunt Edna was to a great extent tongue-in-cheek, Rattigan's defense of her tastes gave the champions of new drama ammunition with which to attack him and his work. It did not help that Rattigan depicted a middle-aged maiden lady living alone in a West Kensington flat as his intended audience. Granted, the quality of Rattigan's later work is uneven, and he diluted his reputation with some hackwork, particularly the Hollywood screenplays he wrote late in his career, *The Yellow Rolls-Royce* and *The V.I.P.s.* Rattigan craved popular success and enough money to support a rather lavish lifestyle. He was, however, always sensitive about his reputation and hurt by attacks on him and his work. Now, Rattigan's best work, like Coward's, is part of the standard repertoire. He would be happy to know that he is now seen as the superb craftsman he was and as one of the best chroniclers of British manners and mores of his century. In much of his best work, Rattigan's subject is the conflict between sexual desire and marriage.

LOVE AMONG THE NARCISSISTS

Rattigan's background was appropriate for the sort of plays he wrote. His father, Frank, was a diplomat who lost his position through some diplomatic gaffes and an ill-judged sexual escapade with Princess Elizabeth of Romania. Despite his downfall, he wrote a self-serving memoir of his years in the diplomatic service. He spent his later years in the company of a succession of bubble-headed blondes. Terence, who was devoted to his mother, resented his father's behavior and dreaded Frank's visits to his school with a blonde companion in tow. Frank, or "The Major," as he liked to be called, like the bogus Major in *Separate Tables,* wanted his son to be a diplomat, but Terence was drawn to the theater early and may have known on some level that his homosexuality would be a handicap in the foreign service. He did go to the best public schools and to Oxford, though he did not complete his degree.

Terence Rattigan did not enjoy the sort of long-term relationship that Somerset Maugham and George Kelly had. There were lots of one-night stands and a series of turbulent affairs with boyish-looking younger men, particularly with Michael Franklin, a handsome young man (19 years old when the 42-year-old Rattigan met him) who, according to one biographer, "made no secret of the fact that above all he wanted to be looked after, preferably by a somewhat glamorous figure in the arts."[29] As Geoffrey Wansell puts it: "Tempestuous, temperamental, possessive, insecure, argumentative, and yet capable of enormous affection towards his friend and mentor, the Midget [Franklin's nickname among Rattigan's friends] was to become a fixture in the Rattigan household, even though he was never to take up permanent residence there."[30] Rattigan was not one to share all aspects of his life. Lovers were to stay in the background while the celebrated playwright basked in his glory and his social life. They were to be out of sight particularly when his mother was in residence. Like many gay men in public life in the days when homosexuality was illegal, Rattigan remained extremely cautious, even after the antihomosexual laws were relaxed.[31] Rattigan's inner circle knew about the boyfriends, specifically the petulant Franklin, who did not endear himself to the playwright's coterie. Biographer Michael Darlow notes, "However unscrupulous, ungrateful or difficult his boyfriends, Rattigan could still feel sympathy for them—a fact his straight friends found incomprehensible."[32] Perhaps on some level, Rattigan, internalizing the virulent heterosexism of the period, felt he deserved the exploitation and humiliation Franklin gave him. There is something of Franklin in the dancer Ron Vale in *Variation on a Theme* (1958), of whom a former admirer observes, "You don't seem to understand that the Rons of this world always end up hating the people they need. They can't help it. It's compulsive. Of course it probably isn't plain hate. It's love-hate, or hate-love, or some other Freudian jargon—but it's still a pretty good imitation of the real thing."[33] Michael Franklin knew that Ron Vale was in great part a portrait of him and acknowledged it in an opening night telegram: "From Michael, without whom this play would never have been written."[34] However turbulent their relationship was, Rattigan and Franklin stayed close right up to Rattigan's death.

Variation on a Theme is not one of Rattigan's most successful works—it opened when he was most under attack from critics who championed the new, angry kitchen sink dramas of the Royal Court Theatre—but it is one of his most revealing. The theme on which variations are played is Dumas's *La Dame aux Camelias* and Verdi's operatic adaptation, *La Traviata*, strains of which are heard in Rattigan's play. Rather than the

courtesan with the heart of gold and callow bourgeois young man of the originals, Rattigan gives us two narcissists who are drawn to each other because they are birds of a feather. Rose Fish, our heroine, is a working-class girl from Birmingham with a strong ambition to climb the social ladder. She had been a typist who married her lawyer boss. After he died two years later, Rose had taken her inheritance and set herself up in the South of France where she attracted a succession of wealthy husbands—an English lord, a French marquis, and an American movie star. She is now engaged to a ruthless German black marketer and gangster. In Dumas's time, Rose would have been a courtesan. In the twentieth century, she marries her sugar daddies, for a time at least. The marriages have been business ventures, founded neither on love nor on sexual attraction: "I've never in my life found any man devastatingly attractive. Just as well, or I might have been devastated, and that would never have done" (181). She knows that she is not "an awfully nice or rewarding person," but she is a survivor, living in her Riviera home with her sixteen-year-old daughter, whom she despises, and a loyal friend-confidant, a fallen aristocrat who has lost her fortune at the gambling tables. Like the nineteenth-century models for her character, Rose has tuberculosis and is not doing a very good job of taking care of herself.

Enter "Anton Valov," or Ron Vale, a twenty-six-year-old ballet dancer also from Birmingham who is being kept and promoted by choreographer Sam Duveen. Rattigan has to make Ron and Sam's relationship nonsexual, but it is clear that Ron has slept his way into his current position with Sam's ballet company. Ron insinuates his way into Rose's home, and Rose is immediately attracted to him because she sees him as a version of herself: "Come to think of it you *are* me. At least—me nine years younger...If you really do like me at all you're a narcissist, Ron" (182). They are both narcissists and become lovers, which threatens Rose's relationships with her crass German benefactor and her friends. Rose sees herself as Ron's mentor in the ways of the world as well as his lover. Ron's love does not come cheaply, and Rose is constantly buying him expensive clothes and even a sports car. He can rationalize his position on the receiving end of another's largesse: "What's wrong with looking after yourself?" (206). Fortunately, Rose has a sense of humor about Ron's opportunism. When Ron says his reputation among his fellow dancers is making him feel "cheap," Rose ripostes, "Oh, but that's the last thing you ever ought to feel, Ron" (193). He is quite expensive, but Rose is willing to pay the price. Nonetheless, Ron is not satisfied with his position because he is not included in all of Rose's social events (the refrain of many of Rattigan's lovers).

The central confrontation scene in *Variation on a Theme* is between Rose and Sam, Ron's former protector and choreographer. Sam has recovered from his infatuation with Ron and understands how Ron always comes to despise the people who need him and take care of him. After Sam tells Rose that "the record for loving Ron up to now is, I believe, six months," Rose responds:

> *Rose*: What's so damn hard about loving Ron?
> *Sam*: What's hard about loving anyone who can't love back?
> *Rose*: He can love back. He loves me. *(SAM says nothing)* Anyway he needs me.
> *Sam*: Oh, yes. He's always needed people and always will. (215)

Later Rose claims, "I find his needing me is the—well—the best thing that's ever happened to me, and without it I wouldn't see much point in going on living" (218). The discussion with Sam is one of the most extended discussions of the nature of love in Rattigan's work. The only kind of love Rose can know is the one-sided relationship she has with Ron. She knows that if she is the giver in this relationship, Ron is the taker: "Love means giving, doesn't it—and what have you ever done all your life except take—take anything from motor-cars to other people's love" (237). If her giving relationship with Ron is transitory, so are her taking relationships. Rose wants to be needed, not by her husbands or her daughter, but by someone just like her, and she knows exactly what that will cost—her fortune and, given her poor health, her life. Sam has already envisioned Ron's future after Rose: "Of course he won't be able to go back to the ballet, because at his age you can't give it up even for six months, Besides, he'll have gone to seed a bit by them, probably off the rosé and the brandy, I should think. Still, in whatever queer bar he finds himself in London or Paris or New York, I'm sure he'll always be pointed out with some envy as Rose's fifth—'lucky guy. Doesn't have to work. He was a dancer once, they say. Hard to believe now, looking at him'" (218). Despite his affair with Rose, Sam sees Ron as gay.

Variation on a Theme offers a jaundiced view of love, but one that Rattigan presents with conviction. Critics thought Rattigan was writing a coded play about a homosexual relationship. One opines: "The subject should be a homosexual relationship between a bored and aging rentier and an oily male tart."[35] Rattigan could not have had that play produced in 1958, and he did not see much difference between his relationships and those of some of his heterosexual friends—the play is modeled as much on

the romantic problems of some of his women friends as on his own fraught amours. *Variation on a Theme* suggests that, for Rattigan, love could not be separated from need or from narcissism. In its own way, the relationship of Rose and Ron (even their names are alliterative) is happier than most of Rattigan's romances.

Love was not something that came easily to Rattigan, and his best work is about either failed or thwarted love, particularly in marriage or in an intense, passionate romance. Throughout his best work, he explores the relationships between love and sex and between love and need. Can a person's desire for an intimate connection with another ever be satisfied? His characters, particularly his women, want something they cannot find in a relationship with a man and thus are forever unsatisfied. Like Maugham's female characters, they can be cruel and destructive, but Rattigan seems sympathetic to their plight as he understands the frustration of the men who can never fully satisfy the women in their lives. Masculine qualities are split between two men: one solid and rational, but relatively sexless; the other sexy, but unreliable. Neither is enough for the woman, but given the choice, she will opt for the sexy one. Rattigan's critics in the 1950s and 1960s saw him as stodgy and prim about sex, but actually his best plays, like those of his contemporary Tennessee Williams, are candid about the power of sexual desire. Rattigan's characters do not have the words for the desire they feel—the censorship of the time forbade the use of those words on the stage—but they act on it nonetheless.

"MARRIAGE IS A KIND OF WAR"

Perhaps the place to begin a consideration of Rattigan's depictions of marriage is his London and Broadway success, *Separate Tables* (1954). In *Table by the Window,* the first of the two one-act plays that comprise *Separate Tables,* both set in a rundown Bournemouth resident hotel, ex-model Anne Shankland, separated from her second husband, arrives to try to win back her first husband, John Malcolm, now an occasional columnist for a small, left-wing newspaper. John pieces together a small living and is sleeping with the young manageress of the hotel. Anne had married John, then a Labour cabinet minister, when she was thirty years old and had had her fill of the party circuit. Their marriage had been brief and turbulent, and John went to prison for physically attacking Anne and a policeman who tried to restrain him. Anne then married John's opposite, a genteel man who lacked John's virility and passion.

From the beginning, Anne knew that this would not be a passionate marriage: "But he was gentle and kind and made me laugh and I was fond of him. I went into it with my eyes well open. I thought I could make it work. I was wrong" (102). In time, she came to despise him for not being enough of a man, but "a mouse" who could not satisfy her sexually or emotionally. Now she is forty years old, lonely, and dependent on pills. There is a pattern in Rattigan's plays of women who marry aristocratic or middle-class husbands with public school and university background who cannot satisfy their wives. Men of Rattigan's background are portrayed as sexually and emotionally inferior to physically active men of poorer backgrounds, like John.

When Anne tells John of her tame second marriage, he jokes, "Girls, which husband would you choose? One who loves you too little—or one who loves you too much?" (102). Having experienced the "too little," Anne, incapable of being on her own, tries to go back to "too much." Deeply hurt the first time, John resists. When Anne asks John why he married her, he responds, "Because my love for you at the time was so desperate, my craving for you was so violent, that I could refuse you nothing that you asked—not even a marriage that every prompting of reason told me must be disastrous" (114). John's primary motivation had been overpowering sexual desire. Unfortunately, his model for a wife had been his hardworking mother who had sacrificed "her health, strength and eventually her life looking after us children and keeping the old man out of trouble" (114). Like most of Rattigan's wives, Anne is far too narcissistic for such devotion. Children would ruin her figure, and men are to be controlled. Anne quickly realizes that the best way to control John was to deny him what he most wanted from her—sex:

> *Anne*: Isn't it a principle of war that you always play on an opponent's weakness?
> *John*: A principle of war, not necessarily of marriage.
> *Anne*: Marriage is a kind of war.
> *John*: It is for you.
> *Anne*: For you too, John. Be fair now.
> *John*: And the weakness you played on was my overpowering love for you.
> *Anne*: You can put it that way, if you like. There are less pretty sounding ways. Besides you and I could never agree on *that* aspect of married life. (116)

It is typical of Rattigan's relationships that one partner needs sexual satisfaction more than the other. Anne's response to John's excessive (as she saw them) demands had been to lock the bedroom door. So John had kicked in the bedroom door and physically attacked her, thus ending their marriage and his promising political career. By the end of their discussion at the Bournemouth Hotel, John is so enraged and frustrated that, once again, he attacks her. The need is still there, however, and now, given Anne's loneliness, more mutual than before, if still destructive. John is right when he tells her, "Our needs for each other are like two chemicals that are harmless by themselves, but when brought together in a test-tube can make an explosive as deadly as dynamite" (128). Nonetheless, they make another attempt at a marriage.

John and Anne's reconciliation is far from happy, but it is an antidote to the loneliness they both feel. Michael Darlow observes that in this play "love is seen as a disaster. The principal characters are like addicts; once they have tasted each other they cannot overcome their dependence, even though they know they will destroy each other."[36] Tennessee Williams's Blanche DuBois says that the opposite of death is desire. In Rattigan's world, desire is never fully satisfied and love is never totally reciprocal. The other married couple in *Separate Tables,* the medical student, Charles, and his wife, Jean, seem even less compatible. Charles combats Jean's baby talk and cloying devotion with irony:

> *Jean*: I've been thinking all afternoon how much I loved you. Funny how it seems sort of to have crept up on me like this—Did it creep up on you too, or did you lie in your teeth before we got married?
> *Charles*: I led in my teeth. Now take baby up to beddy-byes, dear, and leave Daddy to his worky-perky—or Daddy won't become a docky-wocky. (134)

When Jean kisses him, "*he turns from her caress a trifle brusquely.*" Charles is equally irritated by Jean's conventional morality and willingness to join in the campaign against another occupant of the hotel as she is by his liberalism. This marriage is equally as doomed, but Rattigan's work displays a bleak picture of most relationships: spouses, lovers, parents, and children.

The couples in *Separate Tables* married out of some sense of love, however illusory or destructive. The marriage of failing tycoon Gregor Antonescu and his wife in *Man and Boy* (1963) is an example of marriage as a business proposition. When we meet Gregor, he is at the end of a magnificently

successful, if somewhat crooked, career as a businessman who will do business with anybody: "But Stalin—there is a man after my own heart. I find him a very level-headed businessman" (416). Gregor's speculations have caught up with him, as has his failing health. His young wife, Florence, began, like Rose Fish, as a typist. Now, she is the immensely rich Countess Antonescu, but she is dissatisfied with the limitations of her role in her marriage. She resents her position as "head of the Antonescu harem…All I'm really good for is sex and signatures" (452)—because she is the titular head of the Antonescu trust, which her husband uses to finance some of his shady speculations. Florence would like to have been loved by Gregor—to be a real wife—but it is too late for that, and Gregor is not capable of that kind of feeling. He does not want to be loved by Florence any more than he wants to be loved by his son. Now he wants his wife to stay with him as his heart fails and his businesses crash. Florence, who repeatedly states that she hates illness, asks why he wants her with him instead of his son: "Because you're here—because you're my wife—because that dress you're wearing and those jewels and that Lincoln and the chauffeur are mine—because even your title is mine—bought and paid for by me—and because I think you owe me in return one hour of my last night on earth." Florence responds, "Perhaps it could have been different if you'd wanted it before. But you never did, did you? Not till now, and now—well—it's just too late, that's all" (464–5). Gregor cannot be angry at Florence's departure. It is the price of treating a wife as a possession. Antonescu has lived for his career. His marriage and his son are the collateral damage of his materialism. The sort of turbulent love Rattigan depicts in *Separate Tables* is at least based on some need and passionate feeling. In *Man and Boy*, we see a marriage as another of Antonescu's failed business transactions. Marrying for love at least offers brief, transitory satisfaction: compromise marriages never work.

IMPERFECT TRIANGLES

Rattigan's formula in *Separate Tables* is one he used again and again: an emotionally needy woman has married a "tame" man who cannot satisfy her emotionally or sexually and becomes drawn to a more "masculine," sexual character. In two of Rattigan's most respected works, *The Deep Blue Sea* (1952) and *The Browning Version* (1948), the woman cannot find full satisfaction with either man because neither man is complete.

Hester Collyer, the central character in *The Deep Blue Sea*,[37] is a well-bred vicar's daughter from Oxford who made what she thought would be

a "good marriage" to a distinguished judge. William Collyer is a decent man, but their marriage is without passion and without children, the sign in the days of theatrical censorship that the marriage had sexual problems. Rose is able to articulate the basic problem in their marriage: "You see, Bill—I had more to give you—far more—than you ever wanted from me" (1; 634–5). One has to read a lot into Rattigan's words because of the censorship of the British stage at the time, but here, the "far more" that Hester had to give is physical. William Collyer is a decent man who loves his wife in his way. Unfortunately, it is not Hester's way. So she runs off with a different sort of man altogether, a former Royal Air Force fighter pilot, Freddie Page. Freddie has introduced Hester to sexual satisfaction, but he cannot satisfy her emotionally. Hester and Freddie are living as "Mr. and Mrs. Page" in a shabby bedsit. Freddie is frustrated that he cannot get work and sick of Hester's emotional demands. When the play begins, Hester has attempted suicide because Freddie has forgotten her birthday. When her estranged husband shows up to see if Hester is all right (a neighbor has called him), he asks her, "But how, in the name of reason, could you have gone on loving a man who, by your own confession, can give you nothing in return?" Hester responds, "Oh, but he can give me something in return, and even does, from time to time" (604). William wants a rational explanation from Hester, but reason has nothing to do with her behavior. The "something" she gets from Freddie is occasional sexual satisfaction, but it is not enough for her, and Freddie cannot deal with Hester's emotional or sexual demands: "A clergyman's daughter, living in Oxford, marries the first man who asks her and falls in love with the first man who gives her an eye. Hell, it's not that I'm not in love with her too, of course I am. Always have been and always will. But—well—moderation in all things—that's always been my motto" (611). Hester's demands are not moderate. Freddie has started drinking excessively and leaves Hester for a job as a test pilot in South America. He has to get away from her to survive: "We're death to each other, you and I (626). Freddie and William love Hester but can live without her. The issue is whether Hester can live without a man.

There is a definite gender divide in *The Deep Blue Sea*. Unlike Hester, the men can control their emotions. Philip, the young husband who lives upstairs, tells Hester about how he had been able to give up a passionate affair with an actress: "It *is* really the spiritual values that count in this life, isn't it? I mean the physical side is awfully unimportant—objectively speaking, don't you think?" (636–7). Hester cannot balance her life that way, in part because she has nothing else in her life but what men can offer

her. She rejects Philip's advice as she has rejected William's generous offer of reconciliation. She wants an impossible all-consuming love but will have to settle for nothing. Her neighbor, a doctor who has lost his license to practice, has advised her to live without hope and focus on her painting. Perhaps in finding a vocation she will be able to balance her life as the men she knows can. Critic John Russell Taylor sees Hester as an unsympathetic character: "Hester is really a silly woman with no internal resources whatever, asking for no less than that she should be able to centre her life entirely on a man whose life will be centred on her."[38] She is, for Taylor, another example of "Rattigan's destructively neurotic female."[39] Such a reading makes Rattigan something of a misogynist; however, the beauty and complexity of Rattigan's plays are rooted in his ability to understand and sympathize with all of his characters. Here Hester, however flawed, is as sympathetic as her baffled husband and frustrated lover. Hester's demands stem in great part from the limited opportunities a smart upper-middle-class woman had at the time. At least her art courses will give her an interest and, perhaps, a sense of self separate from men. Learning to live alone with oneself is, for Rattigan, a positive resolution.

We have the same kind of formula in *The Browning Version*. Millie Crocker-Harris is the frustrated, embittered forty-something wife of a schoolmaster, Andrew, who admits that he is spiritually dead and physically dying from a heart condition that is both real and metaphorical. As far as Millie is concerned, her husband "is not a man at all" (402). Andrew is painfully aware of the failure of their marriage: "Both of us needing from the other something that would make life supportable for us, and neither of us able to give it. Two kinds of love. Hers and mine" (405). So "the love that we should have borne each other has turned to bitter hatred" (406). Andrew expresses his hatred through passive aggression, Millie through outright cruelty.

Millie is having an affair with Frank Hunter, a younger, very popular schoolmaster, one of many affairs she has had and has admitted to her husband as a kind of punishment for his failings, but Frank tries to keep his distance from her demands, and ultimately he drops her when he witnesses a moment of cruelty toward her husband. At the end, husband and wife sit down to another grim dinner together. Marriage in *The Browning Version* is an awful trap. Given the harsh divorce laws of the time, leaving Millie would brand her as a faithless wife and worse, and Andrew does not want "to add another grave wrong to one I have already done her" by marrying her (405). Millie has nowhere to go, as she has no marketable skills.

SECRETS AND LIES

In the plays I have discussed thus far, spouses and lovers are highly, sometimes violently, articulate about their feelings, whether passionate love or bitter hatred. In the early play *After the Dance* (1939) and the later play *In Praise of Love* (1973), Rattigan looks at relationships in which what is unspoken either saves or destroys a marriage.

In Praise of Love is based in part on the illness and death of the radiant comic actress, Kay Kendall, and her husband Rex Harrison's determination to keep the seriousness of her illness from her so she could enjoy her last weeks. Kendall and Harrison were friends of Rattigan's, and Harrison played the lead in the Broadway production. Rattigan's diagnosis of terminal leukemia also lay behind the play's creation. The play takes place in the book-filled Islington flat of literary critic Sebastian Cruttwell and his wife, Lydia. The setting expresses Sebastian's world—books and chess, the perfect game for a manipulative, combative intellectual, and Lydia's place as servant and maintainer of Sebastian's world. Everything seems to exist to protect this self-centered Marxist critic who was once a fine novelist. Sebastian, then a British intelligence officer, had met Lydia when she was working in a brothel in Berlin. Horrified by her stories of her past in Estonia—her avoiding execution at the hands of the Nazis and thralldom to the Russians—he married her so she can get a British passport. Lydia's feelings toward Sebastian are more intense: "Our agreement—kind of unspoken—was that once in England we'd get ourselves a divorce. But he was writing a novel then, and I was typing it, and collecting material, and generally making myself useful...Too useful to be got rid of—deliberately...I was in love with him—always have been—in spite of" (2: 580). That was twenty-eight years ago, and still, Lydia has never confessed her feelings to Sebastian, nor can she tell him how ill she is: "Because I won't bore him. I love him too much for that...is there any surer way of boring our nearest and dearest than by getting ourselves a long slow terminal illness?" (576). Lydia's concern is finding someone to care for the helpless Sebastian after she is gone. He is one of those men who are incapable of doing anything for themselves. Lydia hopes that their son might step in, though Sebastian despises his liberal, non-Marxist politics (Like Rattigan, Sebastian's son Joey is an ardent supporter of the Liberal Party) and is totally uninterested in his aspirations as a writer. Lydia even considers asking Sebastian's mistress to care for him.

As Lydia hides her feelings from Sebastian, he hides his from her—namely, that he knows of her illness and has realized, just as he is about to lose her, that he loves her very much. Neither Lydia nor Sebastian can express their true feelings to each other. Instead, they confide in Mark,

an extremely successful American novelist who loves them both. Often in Rattigan's plays, a spouse can only admit his or her feelings to a third party. This can be seen as a convenient dramaturgical device, but it underscores the inability of lovers or spouses to communicate candidly with each other. Sebastian describes a drunken moment in a San Francisco bar when Mark had confessed his feelings of love for him and even more love for Lydia. Sebastian had never been jealous of Lydia's relationship with Mark because for a long time he did not care enough. Now, he feels that he needs to maintain the same air of indifference even though his feelings for Lydia have intensified. Sebastian admits to Mark that he suffers from what he sees as the "English vice": "It's our refusal to admit to our emotions. We think they demean us, I suppose" (618). Lydia is not English, but years of subterfuge in order to survive have given her an appreciation of the value of deceit: "Honesty between people who love each other, or let's say who should love each other, is the thing that matters least in this life…It was a much happier world when people told us little lies about ourselves" (605).

The only time fierce emotion is outwardly expressed comes when Lydia physically attacks Sebastian for forgetting their son's debut as a television writer. Above all, she wants father and son to be close when she dies. She does not know that Sebastian had forgotten because he was so upset when he had learned that afternoon that Lydia had only a few months to live. In essence, Sebastian has protected Lydia from his knowledge by continuing his usual self-centeredness: "Being what we both agreed God made me does have its advantages when dealing with a dying wife" (613).

At the end, Lydia discovers that Sebastian knows about her illness and is, in a loving way, trying to protect her, while Sebastian's illusion that Lydia does not know is protected. Sebastian reconciles with the son he has either ignored or attacked for his politics—he will need Joey after Lydia dies. Father and son play chess while Lydia happily looks on. In avoiding sentimental confessions, Rattigan is more true to his characters and creates an even more powerful emotional denouement. There is still a lot of pretending going on, but the pretense is an expression of love.

In *After the Dance,* inability or unwillingness to confess one's true feelings destroys a marriage and at least one life. The wider context of this fine play is a clash of generations. On one side, a group of thirty-somethings are still trying a bit too desperately to continue the party they began in the 1920s. Their reminiscences about past parties remind me of Noël Coward's 1924 song "A Marvelous Party." As one character notes, "I think it's obscene to see a lot of middle-aged men and women behaving like children at a school treat. It's the bright young people over again, only they never were bright and now they're not even young."[40] Rattigan is balanced

in his satire. The representatives of the more sober, idealistic twenty-somethings may be earnest, but they are either weak and confused, like David's cousin and assistant Peter, or ruthless, like Peter's fiancée Helen.

At the heart of the play are the host and hostess of the continuous party in their Mayfair flat, David and Joan Scott-Fowler. Rattigan is always careful to have a play's decor mirror his view of the central characters. Here, though it is 1938, the furnishings are of 1920s vintage, and Joan repeatedly plays a broken record of a 1920s dance tune, "Avalon." The thirty-somethings will themselves into a time warp, ignoring the realities of the Depression and the impending war. David and Joan have been married for twelve years. As David puts it, "It was just one of those things that happened: we'd been having an affair. And then one day we were a bit drunk and we thought it might be fun to be married" (44). Their illusion is that they never really loved each other, but were merely good friends. David says to Joan, "I'm glad in a way we didn't make the mistake of falling in love with each other. I sometimes wonder if ours isn't perhaps the best basis of all for marriage" (61). Yet, they are devoted in their way. Independently wealthy David claims to be a scholar writing a book on the history of Naples, but he does not have the discipline to do the work and ends up dictating drunk in the middle of the night. David already has sclerosis of the liver and will not live long if he does not change his ways. Joan is an enabler of David's drinking and lack of focus, but she does so because she thinks that is what he wants. She has molded herself into what she thinks David wants her to be, voicing chic cynicism and seeming not to take anything seriously, but always the life of the party. Everything that is not fun is "a bore" or "poison." Enter serious young Helen who is determined to save David from the party that is literally killing him. Oblivious of their feelings, Helen can leave young Peter who loves and needs her and coldly tell Joan that David will leave her. Joan is able to keep up the mask of witty detachment until Helen exits. John, their friend, hanger-on, and detached observer, tells the distraught Helen: "You should have let him know you were in love with him. That's all he wants, really—someone to be in love with him," but Helen believes, "I'd have bored him to death if I ever let him see it" (51). Joan is frightened of boring David with her love, and David of boring Joan with his desire to change. A few moments later, Joan, unable to conceive of life without David, takes her life. Eventually David, realizing that he can never live the austere, serious life Helen envisions for him, picks up the bottle of liquor that will ultimately kill him and plans to go to another party. But it is 1939, and the marvelous party will soon be over. The young, working-class love of one of David and Joan's set has already been drafted into the army, and young Peter knows that the future is bleak and uncertain. In his introduction to *After the Dance*,

Dan Rebellato observes, "It has become commonplace to criticise Rattigan's plays on the grounds that they repressedly avoid the display of emotion. But in fact the reverse is true. What is remarkable in this play is the skill with which Rattigan depicts the appalling forces that conspire to make emotions impossible to express, *and* the emotions which lie undeclared" (xxvii). *After the Dance* comes as close to real tragedy as any of Rattigan's plays because David and Joan have been socialized to avoid real feeling. Joan's love for David is unspoken but real, far moreso than Helen's fantasy of saving David or David's fantasy of being able to become a serious person. Joan was partly right all along—deep down, David is incapable of change.

Rattigan's view of love and marriage is never rosy. In fact, it is not clear whether he believed that a successful long-term relationship between two people is possible. The most powerful emotion that brings people together is loneliness, but ultimately, it cannot keep them together.

Terence Rattigan's career spanned four decades. By the time he died in 1977, his friend Harold Pinter, always an admirer of Rattigan's work, had become the preeminent British dramatist, John Osborne's ranting misogyny was already a thing of the past, and Joe Orton, whom Rattigan championed, had been dead for over a decade, though his works were often revived. We can see now that there are more similarities than differences in the depictions of marriage we see in Pinter's work. Both he and Rattigan were masters at depicting the cruelties spouses and lovers can inflict on each other.

Noël Coward and Terence Rattigan became closer friends as they aged and suffered critical brickbats together. Coward saw himself as Rattigan's mentor in both life and art. When Coward thought Rattigan was drinking and eating too much, "I lectured him mildly. I think he must be careful now that he is in his forties: he has so much to contribute and it mustn't be frittered away."[41] Rattigan was often troubled by Coward's criticism of his work but deeply grateful for the older playwright's loyalty and concern: "There is no judgment I would rather have about a play than yours (except perhaps the public's which, I sincerely believe, you and I are the last 2 playwrights on earth to continue to respect) and a word of praise from you is worth a paean from the press."[42] Over the years, both writers managed to balance gay lives and public respectability at a time when homosexual behavior was severely policed. They also managed to write highly successful plays that challenge conventional notions of love and marriage. If they seemed too establishment to the angry young men of the 1950s, we can see them as quite daring for their time. We can also continue to appreciate their mastery of dramatic form. At this point in time, they seem to have outshone their rivals and harshest critics.

4. Emlyn Williams: Growing into Marriage ◯

Doctor Jekyll is anxious to marry you if you'll have him, but Mr. Hyde insists on being at the wedding.

Emlyn Williams, *Accolade*

In 1937, George Emlyn Williams wrote and starred in a play entitled *He Was Born Gay,* codirected by and costarring him and John Gielgud, whose homosexuality was made public after a 1953 arrest in a Chelsea men's room.[1] Needless to say, Williams meant something quite different by "gay," but for our purposes, the title of this rather flimsy historical romance about the son of Marie Antoinette hiding out in a Dover inn is a fitting epigraph for a study of Emlyn Williams, whose life is a fascinating chapter in the history of gay narratives of marriage. When twenty-two-year-old Emlyn Williams made his professional stage debut in London in 1927, the year his memoir *Emlyn* begins, Somerset Maugham was the most successful writer in England, Noël Coward's star was in its ascendance, and Terence Rattigan was a schoolboy who would in nine years have his first play on in the West End. Coward would become a close friend. Williams met the "strikingly handsome" Rattigan at a soiree at John Gielgud's flat in 1934 and had great success playing barrister Sir Roland Morton in the original production of Rattigan's *The Winslow Boy* a dozen years later. Though he wrote twenty plays and starred in many plays and films, Williams never quite had the same place in British theater history as these artists. Like them, he wrote commercial fare, but with less consistent success. Nonetheless, in his first eight years in London, in addition to establishing himself as a stage and screen actor, Williams wrote a series of commercially successful plays, including the oft-revived thriller *A Murder Has Been Arranged* (1930), the British adaptation of Sidney Howard's *The Late Christopher Bean* (1933), and the immensely successful *Night Must Fall* (1935), which made him

a stage star and a wealthy man, as the play became a regular offering of regional and amateur theaters and was twice made into a movie.[2]

Emlyn Williams's place here is not primarily as a playwright or actor but as a memoirist. In his middle age, Williams wrote two volumes of autobiography: *George* (1961), which focuses on his boyhood in Wales and his education there and at Oxford and ends with the beginning of his theatrical career in London in 1927, and *Emlyn* (1973), which continues the saga up to his marriage and the opening night of *Night Must Fall* in 1935. There is no sequel covering the years after 1935; Williams's interest in chronicling his life ends at the moment of his heterosexual marriage. Williams's description of his sexual and emotional journey to theatrical success, maturity, and heterosexuality offers a quasi-Freudian narrative of "maturing" into heterosexual marriage. Williams presents his three major homosexual relationships as typical—one could almost say stereotypical— paradigms of homosexual attachment: the anguished, unrequited love of a heterosexual Oxford classmate, discipleship to an older, self-destructive man, and sexual obsession for a young, amoral, working-class man.

FEVERS

Williams was raised in a Welsh-speaking, working-class family but was a promising student who eventually received a scholarship to Christchurch College at Oxford University. There he devoted himself to the Oxford University Drama Society and left before he graduated after a nervous breakdown "precipitated," as he describes it, "by an emotional friendship with another Oxford undergraduate."[3] The "emotional friendship" was one of two strong infatuations Williams had at Oxford. Seeing twenty-one-year-old American actor Tom Douglas inspired the first crush. The second was a young friend, Charles, whom Williams chose to be assistant stage manager on one of his plays. In *George,* Williams beautifully describes the anguish of unrequited infatuation. Though the young undergraduate knew his friend was "unattainable," he felt the powerful, mixed feelings he would experience again a few years later for other, more requited loves:

> Love is one thing, obsession another…As with all writers in embryo, one narrow-eyed corner of me was watching, just as the sick doctor, locally anaes-thetized, under the knife, cannot help following—even as he winces—the details of his own ordeal. I found myself able to see another human being, one moment as the magical loved one and the next—with the cynicism of the observer—as a creature as ordinary as his neighbor, with the mundane defects,

and the mundane qualities too, which will reassert themselves when the fever has abated, sometimes, indeed, it is possible, with a devilish double vision, to see the two figures at once, superimposed. And it is not true that a capacity to analyze one's own disease halves the pain. Possessive, though not to be possessed—covetous of that which could not be mine, which I would reject if it were pressed upon me—I knew what it is to be tormented when the water is salt and must not be touched.[4]

Throughout Williams's work, we see the sort of self-consciousness and double vision found in this passage. Like a character out of Racine, he experiences overwhelming desire while judging that desire as disease—disease imagery is omnipresent in Williams's descriptions of his homosexual attachments.

While *Emlyn* chronicles Williams's string of successes and failures as writer and actor over his first eight years in London, its real thrust is as a chronicle of Williams's sexual history during that period. Unlike Somerset Maugham, who tried to prevent any account of his personal life, or Noël Coward, who was cagey about his love life in his many volumes of autobiography, Williams was extremely candid about his gay life in London in the 1920s. In fact, *Emlyn* is more important as a chapter in gay history than as a piece of theater history. In it, Williams offers vivid descriptions of gay haunts in London and New York City and a sense of an emerging gay argot.

Although *Emlyn* was published in 1973 in the midst of the post-Wolfenden, post-Stonewall era of gay liberation (indeed, he could not have written it before the decriminalization of homosexuality in Britain), for all its candor, it reflects the attitudes of an earlier era. Williams offers the kind of narrative supported by the prevailing Freudian psychology of the time as he depicts himself moving from immature, obsessive, and dysfunctional homosexual relationships to a "mature" heterosexual marriage with a very understanding wife. Williams's imagery follows familiar patterns, from illness to health and from confusion to "In the Clear," the title of the chapter chronicling his decision to marry Molly O'Shann.

Williams's gay life in London during that period moved from sexual experimentation to an affair with an alcoholic older actor, to an affair with a young, working-class Welshman who served as driver, assistant, and lover, and to marriage. For a man who wanted success in the theater and film, Williams's youthful life in London was bound to cause some anguish, and his confusion was typical of homosexual men in a period in which such men were decried as "Goddamn British pansies"—"The word was new but it froze us" (*Emlyn*, 40)—and one could be thrown out of a café, as he was, for being too friendly to another person of the same

sex. Unlike many of his peers, the young Williams found the experience exhilarating: "I wondered why I was not feeling dashed. On the contrary, I felt dashing" (12–3). Later, he describes vividly the British film industry's notion of a daring presentation of gayness, which is not so different from that of Hollywood at the time:

> In the Jessie Matthews "story," her young lover (Ralph Richardson) would be shown buying the chorus-girl flowers. How to get the scene off the ground, huh?
>
> "I got it," said Victor [director Victor Saville], his glasses glistening with schoolboy mischief, "we'll go out on a limb with the guy behind the counter, let's make him a *fairy!* How sophisticated can you get, huh? Oh, we don't *say* so, good God, no, that would be bad taste. No, we'll just have him smelling the flowers and saying, 'Sheer heaven!'"
>
> To show how sophisticated he could get, Victor put a hand on one hip, sniffed imaginary flowers, shut his eyes and said, "Sheer heaven!" It was terrifying. (296)

How could one help being conflicted about one's sexuality under such circumstances? But Williams's own depiction of the effeminate behavior of many of the homosexuals with whom he came into contact is quite scathing, as we see in his description of a gay party on the Upper East Side of Manhattan: "I looked for the house. I did not need to, I could hear it: a distant buzz which changed, as I got nearer, to a shrill hullabaloo varied with cackles of parrot-laughter...Here they all were, from sixteen to sixty, weirdly womanized and each dispensing to his opposite the vivacious stare of an overexcited schoolgirl, with an occasional dislocation of the eyes and a tip-up of heels to glimpse more of the landscape" (270). Throughout the memoir, Williams expresses his distaste for effeminacy, often using the kind of bird imagery employed here. Yet Williams's descriptions of gay London and New York of the period are fascinating and surprisingly free of guilt. He describes his forays into the wildlife of Hyde Park and Hampstead Heath, London's most famous cruising ground: "Hyde Park is extensive, Hampstead Heath immense and the grass warm enough to lie on; looking up from my studies to find a stranger near me, I did not always return to my book. Vague monosyllables eased into an interlude filled with lazy silences and empty of names and addresses, a drift towards the casual fraternization when stealth had to set in and newspapers were flung negligently across...The unknown drew me: drew the mind as well as the body" (13). He is less comfortable in the interior spaces of London gay nightlife, like the opulent Criterion Restaurant on Piccadilly Circus: "The Criterion Restaurant was staid enough—luncheons, *thé dansants,* banquets—until 10 P.M. By then, the great ornate hall, reached

by a staircase descending from Lower Regent Street, had been emptied of respectable clientele and refilled with well-behaved male trash" (17). And he offers a description of New York's famous Everard Baths (still a gay haunt in 1977 when it was the site of a tragic fire that killed nine men) that turns it into a purgatorial site of ghosts and phantoms: "By its eerie light I saw that passages not only led crossways but girded the area in a never-ending circle; along these padded noiselessly a slow perpetual two-way procession of white-faced white-draped ghosts, the white so washed out that it was grey" (55). Williams's description emphasizes what he feared most, loneliness. Williams needed a comfortable relationship. Like many gay men of his time, he eventually found it in a heterosexual marriage.

At first, Williams is aware that his sexual attraction is totally toward men, but he is compelled to see that as a character flaw. He describes a moment when he walks into an actress's dressing room and finds her naked above the waist. He attributes his lack of sexual thoughts about her or any woman thus far in his life to immaturity rather than homosexuality: "It was because I had a fear of entanglement, not only of emotional trouble but of day-to-day responsibility" (51). Despite his lack of sexual interest in women, Williams wants to see himself as sexually confused rather than homosexual: "As for sex, I was standing stock-still in the middle of the road, and that's as good a way of getting run over as any" (210). Lonely and confused, Williams is torn between what he should want from a woman and his desire for a male partner:

> First, I imagined living with a woman: she would be plump, sensual, fond but not possessive, prone to stray affairs and amusing about them, down-to-earth and yet house-proud...
> Remained the Friend: the same age as me, simple, clean-cut, male and at the same time broadminded, affectionate; not a writer, and definitely not an actor. But where was he? There was nobody. (143)

I find it interesting that the possible female companion is merely "woman" while the male is "Friend." While Williams can envision a "sensual" woman, the affectionate male friend seems much more linked to the possibility of a close relationship. Ultimately, Williams will continue to feel sexual desire for men but will find the friend he seeks in his wife.

For four years from 1930 to 1934, Williams had a turbulent relationship with Bill Wilson, a fellow actor nineteen years older than he. Emotionally scarred from service in World War I, Wilson was a competent supporting actor and a lonely man with no close friendships. Williams's biographer James Harding notes, "Although a sociable drinking companion

and an amiable acquaintance, he remained a man of mystery. No one had ever heard from him the secret of his illegitimate birth, a result of a passing union between a chorus girl and a nobleman closely related to the royal family."[5] Shortly after Bill arrives one night on Williams's doorstep, they become lovers and fast friends. Harding is always eager to reinforce Williams's tendency to psychoanalyze his relationships with his lovers: "The situation is a familiar one. Kept at a rigid distance by his mother, remote from his father, separated from both parents by virtue of intellect and emotion, Emlyn sought an older man for the love he could not find with either of the pair who created him."[6] Although Bill is nineteen years older, Emlyn relishes the idea that he is the more needy partner of the two: "And 'this' was possessive love. I wanted—for the first time in my life, and the last—to own another human being, to dominate a man potentially superior to me and who, unflawed, could have dominated me. I craved to rivet the broken pieces together, to coax the rusty watch to tick" (169). Williams understands that his relationship with Bill is not merely friendship, but "a love imbued with the physical" (ibid.). As a result, he pathologizes the relationship: "I dwelt on the fact that since he was nineteen years older he could have been my father; to me Freud was only a name but I recognized the flavor of incest and it refused to repel me" (ibid.).

Williams was also drawn to see his relationships as potentially violent, a complement to his growing fascination with psychopathic murderers. He describes how, in 1931, he became fascinated with a German serial killer of young men. He even went to Hanover to look at the crime scenes and check police records. As Williams thinks about the Hanover murders, he becomes fascinated with the subject of "sexual license in relation to murder," which leads him to think about Bill's possible hidden depths: "I thought of Bill, of the knowledge that he had a wild side to him. So did I. We were both liable, at moments, to try anything once. Twice. And in 1931 'anything' shocked many people" (198). Is Williams suggesting a sadomasochistic element to their sexual experimentation? Is it the lurking sense of criminality of their illegal sex life that leads Williams to extrapolate to more violent, deadly forms of criminality? Sitting in the Hanover railway station where the serial killer had picked up his young victims, Emlyn moves from imagining himself as one of the victims of the seemingly bland, forty-something serial killer to imagining Bill as the killer: "Yet...Did Bill not describe himself once, jokingly, as a Jeckyl and Hyde? And the double life he was referring to—does it not in many ways match that of the consistent criminal? The cool subterfuges, the bold deceptions; the dark side streets, the door carefully locked, curtains checked for the

fatal chink of light..." (199). Why did Williams need to imagine a dangerous side to his relationship with Bill? For the rest of his life, Williams was fascinated with the mix of sex and murder contained in stories of serial killers, the seemingly ordinary men and women who had broken through "the wall of unbreakable glass" that separates civilized behavior from "the yawning pit" (199). This fascination led to some of his most famous work as a writer and actor. How much did this have to do with his secret life that could lead at any moment to arrest and social disgrace?

Eventually, Williams gets tired of being "My Father's Keeper" (the title of a chapter about his relationship with Bill), and his feelings veer from anger at Bill's lack of self-discipline to guilt at his poor treatment of a man who depends totally on him for "abiding affection" (272). Having lived through a childhood with an alcoholic father, it is no surprise that Williams had complex feelings about Bill's drinking. Emlyn and Bill endure a series of split ups and reconciliations: "Our relationship was not easy, we met every other day for a meal and sober he often spent the night," yet Williams understands that even though he loves this weak, self-destructive man, he "could do nothing for him" (293).

The point of no return in Williams's relationship with Bill comes when Bill discovers Emlyn in bed with Fess Griffith, a twenty-year-old, working-class Welshman who had become his lover and driver. Actually Bill, drunk, brought Fess, whom he found in a pub, home one night for a ménage a trois that was supposed to be a one-night stand, but Fess returned to Emlyn's doorstep. The raffish, young Welshman was a more attractive lover than the alcoholic, older actor, and soon Bill was out for good. While Williams went off on a European holiday with Fess, Bill died of pneumonia. In a fascinating act of rationalization, Emlyn sees Fess as a link to Bill, the only legacy he received from his deceased lover: "And the deceased cannot alter their wills; what they have left to the living is irrevocable. This silent boy, with the lithe, smooth body and the amiable smile, was my bond with the dead man" (346). Guilt ridden over deserting Bill, Williams finds Fess's presence "essential," but he also finds the affair "disturbing": "I had no affection for him because I knew he had none for me or for anybody else" (349). James Harding sees Fess as an example of "rough trade." Harding's lengthy description makes the reader wonder how he became such an expert on this sort of young man:

> The Fess type was, and is, immemorial. He is street-wise and charming. He is often to be found as the companion of elderly gentlemen, or of persons older and richer than he. Wealthy stockbrokers take him away for the weekend to

Boulogne, although he readily sleeps with women too, sometimes for pleasure only. His speech is monosyllabic and his background obscure. There may be an orphanage or a broken home, or Borstal somewhere in the past. Occasionally he surprises with a native witticism. He likes to smoke other people's cigarettes and graciously accepts when a drink is offered. He is unfailingly obliging. He might not be above driving away an unminded car or making off with a bag left at a railway station. To date that is probably the worst thing he has done. What will happen, though, when his looks fade and his charm is gone? There is a hint of danger about him that makes him irresistible.[7]

Williams's biographer turns Fess into a type, but *Emlyn* reads most like a drama during the section covering his crisis over Fess. Emlyn's response to him seems to echo his obsessive feelings toward his friend at Oxford. Throughout the months of his affair with Fess, Williams is plagued by extremely mixed feelings: "he not only obsessed me, he bored me" (351), yet he finds it difficult to get over his attraction to this feckless young man.

The confusion over Fess is exacerbated by Williams's relationship with Molly O'Shann. For years, Williams had been friends with Molly and her husband. When Molly's husband left her for another woman, Williams's friendship with her remained close, though chaste at first, until shortly after Bill's death, when while still involved in an obsessive affair with Fess, Williams had impulsively asked Molly to marry him. This impulsive action leads him to realize that his homosexuality "never fulfilled me either physically or emotionally. Indeed, remaining obstinately adolescent, it had caused me active pain" (340). Yet he does not deny it and dreads being cut off from the "freedom" to indulge that side of his personality (341). Throughout the months he is involved with both Fess and Molly, Williams is "in a bad way" (347), plagued by confusion. His feelings for Molly are comfortable while he is in anguish over Fess: "I was waiting for him in a torment I had not expected and if he entered now I would feel tormented relief. If she appeared, I would be delighted by the sight of the person I loved" (347). Molly is something of a saint, totally understanding her fiancé's sexual orientation and confusion and allowing him to see Fess in order to cure himself of that relationship. After he drives Fess off for cheating him out of some money, Williams puts on Fess's shoes and imitates his walk: "I took off my sneakers and, with the excitement of a secret act, inserted my own feet into the abandoned shoes. They were big on me. I walked a couple of steps, tried to imitate the bandy walk, came to my senses and kicked them off. But I did not throw them away. I went back in, opened the bottom drawer of my desk and stuffed them into the back of it" (369). Obsession had transformed into identification. Williams could see the kinship between this sort of behavior

and that of the marginal criminals he created and portrayed. Ultimately, after much ambivalence on Williams's part, Fess left him for good.

Though the choice was not totally his, Williams claims that, with marriage to Molly and a child on the way, "Fess Griffith was exorcised, for good" (387), but Williams's identification with Fess was enacted nightly as Williams played the murderous Dan in his hit play *Night Must Fall.* James Harding opines that Dan is, as Williams wrote and acted it, greatly based on Fess Griffith: "For Dan was Fess, even unto the rough Welsh accent. He had the charm of Fess, the worldly wisdom, the nonchalance, the aura of danger. He was what Fess might easily have become, graduating by way of petty theft and forgery to the worst crime of all."[8] In his preface to the collected plays, Williams expresses this more cautiously: "for physical characteristics and idiom, a contemporary I knew who was not a criminal but might have been."[9] To complete the identification of his Dan with Fess, Williams wore onstage every night the pair of shoes Fess left in his kitchen—"it seemed the most natural thing in the world that I should wear them on stage" (301). Williams did not exorcise Fess—he absorbed him. He had imagined his first lover, Bill, as a potential murderer, and now, he had created a thriller in which the relatively harmless Fess, prone to cheating a friend out of a few pounds but no more, is a psychopathological killer. It is one thing to write this character, but what was the experience of literally wearing Fess's shoes as the charming murderer night after night?

Though Williams and Molly remained happily married until her death in 1970 and had two sons who followed in their father's footsteps, it is interesting to note that the newlyweds' social circle was, to put it mildly, *très* gay: John Gielgud, dancer-choreographer-actor Robert Helpmann, author Rodney Ackland, Noël Coward, and author Beverley Nichols. It would have been interesting to have a sequel to *Emlyn* that recounts exactly how Williams dealt with his bisexuality for the rest of his career and life. A candid letter written to Molly while he was appearing in New York assured her there were no other women in his life, but "occasionally I have encounters of the other sort, but never more than once with the same person, and more and more half-hearted, a matter of expediency—cold-blooded almost with the heart beating (if anything) slower rather than faster."[10] The Williams marriage, then, was typical of many marriages of men who were sexually drawn to men but needed the companionship and stability that only seemed possible at the time within a heterosexual marriage. British and American theater in Emlyn Williams's lifetime seems filled with famous examples of such marriages. Fortunately, Molly was an unusually understanding wife.

AN IDEAL WIFE

"Rather too autobiographical for my liking," John Gielgud commented after the opening night of Williams's 1950 play, *Accolade,*[11] in which the author starred. But there was always something of Williams in his most interesting work. Fess was partially behind the central character in *Night Must Fall,* along with Williams's fascination with serial murders. *The Corn Is Green* is based in part on Williams's own education and his beloved teacher, Sarah Grace Cooke. *Accolade* is far more dangerous in that it is a thinly disguised picture of Williams's life and marriage and in that the playwright-actor took the leading role in its London premiere. One can only conjecture why Williams came so close to exposing his own secret life. Certainly, the dynamics of the marriage in the play reflect somewhat on aspects of Williams's marriage. It is no wonder that Molly "shared in silence" Gielgud's opinion.

Will Trenting leads a double life. He is a distinguished, Nobel Prize winning author who is about to be knighted and is happily married with an adoring teenage son. But he is also Bill Trent, who has a penchant for orgies in seedy rooms over pubs. His wife, Rona, knows all about his double life. Indeed, their meeting was anything but conventionally romantic. After meeting "shy, well-behaved" Will at a party, she goes off to the Chelsea Arts Ball. In *Emlyn,* Williams offers a three-page description of this annual event at the Royal Albert Hall: "To slow music, men with earrings strutted past in harem trousers, dressed as nearly as women as they could manage without being arrested, while some of the 'original' creations defied the eye."(309). In his history of queer London, Matt Houlbrook describes the ball as "the centerpiece of the Metropolitan social calendar, a New Year's Eve costume ball that attracted massive media attention and crowds of up to 7,000 socialites, artists, and ordinary Londoners in elaborate fancy dress... Hundreds of working-class queans [*sic*] flocked to both balls [the Chelsea Arts Ball and Lady Malcolm's Servant's Ball], discarding the masks they wore in everyday life, wearing drag, dressing outrageously and socializing unashamedly while never appearing to be anything out of the ordinary.[12] In *Emlyn,* Williams notes the clientele in the tiers of boxes at the Albert Hall: "While the top tier, the cheapest, was fleetingly occupied by half-naked Chelsea riff-raff clad in cocoa sunburn and shameless bananas, the next down was grander and packed with fauns and nymphs discreetly veiled, wicked cupids and little Mozarts of indeterminate sex" (309). Williams is clearly appalled by the more outrageous camp behavior he sees at the ball, but in *Accolade,* the Chelsea Arts Ball becomes a site of

heterosexual abandon. The lord chamberlain would never have allowed a description of homosexuality to be heard onstage, and Williams, like his colleagues Coward and Rattigan, understood that everything had to be made heterosexual. In *Accolade,* Rona describes how she had walked into an unlocked box and found Will having sex with two women. He invited her to join in.

Her response was to want to marry him even though his proposal could not have been a clearer statement of his intention to continue his double life: "Doctor Jekyll is anxious to marry you if you'll have him, but Mr. Hyde insists on being at the wedding."[13] From the start, Rona is complicit in Will's continued sexual escapades as Bill: "It was always understood that Will should lead his own life side by side with his life with me...I'm making it sound awful but we knew what we meant to each other and it worked. I thought it did" (85). For his part, Will got married to get some control over his life: "I liked living in the mud and didn't care who knew it. Trenting the Tramp. But I was a physical wreck, it was killing my work. So I got married. And that gave me security, steadied me down. Damned useful. I had it both ways" (70). Will has a stable marriage and regular forays to the wild side. Will's main concern when the play begins is that his knighthood, and the respectability attached to it, will force him to behave himself: "Well, now I've *got* to behave myself. *(Mimicking)* 'Sir William, you can't go here, you can't be seen there'" (41). Defiantly, he rushes off, presumably to another orgy, but common sense and some old drinking buddies waylay him.

Unfortunately, on the day of Will's knighthood, it is revealed that at an orgy in Rotherhithe Will had unknowingly had sex with a fifteen-year-old who looked much older. Her father, a frustrated writer, wants to use his knowledge of the event to wield power over Will. When Will treats him coldly, the man decides to have Will charged with willful procuring of a person under the age of consent. Will becomes the object of scandal and ridicule. There is no tragic ending. Rocks fly through the window, servants and fair weather friends have deserted them, but Will, his wife, and son stand defiantly together as a family when the curtain falls. They will have to move to remote Guernsey, and son Ian will have to be tutored at home, but he understands that it is the people throwing rocks who are in the wrong: "What's it got to do with them?" (93).

The marriage of Will and Rona is presented as an ideal, enlightened marriage. Will may go off on the occasional orgy as his alter ego Bill, but he adores his wife: "If I hadn't married you, I would not have lived" (91). Rona helps Will with his writing and seems to be his best friend as well as his spouse. She is not shocked or angry to discover that Will had sex with

an underage girl at an orgy he arranged in a waterfront pub. Of course it is never suggested that Rona might be entitled to sexual infidelity—that is a male prerogative. When scandal hits, Rona is totally supportive, though she does express doubts about her complicity in his behavior. He accepts his knighthood only because she wants him to and the honor has put him more in the public eye: "Did I encourage him to think there was no harm? If he hadn't married, he wouldn't have accepted the knighthood anyway, and none of this would have happened" (91). Rona's doubts are about not the appropriateness of Will's behavior but the danger of being found out. This sort of enlightened behavior is the way of the world in *Accolade*. Rona's friend Marian admits to knowledge of her husband's mistress and illegitimate child: "I'm sorry, but I've come to accept Gerald. He's my husband and that's that. Nobody could accuse me of being strait-laced, over a weakness I can understand" (86). Monogamy is not the norm in the marriages in *Accolade*. There can be love without fidelity.

According to James Harding, Williams's first idea was that the scandal would involve sex with underage boys à la Oscar Wilde, but in 1950, this would never have been allowed by the lord chamberlain. So Will Trenting faces a heterosexual scandal. However, anyone who knows Williams's own story can see how close to the wind he is sailing in this play. *Accolade* was only moderately successful.[14]

In *Emlyn*, the playwright-actor asks, "Is everyone two people, constantly?" (367). Will/Bill in *Accolade* is honest about being both Dr. Jekyll and Mr. Hyde. Williams was probably bisexual. The problem was that one side of his dual sexual nature was socially acceptable and the other literally criminal until the last years of his life when he tried to present his sexual history as a progression from adolescence to maturity, from disease to health. Yet it is also clear from his writing that he knew his dual nature would always be there. Ironically, the work for which he is best known now is not his theatrical fiction but his memoirs of his divided life. In *Accolade,* Will Trenting concludes, "if you're a member of society, you have to conform or crack. You can't have it both ways" (96). Like Will Trenting, Williams's life was an attempt at compromise.

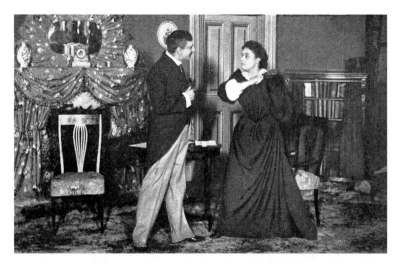

Figure 1 Rose Coghlan and Maurice Barrymore in the climactic confrontation between Mrs. Arbuthnot and Lord Illingworth in the 1893 American production of Oscar Wilde's *A Woman of No Importance*. *Photo courtesy of Lebrecht Music and Arts.*

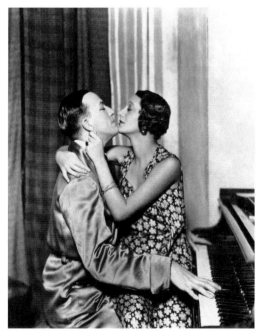

Figure 2 Noël Coward and Gertrude Lawrence as Elyot and Amanda in the original production of Coward's *Private Lives*. *Photo courtesy of Lebrecht Music and Arts.*

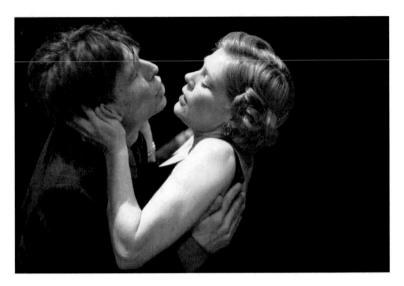

Figure 3 Iain Glen and Gina McKee as John and Anne in the 2010 Chichester Festival Theatre revival of Terence Rattigan's *Separate Tables*. *Photo courtesy Lebrecht Music and Arts.*

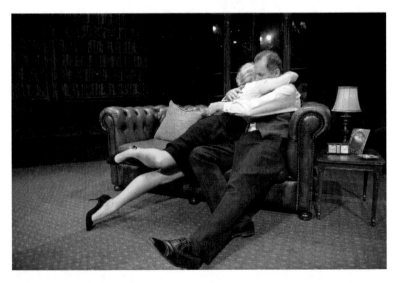

Figure 4 Aidan Gillett and Saskia Wickham as Will Trenting and his very understanding wife in the 2011 Finborough Theatre revival of Emlyn Williams's *Accolade*. *Photo by Helen Warner.*

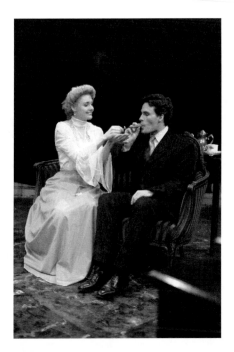

Figure 5 Christy McIntosh and Jeff Pucillo as Becky and Tom Warder in a moment of intimacy in the 2006 Metropolitan Playhouse, New York City, revival of Clyde Fitch's *The Truth*. *Photo by Mary Rose Devine.*

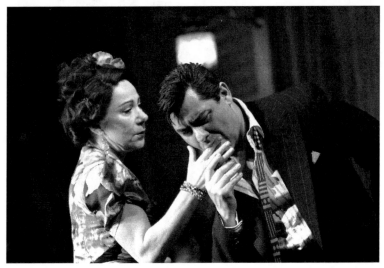

Figure 6 Zoë Wanamaker and Darrell D'Silva as Serafina and Alvaro in the 2006 Royal National Theatre revival of Tennessee Williams's *The Rose Tattoo*. *Photo courtesy Lebrecht Music and Arts.*

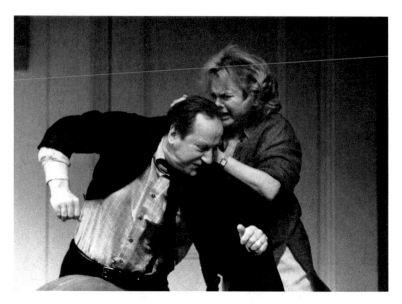

Figure 7 Bill Paterson and Sheila Gish as the battling Jack and Jill in the 2001 Royal National Theatre production of Edward Albee's *Marriage Play. Photo by John Haynes, courtesy Lebrecht Music and Arts.*

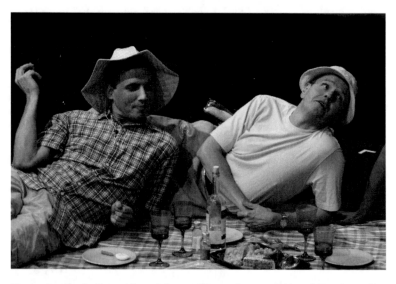

Figure 8 Doyle Reynolds and Steven Emanuelson as Carl and Bernie on Fire Island in the Actor's Express, Atlanta, production of Terrence McNally's *Some Men. Photo by Chris Ozment.*

5. Clyde Fitch and George Kelly: Spunky American Wives and Domestic Monsters ∾

I always felt I was temperamentally unsuited to marriage"

George Kelly

Clyde Fitch and George Kelly have been ignored by most scholars of American drama. They were comic playwrights and creatures of the commercial theater, thus considered not worthy of the same consideration as our "serious" writers. Fitch was constantly attacked for being too superficial, and critics did not know what to make of Kelly's plays after his first three Broadway successes. If Fitch and Kelly are written about at all now, it is because they have come under the purview of gay studies. These two playwrights offer interesting portraits of repression and expression of homosexuality in the early twentieth century. Fitch was a closeted workaholic, terrified of the fallout from the Oscar Wilde scandal; Kelly spent most of his adult life in a kind of gay marriage. However interesting their lives are in this respect, Fitch and Kelly also deserve to be recognized as fine theatrical craftsmen who, for a time, achieved considerable popular success.

The work of both playwrights focuses on women. Fitch's central characters are either wealthy, headstrong young women whose primary goal is a loving marriage, or young wives with character flaws that almost destroy their marriages. Kelly's plays center on middle-class wives who do not find emotional or physical satisfaction in their marriages. While Fitch was criticized for the forced happy endings of his plays, Kelly's plays became darker and more pessimistic during his thirty-year career as a playwright.

I knew, of course, that everybody regarded me as a sissy; but I would rather be misunderstood than lose my independence.

Clyde Fitch[1]

From 1890 until his untimely death in 1909, Clyde Fitch was the most popular, prolific, and financially successful American playwright of his time. He wrote sixty-two plays, thirty-six of which are original works (others are adaptations of other plays or novels). In 1901, he had four plays running on Broadway. In addition, he wrote poetry, a novel, and children's stories. He directed and designed most of his Broadway productions, sometimes three or four in a season. Fitch was, to put it mildly, a workaholic, and there is little doubt that his demanding schedule took its toll: he was only forty-four when he died. He was also known as a brilliant raconteur and party giver. His mansions in Greenwich, Connecticut, and later, Katonah, New York, were often filled with A-list guests.

Despite Fitch's success with audiences, critics attacked him for his focus on women even though writing vehicles for popular leading ladies was crucial to success in the commercial theater of his time. It did not help that the flamboyant Fitch and his plays did not gel with the norms of manliness that were dominant in the Teddy Roosevelt era: "The fear of womanly men became a significant cultural issue in the late nineteenth century, one discussed by men in a new, gendered language of manly scorn."[2] Fitch was for some such an object of scorn. A year after Fitch's death, one article about the playwright was titled "Sissy Boy Who Became a $250,000 a Year Dramatist."[3]

Writing about Clyde Fitch poses a number of problems. First, how does one write about a maker of popular theater? In his essay, "The Play and the Public," Fitch proudly proclaims that "the theatre in our day is principally to entertain."[4] Oscar Wilde and Somerset Maugham were also highly successful makers of popular theater, but there is a rich element of social satire in their work and a dark side that gives their work complexity. Fitch's essay "The Play and the Public" demonstrates his knowledge of and sensitivity to the Broadway audience he wanted to please:

> The typical general audience such as I have spoken of, leavened with a little of every class and kind, is the one that the manager dearly loves. They pay for their tickets and demand only a just return. It is a composite gathering, difficult to please from all points of view; a gathering anxious to be amused, satisfied to be interested, willing to be moved, but absolutely intolerant of being bored. I think it would rather, in the bulk, be entertained by a worthy medium than an unworthy, and it stops to differentiate just about that much. (xxvi–xxvii)

Fitch's portrait of his audience easily includes Rattigan's "Aunt Edna." Like Wilde and Maugham, Fitch wrote to please and to succeed in the commercial theater, which made him a rich man. While he aspired to follow in the footsteps of his friend and, possibly, former lover, Oscar Wilde, he is more an heir to the French popular playwrights Augustin Scribe and Victorien Sardou and Irish playwright Dion Boucicault. His plays are situation comedies and melodramas in which one situation is stretched into a full-length play. What richness his plays have comes from the surplus of period detail that reflects some sense of the life of the affluent New Yorker at the turn of the twentieth century. Many scenes are dominated by secondary characters who are there to give the play a social context but do nothing to further the narrative. In Wilde's plays, the characters who provide the social background embody the author's most incisive social criticism. Fitch, however, was too eager to please to risk offending his audience. Nor is there any of the richness one finds in a handful of plays by his contemporaries, like James A. Herne's *Margaret Fleming* (1890) or William Vaughn Moody's *The Great Divide* (1906), a play that offers a nuanced critique of contemporary gender definitions, but these men did not have the commercial success Fitch had. Fitch is important to the theater historian, but it is difficult for the critic to write about plays that are so thin. There is nothing much to analyze here. In an insightful essay written some years after Fitch's death, friend and scholar-critic Montrose J. Moses explains the pitfalls of Fitch's alliance with Broadway producers Charles and Daniel Frohman, who occupied "commanding, almost dictatorial positions": "Their growing belief in the 'star' system had a disastrous effect on the plays of the period and, in the case of Clyde Fitch, served to limit his innovation and to direct his construction."[5] According to Moses, Fitch succeeded commercially and often failed artistically because he was such a creature of the commercial theater: "It was a conventional theatre with conventional rules for success; and Fitch played [by] these rules, since there was no other way for an American dramatist."[6] This may explain the unnecessary spectacle in Fitch's plays. The rolling ship that provides the setting for act 1 of *The Stubbornness of Geraldine* was a popular effect in late nineteenth-century melodrama. The gallery housing the Apollo Belvedere in Rome in act 2 of *The Girl with the Green Eyes* provides a lovely scenic backdrop, and the tourists who gather there offer some amusing comic moments, but they have nothing to do with the principal action. Broadway audiences loved spectacle, and Fitch wanted to give his audiences what they wanted. When Fitch aspired to the serious drama his critics demanded of him, he produced melodrama like *The Truth,* with its scene of attempted suicide, and *The City,* with its blackmail and murder.

Despite, or because of, his success with audiences, Fitch was excoriated by many reviewers. Critic William Winter calls him "a crude and frivolous playwright."[7] Fitch did not take such criticism lightly: "He wanted everyone to believe him earnest, and a large part of his sensitiveness to criticism was due to the fact that the newspaper writers never would believe him either sincere or earnest. They always slurred him in ways that hurt."[8] Fitch was quite combative in response to negative criticism while at the same time wanting critics to see him as a friend. His letters to *New York Times* critic John Corbin, who alternately praised and damned his work, are typical expressions of the playwright's personality. He argued vehemently with Corbin's negative criticism while asserting his fondness for the critic and offering invitations to his home. Fitch wanted to be liked and accepted as an artist and as a unique personality but felt beleaguered. He wrote in a letter to Corbin, "On the whole I have done my work against antagonism, public and private, misrepresentation of my character and life, public and private, and ridicule and belittling of my work…"[9] The playwright was obviously touchy, not only about his work but also about comments about his private life. As we shall see, he may have had good reason for such sensitivity.

Although Fitch's contemporary champions and biographers, particularly his friends Virginia Gerson and Montrose J. Moses, present a man without a sex life, in recent years, at least in the field of gay studies, conjectures about Fitch's private life have overshadowed his work. He would be horrified to know that he is primarily known now as a lover of Oscar Wilde and as an example of an old-fashioned queen, a "sissy boy" made good. One can read the evidence gay critics and historians use in a number of ways, but Fitch has been outed, and outing seems to be a subject on which he had strong opinions. Gary Schmidgall quotes a letter Fitch sent to a homosexual friend, Dewitt Miller:

> Over lunch at Delmonico's, it seems Miller had spoken of "certain temperaments of men for the not ordinary sexual enjoyment," mentioned several names, and then expressed a desire "to write up the subject." Fitch continued, "thinking it over afterward, I felt that it was something I did not at all approve of. I felt and feel you could have no right to do this, to expose what would ruin the reputation of many men living and dead who had fought hard against their temptations and done all in their power to make up for their secret life…I believe this temperament belongs to them, and they are answerable for it to God (who perhaps is <u>also</u> answerable to them) and not to the world who would condemn or damn them. Their family, their <u>mothers</u>, should be remembered." Fitch added at the end, "I ask that you will <u>answer</u> [double underline] <u>but</u> [triple underline] destroy this letter."[10]

This is an interesting letter for a young man to write in 1891. Fitch expresses great sympathy, if not empathy, for the men who must live secret lives. I find most striking his comment about God being answerable to these men, as it suggests that Fitch believed that homosexuality was innate, God given. For him, it was neither a moral flaw nor a disease, and damnation would come not from a divine power but from "the world," which harshly judged and punished these men. Thus, their sexuality had to be kept secret, particularly from mothers who would be hurt and shamed by revelations about their sons. Fitch wrote that his mother was "the one great love of my life. I have loved others, but it has seemed to me that beneath and above any other affection was my love for my mother."[11] Friend and biographer Archie Bell wrote, "From birth to burial his mother was with him, closer to him than the world may appreciate and have the mind to comprehend."[12] Clearly Fitch did not want his mother to know about his "secret life," if he indeed had one. Fitch's letter to Dewitt Miller is a liberal defense of a homosexual's right to privacy and an expression of his fear of public and maternal condemnation. Homosexuality was at least something he had thought about at a time when it was unspeakable, and he worked and socialized with a number of known homosexuals.

This and other material on Fitch raise a number of issues as to how we read clues of the homosexuality of figures from the past. There is no doubt that Fitch displayed signs we tend to read as homosexual, but to what extent did he express himself sexually? His public claim was that his life was totally devoted to his work. In 1904, Fitch wrote to John Corbin after he had written a highly critical article on Fitch's plays:

> About *me* you must recognize one thing, if you *want* to,—I live in and entirely for my work, but *not* as a *pastime*, nor as a *business*. I study it and work in it and live in it *winter* and summer, year after year. I have no other principal interest, no business, no wife or children. I give all I have to my work and to the few friends I can count on my hands.[13]

This was the public image Fitch wanted. There is no doubt he was a workaholic, and we have no evidence of a sex life after he achieved his first success in 1890. Gary Schmidgall writes of the "sad closeted path"[14] Fitch trod in his years as a public figure, and Archie Bell notes that "he lived alone and was lonely."[15] However, a solitary, bachelor life does not necessarily denote an unhappy, repressed homosexual.

If Fitch and his contemporaries present an accurate picture of his life, it may partially explain the relative sexlessness of his plays (the prevailing mores are also part of the reason). Oscar Wilde's sexual double life may have led

him to a fascination with the question of what one could get away with in society and what secrets needed to be kept. Somerset Maugham's cynicism about love and his relationship with Syrie led to his pragmatic, sexually active female characters. Secrets in Fitch's plays turn out not to be secrets at all, and monogamous marriage is always upheld. It is not surprising that contemporary scholars find Fitch's life potentially more dramatic than his work.

If Fitch was the "sad closet case" Schmidgall describes, would he have conceived of himself that way? George Chauncey notes that "gay people in the past did not conceive of themselves as living in a closet," but he goes on to state, "Many gay men, for instance, described negotiating their presence in an often hostile world as living a double life, or wearing a mask and taking it off."[16] Fitch once said, "I live my life in the midst of shams."[17] Was he referring to his private life or his life in the theater? We do have evidence of one brief romance that may have been his first and his last.

FITCH AND WILDE

In 1914, five years after Fitch's death, American art dealer Martin Birnbaum wrote a little (thirty pages) book entitled *Oscar Wilde: Fragments and Memories*. Birnbaum himself is something of a mystery. Though of relatively humble origins, he became a leading art connoisseur who hobnobbed with the wealthiest strata of New York society. A Hungarian Jew, he emigrated to New York's Lower East Side with his family. After graduating from City University of New York, he worked his way through Columbia Law School by giving violin lessons. Law, however, was not his passion. A wealthy woman needed a young lawyer to help her settle some matters in Europe. Birnbaum was hired, and through this woman's largesse, he was able to travel all over Europe in a relatively grand style. This led to connections that allowed him to become a successful art dealer and a major collector. Birnbaum never married.

I wonder why this man wrote a little book on Oscar Wilde, who was still unmentionable in 1914 and was certainly equated with what was then called degeneracy. The short book is a rambling series of episodes about Wilde that Birnbaum must have heard from acquaintances. Throughout, Birnbaum's stance is one of an admirer who is sympathetic to the tragedy of Wilde's downfall: "It was this enviable measure of success in life and in every form of literary endeavor that made the scandal of his downfall so shocking and deplorable. He was brought to a full stop at the very height of his splendid career, and was suddenly driven back to the depths where he had once gone for sensations, after tiring, as he said, of being on

the heights."[18] This passage presents Wilde as a victim, not a degenerate criminal.[19] He is the central figure among artists and poets who fascinate Birnbaum, such as Aubrey Beardsley and Ernest Dowson.

The first anecdote in Birnbaum's book on Wilde concerns an episode in the relationship between Wilde and Clyde Fitch. Montrose J. Moses and Virginia Gerson, for years the major source of material on the playwright, never mention Fitch's friendship with Wilde. Yet they knew Fitch better than Birnbaum, who accompanied Virginia Gerson and her sister to some of Fitch's parties. In a later memoir, Birnbaum recalls,

> Clyde Fitch, the most prolific playwright of his time, was the closest friend of the Gersons [Minnie and Virginia Gerson and their octogenarian father] and held regular salons of artists. Virginia co-edited the volume [with Montrose Moses], and very soon I was invited with some of the celebrities named above to Fitch's exotic home on East Fortieth Street and to Quiet Corner, his country place at Greenwich, Connecticut. I was included probably because I could help to entertain the house guests with my violin.[20]

Later, he notes, "The weekend parties given by Fitch to which I was invited with the Gersons were always brilliant. Once when we gathered at Quiet Corner on the eve of our host's annual departure for Europe, I bemoaned the mundane nature of my existence."[21]

Where did Birnbaum hear the anecdote about Fitch and Wilde he recounts at the opening of his book? Perhaps it was passed on by Virginia Gerson or by Fitch himself. In the original 1914 New York publication, Fitch is presented only as "an ambitious young American."[22] He is later named in the 1920 London edition. Birnbaum presents Wilde as a sympathetic friend and supporter when Fitch was an unknown in London: "Like all generous spirits, [Wilde] liked to praise, and when they met socially at the houses of London's smart set the kindly interest of the celebrity was highly appreciated by the younger playwright. Their acquaintance had long since ripened into a fine friendship."[23] Birnbaum does not mention that some of the "smart set" with whom Fitch socialized included Wilde's gay friends Marc-André Raffalovich and Robert Hichens, author of *The Green Carnation*. Both Raffalovich and Hichens later turned against Wilde. Birnbaum's anecdote both associates Fitch with Wilde and disassociates him from Wilde's rampant, scandalous pederasty:

> One gloomy, rainy afternoon, the two men met on a deserted street. Wilde was driving in a hansom and he invited his friend to take the vacant seat beside him. Fitch accepted, and at once began to remonstrate with Wilde regarding certain ugly rumors which were circulating in London about him. The poet

attempted to turn the matter into an epigram, but his friend would not be put off. He wanted a plain answer to the charges. Wilde refused to discuss the topic and finally called to the driver" "Stop to let this man out! I invited him for a drive, but he is not a gentleman!" ... The old relationship ended then and there, but Fitch always admitted his obligation as an artist to Wilde, continued to look upon him as his intellectual inspiration, and was among those who came to Wilde's aid after his release from prison."[24]

Though he was a friend of Fitch, Birnbaum's sympathies seem to be with Wilde. He seems to share Wilde's view that Fitch's insistence on getting the truth was "ungentlemanly." Why would Fitch be so dogged in his determination to get an explanation from Wilde? On the other hand, it is a story that exonerates Fitch from any sympathy with Wilde's homosexuality or pederasty. Birnbaum notes that "before the rupture a voluminous correspondence existed between them."[25] None of the correspondence appears in *Clyde Fitch: His Life and Letters.* After the rupture Birnbaum describes, Wilde and Fitch were still corresponding. In a letter to Leonard Smithers, written from Dieppe in 1897, Wilde is frantically looking for money as he often was in his last years in exile. He writes, "I intend, by the advice of Clyde Fitch, to ask the *New York Journal* for £200 [for a poem]."[26] For Fitch, 1897 was not a good year as a playwright, so all he could offer Wilde was advice. Clearly they were still on cordial terms.

Like Wilde, Fitch attempted to present a sparkling picture of contemporary high society, but the wit and the satiric vision are lacking. Throughout his life, Fitch played the role of the witty bon vivant and flamboyant figure that Wilde had been. Somerset Maugham claimed that Fitch was "the most brilliant conversationalist of this period."[27] William Lyon Phelps notes, "He was one of the most brilliant talkers I ever knew—his wit was spontaneous and inexhaustible."[28]

Over half a century after Birnbaum's book, Wilde scholars began studying the available remnants of the previously unpublished, "voluminous" Fitch-Wilde correspondence. A number of Fitch's effusive letters to Wilde were in the collection of Oscar Wilde correspondence at the Clark Library at the University of California, Los Angeles. Wilde scholars Gary Schmidgall and Melissa Knox and gay theater historian Kim Marra see these letters as evidence of a sexual relationship between Wilde and Fitch that may have had more emotional significance for the American than for Wilde. Fitch went on long spring-summer excursions to England and Europe every year since 1888 and met Oscar Wilde that year, probably through André Raffalovich. Fitch's ardent love letters to Wilde are convincing evidence that there might have been a sexual liaison between these

men. How else can one interpret passionate outpourings like those found in these three letters (undated but probably from 1888 or 1889)?

"Nobody loves you as I do. When you are here I dream. When you are away I awake."

**

Oh! You adorable creature. You *are* a great genius and Oh! such a sweet one. Never was a genius so sweet, so adorable. Plod thro' yr history and you will find no other.

And I—wee I—i [*sic*]—am allowed to loose the latchet of your shoe…Am bidden tie it up—and I do, in a *lover's knot!*

You are my poetry—my painting—my music—You are my sight—and sound, and touch.

Your love is the fragrance of a rose—the sky of a summer—the wing of an angel. The cymbal of a cherubim.

You are always with me that [though?] I have not seen you since Time—it stopped when you left.

**

It is 3. And you are not coming. I've looked out of the window many times. The brown is blurred, quite colorless, and the silver heart is leaden.

—————I have not slept. I have only dreamt, and thought. I don't know where I stand, nor why. I don't care I only want to be *there. There.* You were right. Away with knowledge. It is only grievous to know. I will only wonder & love.

Passionately yrs[29]

Fitch's letters sound like outpourings of first love combined with hero worship. It is interesting to note how incautious Fitch was in his letters to Wilde. He did not seem to worry about what might happen if his letters got into the wrong hands. Wilde obviously kept the letters just as, against Fitch's clear instructions, Dewitt Miller kept his letters from Fitch, now housed at the New York Public Library. The two responses we have from Wilde to Fitch are friendly but nowhere near as passionate as Fitch's protestations of love. We know that Wilde was not always cautious in his correspondence. Fitch, then twenty-four years old and not yet established as a playwright (his first successful play would come a year later), clearly had a crush on Wilde, then a successful poet and short story writer but not yet a celebrated novelist or playwright. Even if the other letters could

be attributed to Fitch's enthusiasm, the 3 A.M. letters are convincing evidence that there was a sexual component to the relationship that Fitch experienced as high romance. Melissa Knox believes that the letters reveal "what seems to have been a wonderful affair."[30] Wilde's feelings seem less ardent.

In light of his adoring letters, how do we explain Birnbaum's story of Fitch's behavior in Wilde's carriage years later? Though whatever romance there had been ended years before, there may have been some jealousy. Or did Wilde's unfolding scandal terrify Fitch? If Wilde was exposed, would Fitch, now a known playwright, suffer guilt by association? Birnbaum's anecdote presents a man in the throes of panic.

THE SISSY

The remnants of his relationship with Oscar Wilde present evidence of Fitch's homosexual activity at one moment in his life and, perhaps, the catalyst for Fitch's later image as a man totally devoted to his work. Fitch's image as a "sissy boy" would certainly be read by some of his contemporaries as a sign of homosexuality.

Fitch's strong feelings for Wilde may be partially explained by the fact that the young writer finally found a kindred spirit in terms of personal style. As we shall see, from preparatory school on, Fitch had gone against the grain of conventional American masculinity by adopting a personal style based on the aestheticism Wilde advocated. Moses and Gerson note that, in the period after his first trip to England and Europe, Fitch "was very aesthetic and romantic looking":[31]

> He would greet his callers in a blue velvet coat, with a rose-pink carnation in his buttonhole, while around was a pleasant consciousness of flowers, incense, and brewing tea. Like a high light in this dim picture of color, catching the full reflection of the fire, sat "Rosetta," a yellow kitten, wearing a wide yellow ruffle around her neck, immovable as a golden sphinx."[32]

His first hit play, written to order for actor Richard Mansfield (many of Fitch's plays were vehicles written to order, usually for up-and-coming actresses), was a version of the life of Regency fop Beau Brummell. Writers about Fitch are correct in seeing his desire to defy current masculine fashion.

At a time in which strict norms of masculine behavior were operative, any "unmanly" behavior fell under a pejorative rubric. Historian George

Chauncey observes that in the late nineteenth century, "men began to oppose themselves in opposition to all that was 'soft' and 'womanlike.'"[33] The result was the emergence of terms of derision for men who were not adequately masculine—terms like "sissy" and "fairy." E. Anthony Rotundo traces the history of the most popular epithet, "sissy": "Originally a slang term for 'little sister,' it did not appear in the *Oxford English Dictionary* until the 1890s. Then, suddenly, four such usages appear and all of them come from the United States. Americans quickly seized upon the word with an enthusiasm that suggests the fulfillment of a great need."[34] A "sissy" was a womanly man, unassertive, timid, physically weak, slender, polite, and fond of female companionship. Rotundo goes on to point out that "[by] the end of the [nineteenth] century, men were using the same terms of scorn for homosexual males that they used for artistic, tender-minded or reformist men." Sissies were frightening because they straddled the line between masculine and feminine and because they were equated with homosexuality.

Clyde Fitch may have been a phenomenal success, but he could never escape the image of the sissy and the fairy. In 1926, Yale English professor William Lyon Phelps wrote a volume of essays on leading modern dramatists. In the midst of essays on James M. Barrie, George Bernard Shaw, John Galsworthy, Maurice Maeterlinck, and Edmond Rostand, writers who had penned theatrical classics, was an essay on Clyde Fitch, who was hardly in the same league with these authors, a fact that Phelps reiterates in his essay. Speaking about one Fitch play, Phelps notes that, "[l]ike all of the plays of Clyde Fitch, *The Climbers* is full of limitations and full of faults."[35] Later, damning with faint praise, Phelps states, "He was always serious, if his plays were not; he never left anything to chance, and he followed his calling with a devotion that cost him his health and his life."[36] If Phelps contends that Fitch is not in the same league with the other dramatists in his volume, why include him? The simple answer is that Phelps had known the playwright since high school. The essay gave Phelps a chance to reminisce about Fitch in decidedly unflattering ways. Before Phelps discusses Fitch the playwright, he describes Fitch the sissy. Here are some of his descriptions of the boy he knew in high school:

> His gait was strange, the motive power seemed to dwell exclusively in the hips; if you can imagine a gay sidewheel excursion steamer, with the port and sideboard wheels moving in turn instead of together, you will get a fair idea of the approach of William C. Fitch. His face was impressively pale, looking as if it had never been exposed to the sun...His manners were absurdly affected

until we found they were invariable; he was never caught off his guard. His language, judged by schoolboy standards, was ridiculously mature...His voice was very high, frequently breaking into falsetto, and even in ordinary conversation it sounded like that of an hysterical woman who had just missed the train...[37]

We thought he was effeminate, a mollycoddle, a sissy; we did not know that he had the courage of his convictions, and was thus the bravest boy in school.[38]

Years later, when Fitch and Phelps walked down the street in New Haven, Phelps was struck by Fitch's attire: "He had an extraordinary suit, only partially concealed by a gorgeous overcoat, and on his head was the most amazing hat ever worn by a male creature. Everyone we met stopped to stare; so as far as I could make out, he was quite unaware of the sensation it produced."[39]

If Phelps is not a wholehearted admirer of Fitch's plays, he does respect Fitch's courage to be who he is despite its violation of current norms of masculine dress and behavior and despite his great success: "Judged by the standards most people use in estimating success, he was right and all the rest of us were wrong."[40]

At Amherst College, his dress was so colorful that he received an anonymous letter threatening him with violence if he ever wore the outfit again. He decided to continue to defy convention and accept the consequences. His fraternity brothers seem to have accepted his eccentricities and cherished his wit and love of a good story. Yet we get some sense of his sense of style from the reminiscence of one fraternity brother: "I never saw him flare into a temper even if by accident we did break a vase or upset a dish."[41] We see even more in a letter he wrote to a college friend:

My dear Frank:

Here is a little bowl of daisies for the Gym Captain of '85, with the heartiest congratulations for his victory in the contest for the Gilbert prize.

 I would they were hot-house roses (metaphorically, you know), but the horrible, almost criminal, state of my finances confines me to these poor weeds.Believe me joyfully and with love.[42]

Sending flowers to an athletic college chum was hardly the norm in 1884, but Fitch managed to get away with it through his simple integrity. He had considerable success as the leading lady in college theatricals. At the time, it was the convention in men's colleges for women's roles to be played by men, but Fitch was the first nonsenior to be cast in a leading role in

the senior play. His portrayal of the young women of eighteenth-century drama was clearly impressive. Later, when he directed his own plays, he was masterful at showing his leading ladies how to perform the roles he created for them. His taste was impeccable: he spent a good deal of time during his European trips buying antiques and objets d'art for his homes, which were ornate, to say the least.

Fitch's friends loved him for his loyalty, generosity, brilliant wit, and love of entertaining. In theater, he found a world in which he would be accepted, particularly given the success and power he attained. His plays were produced by Charles Frohman, who was probably homosexual, and his agent was lesbian Elisabeth Marbury. Detractors ridiculed his "sissiness". Now, scholars like Kim Marra and Gary Schmidgall equate that "sissiness" with homosexuality. Combined with the letters to Wilde, they make a good, if not airtight case. Here is Marra on Fitch's reaction to Wilde's downfall:

> The public spectacle of Wilde's rise and fall greatly heightened the risk factor for those with same-sex affectional preferences and alternative lifestyles throughout Anglo-American culture. Fitch, who had shared the master's bed as well as his theatrical aspirations, had particular reason to be afraid. Wilde had left him with a fully awakened sexuality and a mounting terror that it would run out of control and destroy him. The younger Fitch was still struggling for lasting success in a highly public profession where the stakes for his conduct were becoming much greater. After Wilde, there is no evidence that he had any other such exhilarating romances. He traveled with a variety of male companions and kept valets and butlers around him at home, but he remained fastidiously discreet about his private life. At the most intimate level...he remained profoundly lonely and drove himself to fill the void with his work.[43]

This is a coherent, convincing narrative, though much of it is conjecture. For instance, Marra attributes Fitch's "cultivation of the pose of the dandy" to Wilde's influence, yet it is clear that Fitch's taste in clothing and home furnishings began back in preparatory school. Fitch's letters do not seem those of a lonely, unhappy man. Yet Marra offers the gay studies version of Clyde Fitch.

But what has this to do with Fitch's plays? We can see Wilde's own complex relationship to London society in his plays, which are greatly about the dangers of exposure and the secrets that society is willing to maintain. We can see Maugham's cynical attitude about love and his complex feelings about women in his plays. Both men succeeded by being a bit daring; they wanted to shock as well as amuse. Perhaps Fitch's

strong desire above all to please his audience is in part the outsider's hunger for mass acceptance when a fulfilling private life is not possible. He certainly knew what his audience wanted even if his critics wanted something more serious.

LOVE AND MARRIAGE

With few exceptions, Clyde Fitch's social comedies center on a bright, headstrong, young American woman. One can see a bit of Henry James's Daisy Miller in Fitch's version of the American girl: charming and attractive, but often with a self-destructive impulse. The narratives focus on either a turbulent courtship that only leads to marriage because of the strength of character and romantic faith of the wealthy, tough heroine (e.g., *The Stubbornness of Geraldine, Her Own Way*) or on a marriage in trouble because the wife has a flaw that causes her noble husband to lose his trust in her (e.g., *The Truth, The Girl with the Green Eyes*). Fitch's heroines always win the day in denouements that are seldom convincing. Perhaps that is why William Lyon Phelps observed that Fitch could not write a good last act—he had to give his audience a happy ending even if narrative logic demanded a darker conclusion. The pathological liar and the jealous neurotic could both be cured and become good wives to their stalwart, devoted husbands.

Unhappy marriages must be saved because Fitch's audiences saw divorce as too scandalous an alternative. Divorce is also unlikely because Fitch's spouses, however flirtatious, would never be sexually unfaithful. The worst that happens in his plays is a dangerously ardent kiss. There is an innocence to Clyde Fitch's plays that reminds me of early television situation comedies. A wife or suitor has some "splainin' to do," but ultimately all is forgiven. Women may be weak, but they are deeply in love with their husbands, who are men of character.

The Stubbornness of Geraldine (1902) is a typical Fitch courtship play. Geraldine Lang is a wealthy heiress who has lived abroad under the care of governesses since the death of her parents when she was five years old. Her wealthy uncle has just died, leaving her an immense fortune, which has enabled her finally to move back to New York. Geraldine is the perfect American girl, handsome, "with the love of life in her face and speech and manner" (3; 21). Through its romantic narrative, *The Stubbornness of Geraldine* offers a picture of American ideals at the turn of the century. Geraldine may have been away from her native land, but she is as

patriotic as a character in a George M. Cohan musical: "The day I sailed, a pale, small, timid girl, this same uncle gave me, to wave from the boat, a little stars and stripes; Uncle Ray DID *love* his country—as well as a few other things! Perhaps you'll think it silly of me, but from that day I've never let go that little flag" (28). Geraldine falls in love with a mysterious Hungarian who is traveling under an assumed name. Like a good capitalist immigrant intent on pursuing the American dream, he wants to establish a wine importing business in the United States. "Mr. Carlman" will not propose to Geraldine until he has proven himself in the United States and is worthy of her. In reality, he is a Hungarian count who has been mistaken by Geraldine's protective friends as the count's wastrel brother. Geraldine refuses to believe the rumors and remains steadfast in her love: "I don't think it's *stubbornness* this time, I think it's *love*. No woman can *pretend* she *loves* a man, unless she has *faith in him*, and the only one *able* to destroy that *faith* should be the *man* she *loves* (146). Eventually, of course, her faith and love are justified. In the meantime, Fitch gives us rolling ships, characters with stage comic German and middle-European accents, lavish sets, a Hungarian orchestra and dancers, and a story built on rather flimsy coincidence. At the heart of this entertainment is the romance of a wealthy American with an unerring sense of character and a European nobleman who deserves her because, like a good American, he wants to work for a living and earn his own fortune. Like any successful commercial playwright, Fitch is careful to endorse the values of his audience.

 The Truth (1907) is one of Fitch's attempts at a serious play on a modern marriage. It is one of the four new plays (directed along with *The House of Mirth*, adapted from Edith Wharton's novel, *The Girl Who Has Everything*, and *The Straight Road*) and two revivals (*Captain Jinks of the Horse Marines* and *Beau Brummel*) Fitch had on Broadway that season. Fitch was mass-producing product for the Broadway stage with mixed results. The central character of *The Truth*, Becky Warder, is a happily married young woman who happens to be a pathological liar. Though her own background would seem to militate against a society marriage, she has the ideal husband, rich, successful, and totally honorable: "[Tom] Warder is a strong and sensible, unsuspicious man,—no nerves and no 'temperament,' nothing subtle about him; he is straightforward and lovable" (4; 231–2). What does it mean for a masculine character to be "lovable"? He seems to have found the ideal companion, for his wife is described as a "pretty, charming, volatile young woman, sprightly, vivacious, lovable" (220). Fitch's use of "lovable" is a symptom of one problem with his plays. Becky is a liar

who almost destroys her marriage and the marriage of one of her friends. In what way is that lovable? Yet Fitch wants the audience always to be on her side, to see that despite her weakness she is totally devoted to her husband. If both central characters are always "lovable," the dramatic stakes are going to be low.

The play is candid in presenting Becky and Tom's relationship as an ardent, sexual one. At the end of the first act, it is clear as it could be in a play of the time that the couple is about to go to bed:

> *With her arms about his neck she slides onto his knee, like a child.*
> Becky: I've let Perkins go out and you must hook me up the back.
> *And they both laugh gaily as he embraces her and THE CURTAIN FALLS.* (282)

Becky wants above all to be liked. She can engage in an innocent flirtation with her friend's estranged husband because she is innocent and cannot believe he would have ulterior motives. Moreover, the man's wife is presented in the first scene of the play as vain and foolish and later as vengeful. Becky lies because she does not want anyone to be angry with her. Fitch also explains her dishonesty through exposition about her childhood. Her mother had left her father when Becky was very young, and she was left to be raised by a feckless father: "I always hated the plain truth. I liked to trim it up a little" (395). Unfortunately, her father and the woman he lives with are written as the stock older comic couple of nineteenth-century theater. He is a comic wastrel, and she is pretentious and eager to be made an honest woman. They, of course, will agree to marry by the final curtain.

Becky has been having regular tête-à-têtes with Lindon, the husband of one of her friends. Eventually, the jealous wife has a detective watch her wayward husband and obtains proof of the meetings. Tom, a man of the world, understands that Lindon's motives are less innocent than his wife's and forbids Becky from seeing him. Becky continues, and Lindon shows his true colors by forcing her into an embrace. Tom finds out and loses all trust in his wife: "You don't know what's true when you hear it or when you speak it! I could never believe in you again! Never have confidence! How could I? Ask any man in the world, and his answer would be the same!" (358). Tom may lose all faith and trust in his wife at the end of the second act, but there is no doubt in a Clyde Fitch play that these two lovable people will be back together at the final curtain. Becky has learned her lesson, and Tom has learned that he cannot expect perfection.

The play follows the laws of popular theater rather than honest character portrayal.

Fitch had great faith in *The Truth,* but the New York critics savaged it, and it did not succeed with audiences. The 1906–07 Broadway season included productions of three plays by Bernard Shaw and four plays by Henrik Ibsen. New York critics were beginning to demand that American plays at least aspire to the standards of modern European drama, and with so many Broadway productions to choose from, audiences seemed to be tiring of Fitch's amiable plays. However, *The Truth* was a big hit in London the same year that Somerset Maugham had his first audience success with *Lady Frederick,* and part of its London success was the casting of popular star Marie Tempest as Becky.

The Truth follows the same formula as *The Girl with the Green Eyes,* which opened on Christmas night in 1902. Here Jinny, the wife, is constantly jealous while her noble husband, John Austin, is secretly trying to save her bigamist brother and his two wives from scandal and ruin. John has promised secrecy, and Jinny is sure he is having an affair with one of the women he is trying to save. Finally, John snaps, "You have insulted my love for you to-night as you've never done before; you've struck at my own ideal of *you*; you've almost done, in a word, what I warned you you might do—*kill* the love I have for you!" (3; 384). John leaves and Jinny attempts suicide, to be rescued in the nick of time by her forgiving and repentant husband: There's one thing stronger even than jealousy, my Jinny. And that's LOVE! That's LOVE!" (421–2).

The Girl with Green Eyes is filled with secondary characters with comic tics, like the constantly dyspeptic young man and the tourists who comment on the Apollo Belvedere. Melodrama and comedy mix without the creative tension between them that makes Wilde's plays complex. The tourists in Rome are certainly based on Fitch's experience watching his countrymen abroad, but they have nothing to do with the action of the play.

Marriage in Fitch's plays is a necessity. Marriage may have rocky moments, but ultimately, husband and wife will affirm their love. Where is the lonely bachelor in all this, the man who sought his emotional fulfillment from the applause of his audiences and the love of even his critics? Perhaps the innocence and naïveté we see in his outpourings of love for Wilde were too much at the heart of his own character. They certainly become the basis for the personalities of many of his female creations. His letters and plays show a man too eager to please to have the courage to be a major artist. Yet he represents the theater of his time, warts and all.

GEORGE KELLY: A GAY MARRIAGE OF SORTS

Mary: Why, I thought you'd have been married years ago.
Tesh: I shouldn't care for it.

The Flattering Word[44]

Gene Tesh, the central character in George Kelly's early one-act play *The Flattering Word*, written for the Orpheum vaudeville circuit shortly after World War I, is skeptical about marriage. The actor-playwright wrote the part of Tesh, a touring actor, as a leading role for himself. Like Tesh, Kelly did not care for conventional heterosexual marriage, telling interviewers, "I always felt I was temperamentally unsuited to marriage."[45] This was not quite true, for the decades-long homosexual relationship he shared with William Weagley was a kind of marriage. Kelly's full-length plays, written between 1922 and 1946, are cynical satires on middle-class, American domestic life. His Gene Tesh may have become disillusioned playing husbands onstage, but in Kelly's plays, marital disillusionment is rife, particularly among the wives for whom marriage was once the goal.

George Kelly's career as a maker of Broadway hits was short-lived. After years of apprenticeship as a performer and writer of skits and one-act plays for vaudeville, Kelly had a major Broadway success in 1922 with *The Torch-Bearers,* an expansion of one of his vaudeville one-acts. After two more hits in the mid-1920s, *The Show-Off* and *Craig's Wife,* both of which were filmed by Hollywood multiple times, Kelly's star waned. His gift for comic exaggeration and wry colloquial speech was at the heart of the success of his first two Broadway hits. The more serious *Craig's Wife* appealed to audiences at a time when presentations of the dark side of the American middle class, like the novels of Sinclair Lewis, were popular. After that, Kelly tried to write what one might call serious comedies with mixed results. He kept writing plays into the 1940s, but nothing clicked with audiences. The later plays were considered mean-spirited and unsympathetic toward their female characters. Two of his sharpest critiques of marriage, *The Fatal Weakness* and *The Deep Mrs. Sykes,* were produced at the end of World War II when the primacy and validity of the nuclear family as an affective and consuming unit was not to be questioned. Fortunately, Kelly had made enough money from his 1920s hits, Hollywood adaptations, and wise investments to live comfortably for the rest of his long life. Kelly may not have had a hit since the mid-1920s, but *The Torch-Bearers* and *The Show-Off* were staples of amateur and university theaters

throughout the first half of the twentieth century, and *Craig's Wife* was still fodder for Hollywood diva vehicles in 1950 when Joan Crawford played the obsessive Harriet.[46] By the time he died in 1974, American culture had changed radically.

Like Somerset Maugham, Kelly did not want his personal life discussed. William Lynch notes in his essay on Kelly, "He was scrupulously consistent in his refusal to discuss his private life, especially his youth, and was careful to destroy any material that would be of any possible assistance to a biographer."[47] There were two reasons for this. Unlike the upper-middle-class, university-educated playwrights who dominated the theater in the early years of the twentieth century (e.g., Clyde Fitch, Edward Sheldon), Kelly came from a poor Irish Catholic family at a time when there was considerable prejudice against Irish immigrants: "Because he was ashamed of his early life, embarrassed that his parents were poor, that he had nine siblings—only immigrant Irish were capable of such prolificity—and that he quit school in the fourth grade, George Kelly invented any number of fictions to conceal the truth about his upbringing. For example, he claimed that he was educated by private tutors, a complete fabrication."[48] Three of Kelly's brothers made a fortune in bricks and construction, hardly aristocratic occupations. Another, Walter, was a vaudeville star. Through the success of the Kelly brothers, the family moved from poverty to affluence and to some social prominence as one of Philadelphia's richest and most powerful families. John, George's brother, was a building contractor who became chairman of the Pennsylvania Democratic Party. He and his son were celebrated oarsmen, winning such blueblood events as the Henley Royal Regatta. His daughter, George's niece, was actress Grace Kelly, who became a princess, thus giving the family links with minor old-world aristocracy. Though the Kelly family story is a rags to riches saga, George wanted the public to think the family had always lived like princes: "He preferred to think he'd been born into a household of wealth, where cooks, butlers, maids, and chauffeurs could be summoned by the ringing of a bell, and high tea was routine."[49] Yet the play Kelly wrote about the lives of American aristocrats, *Behold the Bridegroom* (1927), is his least credible and theatrically effective. Unlike Clyde Fitch and Philip Barry, Kelly did not know this world from the inside. What he knew and could capture were the coarseness of speech, destructive envy, and social pretensions of people either on the way up or perpetually trapped near the bottom—people like Daisy Mayme Plunkett, who could assert, "I think it's better to be wise than happy: because if you're wise you've always got something; and if you're just happy, you haven't."[50] Despite the myths he tried to create about

his background, he wrote best about the world he knew, the world of hard-working, unsophisticated folk. His great gift was an unerring ear for the idiomatic speech of working-class and lower-middle-class Philadelphians (most of his plays are set in his native city). This was the audience he wrote for in his early years in vaudeville wherein he got his training as actor, writer, and director. Broadway audiences and critics celebrated only the plays that seemed to make fun of his characters. Kelly at his best, as in *Daisy Mayme*, took his characters quite seriously.

The Kelly brothers, particularly George, were fortunate that the matri-arch of the family, Mary Costello Kelly, was an avid reader, particularly of literature and history: "Reading, as all through her life, was Mary Kelly's escape from harsh reality. By the time she was fifteen she was able to quote whole scenes from Shakespeare, something her son George did equally well, and often the pair would compete, one quoting the opening line of a scene and the other continuing with the rest."[51] Like his mother, George was an autodidact. According to family members, he also learned his mother's strict sense of morality: "In art and in life, Kelly increasingly developed an austere, judgmental voice that seemed to replicate the strin-gent pronouncements of his mother, who 'laid down the code of justice in the family.'"[52] Something of his mother's voice is heard in the many matriarchs who dominate Kelly's plays.

There was a second reason for Kelly's reticence about his private life. Like Maugham, he was a homosexual at a time when homosexuality was universally condemned. It certainly was not accepted in his own Irish Catholic family who, as social arrivistes, were eager to cloak themselves in the mantle of respectability. Nonetheless, like Maugham, Kelly had a kind of gay marriage. For most of his adult life, he lived with William Weagley, whom he probably met when Weagley was a bellhop in a hotel in which the playwright was staying (Kelly seems to have had a penchant for bellhops—he paid for the education of another, who may have been black-mailing him). Arthur Lewis, who wrote a popular history of the Kelly fam-ily, thought Weagley an unlikely partner: "a slightly built, plain-looking unsophisticated, high school educated (the commercial course), lonely small-town bookkeeper."[53] One must remember, however, that Kelly had even less education. There was no need to keep up any pretense around Weagley.

From the time they met, Kelly treated Weagley as both servant and partner: "Even though he might have prepared and served the meal, Bill Weagley's place, regardless of who was present, was that of cohost, his seat at one end of the table."[54] Kelly demanded that Weagley be included in all

invitations. Friends who would not invite them as a couple were cut out of Kelly's life. This was unusual and quite daring in the 1930s, 1940s, and 1950s, but Kelly clearly saw his relationship with Weagley as a marriage and demanded that it be accepted as such. The only exception was his family. In their Philadelphia homes, Weagley was treated as a servant. One friend commented, "the family really treated Weagley horribly."[55] They did not invite him to Kelly's funeral. They were probably too self-conscious and insecure about their social position for such a gesture. Weagley sat weeping quietly in the back row.

Weagley had no career other than being companion to and housekeeper for Kelly. In other words, their relationship was like the conventional marriages Kelly satirized in his plays. However, Kelly and Weagley did not live in the hermetic world of most middle-class Americans. They traveled and socialized with theater and film luminaries, a social world in which class was relatively unimportant and homosexuality was more acceptable. Weagley shared the fruits of Kelly's affluence and received a generous share of Kelly's estate.

Kelly was also a devoted family member, helping his brothers and sisters financially when they needed it and sending gifts to nieces. When at age eighty-seven he knew he was going to die, he left the home he shared with Weagley in Sun City, California, and traveled back to Philadelphia to end his life with his family. Like the rest of his relatives, first and foremost, he was a Kelly.

Kelly may have been open about his personal life with his friends, but he knew openness with the public was impossible. He died in 1974 when gay liberation was in its infancy. As a product of an earlier era, he would not have understood the idea of public openness about one's sexuality. Given his strict moral code and the mores of the time, it is surprising that he and Weagley lived as openly as they did.

"I DON'T THINK A WOMAN'S LIFE BEGINS TILL SHE'S MARRIED, AND THAT FINISHES IT; SO WHY START IT IN THE FIRST PLACE."

The above pronouncement on marriage is uttered by the alcoholic Mrs. Fentriss in *The Deep Mrs. Sykes* (1945), one of the last plays of George Kelly's to be produced on Broadway. Mrs. Fentriss's husband is a doctor who loves his work more than his wife: "Just give him a bucket of blood and a couple of broken bones and he thinks it's Christmas. And then *I'm*

supposed to sit at home and congratulate myself that I'm the wife of the famous Dr. Fentriss."[56] In addition to being jealous of her husband's profession, Mrs. Fentriss, like many of the other wives in the play, wrongly suspects that her husband is interested in another woman. She is sure he is not interested in her and the feeling is mutual. She finds him "about as interesting as living with a turtle. And a *mock* turtle at that,—if there is such a thing" (100).

Mrs. Fentriss's situation is typical of the wives in Kelly's plays. At the heart of Kelly's work is the impossibility of a loving marriage, mainly because women are stifled and embittered by the limited role of homemaker. A number of writers have accused Kelly of misogyny. While there may be some basis for this—his middle-aged wives tend to be overbearing and mean-spirited—one also feels his compassion for the stifling domestic world in which women have to function. The only women who are happy are women who have careers, but marriage to the wrong man can destroy a woman's opportunities. Mrs. Ferris, the landlady in *Philip Goes Forth* (1931), was a celebrated actress until she met her husband:

> …he was an extremely bad actor. I told him so one day after rehearsal, and he told me that he wasn't interested in acting,—that it was just a preliminary to his writing. So I asked him what he was going to write; and he said he was going to write a *play*, for *me*. So, naturally, I was interested. And the first thing I knew I was married to him. And by the time I got rid of him, I didn't have a dollar to my name, and a five year old boy on my hands. I never even bothered divorcing him; he'd cost me enough as it was.[57]

Mrs. Ferris is the type of independent career woman Kelly admires. She may have lost her career in the theater, but she is landlady and surrogate mother to the tenants in the boarding house she owns. Mrs. Ferris is a survivor, but she, and women like her, is not as ruthless as the acerbic housewives who rule Kelly's kitchens.

Like Clyde Fitch, Kelly did not write interesting male characters. They are, for the most part, solid citizens. They may be loyal to their wives, whom they support financially, but they offer their spouses little emotional comfort. The real bonds in Kelly's plays are between women: sisters, friends, mothers, and daughters. He is also more interested in the experienced middle-aged characters than in the male and female ingénues, who tend to be headstrong and unrealistic. The men see the women clearly but cannot change their often destructive behavior. Mrs. Sykes's (*The Deep Mrs. Sykes*) grown son candidly responds to his mother's "intuition," which is really a gift for giving each situation the worst possible construction: "Listen,

Mother—there's one tenet of that gentleman tradition that I've never been in favor of supporting:—and that's the one that allows stupid women to continue to be stupid" (167). Husbands usually remain faithful but realistic about their wives' limitations, which they view with ironic detachment. Mr. Sykes discusses with his son the gift for intuition Mrs. Sykes is so proud of: "But your mother's intuition must not be wrong, Ralph. It's her principal weapon—for both attack and defense. And to admit the possibility of even a flaw in it, might lead to the collapse of her entire universe. Which should be prevented in the interests of comedy, if for nothing else" (154). We see this comic detachment in Mr. Ritter, the husband of the aspiring, though awful, thespian in *The Torch-Bearers*. Since divorce is not considered a respectable option, even unhappy marriages must go on. When Walter Craig decides to leave his wife and the house she worships, he tells her, "I have no wife to leave—for you neither loved nor honored me," to which she responds, "Well, you married me, whether I did or not."[58] In other words, you are stuck with me. Yet Walter does leave, as everyone leaves Harriet Craig to her one prize possession, the home her husband provided for her.

In his strongest plays, the social environment is that of the American middle class, new to money and short of education and culture but eager to have the trappings of their new wealth, whether it is a feeble attempt at amateur theater (*The Torch-Bearers*), a beautiful home (*Craig's Wife*), or respectability. Mrs. Sykes's husband has made a lot of money, which allows her the trappings of culture but no desire to create. She has purchased three harps but has no desire to learn to play—"I've always thought they were so enormously decorative"—and seethes with jealousy toward her neighbor who is an accomplished musician. (*Mrs. Sykes*, 128). The housewives are more shrewd than intelligent and see themselves as the practical heads of household, though when push comes to shove, the men have the real power. They, after all, control the purse strings. For women like Harriet Craig, that is a husband's primary raison d'être: marriage is a business arrangement. Kelly's wives are often bitter, but this is partly because of the limitations of their position. The often invisible men have work, but women only have the home. As Harriet Craig puts it: "What else has a woman like me *but* her home?" (*Craig's*, 366). Like Maugham's wives, the women in Kelly's plays often praise their own practicality and complain that their husbands are sentimental, but the men can combine love with work. In *The Deep Mrs. Sykes*, the title character's husband tells his son, "A man isn't so badly off at all when he's married to a woman who's in love with him. I think perhaps that's what they meant by 'home'" (149). He does not say anything about a man's love for his wife. In fact, he

sees romantic love as something that exists outside of marriage: "There's nothing quite so valuable in a life as a little romance in the offing—one of those things that never dies—because it's never *quite* allowed to live" (ibid.).[59] Romance must be kept an unrequited feeling: it can never exist in a relationship for long. One middle-aged wife notes, "I think twenty-eight years is too long for any two people to put up with each other."[60] The love inevitably sours, so the wives become discontented, jealous, or obsessive. Mr. Espinshade (*The Fatal Weakness*), gets away from his wife to find his romance with another woman, then tells his wife that he had thought at their wedding, "I shouldn't have married this girl; it isn't right. I'm not good enough for her. And *no* man is good enough for her. She should have been allowed to just pass through her life as a kind of symbol of the romance that every man would like to be worthy of" (196). Perhaps Mr. Espinshade's feelings demonstrate the kind of sentimental ideals that the wives decry in their men. Unable to understand that women are not ideals, they keep their distance in marriage, and their wives' flaws intensify as they become lonely and bitter.

In Maugham's plays, the motivation for the women was greatly sexual. Marriage as an institution did not fulfill the sexual needs of either partner. Kelly is not as interested in sex as a motivation as he is in companionship. Husbands and wives are lonely. Penny, the idealistic, young, married daughter in *The Fatal Weakness,* tells her mother, "There was no reason people should stop *growing* just because they were married" (69). Unfortunately, what we see in long-term marriages is just such a lack of growth. *The Fatal Weakness* offers two generations' unhappiness with marriage. Middle-aged Mrs. Espinshade discovers that her marriage had collapsed long before her husband found another woman. The connection between her and her husband had just severed. She tells a friend, "I haven't been seeing very much of him in the evenings these last few years, unless we went out to dinner or had people in. And on Saturdays he's generally stopped here for a few minutes on his way out to Brookside [golf club], if the weather was good; and if it wasn't, he went on over to Riverview to play handball" (17). Her daughter, Penny, has regaled her husband with her advanced views on marriage: "I think it's an interesting experiment and I think it's an experience the majority of women should have. But, like any other experience, I think if it's persisted in it can become a habit. And I think there are too many really important things that a person can do in his life to allow that" (76). As a result of her diatribes on marriage, her husband, skeptical about any possible future for their marriage, has left home: "I certainly don't intend to devote any more time or energy to building up

something that's going to be thrown overboard whenever it suits *her* convenience" (116). When she discovers that her husband is in love with another woman, Mrs. Espinshade tells him, "I have a daughter that appears to be wiser in her generation than I was; even if her wisdom isn't exactly part of her experience yet. And she's repeatedly assured me here that marriage was simply a habit. Which I accepted pretty much as I have accepted her other pronouncements. But I'm afraid you've completely vindicated her, Paul—by breaking the habit *for* me; and letting me see that there really wasn't much left of our marriage but *my* pride" (194). Yet Mrs. Espinshade still idealizes marriage and regularly attends strangers' marriage ceremonies: "There's always been something so terribly touching to me about two people standing up before all the world and promising to be faithful to each other while ever they live" (89–90). At the end, she is dressing to attend her husband's marriage to the woman he loves: "To prove to myself that I can let go gracefully" (206). Her husband's new marriage is likely to be as unsuccessful as his first because, according to a poem quoted twice in the play, "love/Fulfilled is but the end thereof."(197, 214) A romantic marriage is an impossibility. Penny will go back to her husband because she is not prepared to support herself and her child. Mrs. Espinshade will continue to be supported by her ex-husband. The fatal weakness of the title is the harboring of sentimental illusions about marriage, but the position of wife is still the only one available to most women in Kelly's society.

At the end of *The Deep Mrs. Sykes,* we realize that the deep one is not the suspicious, embittered, middle-aged leading character whose intuition leads her to unfounded suspicions about her husband, but rather Ethel, her daughter-in-law, who sees that it is her husband, Ralph, not Mr. Sykes, who has an unrequited crush on another woman. There are no recriminations when she discusses this with her husband, only understanding and compassion: "at least we'll both know what it is to love someone that doesn't love *us*" (185). When Ralph asks her how married people handle these extramarital infatuations, she responds,

> Just what *I've* been doing, I suppose—most of them—try to *save* their marriages. *I* thought when we started that this was going to be the one perfect thing in all the world—just because I was in love with you. But I had to realize that that's not enough; it's got to be something from *both* sides. And it's got to be *worked* at,—and earned, I suppose,—like any other perfection. (186)

The cliché about George Kelly from the few critics who have written about him is that he is a harsh moralist. Maugham wrote about marriage to

discount its validity. Kelly sees it as a necessity, but as something that with-ers when it is taken for granted. Will Ralph and Ethel have the happy mar-riage that eludes the other characters in the play? Ethel understands that love and marriage are not inevitably linked. She understands the power of unrequited infatuation, which can destroy real relationships because it remains in the realm of the imagination. She knows, for instance, that chubby, unmarried Myrtle, the object of abuse and mockery from her companions, stays and accepts her lot because of her unrequited, unac-knowledged love for Mr Sykes: "I just *know*. One doesn't have to be *told* that kind of thing (190). It is the compassionate, good woman who has feminine intuition, not her suspicious, embittered mother-in-law. Women may bear the brunt of Kelly's scorn, but there are also good women in his plays who are the moral compass.

Kelly admires women who manage to succeed outside the home, whose worlds are larger than that of the embittered housewife, women like Daisy Mayme Plunkett, the title character of *Daisy Mayme* (1927). The central conflict in *Daisy Mayme* is between two women who represent negative and positive attitudes toward life. Laura Fenner is the epitome of Kelly's embittered, provincial, middle-aged wives. Her husband, Dan, whom we never see, is stingy and sickly. Laura is constantly concerned about what other people think. Though she did not speak to her sister for four years, she is intent on the proper forms of mourning being observed for the neighbors' sake. Laura's one hope for financial comfort rests on her successful brother, Cliff, who, like the playwright's brother, is a build-ing contractor. Cliff has been generous with his sisters and their chil-dren. Indeed, he has spent his life looking after his family. Laura wants to make sure that she has control of the family house: "I love this house; I've always loved it; and it would just about break my heart to see some strange woman come into it; especially one that wasn't worthy of it. That's the reason I let both those housekeepers that have been here see that I was up to their tricks" (45). Her hope is that Cliff will let her and her husband move in to the house with him so she can run the house. Laura does not really get along with anybody. She has little respect for her sister, Olly, and she seems to despise anyone outside of her family. She is filled with envy and a good deal of malice. Her nemesis is forty-year-old Daisy Mayme Plunkett who, like Cliff, had devoted much of her life to her family but learned that she had been exploited: "I wasn't supposed to marry; I was needed at home to wait on the rest of them. But the minute they took a notion to go—try and stop them. The last of them went out about four years ago; and left me nice and flat, out in the alley—at thirty-five years

of age—without a home or a job" (82–3). Daisy starts her own business, a dry goods store, and when family members come to her for help, "they don't eat anything out of my hand unless they earn it" (83). Daisy has learned that freedom comes when one gets over his or her illusions, "especially your illusions about your own people" (85). Work has offered her independence and some fulfillment: "I *work* for *my* living; I'm not one of those women that has to hang on some *man* all her days" (179). Given her own experience, Daisy sees right through mean-spirited Laura: "I have a sister that's so much like *you* that you could be her twin. One of those people that goes with her *man*; and after that all is fish that comes to your net—even if it's from your own people" (181). Bitter Laura will have to go back to her rented apartment and unsatisfactory marriage, and Cliff will find some happiness with cheerful, friendly Daisy. This will be a marriage of contentment, not passion, between two independent spirits. In his proposal, Cliff says

> I think we're both sensible enough to make a go of it.
> *She looks at him and laughs, a bit ironically; and he laughs too.*
> *Miss Plunkett*: Oh, I don't think we'd need to worry about that, Cliff.
> (191)

There is no romantic moment here, but romance in Kelly's marriages is an illusion that only leads to bitterness. Cliff's niece, Ruth, is in love with a ne'er-do-well who cannot keep a job. His sisters both have unsatisfactory marriages and depend on him for financial assistance. Both sides have to go into marriage carefully with no illusions but with mutual affection and respect. Cliff and Daisy Mayme Plunkett laugh together. They enjoy each other's company. That may be the best formula for a good marriage. There is little joy in the other relationships we see.

The play ends on a peaceful note. Cliff's niece and ward, May, is playing the piano: "*After several bars, Miss Plunkett slowly shifts her eyes and they meet Cliff's. He smiles, and blows a long line of smoke towards her. Then he laughs faintly. But she only smiles and lets her gaze wander away off again. She is listening to the music of 'To Spring'*" (193). Daisy's vision of her marriage is one of quiet, domestic happiness and of fulfilling a new role as a lady: "I've always thought I'd like to be married—to some steady man—that smoked good cigars—and live in an old-fashioned house—with trees around it—and just sit there in the evening and listen to some doll of a daughter play the piano—while I made dresses for her" (191).

George Kelly was very much a realistic playwright. Like Clyde Fitch, he was meticulous about every detail of the staging, setting, and costuming of his plays, which, at their best, seem to be slices of life. The focus is not on tight narrative but on revelation of character and precision of dialogue. In *Daisy Mayme,* he created the kind of overlapping dialogue that is often a feature of family conversations. Here, the setting is not only the background, but what is at stake. Will this house become a happy home? The baby grand piano is not only a prop, it is also part of the conflict. Laura keeps shutting the lid to stop people from playing, but Daisy loves the music.

Daisy Mayme did not enjoy the success of Kelly's earlier plays. Audiences were expecting something more generically consistent like the farce of *The Show-Off* or the domestic melodrama of *Craig's Wife.* Instead, Kelly presents here characters that are simultaneously comic and serious. The marriage that ends the play is happy, but not dramatic.

The major problem in most of Kelly's plays is that the characters lack substance, but this seems less a flaw on the part of the playwright and more a vision of the emptiness of American middle-class society. Mary McCarthy, who has written the most perceptive essay on Kelly, notes of the women at the center of *The Deep Mrs. Sykes* and *The Fatal Weakness:*

> The personalities of these late heroines are fluctuating and discontinuous. With complexity comes a loss of stability. Emotion with these characters is a kind of bird-mimicry of emotion; and, like amateur actors, they cannot hold a pattern. Mrs. Sykes wobbles between jealousy, masochism, and mediumistic vanity, while Mrs. Espinshade, who is supposed to be a romantic nature, cannot remember for five minutes to feel regret for the infidelity of her husband.[61]

McCarthy claims that the subject of a Kelly play is inanity. I would say that it is banality: a society without culture or values has made people solipsistic and callous. No one in American drama does empty small talk or petty malice as well as Kelly. Here are Laura and Olly, the two middle-aged sisters at the beginning of *Daisy Mayme*:

> *Laura*: I didn't know your suit and hat *were* new.
> *Olly(coming back to the table again for her handkerchief)* Don't tell lies, dear.
> *Laura*: How should I know?
> *Olly*: You knew, all right.
> *Laura*: I haven't seen you since the funeral.
> *Olly*: You know it if I get a new handkerchief; and it's like a red rag to you. (8)

This kind of empty bickering, the substance of many scenes in Kelly's plays, takes place between siblings, mothers and daughters, and husbands and wives on their rare meetings. Kelly's plays are a precursor of the plays of Edward Albee and Harold Pinter. Kelly calls *Daisy Mayme* and these later plays "comedies," but they do not inspire much laughter. Nor do they inspire the pathos of plays by O'Neill, Odets, or Williams. They are dark satires written by a man who had a coldly objective view of his characters. Mary McCarthy is right to see the near-absurdist quality of Kelly's plays: "It is difficult to describe a Kelly play to anyone who has not seen several, simply because it is not like anything else while on the surface it resembles every play one has ever been to."[62] His most interesting plays are not tightly plotted. A neighbor may drop by for a long chat. A conversation may die of exhaustion. A narrative thread is lost then picked up fifteen minutes later. There is plenty of conflict, but it is the kind of conflict that erupts between people who know each other all too well. It is the drama of daily life that fascinated Kelly.

McCarthy calls Kelly "the queerest writer on view in America."[63] She means "peculiar," but I wonder if Kelly's odd vision of the American living room, the setting for nearly all of his plays, is not in part a result of his queerness. Like all gay writers, he approached "normal" heterosexual relationships with a complex point of view. Raised in a heterosexual environment, he had always known that he was a stranger to that milieu. In Kelly's case, he lived in as close to a marriage as one could have in his time, but he saw the toll marriage took on men and women. It is too simple to say, as some critics have, that he was a misogynist and harsh moralist. His view of women was far more complex than that, and his jaundiced view of marriage made it impossible for him to be an advocate of conventional morality.

Clyde Fitch was attacked by critics for being too superficial in his work and suspiciously flamboyant in his demeanor. George Kelly was attacked (unfairly, I think) for his negative representation of women and the darkness of his later plays. He was careful to avoid being the public figure Fitch was. Their lives, work, and critical reception demonstrate the problems of being a homosexual playwright in the United States in the first half of the twentieth century.

6. 1950s Marriages Sweet and Sour: Tennessee Williams and William Inge ❧

Two people living together, two, two—different worlds!—attempting—existence—together!

Tennessee Williams, *Period of Adjustment*

Three playwrights dominated the American theater in the 1950s. Arthur Miller's *The Crucible* (1953) and *A View from the Bridge* (one-act version, 1956) have attained classic status with frequent revivals. Tennessee Williams's output was greater but more variable: *The Rose Tattoo* (1951), *Cat on a Hot Tin Roof* (1956), and *Sweet Bird of Youth* (1959) achieved solid runs of over three hundred performances and received a number of awards. All three were turned into successful Hollywood films. *Camino Real* (1953) and *Orpheus Descending* (1957) were not as successful, though the latter was the basis for the film *The Fugitive Kind* (1959) and was more appreciated through a number of successful revivals and a second, more faithful television version in 1990. The plays of Miller and Williams that were written in this period have stood the test of time. The same cannot be said for William Inge, though he had four solid Broadway hits during the decade, all of which were turned into Hollywood films.

Inge and Williams became friends in 1945. Both were homosexual, deeply neurotic, and plagued by substance abuse. Unlike Williams, Inge could not accept his homosexuality, which was a matter of deep anguish for him. He was also quite shy. In his *Memoirs*, Williams observes, "Bill was a mystery as a person, and he remained one. Ever since he came to New York, probably even before, he found it difficult to open himself up to people, especially at social gatherings." He goes on to note, "His shyness was never awkward: he had true dignity and impeccable taste, rarely associated

with Middle America."[1] His comments at the time of Inge's success were not always as kind. He wrote producer Cheryl Crawford in 1954 that Inge "seems to be living in a state of false complacense [*sic*], peaceful on the surface, but with an apparent suspension of his critical faculties at least regarding his own work, an 'afflatus' that only makes him pompously self-satisfied and showing bad scripts around like fresh-plucked flowers."[2] Inge was fond enough of Williams to dedicate *The Dark at the Top of the Stairs* to him. On the other hand, Williams was not eager to write the foreword to the published edition of the play, though he finally relented: "It is one thing to type three words—'For Tennessee Williams'—on a dedication. It's quite another thing to write several pages on introduction."[3] Whatever rivalries the two had in the 1950s, they both suffered critical brickbats in the following decades. Williams kept writing, but Inge was more easily defeated by the assaults. Williams wrote,

> he could not take a spell of failures after his run of smash hits, so eventually he was cared for by two male nurses.
> I think of a line from *Kingdom of Earth*
> "Life is a rock and a man has to be a rock, too, or one of them's gonna break and the one that breaks is never gonna be life"—or something like that.[4]

Williams saw himself as not only the better writer but also the stronger man and more dedicated artist. Inge felt that Williams was equally neurotic. He told his dear friend, actress Barbara Baxley, who was at the time in rehearsals for *Period of Adjustment:* "Tenn is so insecure about his work and about actors."[5] Like Inge, Williams became more addicted to alcohol and drugs and less coherent after his success waned. Nonetheless, the two writers remained friends. Barbara Baxley called Williams for help when Inge was in his final suicidal state in 1973. Williams lived for another decade, in which he weathered one flop after another.

In their successful work, both Williams and Inge wrote visions of domestic life that both affirmed and questioned heterosexual relations and marriage. In this chapter, I look at depictions of marriage in the plays these men wrote in the 1950s and early 1960s.

"BUT—I PICKED YOUR FATHER"

For many of Tennessee Williams's women, marriage is an economic necessity. The action of Williams's *The Glass Menagerie* hinges on Amanda Wingfield's hapless efforts to provide a husband for Laura, her crippled,

neurotic daughter. Without a husband to support her, Laura will become, in her mother's words, one of those "little birdlike women without any nest—eating the crust of humility all their life!"[6] For all her illusions about the past, Amanda is primarily concerned with economic survival. She tells her breadwinner son, Tom, who is eager to escape their claustrophobic home, "I mean that as soon as Laura has got somebody to take care of her, married, a home of her own, independent—why, then you'll be free to go wherever you please, on land, on sea, whichever way the wind blows you!" (175). Amanda's own economic situation is the result of an unhappy marriage and a disappearing husband. If her stories of past courtship have any semblance of truth, she could have made a "good marriage," in an economic sense, but instead had chosen to marry the man for whom she felt the greatest desire. Marriage of any kind is an unlikely outcome for her dysfunctional daughter.

Blanche DuBois, the heroine of *A Streetcar Named Desire,* knows that marriage to Mitch would mean a modicum of economic security for this now unemployable woman. It could also mean companionship and perhaps some sexual satisfaction. Unfortunately, marriage would also mean a relationship with someone with whom she has nothing in common. Blanche's past catches up with her, and her hopes of economic security through marriage with Mitch are dashed. Even Maggie in *Cat on a Hot Tin Roof,* filled with desire for her feckless alcoholic husband, knows they need his family's fortune. Marriage may mean economic security for women, but the bond that holds a couple together is sexual. Maggie cannot take her eyes off her beautiful husband and is driven almost mad with sexual frustration. Sex is the core of the relationship between Blanche DuBois's sister, Stella, and her husband, Stanley Kowalski, the ultimate alpha male. Yet Williams was always skeptical of whether sexual desire can be contained within marriage and whether a lifelong intimate connection between two people is possible.

A list of marriages in Williams's plays is a catalog of male impotence and, often, violence (e.g., *Baby Doll, Orpheus Descending, Sweet Bird of Youth*) and female sexual frustration. Indeed, like the plays of Terence Rattigan, what was most daring in Williams's work in its time is its depiction of female sexual hunger and pleasure. The life force in Williams's work is the drive toward sexual fulfillment and fertility, and marriage often is a barrier to that.

In many ways, Williams's ideas on sex and marriage are crystallized in his early play *Spring Storm* (1937, published 1999). Young, beautiful Heavenly Critchfield is at the age at which she should be thinking about a

good marriage. Her parents have set their hearts on her marrying the rich, neurotic Arthur Shannon, who has obsessively adored her since childhood, but Heavenly, filled with romantic illusions from trashy novels, is having an affair with the macho, rebellious Dick Miles. They recollect a play they acted in high school:

> *Dick*: Yeah, there was one swell line in that play.
> *Heavenly*: What's that?
> *Dick*: Marriage is last year's love affair.
> *Heavenly*: Oh! You don't want marriage?
> *Dick*: Not the kind that ties ropes around people.[7]

Heavenly is enough a product of her social education to know that marriage is an economic bargain and that the man is supposed to be the steady breadwinner: "I've given up plenty of chances for you. In hope you'd turn over a new leaf and amount to something" (19). Dick (is this choice of names as obvious as it seems?), one of the hypermasculine male characters that fill Williams's and Inge's plays, cannot fit into "respectable" society and does not want a mundane white-collar job. He wants to go work on the levee project: "I want to get my hands on something hard and tough that fights back" (101). When it is clear that she has lost Dick, Heavenly listens to Arthur's protestations of love. Standing in a garden next to a small statue of Eros as a storm is looming:

> *Arthur*: I guess that's why the Little God's so excited.—He likes
> spring storms.
> *Heavenly*: Does he?
> *Arthur*: Yes. They've so much in common you know. They're both so
> damn cruel—reckless and destructive!
> *Heavenly*: Like me. Is that what you mean?
> *Arthur*: Yes. I believe the Greeks were laughing when they made him
> the Little God. Eros is really the biggest god of them all. He's the
> one that's got thunderbolts! (95)[8]

When Arthur finally kisses Heavenly, she realizes that it does not matter who gives her pleasure: "You've done me a favor tonight. You've taught me something very important about the nature of love. It's our bodies we love with mostly. When you kissed me just now, I could have believed it was him, Dick—it gave me the same sensation, exactly the same" (146). With neither Dick nor Arthur willing to marry her, Heavenly decides to

join the ranks of Front Porch Girls—spinsters who while away their time watching and waiting. Perhaps, with her reputation as a loose woman, she could remain sexually active like Alma Winemiller in *Summer and Smoke* or Blanche DuBois in *A Streetcar Named Desire*. When she becomes disillusioned with the idea of love, Heavenly opts to join the other spinsters who people this play.

Women who defy conventional gender roles tend to have tragic ends in Williams's plays. In *Orpheus Descending*, Italian American Lady Torrance is in a barren, loveless marriage with invalid Jabe Torrance. They live over their store, which represents the way in which the economics of marriage destroy the women in the play. Lady's past is one of sexual abandon. Her father had run a wine garden where young couples went to have sex. A Ku Klux Klan-type group, led by Jabe Torrance, burned down the wine garden and killed Lady's father when they discovered he was selling liquor to Blacks. From the outset, Jabe and his comrades are seen as the enemy of sex and procreation. In her father's wine garden, eighteen-year-old Lady had met and fell passionately in love with David Cutrere: "Like you struck two stones together and made fire!— yes—fire."[9] Unfortunately, David had to give up their relationship and marry for money. As a result, at eighteen years of age, Lady had been "sold cheap" into a cold marriage with Jabe. The play takes place years later. Lady dreams of recreating the eroticized world of the wine garden inside the general store. Enter a handsome drifter, Val Xavier, who is a magnet for all the women. Lady offers Val a job and a bed in the back of the store. Eventually and inevitably, Lady goes to Val's bed. There is no conventional love scene: Lady takes what she needs to bring herself back to life and to create new life. Once she realizes she is pregnant, she can let Val go. Her husband is not only dying; he is the bringer of death. He shoots Lady and the child in her womb and incites his old comrades to take a blowtorch to incinerate Val.

Orpheus Descending is Williams in his Southern Gothic mode, but it does present a typical Williams picture of marriage. Fertile, vibrant women are trapped in marriages with weak men. The setting may be a run-down farm or a great plantation. The end may be comic, as it is in *The Rose Tattoo* and *Baby Doll;* conditional, as in *Cat on a Hot Tin Roof;* or violent, as in *Orpheus Descending.* Love and marriage, sex and marriage, love and sex, procreation and marriage—these are not inevitable combinations in Williams's work. In this chapter, I am particularly interested in the way marriage is depicted in Williams's comedies of the period, *The Rose Tattoo* (1950) and *Period of Adjustment* (1960).

"WHAT IS A HUSBAND GOOD FOR!"

The published version of *The Rose Tattoo* (1950)[10] bears the dedication, "To Frank In Return For Sicily," and a percentage of the royalties of the play went to the dedicatee, Frank Merlo, who was the closest thing to a partner Williams had in his life. Williams and Merlo had a passionate night in the dunes in Provincetown in 1947, reunited in New York in 1948, and subsequently lived together on and off for fourteen years. Merlo was not college educated but had managed to make himself part of the postwar, gay literary-cultural set. Before his relationship with Williams, he had been the lover of poet-lyricist John LaTouche. In the early years of their relationship, Merlo was, like Somerset Maugham's and George Kelly's partners, a salaried employee as the playwright's lover, companion, and assistant. There were times when Merlo resented his dependency on Williams, but the principal cause of conflict was between Merlo's desire for order and stability and Williams's restlessness. The playwright was, like Amanda Wingfield's lost husband, "in love with long distance." Nonetheless, Frank Merlo was essential to Williams's precarious stability. Even after their relationship soured in the early 1960s and Williams found another boyfriend, Frank was still his psychological anchor: "As long as Frank was well, I was happy. He had a gift for creating a life and, when he ceased to be alive, I couldn't create a life for myself. So I went into a seven-year depression."[11] Friend and producer Cheryl Crawford observes, "The breakup with Frankie, which Tenn really brought about, was a crazy thing. Frankie was the only one who really understood him, really knew how to deal with him and help him. When Frankie was dying, there was a new form of grief, and maybe a new form of guilt, for Tennessee to deal with, and I think it just broke him."[12] Unfortunately, Frank's death of lung cancer in 1963 came at a low ebb for Williams as a playwright. He lived two more decades but lost both artistic and self control.

The Rose Tattoo began as a tribute to his relationship with Sicilian American Merlo. Williams wrote Elia Kazan, "During the past two years I have been, for the first time in my life, happy and at home with someone and I think of this play as a monument to that happiness, a house built of images and words for that happiness to live in. But in that happiness there is the long, inescapable heritage of the painful and the perplexed like the dark corners of a big room. But the play is not at all personal [meaning autobiographical], though it is dedicated to an intensely personal thing."[13] In his *Memoirs*, Williams recalls, "*The Rose Tattoo* was my love-play to the world. It was permeated with the happy young love for Frankie" (162).

In one notebook entry, Williams describes Frank as "a member of a darker race" (*Notebooks*, 505). Throughout the 1950s, Williams depicted Italians and Italian Americans as members of a sexualized "other" race, more primal than repressed Americans. *The Rose Tattoo, Baby Doll,* and *Orpheus Descending* feature sexually dominant Italian men and fertile Italian women who move from being life denying to celebrating their sexuality. These Italians are often objects of violent prejudice but are more life affirming and openly sexual than the members of the less dark race. In his *Memoirs,* Williams observes, "In Rome you rarely see a young man on the street who does not have a slight erection. Often they walk along the Veneto with hand in pocket, caressing their genitals quite unconsciously...They are raised without any of our puritanical reserves about sex" (141). Just as Williams's New Orleans offers a sexually charged environment for *A Streetcar Named Desire,* so does this mythical Sicilian village on the Gulf coast become a site of fecundity.

The Rose Tattoo moves away from the poetic realism of Williams's previous plays and into a highly stylized environment in which metaphor can dominate. The setting is a Sicilian community on the Gulf Coast, but except for a few visits from American women, outsiders presented as grotesques, the scene could almost be Sicily itself, or at least Williams's fantasy version of Sicily. Ardent Catholicism is merged with primitive superstition. Villagers believe in the herbal cures of Assunta and the witchcraft of old Strega. Above all, this is a highly sexualized environment. The old goat literally keeps breaking loose and women's primal urges for sexual satisfaction and procreation cannot be restricted by conventional morality or the strictures of the Catholic Church. Sex wins.

The central character is Serafina Delle Rose, the adoring, faithful wife of Rosario, a truck driver and gangster who transports drugs under the loads of bananas in his truck. Though Rosario makes a comfortable living, Serafina has her own business sewing clothes. Her living room is also her workshop, dominated by the sewing dummies that become like a silent chorus to her grief, rage, and finally, joy. Serafina is, like most of the characters in this play, exaggerated, a comic harridan and container of sexuality and fertility. In a letter to his agent, Audrey Wood, Williams wrote, ""I now see the woman, the little house, the little proprieties and black dummies and parrot cage and all that as a sort of delicate, almost tissue paper, fence built lovingly around the instinct to protect and preserve and cherish which is the meaning of WOMAN" (*Letters*, 294). However, Serafina is a larger-than-life, often farcical representation of femininity. Note Williams's first description of her: "Serafina looks like a plump little

Italian opera singer in the role of Madame Butterfly. Her black hair is done in a high pompadour that glitters like wet coal. A rose is held in place by glittering jet hairpins. Her voluptuous figure is sheathed in pale rose silk,"[14] and her fleshiness is somewhat held in by the girdle with which she battles through much of the play.

Serafina is proud of her ability to make her husband the center of her life and to satisfy him sexually. She looks down on other wives: "They make the life without glory. Instead of the heart they got the deep freeze in the house. The men, they don't feel the glory, not in the house with them women; they go to the bars, fight in them, get drunk, get fat, put horns on the women because the women don't give them the love which is glory" (342). Serafina feels superior to these cold wives: "I give him the glory. To me the big bed was beautiful like a religion" (342). Despite the evidence, it is inconceivable to her that, given her wifely prowess, her Rosario would put horns on her. In the first scene, she is visited by Estelle Hohenstein, who wants a rose-colored shirt made for her lover, who happens to be Rosario. Estelle gives Serafina a piece of wisdom that is a statement of one of the major themes of the play: "A man that's wild is hard for a woman to hold, huh? But if he was tame, would the woman want to hold him?" (283). Williams's plays are filled with wild men who cannot tame their sexual drive into socially respectable patterns. As Estelle tells Serafina this, a goat gets loose, underscoring the untamable force of nature and sex. When Rosario is shot and his body burned in the fire when his truck subsequently crashes, Serafina miscarries and goes into an exaggerated period of mourning. She will not get dressed and for three years and spends most of her time wandering around the house in a dirty slip. In the meantime, her daughter Rosa has developed into a beautiful fifteen-year-old girl who is hungry for sex. Rosa has fallen in love with a handsome young sailor, but Serafina becomes so obsessed with maintaining her daughter's purity that she takes away her clothes and locks her naked in her room. However, just as the goat will not stay tethered, Rosa cannot stay locked up. Serafina makes the sailor swear by the Madonna that he will respect Rosa's innocence.

Enter young Alvaro Mangiacavallo, "twenty-five years old, dark and very good looking. He is one of those Mediterranean types that resemble glossy young bulls. He is short in stature, has a massively sculptural torso and blush-black curls. His face and manner are clownish; he has a charming awkwardness" (348).[15] When she meets him, Serafina cries, "Madonna Santa!—My *husband's body,* with the head of a clown! (354). Since Rosario's death, Serafina has been praying to the Madonna for "a

sign" of how she should continue her life. Alvaro's entrance seems to be that sign. Serafina sees Alvaro as a kind of reincarnation of her husband. She invites him for dinner but is divided between her loneliness and her sense of propriety. On their first date, Alvaro describes what he wants in a wife:

> *Alvaro*: I am hoping to meet some sensible older lady. Maybe a lady a bit older than me.—I don't care if she's a little too plump or not such a stylish dresser! The important thing in a lady is understanding. Good sense. And I want her to have a well-furnished house and a profitable little business of some kind.
> *Serafina*: And such a lady, with a well-furnished house and business, what does she want with a man with three dependents with the parchesi and the beer habit, playing the numbers?
> *Alvaro*: Love and affection!—in a world that is lonely—and cold!
> (365–6)

Once Serafina accepts the truth about her unfaithful husband, and after a series of comic misadventures, she and Alvaro have sex. When Serafina had last conceived with Rosario she felt the rose tattoo of her husband reproduced on her own breast. After sex with Alvaro, who has had a rose tattoo engraved on his chest, she feels the same miracle: "Just now I felt on my breast the burning again of the rose. I know what it means. It means that I have conceived! Two lives again in the body! Two, two lives again, two!" (414). At the end, she runs up the highway embankment to find Alvaro. Her conception creates a bond between her and the child and between her and Alvaro. Sex equals fertility and marriage. Philip C. Kolin describes the "psychic narration of replication in *The Rose Tattoo* that contributes to the cycle of interrupted/incomplete sexuality. Imitation, copying, is the dynamic of this Williams play."[16] Alvaro is a comic imitation of Rosario. Rosario's rose tattoo is imitated by his smitten mistress, Estelle, and Alvaro who, to win over Serafina, has had the rose tattoo engraved on his chest. It also appears miraculously on Rosa's breast at conception. The shirt Serafina had sewn for Estelle to give Rosario is given to Alvaro. The child Serafina and Alvaro have conceived will replace the child Serafina lost, and Alvaro will replace Rosario as Serafina's husband.

Meanwhile, her daughter Rosa has had her own mock wedding with her sailor, taking his gold earring and putting it on her finger. Rosa offers him not only her body but also eternal love: "I want to give you my heart to

keep forever! And ever! And ever!" (403). Jack will return to his ship, but Rosa will remain devoted to him. *The Rose Tattoo* is a comedy, so it ends optimistically with marriage and progeny, even though the marriages the play depicts cannot contain the characters' desire.

"WHAT AN AWFUL, FRIGHTENING THING IT IS!"

To some extent, *Period of Adjustment* (1960) is a reworking of themes from *The Rose Tattoo,* centering on Williams's favorite conundrum: whether or not social misfits can negotiate some sort of working relationship. As comedy must, *Period of Adjustment* moves toward some sort of connection for its two married couples.

The autobiographical dimension of *The Glass Menagerie* has been discussed many times by the playwright and his biographers. Both its matriarch and Isabel Haverstick, the heroine of *Period of Adjustment,* bear many similarities to Williams's mother, Edwina. Williams's biographer, Lyle Leverich, writes of Edwina, "Militantly forthright and possessed of puritanical opinions, Edwina was frequently disliked for the very thing for which her son was esteemed: a mastery of words. She not merely talked— and talked—she had the ability to overcome friend and adversary alike, usually leaving them limp and defenseless under the sheer weight of words."[17] On Edwina's sexual relations with her husband, Leverich notes, "She continued to resist his fumbling advances, leaving him frustrated and angry. As young as he was at the time, Tennessee remembered hearing his mother's crying protests in her bedroom."[18] Isabel, too, had been raised by staunch Christian parents and had become an exaggerated version of certain stereotypical qualities of southern women of an earlier generation: prim, garrulous, and a bit delicate, though tougher than she seems. She has lost her nursing job because she fainted in the operating room. She needs a husband to support her, but like Edwina Williams, Isabel has a horror of sexual relations and is, to put it mildly, voluble.[19] She marries George, whom she met when she was a nurse in training at a veteran's hospital and he was a patient suffering from what we now call posttraumatic stress disorder, which manifested itself in uncontrollable shaking. Like many of Williams's women, Isabel's feelings for George had been sexual, but she had also been attracted to his weakness: "So *handsome*? And so *afflicted*? So afflicted and *handsome*?"[20] He had been attracted to her because he mistook her back rubs (which she was required to give) as signs of sexual interest: "I DIDN'T TOUCH YOUR BODY EXCEPT AS A NURSE

HIRED TO DO IT" (51). As they leave St. Louis in the used hearse he has purchased (can there be a Williams play without some image of death?), George tells Isabel that his self-consciousness about his shaking has led to him quitting his job. So the marriage begins with no money and only George's impractical dream of raising longhorn cattle for television westerns. Isabel is terrified of poverty and horrified at her husband's crude, drunken sexual overtures on their wedding night at the Old Man River Motel:

> [He] Threw off his clothes and sat down in front of the heater as if I were not even present... Continuing drinking... Then began the courtship and, oh, what a courtship it was, such tenderness, romance! I finally screamed. I locked myself in the bathroom and didn't come out until he had gotten to bed and then I slept in a chair. (33)

So Isabel is left with the two central problems faced by many of Williams's heroines: looming poverty and a sexual standoff.

The action of *Period of Adjustment* takes places at the suburban Memphis home of George's army buddy, Ralph. A large Christmas tree dominates the small living room and Ralph's gifts for his wife (a fur coat that has taken all of his savings) and for their son are in place under it, but Ralph's wife has left with their son: "I quit my job so my wife quit me" (21). Ralph had married Dorothea despite her homeliness because her father was wealthy and seemed to be at death's door. But the rich and mean have a way of hanging on, and Ralph feels trapped working for his father-in-law and married to the boss's homely daughter. To compound his misery, he is sure his wife is turning their son into a sissy (echoes of Williams's father). Ralph and Dorothea's home is one of a row of identical Spanish-style bungalows that have been built over a cavern. The homes are slowly sinking as the living death of conformity and spiritual emptiness overtakes the neighborhood. Can a marriage, founded literally on shaky ground, thrive?

Williams works his way toward an unconvincing denouement in which the two couples find a way to begin again on building their marriages. Ralph comes to appreciate his wife, and she respects his decision to free them of her parents' domination. George learns the need for tenderness with his wife, and Isabel realizes, as many of Williams's women have before her, that she will need to take care of her husband. The men are victims of the wars they have had to fight (i.e., World War II and Korea), as Ralph points out to his in-laws: "We both of us died in two wars, repeatedly died in two wars and were buried in suburbs named High Point" (85). These former war heroes feel emasculated in American society of the

1950s. They dream of heading west because they believe they can regain a lost masculinity: "There *is* dignity in that sky! There is dignity in the agrarian, the pastoral—way of—existence! A dignity too long lost out of the—American—dream" (197). Part of that manhood is the benevolent domination of women that is part of the western movies playing on Ralph's television set. Isabel realizes that George's bullishness is a result of a sexual fear all men share: "Inside or outside, they've all got a nervous tremor of some kind, sweetheart… The whole world's a big hospital, a big neurological ward and I am a student nurse in it" (93). In this dysfunctional world, nothing is more terrifying than marriage:

> *Isabel*: What an awful, frightening thing it is!
> *George*: What?
> *Isabel*: Two people living together, two, two—different worlds!—attempting—existence—together! (90)

Part of what makes marriage difficult is sexual incompatibility. George and Isabel's wedding night is a disaster because he is clumsy and she is frightened. He finds her response a sign of frigidity and an assault on his masculinity. He tells Ralph, "I put them [women] in five categories. Those that worship it, those that love it, those that just like it, those that don't like it, those that just tolerate it, those that *don't* tolerate it, those that can't stand it, and, finally, those that not only can't stand it but want to cut it off you" (209). He sees Isabel as the castrating kind. Ralph has a different problem with his wife: "Pore ole Dotty. She's got so she always wants it and when I can't give it to her I feel guilty, guilty" (202). The resolution happens, inevitably, in bed.

In Williams's world, one sees the norm from which his characters diverge, though that norm is seldom presented in positive terms. Ralph's successful in-laws in *Period of Adjustment,* the McGillicuddys, are rooted in the world of money, possessions, and acceptance of too little: "I gave you a fatherly talk. I told you that monotony was a part of life" (78). Mr. McGillicuddy also has to fight for dominance over his own bossy wife. Ralph, a war hero, cannot stand being subordinate to this overbearing man: "It wasn't till I found out she despised you as much as I did that I was able to make real love to Dotty" (227). Neither of them wants the routine life her parents have planned for them.

At the end of *Period of Adjustment,* both couples face an uncertain economic future and the question of whether husbands and wives can really support one another through their anxieties. At the same time, Williams

wants us to see the humor in these characters—even the humor in living over a cavern. Isabel says, "I don't think a married couple can go through life without laughs any more than they can without tears" (29). The reconciliation Williams offers is, typically, sexual. George and Isabel's marriage is about to be consummated, and Ralph is back in bed with the wife he claims is unattractive. Williams believes in his Big Mama's dictum that both the problems in a marriage and their solutions occur in bed. Yet, this ending is unconvincing because we see no evidence that there is any foundation for the two marriages Williams depicts, either in emotional affinity or even in that sine qua non, sexual desire. The bond seems to be fear of loneliness, but the characters have already expressed the fact that they still feel lonely even in their marriage. The basic problem is that Williams is trying to present something he really does not believe in—lasting, happy, heterosexual marriage—yet he is writing for Broadway success in a genre alien to him: domestic comedy. (Was he aware that McGillicuddy is Lucy's maiden name in the legendary sitcom *I Love Lucy?*)

Williams believed that there are moments in sexual union that can approach the mystical, but the combination of sexual hunger and Puritan guilt many of his characters experience makes even that difficult. Both women in *Period of Adjustment* begin their marriages terrified of sex with their husbands. Ralph's wife is quickly cured of her "psychological frigidity," and Isabel at the final curtain will have sex with her husband on her terms.

Williams, writing in the conservative 1940s and 1950s, tried in *Period of Adjustment* to celebrate marriage, but at best it is a kind of compromise. *Period of Adjustment* was not a success as a play or a film (very poorly cast), but a 2006 critically acclaimed London revival shows that the play was underrated in 1960.[21]

A year after the Broadway production of *Period of Adjustment*, Williams's last successful play, *The Night of the Iguana,* was produced. In many ways, though heterosexualized, this is Williams's most revealing self-portrait. Shannon, the emotionally unstable, hypochondriac, lapsed cleric who cannot control his appetite for underage women is confronted with the spirit, in the form of a forty-year-old artist and mystic, and the flesh, in the form of a middle-aged widow with an appetite for hunky young Mexicans. The play argues not for marriage but for the need for some kind of relationship. Hannah, the mystic, tells Shannon, "We all wind up with something or with someone, and if it's someone instead of something, we're lucky, perhaps…unusually lucky.[22] Hannah knows

that, while the relationship may not be permanent, it does go a long way to heal loneliness and fear. The widow, Maxine, who wants Shannon to stay with her, claims to "know the difference between loving someone and just sleeping with someone" (329). She also knows that she and Shannon have "reached a point where we've got to settle for something that works for us in our lives—even if it isn't on the highest kind of level" (329). At the end, the relationship Shannon establishes is far from conventional. He and Maxine will live together and run the inn, which will be a sexual haven: "I've got five more years, maybe ten, to make this place attractive to the male clientele, the middle-aged ones at least. And you can take care of the women that are with them. That's what you can do, you know that, Shannon" (374). Maxine's and Shannon's emotional and physical needs will be met. This is far from the traditional heterosexual marriage Williams tries to valorize in *Period of Adjustment,* but it is perhaps a more honest picture of his own sense of the possible balance between desire and loneliness.

WILLIAM INGE: STUDS AND HOUSEWIVES

Tennessee Williams invited William Inge, then a drama critic for a St. Louis newspaper, to the Chicago pre-Broadway tryout of *The Glass Menagerie.* Seeing Williams's brilliant play convinced Inge that he too could be a playwright: "Williams had fashioned this marvelous and wonderful play out of the raw material of his own life, out of his own family, out of his own emotions; and Inge knew he could do the same."[23] Williams encouraged Inge and helped him find a producer for his first play, Margo Jones, director of Theatre 47 in Dallas, Texas, and an agent, Audrey Wood. That play, *Farther off from Heaven,* was not a success, but Inge who, like Williams, constantly revised his work, produced a version of the play eight years later as *The Dark at the Top of the Stairs,* which was his longest-running Broadway success and the fourth of his plays to be adapted for the screen. Williams and Inge remained friends, but Williams bristled at Inge's greater success on Broadway in the 1950s. In the next decade, both men suffered from homophobic critical assaults and the diminution of their own creative powers, partly as a result of substance abuse.

Not long ago, one of my colleagues considered directing a student production of William Inge's *Bus Stop,* which he admires. Many of us shuddered at the thought, and the production never materialized. That response is typical of the current attitude toward William Inge, considered

by many to be a dated, limited playwright whose work simply does not rank with that of Tennessee Williams, Arthur Miller, and Eugene O'Neill. History has not been kind to Inge. We now look at two of Williams's less commercially successful plays from the 1950s, *The Rose Tattoo* and *Orpheus Descending,* and see fine plays that were not properly appreciated in their own time. We think less of Inge's consistent string of commercial successes, *Come Back, Little Sheba*, *Picnic, Bus Stop,* and *The Dark at the Top of the Stairs,* perhaps attacking him for his success. If he was that popular, we seem to ask, how could he be good?

During the 1950s, William Inge wrote four critically lauded, prizewinning, commercially successful plays, all of which were turned into successful Hollywood movies that are among the best-known films of the decade. Indeed, the cover of the published collection of Inge's plays shows, next to the title of each play, a picture of the star of the film version.[24] The film version of *Bus Stop* is one of Marilyn Monroe's more famous vehicles, and *Picnic* was a success for Columbia's sex kitten, Kim Novak. *Splendor in the Grass*, with a screenplay by Inge, was one of the most successful films of the early 1960s. As with Williams, Hollywood made Inge a wealthy man. He, like Williams, vividly portrayed the power of sexual attraction and repression that were part of the spirit of the time and that created successful movies. Like Williams, Inge's best years as a playwright ended with the 1950s.

The man was a wreck. His chronic alcoholism caused the producers of *Come Back, Little Sheba* to ship him off to a sanitarium and to later make him a virtual prisoner in his hotel room with a minder to keep him off the booze. Like Doc, the play's protagonist, he could not keep away from the bottle for long. Constantly in psychoanalysis, he was prey to all sorts of phobias and, not surprising for the time, was never at ease with his homosexuality. In contrast, Tennessee Williams never tried to keep his sexual orientation a secret. It is in his plays and very much a part of his life. But Inge lived in fear that his secret would be exposed and that his frail success would somehow be destroyed. Perhaps this is why secret sexual transgressions are so central to the action of his plays. Eventually, Inge tried to write gay characters, first in two one-acts he meant for therapy, not production, and later in the disastrous *Where's Daddy?*[25]

Inge was a regional playwright who gave theater and film audiences a Midwest built on memory and myth, a corollary to Williams's South. His work is set in or near Kansas, the center of the United States, equidistant from Broadway and Hollywood. When Inge was born in 1913, the western part of the state still had vestiges of the Wild West. Dodge City,

after all, was the setting for many westerns, a place of cattle, cowboys, brothels, and gunfights. The eastern side of the state was more civilized. Inge's Kansas is a world of back porches and greasy spoons. Above all, it is a world of discontent and claustrophobia. Inge's work does not have the bite of Sinclair Lewis's novels of small-town claustrophobia, but it is deeply sad, the Midwest of New York audiences' imaginations. Like the St. Louis of Williams's *The Glass Menagerie,* Inge's country may also stem from his memory, but it is decidedly prosaic. Though Hollywood tended to render them in wide screen and Technicolor, his plays are painted in shades of grey, like Kansas in *The Wizard of Oz.* However, Inge's characters cannot echo Kansan Dorothy in *The Wizard of Oz,* "There's no place like home." In this world, marriage is the rule, but that does not mean that marriages are happy.

I am interested in the ways in which Inge both critiques middle-American ideals and supports the sex/gender system of his time. As with Tennessee Williams, there are two William Inges: the William Inge who wrote the hit Broadway plays and the "William Inge" who was the source for the screenplays of the hit films adapted by other writers from his plays. They merge in Inge's last successful film, *Splendor in the Grass.* Looking at both Inge's plays and the films made from them can tell us a lot about mores and attitudes in the 1950s.

"I'VE ALWAYS CONSIDERED MARRIAGE BETWEEN A MAN AND A WOMAN A DIVINELY BEAUTIFUL INSTITUTION."

This is the utterance not of some pundit from the Christian right, but rather that of Pinky Pinkerton, the lonely, pudgy, gay, middle-aged professor in William Inge's 1965 flop, *Where's Daddy?* Throughout the play, Pinky is the spokesman for traditional family values, trying to ensure that his former ephebe is a responsible husband and father. Pinky goes on to say, "I've been so idealistic about marriage, I've never felt I dared to face the reality of it."[26] According to his biographer, Ralph F. Voss, Inge was never able to enjoy his success or deal with his later failures: "That is because he could not accept his sexuality; and stemming from that, he was in most ways profoundly alone, with no loved companion of either sex to share his life."[27] Inge's primary subject was loneliness, and his own life is a sad example of a man desperately and unsuccessfully trying to accept or conquer his homosexuality, even after years of psychoanalysis.[28] His depiction

of marriage in his most successful plays is more complex and nuanced than Pinky's advocacy. Like Williams, Inge was fascinated by the relationship between sexuality and sexual desire and the institution of marriage. Marriage in his work begins with sexual desire and ends with entrapment or escape. Like Williams, Inge presented again and again women's desire for virile, attractive men, but those men find it difficult to settle down. *Picnic* (1953) and *Bus Stop* (1955) open with middle-aged women who have been deserted by their husbands. In *Picnic,* Flo, a widowed mother of two teenage girls, talks to her daughter about her late husband:

> *Flo*: Your father wasn't home much. The night Millie was born he was with a bunch of his wild friends at the roadhouse.
> *Madge*: I loved Dad.
> *Flo*: Oh, everyone loved your father.
> *Madge*: Did you?
> *Flo* (*After a long pause of summing up*): Some women are humiliated to love a man.
> *Madge*: Why?
> *Flo*: Because—a woman is weak to begin with, I suppose, and sometimes—her love for him makes her feel—almost helpless. And maybe she fights him 'cause her love makes her seem so dependent.[29]

This is the typical Inge couple: a wild, strong man incapable of totally settling down and a woman who in some way resents her own need for the man. At the opening of *Bus Stop* (1955), Grace, the owner of the small-town café is talking with her teenage waitress, Elma, about her empty home. When Elma asks Grace why, if she is lonely, she does not ask her husband to come back, Grace responds, "'Cause I got just as lonesome when he was here. He wasn't much company, cept' when we were makin' love. But makin' love is one thing, and bein' lonesome is another. The resta the time me and Burton was usually fightin'" (155). Marriage begins with sexual desire, but that is not enough.

If older people are not much of an advertisement for marriage, the young couples in the play still run off to get married at the end even if those marriages do not look very promising. After the final curtain of *Picnic,* Hal and Madge will live in a basement room while he works as a bellhop and she gets a job as a waitress, but nothing in his past suggests that he is

capable of keeping a job or a woman. When the sexual attraction wanes, the marriage will be another disaster. At the end of *Bus Stop,* Cherie will follow Bo to his isolated ranch in Montana, but this is not a marriage made in heaven. The happy endings of Inge's plays about courtship are at best bittersweet. The two plays that focus on marriage, *Come Back, Little Sheba* (1950) and *The Dark at the Top of the Stairs* (1957), are even darker.

"WE HAD AWFUL GOOD TIMES—FOR A WHILE, DIDN'T WE?"

Come Back, Little Sheba, Inge's first Broadway play, produced by the Theatre Guild in 1950, was a moderate success that achieved a then respectable six-month run and a film sale. It established Inge as a playwright of note. It contains the essence of postwar American realism: unglamorous central characters in a dreary, claustrophobic regional setting. There is none of the poetry of *The Glass Menagerie,* Tennessee Williams's picture of midwestern entrapment, also set in St. Louis. The married couple in *Come Back, Little Sheba* is a study in disillusionment. While in medical school, "Doc" Delaney had gotten Lola, his beauty queen girlfriend, pregnant. Given the mores of the time, Doc had to drop out of medical school and marry Lola. Though she had a difficult pregnancy, Doc had not wanted Lola to go to a doctor because the birth of their child would have been only a few months after their wedding, and his strong sense of propriety had taken precedence over medical considerations and the safety of their child. Lola lost the child and could not have another. Doc had to become a chiropractor instead of a physician. Though he makes less of an income than he had dreamed of, he will not let Lola work, thus trapping this gregarious woman in her home. When the play begins, Doc and Lola have been married for twenty years. Over the years, Doc's unhappiness has led to alcoholism with incidents of violence against Lola, Lola's to a clinging neediness and signs of clinical depression. The house is messy and lonely, unfulfilled Lola tries to find (nonsexual) companionship in the daily visits from the milkman and mailman. Even their dog, Sheba, has run away from this sad home. Doc is in the kitchen making breakfast, and the point is made twice in the opening moments of the play that this is the wife's job. Lola herself admits, "I oughta be gettin' your breakfast, Doc, instead of you gettin' mine" (7).

To augment Doc's income—he drank away a large inheritance from his mother—he and Lola take in a boarder, a vivacious if amoral (for the time) college student, Marie. For Lola, Marie is the child she never had

and a reminder of her vibrant youth. For Doc, Marie is golden youth and beauty, and he finds himself smitten and deeply jealous of Marie's hunky boyfriend, Turk. He is also jealous of the attention Lola lavishes on Marie and her boyfriends. Lola has taken to watching Lola and Turk "make out" in the living room, a vicarious substitute for sexual fulfillment, and she fixes both the house and herself up to receive Marie's more proper fiancé, Bruce. When Doc discovers that Marie and Turk are having sex, he starts drinking and, in a drunken rage, threatens his wife with an axe.

At the end, Marie has gone off with Bruce. For better or for worse, Marie knows that marrying a good breadwinner is more important in the long run than having satisfying sex with a stud. Marie's marriage will be a compromise, but Inge is not one to imagine connubial bliss. Poor Lola has neither a reliable breadwinner nor a stud. Doc returns home from the hospital and confesses his need for her. He and Lola will continue to make the best of their severely diminished lives.

There is a lot that is autobiographical in *Come Back, Little Sheba*. Doc, like his creator, is the son of a doting, overprotective mother and is an alcoholic who cannot stay in a state of recovery. Clearly, the depression that Doc and Lola experience was not unknown to Inge, who was in and out of psychiatric clinics. In the preface to the published collection of his plays, Inge comments on how his success brought him no joy. After *Come Back, Little Sheba* opened, Inge described himself as a sad-looking creature, "too depressed to care" that others could not understand why he was not euphoric at his success (v).

Disappointment is the leitmotif that runs through the entire play. Doc is disappointed at his career and the slattern his once beautiful young wife has become. Lola is only happy when she reminisces about her courtship with her husband. Yet the play provides two possible causes for Doc's mediocre life. On one hand, it is the result of weakness on the part of a pampered boy who never grew up. On the other hand, Doc's unhappiness and alcoholism could be interpreted as the result of trying to follow the prevailing morality of America at the time Doc came of age. If you get a girl pregnant, you are expected to marry her. If a child is due soon after a wedding, you hide that fact to protect your and your wife's reputations. A working wife is a sign of a husband's failure to be a proper breadwinner. Conventional middle-American morality ruins Doc, and living with the consequences diminishes him. He is totally unsettled by Marie's behavior, not only because he is attracted to her but also because he sees in Marie and Turk two people who do not care about the consequences of their sexual activity. Marie will marry the man who will provide for her and

her children, but she will have fun with Turk until her fiancé arrives. She knows what men are for and will make the most of her situation. Doc is totally unsettled when he discovers that Marie is not virginal. Inge's stage direction notes, "*The lyrical grace, the spiritual ideal of Ave Maria is shattered*" (44).

I speak of *Come Back, Little Sheba* as if Doc were the principal character. The play really focuses on his wife, Lola. Childlike and desperately lonely, Lola is the true victim—of the morality that limits her choices and of a husband too weak and self-centered to make her life better. Yet she is also a survivor who will make the most of her diminished world. When Doc returns from the alcoholic ward, he says to his wife, "*Please* don't ever leave me. If you do, they'll have to keep me down at that place all the time" (67). She will be a loyal wife and displace her disappointment onto the disappearance of her puppy, Sheba. "Some things should never grow old. That's what it amounts to, I guess" (8). In Inge's plays, to evoke Shakespeare, age withers and custom stales.

The dynamic of Doc and Lola's marriage almost parodies gender roles in the 1950s. Lola refers to her husband as "Daddy," he to her as "Baby." Both are cases of arrested development, supporting the notion that only the responsibility of rearing children forces adults to "grow up." Yet Doc is the one who needs mothering. At the end, Lola has fixed herself up and cleaned her house. She has accepted her wifely role and will take care of her weak husband.

Come Back, Little Sheba would be an almost unbearably sad melodrama were it not for the balance of pathos and comedy Shirley Booth, its leading lady, managed. *Come Back, Little Sheba* is Booth's greatest triumph. Born in 1900, Booth began her stage career at the age of twelve and was the plain Jane second banana in plays like Philip Barry's *Philadelphia Story*. When Hollywood adapted plays in which she had appeared, more conventionally attractive actresses were given the roles. She had an odd voice better suited to comedy than serious drama. Despite her appearance and voice, Booth was highly respected as an actress and comedienne. After her success in *Come Back, Little Sheba* on stage and film (she won the Academy Award for Best Actress in 1952), she continued to star in Broadway shows, most notably Arthur Laurents's *The Time of the Cuckoo* (Katharine Hepburn starred in the film version, *Summertime*) and two musicals, *A Tree Grows in Brooklyn* and *Juno*. Paramount offered her a four film contract after *Sheba*, but none of the films were a big hit. She appears as Dolly Levi in the underrated film version of Thornton Wilder's Broadway hit, *The Matchmaker,* and gave the character a warmth and dignity missing from

Ruth Gordon's grotesque onstage performance and Carol Channing's even more cartoonish Dolly Levi in the musical version, *Hello, Dolly!* Television embraced her as a sitcom eccentric in *Hazel,* a series about an oddball maid. Now her performance in Inge's play has attained the status of camp and is even quoted by drag queen Prior Walter in Tony Kushner's *Angels in America.*

Booth manages to make the slattern, cloying, and voyeuristic Lola like-able. In the 1952 film version directed by Daniel Mann, who had also directed the play, Booth first appears coming down the stairs in a frumpy bathrobe. As she passes a small clock, she gives the chain a yank so that time will continue. The gesture is not only funny but also an image of how aware she is that time is weighing on her. Her puffy face can register loneli-ness, bafflement, and a deep fear of her husband's suppressed anger, which explodes when he's drunk. The producers of the film cast Burt Lancaster as Lola's unhappy, alcoholic husband. Lancaster, physically more Turk than Doc, captures Doc's control and defeat, but when he explodes, there is no doubt that he could kill Lola and that his rage will not so easily sub-side. On Broadway, Doc was played more appropriately by pudgy, older character actors.

The film version, adapted by Ketti Frings, makes some structural changes in the play. Doc's alcoholism and participation in Alcoholics Anonymous are presented in greater detail, which changes the focus some-what. The major alteration is in Marie's character. The film opens with Marie coming to Lola and Doc's house looking to rent a room. Starlet Terry Moore is wearing a sweater so tight it is a wonder she can breathe. In the film, Marie is basically a "good girl." She is smitten with hunky Turk (blonde Richard Jaeckel, who later specialized in playing Nazis) but ultimately does not go to bed with him and staves off what approximates attempted date rape. Marie is not the amoral opportunist of Inge's play. If she were, Hollywood morality would demand that she be punished as Lola has been punished for her premarital sex.

The moderate success of *Come Back, Little Sheba* on Broadway estab-lished Inge as someone whose plays would get produced. The greater suc-cess of the film guaranteed that his plays would be bought by Hollywood. Why was this dark melodrama filmed with a nonstar in the lead such a success? One answer can be found in the film's quiet questioning of conventional morality and presentation of sex. Like the joke about the Lifetime Channel, *Come Back, Little Sheba* is a film for women and gay men. It shows how women and men can be trapped by the sexual morality of the period. I saw classmates of mine in high school in the 1950s have to

give up their education and take a job to support the girl they "knocked up" and the resulting child. The pregnant girl was not allowed to stay in school. In a time when divorce was itself not respectable, what happened to these couples? Inge's play and the film made from it show Doc and Lola as victims, not malefactors.

There are two kinds of men in *Come Back, Little Sheba*, "good" men who try to follow conventional morality and who believe that there are only two kinds of women, virgins and sluts, and studs like Turk who live for sexual pleasure. When Doc hears Turk's voice in Marie's room in the morning, it sounds to Doc "*like a sated Bacchus*" (44), a force beyond morality. To Doc, such sexual confidence and pleasure is horrifying. It is easy to read Doc's horror at Turk as an expression of Inge's own horror of his attraction to men. Like Williams in *A Streetcar Named Desire*, Inge offers his audience a slice of beefcake with Turk modeling in the living room for Marie's drawing homework. Turk may be decently attired in his gym suit, but his javelin-throwing pose is reminiscent of the magazines that passed for gay porn in the 1950s, filled with seminude men in classical athletic poses. All Turk needs is a posing strap instead of his track shorts. Admiring Turk's physique, Lola cannot understand why women can pose nude but men must be decently covered. I am sure the gay men in the audience wondered the same thing: "If it's all right for a woman, it oughta be for a man" (23). All this is kept in the film, and we can see from Lola's admiring glances at Turk that her sexual appetite has not faded completely. Lola's admiration of Turk's body, like Doc's of Marie, is an instance of the theme that runs through Inge's work of an older person attracted sexually to youth. In Inge's *Bus Stop* (1955), another doctor, Gerald Lyman, is in trouble because he cannot control his desire for teenage girls. Hal in *Picnic* (1953) has an older "babe" who helps him out in return for sexual favors. Like Williams, Inge presents his men as objects of desire. Richard Jaeckel's Turk posing in his gym suit is as revealing and overtly sexy as Terry Moore's Marie in her sweater.

At the end of the play, Lola recounts a dream to Doc. She is in her high school stadium watching the Olympics with Marie. Turk comes out on the field to throw the javelin:

> …and you know who the man in charge was? It was my father. Isn't that funny? But Turk kept changing into someone else all the time. And then my father disqualified him. So he had to sit on the sidelines…and guess who took his place, Daddy? You! You came trotting out there on the field as big as you please…You picked the javelin up real careful, like it was awful heavy. But you threw it, Daddy, clear, *clear* up into the sky. And it never came down again. (68)

Lola's real daddy, who probably insisted that she marry Doc and who does not let her come back to his home when Doc gets drunk and dangerous, is still in charge. Virile Turk turns into Doc, who was once sexually vibrant. In Lola's dream, Doc regains his virility, though his phallic javelin disappears. At the end of the dream, Lola sees her beloved Sheba, but Doc does not let her stop to care for the dog: "You kept saying, 'We can't stay here, honey; we gotta go on'" (69). Throughout the play and film, Lola lives for memories of her youth while Doc reminds her that the past is irretrievable.

"THE MAN'S GOTTA TAKE THE LEAD, KID, AS LONG AS HE'S ABLE"

Most people know Inge's play *Picnic* (1953) from the highly successful film (screenplay by Daniel Taradash, directed by Joshua Logan) starring Kim Novak, looking and acting neither eighteen nor convincingly virginal, and William Holden, looking old enough to be her father. The play, also directed by Joshua Logan, had been a hit. Both play and film seem to reflect the decade's confused attitudes on gender, sex, and marriage.

The part of the small Kansas town we see at the opening of *Picnic* is an all-female world that has just been invaded by a young, handsome vagabond, Hal Carter. Sixty-year-old Helen Potts, who has hired Hal to do odd jobs for the price of breakfast, lives with her sick mother who is "too mean" for a nursing home. The elderly Mrs. Potts had chased after her daughter when she ran off to be married and then forced an annulment of the marriage. Helen is delighted to have a shirtless young man working outside her house. Her neighbor, Flo Owens, is raising two teenage daughters. Her husband, who had a reputation for being wild, died some years before. Flo rents a room to Rosemary, who socializes with her fellow spinster schoolteachers when she is not with her sometime boyfriend, Howard. These women's lives follow a similar pattern. They are attracted to men who are not likely to be domesticated. Flo's husband had not even been around when their youngest daughter was born. Howard likes to have a good time with Rosemary but is happy to stay single, drink his bootleg whiskey (Kansas was a dry state at the time), and pay occasional visits to the local prostitutes. By the end of the twenty-four hours of the play's narrative, Howard has responded to Rosemary's desperate pleas for marriage: "Oh, God, please marry me, Howard, please" (131). His reasoning for doing so is far from romantic: "A man's gotta settle down some time.

And folks'd rather do business with a married man" (139). Marriage is necessary for a woman to have a respectable place in small-town society and is a sign of maturity for men. For Rosemary, as for many of Inge's characters, marriage is a means of conquering a desperate loneliness. As R. Baird Shuman observes of Inge's plays, "What the world generally looks on as love more often is the compromise that men and women are forced to make to keep from going through life alone."[30]

During the course of the play, Hal Carter gets all the women stirred up. Helen Potts feels a new lease on life from having a man around the house. Rosemary makes sexual overtures to Hal and attacks him viciously when he is not interested. Flo's sixteen-year-old daughter, Millie, develops a hopeless crush on him. The action centers, however, on the relationship of Hal and Flo's older daughter, Madge, who is beautiful but not too bright and has a job at the local five and dime store. She is being courted by the most eligible young man in town, Alan Seymour. Alan is handsome (played originally by Paul Newman), wealthy, well educated, and kind. As Flo points out, "It'd be awful nice to be married to Alan. You'd live in comfort the rest of your life" (81), but Alan's idea of a good time is listening to classical music and proper kissing. As Madge tells her mother, "Alan's not like *most* boys. He doesn't want to do anything he'd be sorry for" (80). This does not seem to be a wholehearted compliment. Madge is self-conscious in Alan's upper-middle-class society and feels inadequate: "It's no good just being pretty. It's no good" (84). Alan gets left alone at the end of the play—Inge's sensitive, artistic men always end up alone. Madge wants someone sexier—Inge, like Williams, acknowledged women's desire for sexual satisfaction.

Hal, too, feels out of place. The son of a drunk, he had entered college on a football scholarship but was looked down on by the middle-class college boys for his lack of social grace and intellect. He had also been envied the adoration he received from the college girls. After flunking out of college, Hal had gone to Hollywood, the logical destination for a young man who lives totally in a physical world. There, he began a pattern of being dependent on and, later, victimized by women. In Hollywood, he had an affair with an older "babe" who got him a screen test. Later, hitchhiking, he had been picked up by two women who held a gun to his head until he thoroughly satisfied them, then robbed him. Like Williams's studs, Hal is not satisfied with his allotted role of servicing women, but he has no other skills. He knows that "[t]here's just no place in the world for a guy like me" (126).

Madge and Hal feel an instant attraction, and, after one of the more famous camp lines from plays of the period, "We're not goin' on no

goddamm picnic" (127), they have sex under a bridge in the back of Madge's boyfriend's car. This incident, which, in typical small-town style, is seen and gossiped about, turns Hal's only friend, Alan, against him and forces Hal onto a passing freight train to Tulsa where he can become a bellhop. Madge, whose reputation is now ruined, decides to follow Hal to Tulsa.

Like Williams's working-class stud, Stanley Kowalski, Inge's Hal spends much of the play either in a tight or soaking wet T-shirt or shirtless. Like Turk in *Come Back, Little Sheba,* he models in classical poses like a 1950s beefcake. Hal is just another 1950s rough trade fantasy, all body but not much in the way of brains, the male equivalent of the dumb blonde. This male fantasy may be a product of Inge's own sexual fantasies, but what is more interesting is that this sexual fantasy was enormously popular in the period. The success of the play and, later, the somewhat miscast film version in which William Holden's Hal seems decidedly middle aged show that such a fantasy was popular with women and acceptable to men. Like the heroes of westerns so popular at the time the drifter stud has not been domesticated (the best Hal can offer Madge is a room in the basement of a hotel, hardly a sign of domestic stability). Hal takes what he wants, and women love him for it. Yet heroism is impossible for him in this bourgeois, small-town world.

Inge and director Joshua Logan argued over the ending of the play. Inge believed rightly that there was no future for Hal and Madge. Madge would now have "a reputation" in her small town, and Hal would continue his life as a drifter. Eager for another hit, Logan thought audiences would demand a happier resolution. At the out-of-town tryout of *Picnic,* audiences did not like Inge's ending, so eventually he was forced to have Madge pack her suitcase and follow Hal: "All right, I'll write it," Inge wrote Logan, "but I want you to know I don't approve."[31] Later, he published his preferred version of the play as *Summer Brave* in 1962. A Broadway production of this version in 1975 was not a success, but by this time, Inge's work seemed a vestige of a bygone era. Yet the view of marriage as an unhappy compromise is more consistent in this revised version. After Flo discovers that Madge has had sex with Hal and wants to marry him, she gives some motherly advice:

> Listen to *me*. I got things to say. There's true love in this life…and there's something else, excitement and heart throbs and thrills. All of them vanish after a few years, maybe after a few days. Then you hate yourself for being such a fool, to let yourself be tricked, to have given up your entire life and all the years that lie ahead…because one night…something happened that made

blood trickle up your spine…that made your heart beat like a gong inside a cavern…that made you feel all of a sudden…like you'd found the whole reason for being born.[32]

Flo does not make clear what "true love" is. Is it a romantic ideal that cannot possibly exist in the real world? Inge, like Williams, seems to think that moments of sexual rapture are the best we can experience but that they do not last. Marriage is something different. Flo wants Madge to marry Alan, the nice, wealthy boy. Such a marriage will give her economic security but no passion. When Madge responds that Hal needs her, Flo remarks, "Yes, he needs you. He needs you to stay home and fry potatoes and wash his underwear while he's at the pool hall. He needs you to forgive him when he spends all his wages on booze. He needs you to lie to when other women call the house and want to know where he is" (90). Flo obviously speaks from experience. She had fallen in love and married a man like Hal. At the end of this version, Madge is another single woman with a reputation in a small town. The title of this version comes from Shakespeare's Sonnet 98—"Youth like summer morn, age like winter weather; / Youth like summer brave, age like winter bare"—echoing the theme of the glory of youth and bleakness of age that runs through all of Inge's work. Madge is a beautiful woman in her sexual prime. Perhaps she should heed the calls of the horny boys whose cries are heard in the background at the end of the play. Sex is real. Love is a myth.

In a way, *The Dark at the Top of the Stairs* is a sequel to *Picnic*—what happens when the wandering stud tries to settle down.

"DON'T SCOLD ME, DADDY"

After two hit plays about troubled courtships between studs and runaway women in *Picnic* and *Bus Stop*, Inge elaborated his vision of the politics of marriage in his strongest play, *The Dark at the Top of the Stairs* (1957). The play is actually a rewrite of Inge's first dramatic effort, *Farther off from Heaven* (1945, produced 1947), which he wrote greatly under the influence of having seen Tennessee Williams's *The Glass Menagerie*. One can hear echoes of Williams's play in Inge's work: the financially strapped midwestern family, the traveling salesman father, the shy, neurotic daughter. Where Williams has no easy answers for his characters, Inge gives them a happy ending. Indeed, part of Inge's considerable commercial success in the 1950s was his willingness to compromise in order to have financial success.

The Dark at the Top of the Stairs was produced and directed by Elia Kazan, who is responsible for some of the best and most financially successful major dramatic productions of the postwar period (e.g., *Death of a Salesman, A Streetcar Named Desire, Cat on a Hot Tin Roof*), as well as films like *On the Waterfront*. Like Joshua Logan, Kazan was not only a superb director but also a crafty man of the theater who was always aware of what an audience wanted. He convinced Williams to add the relatively happy ending to *Cat on a Hot Tin Roof*, and I am sure he was happy with Inge's rather sudden, comforting denouement of his semiautobiographical drama. Four years later, Kazan directed Inge's first and most successful original screenplay, *Splendor in the Grass*.

The play is somewhat autobiographical but is also a picture of a cultural change in the American West at a time when conventional notions of virility were threatened. The setting is a small Oklahoma town in the 1920s. Inge points out that this town is "close to Oklahoma City" (224). The urban world of corporate capitalism is beginning to impinge on small-town life, already changed radically by the oil boom that has made many of its citizens wealthy. Rubin Flood is a vestige of an earlier time. His ancestors had settled this area of the West, but Rubin feels the ground has shifted under his feet: "I'm a stranger in the very land I was born in" (298). Rubin has worked for years as a harness salesman, but few people need harnesses now, so Rubin loses his job and must learn how to sell modern farm machinery that is all new to him. Every change is a threat to Rubin's manhood, particularly in an age in which money is the measure of everything: "In this day and age, what's a man like me got to give? With the whole world so all-fired crazy about makin' money, how can *any* man, unless he's got a million dollars stuck in his pocket, feel he's got anything else to give that's very important?" (297). Rubin has been married for seventeen years to Cora. He had met her when she was still in high school, then got her pregnant and "did the right thing" and married her. Rubin and Cora's relationship is a turbulent one. On one hand, there is still a strong sexual attraction between them. Rubin is an older version of Inge's studs, now settled into a marriage that does not quite fit (e.g., Turk in *Come Back, Little Sheba,* Bo in *Bus Stop,* Hal in *Picnic*). He may still be attracted to his wife, but there is at least one other woman on the road. There is no question he is still attractive. Rubin needs to feel his freedom and authority, but Cora wants a traditional, settled life. At the end of the first act, during an argument, she goads him into hitting her.

The children are another bone of contention. Left alone much of the time while Rubin is out on the road, Cora has been overprotective of her

children, who are models of solipsism. Sixteen-year-old daughter Reenie is so self-conscious that she gets violently ill before going to a party. Ten-year-old Sonny is overly attached to his mother and thinks of little but movies and movie stars. Like Inge as a boy, he wins praise and money for his recitations. Rubin is furious at the money spent on clothing for Reenie and simply does not know how to communicate with Sonny, who is accused by his peers of being a mama's boy and a sissy.

By the end of the play, Cora and Rubin are reconciled. He has been able not only to express his fears to her but also to assert his right to be himself: "Just don't get the idea you can rearrange *me* like ya do the house, whenever ya want to put it in order" (298). At the final curtain, Cora and Rubin are on their way back to the marriage bed. Jeff Johnson opines that, while Rubin verbally asserts his masculine supremacy and independence at the end of the play, Cora and domestic normality have really won: "Rubin and Cora, instead of realizing an essential renewal in their relationship, experience only a temporary shift in control, accentuated by Rubin's calling Cora to bed, which hardly rates as submission for Cora. After all, with Rubin temporarily consigned—and content—to stay at home 'pleasuring' her, Cora, at least for the immediate future, is on top."[33] Rubin has shown the ability to be both strong and sensitive. He can still be domesticated.

Cora and Rubin's marriage may be turbulent at times, but it is better than the sexless union of Cora's sister, Lottie, and her husband, Morris. Like Doc and Lola, Lottie and Morris seem happy together and call each other "Daddy" and "Mama," but underneath, there is little bond left. They have not had sex in years, partly because Lottie has never felt anything, but they have also stopped communicating: "Did you notice the way Morris got up out of his chair suddenly and just walked away, with no explanation at all? Well, something inside Morris did the same thing several years ago. Something inside him just got up and went for a walk, and never came back" (278). Rubin may be frightened of his future, but Morris's fears have mastered him. He goes to a psychologist, but it has not helped his fears, and now, Lottie observes, "Ever since you went to that psychologist, you've gone around imagining everyone's unhappy" (275). Lottie tells Cora, "I wish to God someone *loved* me enough to hit me. You and Rubin fight. Oh, God I'd like a good fight. Anything'd be better than this *nothing*. Morris and I go around always being sweet to each other, but sometimes I wonder maybe he'd like to kill me" (279). Rubin says to Cora toward the end of the play, "It's hard for a man to admit his fears, even to hisself...He's always afraid of endin' up like...like your brother-in-law

Morris" (299). Rubin will be saved from that by his ability to communicate with Cora, but that verbal communication builds on the foundation of a healthy sex life. Like Williams, Inge clearly thought sex was the sine qua non of a stable marriage.

The Dark at the Top of the Stairs celebrates the passing of old-fashioned masculinity. With modernity comes a lessening of virility. But the virile man must be allowed his freedom and domestic authority for a marriage to survive.

The unsatisfying film (1960) adapted from Inge's play (screenplay by Irving Ravetch and Harriet Frank, Jr., directed by Delbert Mann) is a more obvious parable of masculine mastery, focusing more on Rubin (a mannered performance by Robert Preston as if he is onstage playing Harold Hill in *The Music Man*) than Cora. The film begins with Cora refusing Rubin's sexual overtures and ends with her eagerly waiting for her husband to join her in bed. Throughout, it is clear that women should let men dominate. Morris tells Rubin, "I admire the way you talk up."[34] His lack of sexual interest in Lottie is a result of her bossiness. Men must learn to be assertive. Even Sonny proudly claims that he has beat up a boy, thus proving his masculinity. Father knows best in this film, and the gender order has been restored at the conclusion.

"I DON'T THINK MUCH ABOUT HAPPINESS EITHER"

So Deena says to her beloved Bud at the end of the hit 1961 film, *Splendor in the Grass,* for which Inge wrote the screenplay with Elia Kazan as director. *Splendor in the Grass* is a recapitulation of Inge's basic themes, young passion versus compromised marriage, and the power of sexual desire, particularly desire for a beautiful man. The setting is Inge territory, Kansas in 1928. Teenage Deena is so in love with Bud, her high school boyfriend, that she literally goes mad when, after she has tried to be a "good girl" and not be "spoiled" by having sex with Bud, he goes off and has sex with an "easy" girl. In this overwrought film, both Deena and Bud are overcome with sexual desire. After becoming mysteriously ill, Bud turns to a doctor for advice, but medicine can offer none. Deena turns to a minister (played awkwardly by Inge), but religion offers no solace or support. Bud wants to marry Deena but cannot deal with the tension his thwarted sexual desire is causing. Eventually, she goes mad with jealousy and desire and has to be institutionalized.

At the film's conclusion, Bud is married to a working-class girl he meets during his brief stint at Yale, and Deena is about to marry a doctor she meets at the sanitarium. Both seem to be compromises, but maturity itself is a compromise. Deena and Bud's parents are living examples of what the future is likely to hold for them. Bud's parents barely speak to each other, and Deena's parents seem to have a close, comfortable but passionless marriage. They are not unhappy, but there was never any real passion in their relationship. Early in the film, Deena asks her mother if she has ever felt as strongly about her husband as Deena feels about Bud. Her mother offers a Victorian view of sexual desire: "I just gave in because a wife has to. A woman doesn't enjoy those things the way a man does. She just lets her husband come near her in order to have children." Deena's generation feels the need to express their sexual desire. She is surrounded by sexual activity. All her peers seem to be "doing it" outside of school dances, in cars, and near the waterfall that is an image of the power of nature. They all want that "splendor in the grass," the loss of which Wordsworth laments in his poem, "Ode on Intimations of Immortality."

Splendor in the Grass was a hit because it sexualizes adolescent rebellion. In *Rebel without a Cause,* made seven years before, Natalie Wood plays a "bad girl" whose instincts turned out to be more maternal than sexual. This was the future wife of the 1950s, loving and nurturing. Seven years later, Woods's Deena is overcome by her hormones and the issue of how to balance sexual needs with the requirement that she be a "nice girl." Passion and marriage are two different things. There is a telling transition: we see Deena run to meet John, her future husband, and they walk off together hand in hand, which is followed by an abrupt cut to the feet of Deena's parents sitting on their front porch intimating that she and John will have the kind of marriage her they have, more friendship than romance.

Inge's unhappy homosexual, Pinky, may see marriage as an ideal, but Inge's plays, like Williams's, present it as a compromise, an imperfect balance of sexual appetite and social convention.

7. Edward Albee: Marriage as Vaudeville ❧

I think we should have married them—the two we were pretending to be.

<div align="right">

Marriage Play

</div>

Edward Albee's career spans over half a century—the longest of any American playwright. While there is a direct link between the life and work of other members of the pantheon of American playwrights—Eugene O'Neill, Arthur Miller, and Tennessee Williams— Albee's plays are more self-contained. Devotees of his work know the basic details of his life, particularly his adoption by a wealthy, dysfunctional couple against whom he rebelled, his complex relationship with his somewhat monstrous adoptive mother, and his homosexuality. Mel Gussow's biography, *Edward Albee: A Singular Journey,*[1] makes a case for reading Albee's life in his work, but the playwright has repeatedly asserted, "I don't think I've ever written about me. I'm not a character in any of my plays, except that boy, that silent boy that turns up in *Three Tall Women*,"[2] the play he admits is a portrait of his adoptive mother.

Albee's partners over his adult life—composer William Flanagan, playwright Terrence McNally, and for thirty-five years, sculptor Jonathan Thomas—have all been fellow artists. Thirty-five years in a loving relationship with another person is certainly a marriage in substance if not in name. Albee himself has stated that his relationship with Jonathan Thomas, which ended with Thomas's death in 2005, was "as valid, as three-dimensional, as intense as any heterosexual relationship would be."[3] Nonetheless, Albee has trouble with the concept of gay marriage because he sees so clearly the negative side of heterosexual marriage: "I don't understand at the same time why so many gays want to be exactly like so many of these awful breeders—these awful hetero types who really behave appallingly. Why do all gay people wish to vanish into this society?

Is it self-protection? I don't know. I just don't want us to be forced to think that we must imitate other people and behave the way *they* do in order to become invisible."[4]

Although Albee has spent much of his life in relationships with men, his work focuses almost exclusively on heterosexual relationships, though he would say the work is relevant to all couples: "I don't see much difference between heterosexual and homosexual relationships, if they are two people really involved with each other, trying to make a life together. I don't see that much difference, except that the homosexual couple have to fight a lot of prejudices and illegalities."[5] The ways in which gay men and women have internalized or dealt with those "prejudices and illegalities" can be the raw material for good drama, but one has to accept that Albee simply is not interested in that subject. In his controversial address at the 1991 OutWrite Conference in San Francisco, Albee stated: "In my own writing I have a couple of gay characters, but I never felt the need to write about a gay theme. I want to write about our society in general—I don't think being gay is a subject any more than being straight is a subject."[6]

However powerful and stylistically varied Albee's work is, the majority of his plays take place in a specific socioeconomic milieu. Whether it is presented realistically, as in *Who's Afraid of Virginia Woolf?*, *A Delicate Balance*, or *The Goat*, or more abstractly, as in *Counting the Ways*, the setting of most of Edward Albee's work is the living room of an affluent, well-educated, hyperarticulate, upper-middle-class, American, married, heterosexual couple. Occasionally, his work relocates to a park bench, a Memphis hospital, or a beach, but the next play will be back home. It has to be, for Albee's primary subject is marriage, or rather, the meaning of the word "love" as it is manifested in marriage. If marriage is love over time, Albee's married couples, who usually have been together for decades, are at a point at which they are rethinking what love is and what emotionally, sexually, and spiritually sustains an individual or a couple.[7]

In *Period of Adjustment*, Tennessee Williams sets his middle-class, suburban living room over a deep cavern into which it was slowly sinking. Albee uses a similar image in *The Goat, or Who is Sylvia?* when Billy says of his father, "Ya see, while great old Mom and great old Dad have been doing the great old parent thing, one of them has been underneath the house, down in the cellar, digging a pit so deep!, so wide!, so...HUGE!...we'll all fall in and never...be...able...to...climb...out...again—no matter how much we want to, how hard we try."[8] In *Period of Adjustment*, Williams's characters are trapped in a setting both realistic and metaphorical that

could devour them if they do not find a way to escape suburban mediocrity and complacency. In Albee's plays, like Williams's, the mode of presentation veers from realistic to abstract.[9] Albee is a master of the form of realistic domestic drama—he knows his Ibsen and Strindberg—but he also is one of the generation of American playwrights who was influenced by Samuel Beckett and absurdist playwrights like Eugène Ionesco. His career began off-Broadway when the tiny Greenwich Village theaters were showcases for new modern European drama and experimental American work. Whatever style he chooses to use in a particular play, Albee's living room is as precarious as the one in *Period of Adjustment*. The crisis in his plays usually begins at the moment in which a married individual realizes the emptiness of his or her life. The greater danger in Albee's world is metaphysical; it is the void, the nothingness that overtakes those leading an unreflective life. The victims do not usually die. Rather, they are left in a kind of suspended animation.

"IT'S NOT A BAD LIFE WE'VE MADE TOGETHER"

The journey for the couples in Albee's marriage plays is usually from complacency and routine to violence, then to either a radical reordering of their lives or an acceptance of the routine. We see this pattern in his 2004 one-act, *Homelife,* a prequel and companion piece to his first play, the oft-performed classic, *The Zoo Story* (1958). *Homelife* depicts a relatively quiet confrontation with only a slight amount of violence. There is no screaming, as in *Who's Afraid of Virginia Woolf?,* nor is there the physical brawl that takes place in *Marriage Play*. Nonetheless, something crucial happens in *Homelife,* and the resolution is not certain. I discuss *Homelife* at length here because I find it typical—almost a distillation—of Albee's marriage plays.

Homelife begins on a quiet Sunday afternoon. Peter, a textbook editor and publisher, is sitting in the living room reading a manuscript. Ann, his wife, is working in the kitchen. Their girls are away. In Albee's plays, men are breadwinners and women are intelligent, articulate, discontented housewives who seem to be oblivious of women's liberation. All the wife's ambition and sense of identity must be channeled through the husband. The gender politics of Albee's plays seems to be stuck in the 1950s, when he began writing. Why do Albee's wives not have careers? No wonder they feel unfulfilled. Albee's husbands are often intellectuals, more cerebral than physical, quite different from many of the male characters in Tennessee Williams's and William Inge's plays.

Reading is not a very dramatic activity, yet characters are often seen reading in Albee's plays, defining them as educated and literate almost to the point of being literary. His characters often quote from books, plays, and films. The act of reading underscores Albee's focus on language, but reading also isolates and separates characters. *Marriage Play* opens with Gillian, the wife, reading her account of her sexual acts with her husband. George in *Who's Afraid of Virginia Woolf?* reads to separate himself from the grotesque goings-on in his own home. He also pretends to be reading to irritate his wife, Martha, and to act like nothing she does is getting through to him. *Counting the Ways* begins with the two nameless characters reading. At the beginning of *Homelife,* Peter is so absorbed in his reading that he does not hear what his wife is saying to him.

Ann's first line is "we should talk."[10] Does this mean that she has something momentous to say? If so, she forgets what it is. Or does it simply mean "we should converse"—"we should communicate." What they have been experiencing on this Sunday afternoon is a cozy silence. What follows is a conversation at times playful but eventually honest, probing beneath the surface of that coziness.

As much as she likes her life and loves her husband—as much as she can affirm "I'm *happy!*" (19)—Ann has reached a crisis point often experienced by one half of a married couple in Albee's plays. Something is missing that can probably never be recuperated, if it was ever there at all. In Ann's case, the love she receives from Peter is not enough to satisfy her: "I know you love me—as you understand it, and I'm grateful for that—but not *enough,* that you don't love me the way I need it, or think I do; that that's not your makeup—not *in* you, perhaps, or that maybe there's no one could do it, could love me as much as I *need to be loved;* or worse... that I think I deserve more than I do, and that deep down I'm... *less* that I think I am" (19–20). Ann's confession is, and I do not mean this to belittle its force or Albee's work in general, typical of the mental and spiritual state of Albee characters who are in crisis. Ann wants Peter's love to fill a void in herself, to compensate for her own sense of inadequacy and for her own lack of self-love. She wants love to be greater, more satisfying, more enlarging than the love she finds in her comfortable marriage. Happiness is not enough. There is no joy here, in part because there is no danger. Everything is too comfortable, and above all, Peter wants comfort: "A smooth voyage on a safe ship" (20). Ann comments, "Yes, that's what we've wanted...and that's what we've had—for the most part. And isn't it frightening" (20). There is no question mark at the end of Ann's last sentence. For her, the placid comfort *is* frightening. Paradoxically, what is missing is exactly the

fearful, unpredictable, dangerous aspect to experience, the aspect Jerry shocks Peter into seeing in *The Zoo Story*. It is only after this realization of the fearful side of domestic complacency that Ann brings up the subject of sex. Peter has already observed that he thinks his penis is retreating, dwindling, like his manhood. Ann tells him that he is good at making love but lousy at fucking: "But where's the...the rage, the...animal? We're animals! Why don't we behave like those...like beasts?! Is it that we love each other too safely, maybe? That we're secure? That we're too...civilized?" (21). Peter recalls a sexual experience in college that did turn dangerous, hurtful, and animalistic and that frightened him deeply: "So I've been careful never to hurt anyone— to hurt *you*; you being everyone for so long now" (24). However much Ann may blame herself, she knows that comfort is not enough and that something essential is missing. Out of nowhere, Ann gives Peter a hard slap across the face, to give them "a little madness" (25). What is missing from Peter and Ann's marriage—from their love—is anything Dionysian, anything abandoned. Twice, Ann confesses that the problem is hers, that she is not happy with herself. She, more than Peter at this point, sees that her happy life is missing half of human experience—that she is missing that in herself. Combining love and marriage, for Albee, is always a question of reconciling opposites that are irreconcilable: sanity and madness, civilization and bestiality, love and sexual aggression. Is a balance between these possible in a relationship? Ann is not the only wife in Albee's plays who tries to provoke her husband to dangerous, uninhibited instinctual behavior. Again and again, Albee uses domestic violence to shake a couple out of complacency.

Throughout *Homelife*, Peter and Ann move in and out of play, of improvisation, and of performing speculations on events in the past or possible future catastrophes. Peter and Ann are typical of Albee's husbands and wives who perform marriage. They put on routines, sometimes for their own benefit, sometimes for an invited audience (e.g., Mrs. Barker in *the American Dream*, Nick and Honey in *Who's Afraid of Virginia Woolf?*), and sometimes, particularly in later plays like *Counting the Ways,* directed toward the audience in the theater. Marriages survive through repetition and improvisation, but these performances are also created as diversion to keep the couple from dealing with the emptiness their marriage has become. These routines are not dishonest; some of the most telling moments take place during them, as when George shoots his wife with the toy gun in *Who's Afraid of Virginia Woolf?* and when Martin tells his wife that he loves a goat in the midst of a parody of a scene from a Noël Coward

play.[11] The routines alter the surface of the marriage, not the substance. But surfaces are important to Albee's characters. This partly explains the obsession with language. Characters often comment upon, appreciate, criticize, or contradict a spouse's choice of word or phrase. Skating on the surface of a statement may keep one from noticing how thin the ice is and how deadly the waters are underneath.

Early on in the play, we find this exchange:

> *Peter*: I thought your family liked me.
> *Ann*: They *do*. "He's a good, solid man," Dad said. I've told you this. "None of this...fly-by-night fiction stuff."
> *Peter*: "Fly-by-night." What does that *mean*? Bats? And how does it relate to fiction?
> *Ann*: I made it up. He never said it. Look it up. (7–8)

Ann is fabricating a past conversation as a means of connecting with Peter through playful banter. Peter picks up on semantics, another favorite aspect of husband-wife games. The surface of a statement is given as much importance as the substance. This little exchange is followed by Peter joking about the most boring book he has ever read (Anthony Trollope's *Autobiography)*. Ann comments, "This is your party thing; this Trollope thing; you do this at parties...It's a *good* one. Keep it; it's a keeper" (8). Points can be scored by catching a partner in a grammatical error, or a partner can be praised for the quality of a tactic or performance. This is conversation as a game, but the game is preferable to and definitely more fun than silence, noncommunication. This kind of affectionate play appears repeatedly throughout the play, though at the end when honest thoughts and fears have been revealed, the couple's game turns both frightening and, briefly, exhilarating as they improvise a cataclysm, a tornado coming toward the house:

> *Ann*: And it would be terrifying and exciting, and it would sweep us all away, shatter the windows, rip the pictures from the walls...!
> *Peter*: *(Fully caught up)*...knock over the cages and the birds would fly out...
> *Ann*: And the cats would see that, and they would catch the parakeets and *eat* them!...
> *Peter*: ...and the girls would see this, and the girls would do—what? Eat the cats?

Ann: Sure; fearful symmetry.
Peter: And what…and what do *we* do then…eat the girls?
Ann: *(Gleefully abandoned.)* Sure! Even more fearful! *(down now, both of them, laughter subsiding, fading into a silence.)*
Peter: *(Finally.)* But who will eat us.
Ann: *(Pause.)* We do that ourselves. We eat ourselves—all up.
Peter: *(Long pause.)* Gobble, gobble. (25–6)

The speculative play gets more childlike as it goes on, but it also moves from almost hysterical abandon to a restoration of calm, and eventually, of routine. For a moment, the couple has created the excitement and danger Ann craves in her marriage. At the same time, the image of devouring one's children, echoing some of the grizzlier episodes of classical mythology, moves to an image of self-devouring, a more violent version of the destructive complacency eating away at this couple.

At the end, nothing is resolved. After reiterating their love for one another, Ann goes back into the kitchen, and Peter takes his manuscript and goes out to the park to read. Ann's last comment is a meaningless cliché—"Don't take any wooden nickels" (26)—which Peter does not hear. Things could go back to the way they were, except that Peter is about to have the fateful meeting with Jerry in the park that is presented in *The Zoo Story*. Jerry will succeed in rousing the animal in Peter.

"SAD HUSBAND, SAD WIFE; SAD DAY, SAD LIFE"

Calling a play *Marriage Play* (1987) underscores the fact that the theme dominates the action and the characters, who are more universal than particular, as suggested by their names, Jack and Gillian (Jill). The title also underscores the "play" in marriage—the games and performances. Jack and Gillian are a decade older than Peter and Ann, past the age of raising children. Even as a young man, Albee focused on middle-aged and older characters at a point in their life of settling in or experiencing a midlife crisis. The latter is the case with Jack, who declares on his entrance, "I'm leaving you." Jack is not leaving because of a "dalliance" with another woman. Like many Albee characters, his situation is more existential. Jack has fallen into despair—"hopelessness," as he calls it:

We come to the moment we understand that nothing has made any difference. We stare into the dark and know that nothing is enough, *has* been enough, *could* be enough, that there is *no way* not to have…wasted the light; that the failure is

built into us, that the greatest awareness gives to the greatest dark. That I'm going to lose you, for example—*have* lost you—no more, no less than fingers slipping from each other, that I'm going to lose me—the light...losing the light.[12]

Jack has come to believe that age is loss and that, whatever he does, he will lose Gillian and eventually lose his consciousness of himself—perhaps through dementia—and ultimately, death. Giving up on his marriage is one aspect of a general surrender. In the face of an overpowering awareness of his mortality, he chooses to simplify, to reduce himself to nothing—to experience a death in life. It is important to note the force of the word "nothing" in Albee's work. In *A Delicate Balance*, Harry and Edna arrive unexpected to their friends' house because of the fear engendered by experiencing nothing:

Edna:...it was all very quiet and we were all alone...

(EDNA begins to weep quietly; AGNES notice, the others do not; AGNES does nothing)

...and then...nothing happened, but...

(EDNA is crying more openly now)...nothing at all happened, but...*(Open weeping; loud.)* WE GOT...FRIGHTENED.[13]

The "nothing" that terrifies Harry and Edna is the existential void that every clearheaded person must face, but it is also their spiritually empty household, the result of their sterile marriage. They claim not so much a hiding place as a family—a loving human community that will offer them "Succor...comfort...warmth" (74). Like everyone, they will have to face "nothing" on their own, comforting each other. In *Marriage Play*, Jack cannot be comforted, and his own home and spouse do not stave off the despair.

Despite the disappointments she has experienced in her marriage, Gillian fights to keep Jack from leaving. When words fail, she resorts to blocking the door, which leads to a heated physical battle, after which more honest conversation takes place. She asserts her independence and his lack of substance: "So go on; leave me; *I'll* survive it. You're not big enough for the gesture. You're...*nothing* (286). Gillian's accusation only reinforces what Jack already believes about himself. If there is no present or future, there are still memories of the past. Gillian's assault makes Jack remember when he was something—when he was handsome and in his sexual prime. He remembers their early dating, when there were four people in the car:

Jack: You; me; and the people we pretended to me—were pretending
to be. Crowded in that little car, jockeying and all.
Gillian: I think we should have married them—the two we were
pretending to be. (294).

They are aware now, if not then, that so much of what they had offered
each other had been a performance of the people they had wished they
could be.

More than any other Albee work, *Marriage Play* deals with adultery and
the conflict between "instinct" and morality. Albee once stated, "Some
animals are monogamous—human beings not among them."[14] Many of
his husbands—and some of his wives—have secretly or openly "cheated
on" their spouses. This is not the central catalyst for conflict, but the plays
insistently question the possibility of monogamy. On one hand, Jack won-
ders, "Why does 'I love you' mean I vow not to put this into that?" (299).
After all, instinct compels a man to do it "with or to whatever is nearby
and to be fancied" (298), even if sex has ceased to have any meaning. In
his despair, Jack no longer wants sex to mean connection, which makes
sex with his wife hateful: "I wish to be alone in it. I can't stand it when it's
you" (300). And he wishes, above all, to live by instinct, which would be
to live totally as an animal without the baggage that comes from human
consciousness, which for Albee is "the one thing beyond the absence of a
tail that differentiates us from other animals."[15] To live totally by instinct
is to cease to be human, yet to live without instinct, without recognizing
the animal within us, is also reductive.

Gillian finds a way to rationalize the loss of passion and joy in her
life—to accept what is left: "Passion in a marriage never dies; it changes.
When the passion of passion wanes, there are all the others waiting to rush
in—the passion of loss, of hatred, the passion of indifference; the ultimate,
the finally satisfying passion of nothing" (302). Jack, however, cannot find
passion or satisfaction in the "nothing" he feels. Gillian accepts the separ-
ateness of marriage. Jack would rather have no marriage at all.

At the end of *Marriage Play*, even after reiterating his intention to leave,
Jack stays seated by his wife, an echo of the end of Samuel Beckett's *Waiting
for Godot*. Without a will to live, Jack does not have the will to leave. In his
own production of the play in Houston, Texas, Albee had Jack and Gillian
holding hands when Jack reiterates at the end that he is leaving her—the
only time that they touch each other except for their fight. Words and
physical imagery contradict each other. The tender connection suggests
that his leaving—if he can leave—is not because he does not love her.

Albee has written about what Jack goes through in his play: "It's that feeling that you're going to be settling in, and that you've had all the experiences you're going to have. You know, you have a relationship going on for many years, and you're very happy, but there's a nagging feeling—have I missed the boat somewhere? Is there not something else that would have been better? And that whole play's about that."[16] If I read something more metaphysical in the play, it is because I cannot help but see a metaphysical dimension to all Albee's work. Glimpses of the void are inevitable for sensitive characters, but nonetheless totally unsettling. Once seen, nothing is the same.

"LOVE MEANS SEX?"

In *Homelife,* sex is affectionate and comfortable but lacking in danger—too much loving, too little fucking. In *Marriage Play,* Jack discusses adultery and the difficulty, if not impossibility, of monogamy for any man. Impotence is also present in these plays as a sign of diminished manhood and as a weapon and tactic in marital battles. *Counting the Ways: A Vaudeville* (1977) centers on the diminution of physical intimacy in a marriage. The play comprises a series of short blackout sketches that are almost musical in their pattern of repetition and variation of themes. There is no set except table and chairs and no specific characters, only He and She. Love is the operative word in this play, which begins with a question that is repeated, often with different responses: "Do you love me?" In one of the most crucial scenes, the husband ponders the meaning of the title of a film from the 1950s, *Love in the Afternoon:*

> *He*: Really? That's what they *mean*? Sex in the afternoon? Love means sex? I mean, to *them*?
> *She*: Sure: love means sex.[17]

Her equation of love with sex may be limiting, but she is painfully aware that sex is no longer working in their marriage, no longer satisfying either on its own or as an expression of love: "Do you suppose stuffing it in me for you fat and flabby is something I enjoy? Putting it in me like a wad of dough...hoping it'll 'rise' to the occasion? Do you think that fills me with a sense of...what? Fills me with anything but itself?...You call it love!" (525). This may be the most vivid image of male impotence in Albee's work, which is full of such images. From Martha's accusations toward George and Nick (*Who's Afraid of Virginia Woolf?*) to Agnes's sadness over

her husband's spilling his seed on her stomach (*A Delicate Balance*), Albee's men have difficulty satisfying their wives. Even if He could "get it up," sex would no longer be the same, given the cares and hostilities that have accrued during the marriage:

> *She*: Love at night? After all the drinks? And too much food? The old arguments hashed over for the guests? The car? That week in Bermuda? The nursing home? All that? The bile and the regrets and the half numb and better off straight to sleep but no, fumbling and a little hatred with each thrust—both ways?
>
> *(Laughs)*
>
> Oh my; love in the afternoon may be one thing, and love in the morning very much the same, they may both be dirty games, but love at night…oh, that has to be love. (528)

She is speaking here of not only times of day but also times of life. In the "night" of their marriage, sex can no longer be an act of love or even pleasure. They come to the bed with too much baggage for it to be merely "dirty games." Given her bitterness, it is no wonder that she has removed the double bed and replaced it with twin beds too narrow for anything but sleep or death, a halfway stage before the penultimate isolation of separate bedrooms.

At the end of the play, after He has asked for the final time, "Do *you* love *me*?" she can only answer, "I *think* I do" (554). The love she conditionally avers is not passion. It is not even warmth. It is conjecture. At this stage in their lives, it is what is left after the battle scars from past wounds, the memories, and the loss of memories (they have trouble remembering how many children they have). She remembers an adage, "Love doesn't die; we pass through it" (527). What we watch in *Counting the Ways* is another Albee couple who has almost passed completely through love, which is now more a question than a feeling.

"AND I HAVE TO BE MARRIED TO A FAIRY"

In Albee's one-act play, *Finding the Sun* (1983), the only two people who profess mutual love are an estranged gay couple who have left each other for more socially acceptable heterosexual marriages. Their relative success, or lack of same, allows Albee to explore the relative importance of love, loyalty, and friendship in marriage. The setting, both realistic and symbolic,

is a New England beach—Nantucket or Martha's Vineyard, perhaps—occupied by a prosperous group of residents and visitors. As well as being a neutral setting, the beach also contains its traditional symbolism of the shore between life and death, and its inhabitants long to find the sun, "the source of all life."[18] Finding the sun would be finding happiness, love, a reason to live—yet a death wish seems more prevalent among the three married couples on the beach. Each of the marriages is a recoupling. For the eldest couple, it is a marriage for companionship. Gertrude, who is sixty years old, has been married twice before to older men whom she has lost "not through carelessness, but time" (203). Henden, Gertrude's current husband, is ten years older than she. His wife of forty-six years has died of a brain tumor, and he married again "to be *married* as much as anything, a continuity"(207). Henden claims to like Gertrude "very much," but that is far from a claim of love. Marriage for them is a custom, socially ingrained and unquestioned. Yet that is enough, perhaps, for people of their age, though marriage does not assuage their sense of isolation, particularly at the thought of death.

The more problematic marriages in the play are those of Henden's son, Daniel, and Gertrude's daughter, Cordelia, and of Benjamin and Abigail. Daniel and Benjamin had been lovers before they married their wives, and while both men are attempting, in their fashion, to be good husbands, they are still in love with each other and cannot stand being apart. If we view the play through the lens of domestic realism, Daniel's and Benjamin's decisions to marry their wives does not seem credible or necessary in the early 1980s when the play was written. It is more part of the experience of men of Albee's generation. Why is it that Albee, who has had serious, long-term relationships, cannot imagine one in his plays? Daniel says to Henden, "There is my *nature* and *Benjamin's* nature and we are doing what we *can* about it, though I think we're *idiots*. We've fallen between stools, Father; we were better perched on our specialness…our disgrace, perhaps…But we are *trying*. Jesus, we're trying!!" (235). In other words, his and Benjamin's marriages are contrary to their nature, but in their case, nature must be resisted through heterosexual marriage. Homosexuality is both "specialness" and "disgrace," a term of shame and abjection, though it is really their compromised attempts at heterosexuality and their betrayal of their wives that can be seen as disgraceful. We are given no reason for the breakup of Daniel and Benjamin's relationship beyond Daniel's shame and wish to marry. Daniel, who may be bisexual, decides to marry socialite Cordelia, after which Benjamin finds Abigail out of loneliness, desperation, and retaliation.

These marriages lead to varying degrees of unhappiness for all four members of this sad marital network. Benjamin is falling apart emotionally without Daniel and in an unsatisfying marriage. Abigail is so desperate that she tries to drown herself. Cordelia, however, has a clear sense of the limitations of her marriage. She likes the fact that "Daniel is more interested in our friendship than our marriage" (226), so that when he one day realizes how silly their marriage is, they will still be friends. The problem is not a lack of sex in their marriage. They claim to love each other, but Daniel cannot offer exclusivity: "I've got a very roomy heart," he tells Cordelia when she asks if he has male lovers (213). And there is still his love for Benjamin. When Cordelia asks Daniel why Abigail does not take Benjamin off "to Peru, or somewhere" to get away from Daniel, he responds, "because, pussycat, then *we'd* have to move to Peru, too, and you *know* how you are with languages" (212). The two former lovers may be married to others, but they are still inseparable. Cordelia accommodates Daniel's infidelities and love for Benjamin. She knows that if he were straight, there would be other women instead of men: "I *like* being his only woman" (225).

However rational the basis for their marriage is, however much they like each other, Daniel and Cordelia are both frustrated, though nowhere as frustrated as Benjamin and Abigail, whose marriage has even less rationale. There is no physical expression of affection, and Abigail is consumed with frustration and jealousy. She would like to believe that Benjamin has changed, but she clearly does not trust him—"I never let him out of my sight" (205)—and seeing him with Daniel reminds her of just how tangential she is to him. Benjamin, on the other hand, would settle for sharing Daniel with Cordelia rather than continue in a miserably unhappy marriage. At the end, Daniel cannot go to his wife, who has been saved from drowning, because he does not know what to say to her. Aging Henden and Gertrude can be content with their marriage because they expect so little out of it. The four younger people want comfort, solace, and love. Loveless marriage does not cure loneliness or one's awareness and fear of "nothing," but love takes more courage than most of these characters can muster.

"I WANT TO SLEEP WITH EVERYONE."

After years of writing more experimental drama, *The Goat, or Who is Sylvia?* (2002) takes us back to the living room of domestic realism, though the

action contained within this setting stretches the limits of realism. Albee has written of *The Goat,* in many ways his most provocative play, that it is "about love, and loss, the limits of our tolerance and who, indeed, we really are."[19] This last subject, "who, indeed, we really are," can be narrowed to the question drama is most equipped to answer, "Who, indeed, are we in relation to other people?" For Albee, "other people" means spouses, family. *The Goat* is a recapitulation of the questions Albee has asked in his work: What is love? What is the relationship between sex and love? How do we channel our animal instincts and to what extent should we channel them? What is a good marriage? What are livable rules for a marriage? To what extent can homosexual and heterosexual love be equated? The play also touches on Albee's central theme that consciousness is crucial to a full life. The protagonist's love of Sylvia the goat is both love and idealization of nonconsciousness. For Albee, renouncing consciousness is renouncing that which separates us from goats. Ultimately, Martin brings suffering upon his wife, his son, and himself, but Albee's work always maintains that with suffering comes growth.

Martin is a prizewinning architect who is considered something of a visionary. At fifty, he has been hired to create a city of the future. He and his wife, who bears the androgynous name Stevie, seem to be a perfect couple who have everything. Stevie is for Martin "the love of my life, the mother of my handsome and worrisome son, my playmate, my cook, my bottle-washer."[20] He tells his fair-weather friend Ross that he and Stevie "have always been good together—good in bed, good out; always honest, always considerate" (561). The marriage has been so satisfactory that Martin has never been unfaithful. Stevie is equally happy. Like most Albee wives, she is a traditional homemaker. Her husband, son, and home are her life, and she almost waxes poetical about her marriage: "I rose into love with you and have—what?—*cherished?* you, all these years, been proud of all you've done" (594). They have a bright, teenage son who is gay, but Martin and Stevie seem to have dealt with that in a manner one would expect from educated, liberal parents. What could possibly upset this ideal household that seems as sunny as something out of a 1950s television sitcom? What would, as Stevie puts it, be so "outside the rules, that doesn't relate to The Way the Game Is Played?" (581). However fulfilling this marriage is, it is still to its members a game with rules, though one does not fully understand those rules until they are broken irrevocably.

The crisis that destroys the marriage and violates the conventions of realistic domestic comedy to which the play seems to adhere is the revelation that Martin is having an affair with a goat. He is not merely "fucking a goat," to use the words of his appalled son, he has fallen in love with a goat. His descriptions of his feelings toward the goat are always spiritual rather than

physical: "It was…an ecstasy and a purity, and a…love of a…(*dogmatic*) un-i-mag-in-able kind, and it relates to nothing *whatever*, to nothing that can be *related* to!" (598). Martin seems attracted sexually and spiritually to the goat's lack of human consciousness, which he confuses with innocence. This is a bizarre form of the midlife crisis faced by many of Albee's characters.

Once Martin's secret is revealed to Stevie and Billy, the marriage is shattered and the family disintegrated. Stevie's response is to seek revenge for a horrible wrong done to her: "You have brought me down to *nothing*! You have brought me down, and, Christ, I'll bring you down with me!" (605). If Martin is in part attracted to the nothing, the nonhumanness of the goat, Stevie rails at being reduced to nothing. If Martin can love her and a goat equally, she is "brought down," her identity, founded on their marriage, shattered. The audience watches her destroy the objects in her living room, creating a visual correlation to what is happening to her marriage.

Billy is the collateral damage, shattered by the breakup of his family. As Martin is judged for moving outside the bounds of conventional morality, so does gay Billy finds himself in an ambiguous relation to social norms. He is accepted and reviled, loved but stung, by his goat-loving father's homophobic slurs. Billy is rightfully shocked at his father's current love affair with a goat and shattered by the imminent destruction of his family. Yet Martin justifies his own behavior by presenting his son's as worse. Martin calls his son a "Fucking Faggot," though he later says "I don't give a shit what you put where" (572). Martin wants everyone to see his relationship with the goat as something loving and beautiful. He cannot understand why other people see it as wrong. But for him, Billy's homosexuality is all about sex, and the sleaziest kind of sex at that:

> Billy: (*To STEVIE [his mother]*). You want me to leave you here with this…this…*pervert*?!
> Stevie: (*To help.*) Just go to your room, Billy, or go outside, or…
> Martin: …or go to one of your public urinals, or one of those death clubs, or…
> Billy: KNOCK IT OFF!! (576)

The hypocrisy of Martin's fulmination underscores the irrationality and arbitrariness of such attitudes. Billy's mother tries to rationalize Martin's behavior: "I said your father's sorry for calling you a fucking faggot because he's not that kind of man. He's a decent, liberal, right-thinking, talented, famous, gentle man who right now would appear to be fucking a goat" (572). One of the issues *The Goat* takes on is the limits of liberalism in the face of transgressive sexual behavior. Martin sees himself as accepting of

his son's sexuality, but at gut level, he is not. Liberal attitudes in this play are performed, not deeply felt. Martin offers tolerance of his son's behavior without understanding how demeaning tolerance is. He alternates treating Billy as sexually depraved and, with his commands of "Go to your room," as a little child.

Later, a comforting father-son kiss between Billy and Martin becomes "a deep, sobbing, sexual kiss" (615). Billy tries to analyze what happened: "It clicked over and you were just another…another man. I get confused…sex and love; loving and…I probably do want to sleep with him. I want to sleep with everyone" (616). Adolescent Billy is at that stage of constant sexual excitement in which his urge for sex is indiscriminate. He is dealing with the problem that arises again and again for Albee's men—the conflict between instinct that urges men to "put it into that" whenever possible and social norms that decide what sexual behavior is acceptable. *The Goat* has Martin's friend Ross as the representative of social convention who can cry "Jesus! Sick!" and thereby put aberrant behavior under both religious and medical jurisdiction. When Ross asks, "Is there anything you people don't get off on!?" Martin responds, "Is there anything anyone doesn't get off on, whether we admit it or not—whether we *know* it or not?" (618). Everything, even religious martyrdom, is sexual. If this is so, then what is the function of sexual morality? Neither gay Billy nor straight Martin is capable of controlling his sexual impulses. However, Martin's supposed friend Ross, the voice of conventional morality, is the least sympathetic character in the play.

Though more horrific than most of his work, *The Goat* is another play about a moment of crisis in a marriage, another work about an ideal of love betrayed. Martin's inability to play by the rules has destroyed a good, loving marriage, and a price has to be paid for that. The play ends with young Billy calling for his parents, "Dad? Mom?" (622). J. Ellen Gainor writes that Billy's two final words suggest "that all such roles are up for renegotiation."[21] Attempts at renegotiation are the central action of all of Albee's marriage plays. The endings are usually question marks because Albee himself is not sure whether the necessary change is possible. Or perhaps it is for his audiences to decide.

Marriage in Albee's work is the ultimate test of whether people can break through the wall of selfhood. Can anyone live up to the ideal of marriage ingrained in us by our culture? Albee holds out the ideal as a yardstick by which he measures his characters and by which they measure themselves and each other. No one, straight or gay, fully succeeds.

8. Gay Playwrights, Gay Husbands, Gay History ✣

He got married, had kids and then came out. That's the ways they did things. Very traditional, very fucked up.

<div align="right">Terrence McNally, Some People</div>

"Gary and I have a kind of a marriage," explains a gay father to his traumatized adolescent son in the groundbreaking 1972 telefilm *That Certain Summer*.[1] That line seemed daring at the very beginning of gay liberation and decades before the gay marriage debate. However, marriage seems the only way for Doug (Hal Holbrook) to explain his relationship with his partner, Gary (Martin Sheen), though Gary, the younger and more politicized of the pair, knows that the lack of a marriage license reflects a lack of social acceptance to society at large. Gary even bristles at the "whiff of patronization" in the tolerance of some of their friends and relatives. However contested the word "marriage" remains for long-term, loving, same-sex relationships, it is the most apt metaphor for them.

That Certain Summer aired forty years ago, but the domestic narrative it depicts continues as a staple of gay drama, film, and television. Out of loneliness and desire to conform to societal norms, a gay man marries a woman who may or may not know of her husband's sexual orientation or of his sexual past. In *That Certain Summer* Doug's wife marries him knowing that he is homosexual: "Like any woman in my position, I thought I could change him." The marriage faces a crisis at the point when the husband's homosexuality cannot be denied by either party. The husband falls in love with a man, and his ex-wife has to deal with the consequences. The wife confronts the male lover of the man she still cares for: "If you were a woman, I'd know how to compete with you."

The airing of *That Certain Summer* was in itself an important event in gay history in that it presented on American network television a drama

that accepted—if cautiously—the validity of a gay relationship and the point of view of a politicized gay man. This chapter chronicles the narrative of the gay husband from its first major presentation to its transformation at the hands of contemporary playwrights. As we shall see, most presentations place the narrative arc of the gay husband within the social and political history of gay men. The transition from unhappy heterosexual marriage to fulfilling gay marriage is seen as part of a larger social evolution.

I begin this chapter with a consideration of a 1961 British film, *Victim,* created by heterosexuals for a predominantly heterosexual audience. This film is a more serious argument for changing the antihomosexual laws than anything seen at the time on the highly censored British stage—or the American stage, for that matter. It depicts a moment in history that still fascinates contemporary playwrights. From there I will look at a recent group of British and American plays that historicize gay marriage and the change in meaning of gay husband. I will argue that gay playwrights present this narrative within a more self-referential, overtly theatrical framework

DETECTIVE: BUT FARR'S MARRIED, SIR.
CHIEF DETECTIVE: THOSE ARE FAMOUS
LAST WORDS.

In its time, *Victim,*[2] was very daring, arousing a great deal of controversy in Britain and initially getting banned in the United States because it uses the taboo word "homosexual." The writers, producers, and directors of *Victim* created the film to argue for the legalization of homosexual acts in part to stop the insidious practice of blackmailing homosexuals, almost all of whom were closeted and vulnerable. The Wolfenden Report, completed and published in the United Kingdom in 1957, argues that sexual acts in private between consenting adults should be legalized. It took ten years before the recommendations of the report were enacted into law. State sodomy laws in the United States were not overturned until the 1970s and are still on the books in fourteen states, even though the Supreme Court invalidated them in 2003. So *Victim* was quite forward thinking, even though it offers little in the way of support for any kind of homosexual relationship. At the time, no mainstream drama touched on these subjects.

Victim, which combines elements of the thriller with domestic melodrama, begins as a chase. Jack "Boy" Barrett, a young payroll clerk at a

construction site, is being pursued by the police for embezzling money from his employer in order to pay blackmailers. We follow him as he tries to get friends and ex-lovers to help him, is arrested, is interrogated, and hangs himself in his jail cell. The enlightened police detective is more interested in catching the blackmailers than in prosecuting Barrett, but Barrett's primary motivation is to protect the man he loves, Melville Farr, a distinguished barrister who is up for a position as prosecutor. Once Barrett dies, the film focuses on Farr, played by closeted gay actor Dirk Bogarde, who was Britain's biggest male film star at the time.

The creators of *Victim* had to be cautious in their presentation of Farr. Films were still censored in Britain, and overt homosexuality would not have been allowed. Thus, the audience has to believe that, while Farr has had an intense emotional relationship with a man at university and, more recently, with Barrett, he has never had sexual relations with either of them. At the point when sex had been inevitable, Farr had always broken off the relationship, leading to disastrous results for the other person. Stainer, his college friend, killed himself after Farr cut him off. Farr's relationship with "Boy" Barrett is equally frustrated. After giving Barrett a lift home from his worksite one day, Farr was attracted enough by the young man to drive by his worksite and offer him rides regularly. This would be relatively innocent were it not for that fact that it represents a violation of class boundaries. There was also, as there was in nineteenth-century sex scandals, a discrepancy in age. In the film, all the ex-lovers Boy turns to for help are middle-aged. However chaste it may be, Farr's friendship with a young workman arouses suspicion. His wife rightfully asks, "How did you meet a boy like that?" From the Cleveland Street scandal in 1889, when prominent citizens were caught having sex with young men in a London male brothel,[3] to the exposure of Oscar Wilde's relations with rent boys a decade later, to the idealized relationship of Edward Carpenter and George Merrill, to fictionalized accounts like E. M. Forster's *Maurice,* the history of gay culture in Britain since the 1880s has been in part the history of the mixing of classes and ages, seen by the dominant culture as dangerous and seen by some gay men as a social ideal. A blackmailer's telephoto lens picks up Barrett crying as Farr breaks off their sexless relationship. The photograph of a barrister and a young workman in tears is suggestive enough to be a problem.

When Farr discovers that Barrett has killed himself to avoid a testimony that might implicate him, he decides to pursue the blackmailers. His investigation leads him into a gay network ranging from booksellers to car dealers, to barbers, to famous actors, to politicians, all more eager

to keep their secret than to see justice done. They are all being shadowed by a sinister-looking plainclothes police officer and terrorized by the unlikely blackmailing team of a mother and her thuggish, self-hating gay son.

The film focuses on the effects of Farr's decisions on his marriage. He has married the perfect wife for the man on the way up. Laura (Sylvia Sims) is young, beautiful, aristocratic and totally in love with her husband. Farr clings to her because a man in his position is supposed to be married and because his marriage keeps him from following his homosexual inclinations. At the end of their first scene together, he asks her, "Do you love me?" When she answers, "Yes," he responds, "A little reassurance helps," as if he needs constant assurances of her love to help him fight his attraction to men. In this noir-style film, the Farr home seems windowless and filled with shadows. This is not the setting of a happy marriage. When Farr comes home from the police station, saddened by Barrett's death and concerned about his role in it, Laura understands that "it takes two to make blackmail" and wants to know the truth about Farr's relationship with Barrett. Farr responds, "When we were married, we had no secrets from each other. I made you a promise. I haven't broken that promise, if that's what you mean." The film does not clarify exactly what the promise was, though Farr probably has pledged that he would not have a relationship with another person, male or female. When Laura asks him if he loves Barrett, he naively responds, "If it was love, why should I try to stamp it out?" It certainly was sexual attraction: "I stopped seeing him because I wanted him." An attraction that does not lead to sex is not illegal, but Farr's relationship to Barrett is still a threat to his marriage and his career.

Because Farr does not act on his homosexual inclinations, he feels superior to the other victims of blackmail that he encounters. They have given into impulses that he keeps in check, but at what price? In Bogarde's depiction of Farr, there is a deadness in the eyes, a blankness of expression that may be attributed to his limitations as an actor—inscrutability was this actor's stock in trade—but it could also be the blank mask of a man who is used to hiding his deepest emotions. Yet Laura sees something else in the photograph of Farr breaking off his friendship with Barrett: "There's as much pain in your face as in his. You haven't changed, in spite of our marriage." Laura understands that Barrett loves her husband enough to die for him: "That thought will remain with you for the rest of your life. I don't think there's going to be room for me as well."

Laura is the ideal understanding wife. There are no emotional outbursts, no threats of vengeance here, only upper-class British civility. When her

older brother asks her if she has found "real love" in her marriage, Laura responds, "Yes. I think so. It's all I've known." The fact that Laura married at nineteen and, after many years of marriage, has not had children suggests that there is little in the way of sexual passion. She has been satisfied with this until she realizes that her husband could feel passion for someone else. No wonder she later says to him, "I'm not a life belt you can cling to. I'm a woman." Laura's description of her marriage reminds one of the sad, sexually unfulfilling marriages we see in some of Terence Rattigan's plays and in works like Noël Coward's *Still Life*. A wife who has never known sexual fulfillment becomes aware that something is missing in her marriage. Somerset Maugham's and Terence Rattigan's unsatisfied wives would have embarked on a sexually fulfilling, if emotionally frustrating, affair. But *Victim* is a movie that had to follow certain moral imperatives—Laura had to remain the good wife just as Farr had to remain a faithful husband.

Farr's decision to give testimony against the blackmailers in court will lead to public disgrace that will ruin his career. He wants Laura to go away during the trial, but she vows to return after the scandal subsides:

> *Laura*: We're going to need each other very much, aren't we?
> *Farr*: After it's all over and the shouting has stopped, I'm going to need you very desperately.
> *Laura*: Need. That's stronger than love.

But is it for a married couple? In the end, Farr has the courage to risk the destruction of his career and reputation to bring the blackmailers to justice and avenge the death of Barrett, but he does not have the courage to have any sort of gay relationship. It is because he has not had sex with the men he has been attracted to that he can safely testify against the blackmailers without getting arrested himself. Nonetheless, film critic Pauline Kael is correct when she writes

> The hero of the film is a man who has never given way to his homosexual impulses; he has fought them—that's part of his heroism. Maybe that's why he seems such a stuffy stock figure of a hero. Oedipus didn't merely want to sleep with Jocasta; he slept with her. The dreadful irony involved is that Dirk Bogarde looks so pained, so anguished from the self-sacrifice of repressing his homosexuality, that the film seems to give rather a black eye to the heterosexual life.[4]

Melville and Laura Farr will stay married despite his homosexual inclinations because, for all the film's advocacy of privacy rights for homosexuals, the film offers no hope for loving gay relationships. One cannot blame

the makers of *Victim* for offering a view of heterosexual relationships that was typical in 1961. To be a homosexual is to be an outlaw at the mercy of both police and criminals. Homosexuals should not be allowed to be blackmailed or arrested for private, consensual acts, but heterosexual marriage is the only loving relationship possible.

If *Victim* presents the narrative of the gay husband as a vehicle for an argument for liberalization of antihomosexual laws, Drew Pautz's conventionally realistic play *Love the Sinner* (2010), creates parallels between the dilemma of an ambivalent gay husband and the Church of England's inability to take a coherent, humane stand on the issue of homosexuality. While volunteering at a church conference on homosexuality in Tanzania, Michael has a sexual encounter with Joseph, a young African who works at the hotel where the conference is taking place. Joseph is manipulative and a bit dangerous. He does not want Michael—he wants Michael's life. "There are always consequences,"[5] he tells Michael, and his continued presence in Michael's life is the consequence of their sexual encounter. "He's a fury" (89), Michael cries, a reminder of his transgression that pursues him relentlessly. Shelly, Michael's wife, knows that theirs is not the passionate marriage she would like, but her biological clock is ticking and a child would justify their unsatisfactory marriage: "I would do anything in the world to have a child, Michael. Anything. Otherwise, what is the point?" (67). When Joseph shows up on their doorstep in England, Michael clumsily tries to balance his marital obligations with his sense of responsibility for Joseph. He knows his marriage is a failure. His wife will have the child she so wants but has lost her love and respect for her husband:

Michael: I repulse her, of course

She doesn't say, but I know what she thinks. I'm her husband

Not the physical stuff

That's bad enough I'm sure, but.

The lies

She's repulsed by the fact that the lies I tell aren't enough to save me or to save her but

Any lie necessary to save us.

"Us."

It's the ice that binds us.

I don't blame her

I feel bad about everything. (114)

Nor can he satisfy Joseph's impossible claims to him. Michael is "trying "to do right by everyone" (114)—his wife, his lover, the church he serves as volunteer, his employees, but as his young African lover points out, that is impossible. As a result, Michael is not honest with anyone. Michael's inability to take a stand is presented in the context of the Church of England's inability to take a stand on homosexuality—its unrealistic desire to please both the American liberals and the African homophobes ultimately angers both groups. The first scene shows us the church conference in which the bishop tries to reconcile the African conservatives and American liberals. Both groups demand that the bishop take a stand, but he sees his position as that of a mediator, not leader, so nothing can possibly be accomplished. Like the Church of England, Michael tries to hold together irreconcilable elements. The greatest weakness in *Love the Sinner* is the liberal guilt that hinders any meaningful action by individual or institution.

GAY PLAYWRIGHTS, GAY THEATER

Though they were created for different media (i.e., television, film, the stage) *That Certain Summer, Victim,* and *Love the Sinner* all place their narratives within the conventional framework of realism using linear time scheme, realistically presented environments, and realistic acting. In my book *Still Acting Gay,* I wrote, "Our best [gay] playwrights have always seen realism as a trap—as the least theatrical of the modes of dramatic representation and the one on which the values of mainstream society are most indelibly inscribed."[6] To some extent, we see this in the works I have discussed thus far in this chapter. While sympathetic with the gay central character, the playwrights are all more interested in the point of view of the society in which that character is placed. Doug and Gary may have forged a successful relationship, but *That Certain Summer* is more interested in the son's reaction to discovering his father's sexuality and in Doug's loss of his son's love, to some extent a punishment for his renunciation of the heterosexual family. However noble in arguing for a just cause, *Victim* offers no way for a gay man to lead a happy, fulfilling life. *Love the Sinner* frames Michael's dilemma within the wider issue of the pusillanimity of church leadership. Given the prominence of the larger issues—the church, the extent of postcolonial responsibility for third-world problems and prejudices—the dilemma of one guilt-ridden gay husband seems small and irreconcilable.

Gay playwrights place the narrative of the gay husband not only within wider political issues but also within more self-consciously theatrical modes of representation. As I wrote in 2000:

> Our [gay] playwrights have developed a dramatic medium that allows space for, in ascending order of importance: *display*, of the male body and queer theatricality; *polemic*, some assertion of where we will not compromise with the mainstream; self-examination, of ourselves as individuals and members of what is called the gay community; *transformation*, through theatricality and irony of the representational and narrative forms which maintain our oppression; and *celebration* of our courage, resistance and difference."[7]

Tony Kushner's much-discussed epic *Angels in America* (1992),[8] the best-known and most influential gay drama, parallels the disintegration of a heterosexual marriage with that of a gay "marriage." Louis Ironson leaves his partner, Prior Walter, because he could not deal with Prior's AIDS. Joe Pitt, a gay husband, is hamstrung by his Mormon upbringing and his political conservatism. His political ideal is the closeted right-wing monster, Roy Cohn. Joe admits to his homosexuality and leaves his wife, but there is no possible reconciliation of his sexuality with his politics or his religion. He is relegated to limbo. His valium-addicted wife goes on her own spiritual and psychic journey after she realizes that her marriage has failed. In the atomized world of *Angels in America*, relationships are not possible: the individual must engage in a solitary journey of self-discovery. Joe Pitt's story fits into the conventional narrative pattern of the gay husband, giving the play's audiences a familiar, prosaic story in the midst of a six-hour drama filled with fantastic events and characters. Joe's story is only one strand in the tapestry of *Angels in America*, which is most significant in its explosion of the conventional form of domestic realism and its use of theatrical devices, which had been developed by leading gay figures in alternative experimental theater, such as Charles Ludlam, the founder, key practitioner, and theorist of the Theatre of the Ridiculous. *Angels in America* uses male and female drag, camp, and heightened theatricality to attack oppression, celebrate difference, and create a stage world that is physical, intellectual, and spiritual. Following Kushner's example, many gay playwrights see realism as one tool, combining it with what Kushner called the "Theatre of the Fabulous." We shall see how most of these works use the same familiar story while experimenting with nonlinear time schemes, a variety of modes of dramatic representation, and self-conscious theatricality. Through this fabulous

theatrical language, gay playwrights insist on a gay point of view on their material.

"WE HAVE A HISTORY OF SORTS"

Alexi Kaye Campbell's *The Pride* (2008), contrasts the sort of compromised marriage we see in *Victim* with a troubled contemporary gay relationship. Four actors play parallel roles in scenes that alternate between past (1958) and present. Campbell wants his audiences to be aware of the changes in theatrical style in his play. At the beginning, "we should feel as if we are watching a 1950s production of a 1950s drawing room play,"[9] which would not be much different from the acting style of Dirk Bogarde and Sylvia Syms in *Victim*. However, by the end of the first act, the realistic trappings of the first scene have disintegrated, and the parallels between the two time periods become clearer: "The different periods should meld into each other" (5), so we can see the similarities between past and present as well as the differences. Eventually, too, there is less contrast in the acting styles between past and present.

At the beginning of *The Pride,* it is 1958, a time not much different from that depicted in *Victim*. Philip is a young man in his thirties who led a rather aimless life until his older brother died and he had to take over the family real estate business. His is bored with his work but too conventional to make any radical changes in his life. He is in a childless marriage with Sylvia, a former actress who has recently started a career as a children's book illustrator. A few years before the play begins, Sylvia had some kind of emotional breakdown, probably when she realized on some level that her husband could never fully satisfy her emotionally or sexually. When the play begins, Philip is meeting Oliver for the first time. Sylvia is illustrating a book that Oliver is writing, and in the course of their work, they have become good friends. Oliver is something of a mystic who, on a recent trip to Greece, had a kind of epiphany about the future for gay men like him: "Many years from now, there will be an understanding of certain things, a deeper understanding of certain aspects of our natures that will make all the difficulties we now feel, all the fears we now hold onto and the sleepless nights we now have seem almost worthwhile" (21). Oliver's book, a kind of allegory of accepting one's sexual difference, is about an orphan boy who believes that he speaks a language only known to him. His isolation is broken when he meets another boy who speaks his language: "The one that he thought

that only he knew" (50). Oliver has been waiting to find the man who can "speak his language," who will affirm that he is not the only person who feels desire for his own sex: "All my life I have been waiting for some confirmation that I am not alone" (58). Unfortunately for all concerned, Oliver comes to see Philip as that person. Sylvia sees Oliver's book as her story. She has found in Oliver a friend who understands her better than her husband does: "That we didn't belong within that absurd little world in which talking about anything remotely significant seems an affront to one's dignity" (94).

After their dinner with Oliver, Philip and Sylvia have a conversation that shows how deeply unsatisfying their marriage is. Philip claims to dislike Oliver just as he disliked a gay actor friend of Sylvia's who committed suicide. Philip found him offensive "in a way that those men can be offensive" (55). Sylvia's fear is of being childless, which would leave her and Philip with only each other: "The two of us. Just us. Alone" (53). She tells of a dream in which she could not see her husband's face. All Philip can do throughout this conversation is accuse Sylvia of irrationality and express fears that she may be having another breakdown. As she later tells Oliver, "He's been very effective in convincing me that I've lost my mind" (100). Clearly, the marriage of Philip and Sylvia is a miserable one, but there seems to be no alternative to continuing it. Like many women in British marriage plays, Sylvia is painfully aware that she is "unloved in the way I want and *need* to be loved" (98). Though she cannot put it into words, she knows that the cause of her discontent is her husband's repressed homosexuality. She also knows that Philip is hiding something that will explode: "I think that anything that is not let out will turn in on you in the end and destroy you. And those around you" (95). Unfortunately, Sylvia is correct. Unbeknownst to Sylvia, Philip and Oliver have a four-month-long affair that has enormous importance for Oliver: "It was the first time that we were together, when we were embracing, that I felt I had a pride. A pride for the person I was" (79). Philip, however, feels nothing but shame and disgust. When Oliver tells Philip he must be honest with himself and with his wife, Philip violently rapes him. When Sylvia discovers the affair, she realizes that she has lost both husband and friend yet still is understanding enough to ask Oliver, "Was he happy? For an afternoon, at least. For a morning. Was he ever happy?" (99). Philip, who wants "an easier life," goes to a doctor for the most grim sort of aversion therapy. By inducing vomiting, the doctor may be able to rid Philip of his sexual attraction to men, but the doctor is silent when

Philip asks if he would also be cured of "the other feelings, I mean, the ones that aren't *exclusively* sexual" (116). Philip would like to vomit away his capacity for loving another man as well as his sexual attraction.[10] The past is not very happy for any of the participants. In 1958, homosexuality takes a kind of courage that conventional Philip is not capable of, and his self-hatred turns him into a kind of monster. His wife has the courage to leave an unsatisfying marriage, not an easy thing to do in the 1950s. What these characters have in common is loneliness, the loneliness of an unloved wife, of a loving man who has not been able to find a soul mate, and of a deeply repressed man who lacks the courage to be honest with himself and those who love him. The hope is for a better future. However, the world of 2008 is not the ideal Oliver envisions.

The Oliver of the scenes set in 2008 is a self-absorbed, neurotic writer who habitually cheats on his partner and makes emotional demands on his female friend without giving much in return. Alternating with the scenes set in 1958, we have a chronicle of Oliver's maturation from demeaning, self-hating sexual encounters to his reconciliation with his partner, Philip, who has left because of Oliver's sex addiction. What keeps Oliver from fully committing himself to Philip is the self-hatred still generated by the world in which he grew up: "There's an expected behavior. People telling you who you are. And you believe them. And, then, of course, you become that very person. The one they want you to be" (71). Oliver believes that he has listened for too long to "the voice that says you're no good, you're unlovable. This is what you deserve" (71–2). His friend, Sylvia, wisely tells him, "You have to stop sucking the dick of your oppressor" (108). The Sylvia of the contemporary scenes is a smart career woman who happens to have a gay best friend who takes advantage of her generosity. She is beginning a serious relationship and wants to lessen Oliver's dependence on her. At the end, on gay pride day at a reunion engineered by Sylvia, Oliver tells Philip, "the only thing that separates us, that makes us different [from other animals], that makes us *human*, is this ability we're discovering, this *thing* we have to instill, to do things with and to give love. And some kind of respect. That's all we fucking have. To listen to each other. To *know* each other" (126). Philip will try to rebuild a relationship with Oliver because "We have a history of sorts" (129), not only their turbulent nineteen-month relationship, but also the history of gay men that is celebrated at gay pride.

Campbell's *The Pride* clearly advocates an ideal of gay and straight marriage built on honesty and love. In 1958, Oliver tells Philip of a visit to a

gay bar and of how he feels that the lonely men in this shadowy place really wanted love, not just an anonymous sexual encounter:

> but because they don't know where…*how* to find it, and because they have been told that this is who they are, that they are these men who stand waiting to touch someone, to touch another man's skin, that they've believed that's *all* they are, but that what they want, what they really want is more than that, what they want is what we can have…an intimacy with someone they can hold onto for a while, that what they want more than anything is to be able to *see* them, to look at them, to look into their eyes and to *know* them. And be known. (79)

Such knowledge is not possible in 1958 because few men have the strength to defy the laws and social taboos. It is still difficult in Campbell's vision of a contemporary world of narcissism and instant gratification. The editor of a men's magazine wants Oliver to write a column on gay sex that will present gay men as role models for heterosexual promiscuity: "I don't mean all the details but kind of the whole thing of sex in public and that kind of thing, making them a bit jealous, you know, kind of saying, well, if you could just walk into a park or a fucking public loo any time of day and there's these gorgeous girls just waiting to be shagged, wouldn't you be up for it? Kind of like gay sex for the straight man" (79–80). Ultimately, as part of his maturation process, Oliver turns down the editor's lucrative offer. In the past, writers like Emlyn Williams presented heterosexual marriage as the transition to maturity for gay and bisexual men as well as heterosexuals. In *The Pride*, one has to grow out of the narcissism that is the public image of homosexuality and mature into a loving relationship. Sylvia tells Oliver on gay pride day, "They reduce you, Oliver, to this person who is shallow. Someone who is defined by his body, by what he does with his body and by his taste in things. Clothes, interiors, whatever…And the thing is, you're so much more than that. And somewhere, *somewhere*, you, Oliver, have agreed with them." (105). If the Oliver of the past is brave enough to resist the taboos against homosexual love, the Oliver of the present must resist being defined as a stereotypical gay man if he is to find love. As a heterosexual marriage is destroyed in the past, a gay marriage is negotiated in the present.

The Pride shows us not only a dark past, but also a present in which gay men are still in a state of transition. At times, it suffers from presenting such a clear-cut point of view. However Campbell's theatrical inventiveness and poetic language carry us along. The play's final vision is of the Sylvia of the past dreaming of telling her husband that when she wakes she

will leave him, not out of anger, but with understanding and forgiveness: "You have only known how to hold onto things and the things you have held onto have died in your hands. Dead ravens in your hands" (113). Throughout the play it is the women, the Sylvias, who are the wise ones; the men act out of fear.

"IT'S CALLED MARRIED LIFE, TOM"

If Alexi Kaye Campbell alternates past and present to contrast the problems of a closeted husband in a heterosexual marriage with those of a gay man resisting commitment, Jonathan Harvey sets his unhappy gay husband against fifty years of gay activism. Of the works I discuss in this chapter, Harvey's *Canary* (2010) is the most heavily influenced by Tony Kushner's *Angels in America* in its free movement in space and time and its alternation of realism with more fantastic scenes as it depicts real and fictional characters. One image frames the action of the play—a young gay boy dancing and spinning in his mother's wedding dress, an image of freedom and defiance that, at the same time, intimates an ideal of marriage. This image is an example of Tony Kushner's Theatre of the Fabulous: "The Fabulous is assertively Camp camp [*sic*], the rapturous embrace of difference, the discovering of self not in that which has rejected you but in that which makes you unlike, and disliked, the Other."[11] Throughout *Canary*, Jonathan Harvey embraces the elements of Kushner's Theatre of the Fabulous: "Irony. Tragic history. Defiance. Gender-fuck. Glitter. Drama."[12] Mary Whitehouse, the antigay moral reformer, is played by a man in drag. As in *Angels in America,* the unhappy wife of a gay man is transported to a series of fantastic journeys and confrontations as she faces the truth of her marriage and her son's death. Characters defy homophobia through ironic performance.

Canary begins in the present as Tom, the chief of London police, is outed and the truth of his son's death from AIDS-related infections has been made public. The press are camped outside Tom's house. His wife and grown daughter are in shock. Through flashbacks, we see Tom's history and its relationship to key events in British gay history. In 1962, seventeen-year-old Tom and his lover, Billy, are happily in bed together. Though the two young men love each other, Tom tries to rationalize their relationship: "Billy, if you're worried. About this carrying on. Getting in the way of marriage. The future. It won't. One day we'll put a stop to it."[13] The police burst in and arrest the two, but Tom manages to evade

imprisonment and save his career by testifying that Billy forced him to have sex. Billy is sent to a psychiatric hospital for aversion therapy that does not have the intended result—he spends the rest of his life in radical, sometimes violent, gay political activity as revenge for his mistreatment. Tom, meanwhile, tries to follow the route laid out for him by his father and the realities of his society. He marries Ellie, but Billy almost sabotages the wedding by dropping Tom's letters to him from the gallery of the church during the wedding procession. Ellie recalls, "So many letters. Raining down on you. Tom rushes to pick them up. You ask what they are. He's evasive. He's always evasive" (58). Years later, when his wife catches him returning home from a neighbor's garage with his shirt ripped (rough sex or a rebuffed sexual overture), Tom confesses his unhappiness:

> *Tom*: I'm dying, Ellie. Every time I step through the door. I see monsters at the bottom of our garden.
> *Ellie*: It's called married life, Tom. I don't see why you think you've got a right to be any happier than the rest of us.
> *Tom*: I don't love you, Ellie.
> *Ellie*: Get a backbone, Tom. (66)

Ellie has lost whatever romantic illusions about marriage she once held. Husband and wife must be strong enough to endure a loveless relationship.

When Mickie, Tom and Ellie's son, is one of the first British men to contract AIDS, Ellie goes into denial while Tom has an honest discussion with him:

> *Tom*: You may be dying, Michael. But there's more life in you than there's ever been in me.
> *Mickie*: I never found love. I never went looking. I was gonna change the world first. Do all that later.
> *Tom*: Better than finding it and turning it away. (76–7)

While Mickie has the courage to be openly gay, Harvey sees that neither Mickie nor his father has a loving relationship that can lead to happiness. As Tom has had the chance with Billy, though it would have taken enormous courage to risk that relationship, Mickie has had the love of his first lover and best friend, Russell, who remains obsessed with him decades after his death. The obstacle to a real loving relationship now is not the law or prejudice—it is the same hedonism that has always been a part of gay culture.

At the end of the play, it is not clear what will happen to Tom. He makes an honest public statement, but does he have the courage to finally be there for Billy? When he asks his wife if she plans to leave him, she responds, "This house is one of the few things in life that give me pleasure. Whether I share it with you or not is immaterial" (97). Billy, back in prison, knows that Tom will not live up to his promise to be waiting for him when he is released: "You didn't do it nearly fifty years ago. And you won't do it now" (99). There is no happy resolution for Harvey's characters. Tom has admitted the truth of his life, but that's a statement about the past, not a plan for the future. In the moral schema of the play, Tom commits the most hurtful act in betraying his friend and lover, Billy. Ellie is partly responsible for her own unhappiness. She actively chooses to ignore the truth of her marriage and of her son's death (the official story she invents is that he was killed in a motorbike accident) and, like Michael in *Love the Sinner,* tries unsuccessfully to find solace in religion. She comes to terms with the truth of her marriage and her son's death through her imaginary journeys. However, Harvey understands that both Tom and Ellie are in part victims of their age and social circumstances.

The same actor who plays Tom also plays moral reformer Mary Whitehouse. Tom is, after all, not only a gay husband but also the head of the police who, for many years, has brutally enforced antigay legislation. Mary Whitehouse's 1971 Festival of Light, the main public event of her moral crusade, is sabotaged by gay activists organized by Tom's ex-lover, Billy.

Canary is a celebration of decades of gay activism. Tom represents an older generation trying to live by society's expectations. Harvey is more sympathetic toward him than he is toward the young twink of the present who cares for nothing but his own pleasure: "Me and my mates went through shit to let you be this apathetic" (87). Like Alexi Kaye Campbell in *The Pride,* Jonathan Harvey laments the lack of political consciousness and gay pride in contemporary young hedonists as he mourns the lack of courage of some members of the older generation of closeted gay men.

"IF WE CAN GET MARRIED WE'LL BE LIKE EVERYONE ELSE"

Samuel Adamson's *Southwark Fair* and Terrence McNally's *Some Men* present a variety of possible choices for gay men: heterosexual marriage, promiscuity, and gay marriage. Adamson's work is skeptical of the idea

of marriage, gay or straight, while McNally offers a celebration of gay marriage

Southwark Fair contrasts the end of a marriage of a gay man and his wife with the abortive wedding ceremony of a young waiter and the deputy mayor of London. Patrick and Toni, his American wife, are visiting London. While Toni ostensibly visits sites of the history of rock and roll, Patrick tries to reconnect with past male lovers. Actually, Toni wants to catch her husband in the act and wreak vengeance on him and his lovers. Toni, is sick of her husband's rationalization that his flings with men are "only sex": "'Only sex': the self-justifying mantra of chicken shits."[14] Patrick wants his marriage to continue—on his terms: "I have a wife. I love her, I do...I love her. She keeps me...on a path...She needs me, too. I'm someone to hate" (90). Toni, however, has decided that it is time to move on: "There's good and there's bad—and I fucking love bad—but if it's wrong, it's wrong" (107). Meanwhile Aurek, the young waiter, is jilted at the altar because his older, highly political partner cannot deal with Aurek's eccentric choice of clothes for a city hall civil union ceremony. Aurek realizes that the legal commitment would not make their relationship any more harmonious: "We didn't need a piece of paper. We'd only need another one for our gay divorce, wouldn't we" (87). Yet, though the new object of his affections is definitely a nonbeliever in gay marriage—"we don't need to get wedlocked, you stupid straight-aping wanker" (80)—Aurek still believes in domestic bliss. Adamson may be critical of the hypocrisy of the wayward gay husband in a straight marriage, but he is also skeptical of gay men's desire for marriage.

These scenes of failed straight and gay marriages are part of a broader picture of real and surreal events in Southeast London presented in a complex time scheme—scenes in act 2 take place at the same time as parallel scenes in act 2. Like the comedies of early modern playwright Ben Jonson (e.g., *Bartholomew Fair, The Alchemist, The Silent Woman*), *Southwark Fair* places somewhat fantastic events within real London settings, offering another variation of Tony Kushner's Theatre of the Fabulous. The play manages to be both whimsical and angry (unfortunately Nicholas Hytner's heavy-handed Royal National Theatre production caught the anger more than the whimsy).

Terrence McNally sees gay marriage as the culmination of decades of gay politics. For almost four decades, McNally has been the chronicler of the lives of gay men. He wrote the first successful Broadway play centering on gay male experience, *The Ritz* (1975), which was turned into

a film the next year. His *Lisbon Traviata* (1989) depicts the dark side of gay life for a particular group of self-hating opera queens, while *Love! Valour! Compassion!* (1994, film version 1997) celebrates gay friendship and love in the age of AIDS.[15] His *Some Men* (2006), dedicated to his spouse, begins and ends at a gay wedding. In between this prologue and epilogue and within a simple unit set, McNally gives us a series of vignettes that offer a history of gay relationships since World War II. Many of these focus on Bernie, whose experiences over the past forty years are McNally's paradigm of what many gay men lived through. We first see Bernie in 1968 in a hotel room with a hustler. Bernie has a good job, membership to the New York Athletic Club, and a wife and kids, but "sometimes I get these urges to be with a man so bad I think I'm gonna go crazy."[16] The sight of the young rent boy naked in front of him elicits tears of joy. Three years later, Bernie has post-squash lunch at the New York Athletic Club with his friend, Will. After three years of furtive extramarital sex with hustlers, Bernie wants to leave his family and come out. Will, who also has had furtive homosexual encounters, is not the least bit sympathetic: "Life isn't about being happy. It's about doing the right thing and the right thing for men like us is staying married and beaming with pride when our kids graduate from Yale or Harvard or wherever the fuck it is they want to go and enjoying our many grand-children and the fruits of retirement" (35–6). Will cannot conceive of a happy gay life: "Gay is not good. It is loneliness and secrecy and a life-time of shame" (38). Ironically, this is an apt description of the closeted life Bernie and Will have led. Terrified of exposure if Bernie comes out, Will breaks off their friendship.

Four years later in 1975, Bernie makes his first visit to a gay bathhouse where he meets Carl, a high-school librarian. At this point, Bernie has gone through a "bad divorce" and has been rejected by his children. In a few minutes, he and Carl move from attraction to friendship to sex. Carl playfully asks Bernie the refrain that is repeated throughout the play, "You wanna get married?" Though they have no ceremony or legal document to support it, Bernie and Carl begin a "marriage" that will last decades. Fourteen years later, in 1989, Bernie is part of a gay community and is visiting a friend in the AIDS ward at a New York hospital. Finally, in 2005, Bernie and Carl have been together thirty years, and Bernie has become close to his gay son, Perry, though they are experiencing something of a generation gap. Bernie and Carl have gone to a beach on the Hamptons with Perry and his partner, Marcus. Perry and Marcus have a birth mother

and are excited about raising a child, but Bernie, who left his own children, cannot conceive of a gay couple raising a child:

> *Bernie*: Babies are not accessories you buy from impoverished Third
> World women. Babies are people; the women who bear them
> are people... What kind of life are they going to provide for that
> child?"
> *Perry*: A better one than he would have gotten in a shack with a mud
> floor and no water or electricity. (89)

Perry says of his father, "He got married, had kids and then came out. That's the ways they did things. Very traditional, very fucked up. Marcus and I aren't going to inflict that kind of trauma on our kids" (ibid.). However much Bernie's life has changed since 1971, he still cannot conceive of a gay nuclear family.

Over the time span of the play, the notion of marriage and children has changed for gay men from the heterosexual families they had to leave to come out to the possibility of raising children with their partners. Unfortunately, the wedding ceremony that begins and ends the play offers none of the rights and protections of heterosexual marriage. In fact, the issue for one half of the marrying couple is the same one we have seen in many plays about heterosexual marriage: is monogamy possible? "Will a ring mean I love Eugene when we get married next month? Does marriage mean we don't sleep with other people? I can't stop or maybe I don't want to, which? I want to be faithful to my partner and I can't be" (96). Michael asks his fellow group therapy members the question that is at the heart of many of the plays discussed in this book: "What is marriage?" Surely, for gay men, marriage to a beloved partner is better than the compromised attempts at "normal" marriages many gay men—men like Melville Farr of *Victim* or Philip of *The Pride,* and also many gay men of my generation, including myself—experienced in the past, but it is always wise to understand just what it is that we are pledging when we speak the marriage vows. Like many contemporary gay playwrights, McNally thinks that love must be at the heart of such a relationship—indeed, love is really what gay men want, but sexual freedom is also part of gay liberation, which is the reason some gay men oppose gay marriage. It makes us just like "them."

David Leavitt writes, "Marriage is a mixed bag. Banal and blissful. Annoying. Companionable. An anchor. By which I mean, I'm glad to be inside one rather than gazing in at one, befuddled, from without."[17] Gay

playwrights of the past had to do just that—critique marriage from without. Contemporary gay playwrights still seem to be fascinated with the compromised heterosexual marriages gay men in the past felt the need to embark upon. At the same time, they want younger audience members to understand the historical context of these compromises. These playwrights seem less willing to depict the dynamic of a long-term gay relationship—perhaps such relationships are not dramatic enough and are raw material better suited for television situation comedy and soap opera. However, the same questions that playwrights pose in their depictions of heterosexual marriage pertain to gay marriage. Is monogamy any more or less realistic for gay couples than it is for heterosexual couples? What keeps a marriage alive over the decades? How capable are people of the selfless love that is the ideal of marriage? For the most part, the gay playwrights who advocate gay marriage seem much more optimistic about the institution of marriage than their gay predecessors, who dramatized heterosexual marriage. They write as political advocates as well as social critics, placing themselves in a wider debate that is still raging.

Notes ∾

INTRODUCTION

1. David Brooks, "The Power of Marriage," in *Same-Sex Marriage: The Moral and Legal Debate* ed. Robert M. Baird and Stuart E. Rosenblum. Amherst, NY: Prometheus Books, 2004, p. 87.
2. David Leavitt, "Notes Toward an Opinion on Gay Marriage," in *The M Word: Writers on Same-Sex Marriage*, ed. Kathy Pories. Chapel Hill, NC: Algonquin Books, 2004, p. 37.
3. Mark D. Jordan, *Blessing Same Sex Unions: The Perils of Queer Romance and the Confusion of Christian Marriage.* Chicago: University of Chicago Press, 2005, p. 6
4. George Chauncey, *Why Marriage? The History Shaping Today's Debate over Gay Equality.* New York: Basic Books, 2004, p. 148.
5. Quoted in Chauncey, *Why Marriage?*, pp. 147–8.
6. Augustine of Hippo, *Augustine Through the Ages: An Encyclopedia*, ed. Allan D. Fitzgerald. Grand Rapids, MI: William B. Eerdmans Publishing, 1999, p. 805.
7. Augustine of Hippo, *Augustine Through the Ages*, p. 805.
8. Southern Baptist Convention, *Baptist Faith and Message (2000 tract).*
9. Brooks, "The Power of Marriage," p. 88.
10. Andrew Sullivan, "Introduction," to *Same-Sex Marriage Pro and Con: A Reader.* New York: Random House, 2004, pp. xxiii–iv.
11. Dan Savage, "Double Standards," in Pories, *The M Word*, p.127.
12. Sullivan, "Introduction." p. xxiv.
13. Sullivan, "Introduction," p. xxv.
14. Chauncey, *Why Marriage?*, p. 141.
15. Paula L. Ettelbrick, "Since When Is Marriage a Path to Liberation," in *Same-Sex Marriage: The Moral and Legal Debate,* edited by Robert M. Baird & Stuart E. Rosenbaum. Amherst, NY: Prometheus Books, 2004. p. 258.
16. David Leavitt, "Notes," pp. 37–8.
17. See my book *Something for the Boys: Musical Theatre and Gay Culture.* New York: St. Martins, 2000.
18. "Marry Me a Little" was one of the songs written to be Bobby's final number and rejected as too cynical for the ending of a Broadway show. It was

reinstated in London and New York revivals in the mid-1990s and placed at the end of the first act.

19. Sean O'Connor, *Straight Acting: Popular Gay Drama from Wilde to Rattigan.* London: Cassell, 1998, p. 10.

1 EDWARD CARPENTER AND OSCAR WILDE: IDEAL AND REAL MARRIAGE

1. Matt Houlbrook, *Queer London: Perils and Pleasures in the Sexual Metropolis, 1918–1957.* Chicago: University of Chicago Press, 2005, p. 207.
2. Matt Cook, *London and the Culture of Homosexuality, 1885–1914.* Cambridge: Cambridge University Press, 2003, p. 138.
3. Sheila Rowbotham, *Edward Carpenter: A Life of Liberty and Love.* London & New York: Verso, 2008, p.192.
4. Edward Carpenter, *Love's Coming-of-Age: A Series of Papers on the Relations of the Sexes.* Chicago: Charles H. Kerr, 1912 (reprinted Whitefish, MT: Kessinger Publishing, 1999), p. 25. Further references are to this edition.
5. Edward Carpenter, *Intermediate Sex,* London: George Allen, 1912 (reprinted Whitefish, MT: Kessinger Publishing, Kessinger Publishing, 1999), p. 32. Further references are to this edition.
6. *Maurice* (1987). Screenplay by Kit Hesketh-Hardy from the novel by E. M. Forster, produced by Ismail Merchant, directed by James Ivory.
7. Oscar Wilde, *The Importance of Being Earnest,* in *The Complete Works of Oscar Wilde.* New York: Harper Perennial, 1989, p. 322,
8. Joyce Bentley, *The Importance of Being Constance.* London: Robert Hale, 1983, p. 47.
9. Franny Moyle, *Constance: The Tragic and Scandalous Life of Mrs. Oscar Wilde.* London: John Murray, 2011, p. 185.
10. Neil McKenna, *The Secret Life of Oscar Wilde.* London: Arrow Books, 2004, p. 88.
11. Quoted in Anne Clark Amor, *Mrs. Oscar Wilde: A Woman of Some Importance.* London: Sedgwick and Jackson, 1983, p. 202.
12. Quoted in Amor, *Mrs. Oscar Wilde* p. 207.
13. Oscar Wilde, *Letters,* edited by Merlin Holland and Sir Rupert Hart-Davis. London: Butler and Tanner, 1962, p. 685.
14. In his play *The Secret Fall of Constance Wilde* (1997), Irish novelist and playwright Thomas Kilroy dramatizes Wilde's marriage. The play is "an historical drama, a Greek tragedy with masked attendants as a chorus, and a Yeatsian Noh play with puppets and Kabuki effects" (Judy Friel and Sanford Sternlicht, "Introduction," *New Plays from the Abbey Theatre: Volume 2, 1996–1998.* Syracuse, NY: Syracuse University Press, 2001). Kilroy focuses on the fact that Constance's father was also arrested for a sexual violation (exposing himself): "I loved two criminals, you see.

Papa–Oscar. Oscar–Papa" (Thomas Kilroy, *The Secret Fall of Constance Wilde*. Oldcastle, Ireland: The Gallery Press, 1997, p. 47). In the play, Bosie (presented as an androgynous ideal and incarnation of Dionysus) tells Constance that what Oscar "does talk about, endlessly I have to say, is your capacity to—accept" (44).
15. *Oscar Wilde: A Life in Letters*, ed. Merlin Holland. New York: Carroll and Graf, 2007, p. 341.
16. Oscar Wilde, *The Complete Works of Oscar Wilde*. New York: Harper Perennial, 1989, pp. 62–3. All references to Wilde's works are to this edition.
17. McKenna, *The Secret Life of Oscar Wilde*, p. 89.
18. Joseph Pearce, *The Unmasking of Oscar Wilde*. San Francisco: Ignatius Press, 2004, p. 186.
19. Joseph Donohue, "Distance, Death and Desire in *Salome*," in *The Cambridge Companion to Oscar Wilde*, ed. Peter Raby, Cambridge: Cambridge University Press, 1997, p. 31.
20. Frank Harris, *Oscar Wilde: His Life and Confessions*, 1918, reprinted New York: Horizon, 1974, pp. 465–6.
21. Peter Raby, "Wilde's Comedies of Society," in *The Cambridge Companion to Oscar Wilde*, p. 150.
22. Alan Sinfield, *The Wilde Century: Effeminacy, Oscar Wilde and the Queer Moment*. London: Cassell, 1994, p. 73.
23. Quoted in McKenna, *The Secret Life of Oscar Wilde*, p. 257.
24. Moyle, *Constance*, p. 8.
25. Richard Allen Cave, "Wilde's Plays: Some Lines of Influence," in *The Cambridge Companion to Oscar Wilde*, p. 225.
26. Kerry Powell, *Oscar Wilde and the Theater of the 1890s*. Cambridge: Cambridge University Press, 1990, p. 85.
27. Joel Kaplan, "Wilde on the Stage," in *The Cambridge Companion to Oscar Wilde*, p. 249.
28. Carpenter, *Love's Coming-of-Age*, p. 93.

2 SOMERSET MAUGHAM'S INCONSTANT SPOUSES

1. Despite his celebrity and family connections (his brother and nephew were viscounts and his daughter married into the peerage), Somerset Maugham never was honored as were his compatriots Coward and Rattigan, both of whom earned knighthoods.
2. Robin Maugham, *Escape from the Shadows*. London: Hodder and Stoughton, 1972, p. 103. Robin Maugham, 2nd Viscount Maugham of Hartfield (1916–1981), was openly and "defiantly" homosexual and candid about his pederasty. His most important works, the novella *The Servant* (1948) and the novel *The Wrong People* (1967), are dark visions of the power dynamic of same-sex relationships. The relationship of Arnold Turner and a fourteen-year-old,

Berber male prostitute, Raffi, in the latter work echoes young Robin's infatuation with the young prostitute Laurent.

3. W. Somerset Maugham, *Collected Plays. Volume 1.* London: Heinemann, 1931, p. viii. Unless otherwise noted, all further references to Maugham's plays and prefaces are to this edition.

4. W. Somerset Maugham, *The Summing Up.* Garden City: Doubleday, 1938, p. 111.

5. Richard Huggett, *Binkie Beaumont: Eminence Grise of the West End Theatre, 1933–1973.* London: Hodder and Stoughton, 1989, p. 26.

6. Jeffrey Meyers. *Somerset Maugham: A Life.* New York: Vintage, 2005, p. 348.

7. John Russell Taylor, *The Rise and Fall of the Well-Made Play.* London: Methuen, 1967, p. 99.

8. Selina Hastings, *The Secret Lives of Somerset Maugham.* London: John Murray, 2009, p. 49.

9. Robin Maugham, *Conversations with Willie.* London: W. H. Allen, 1978, p. 45.

10. Meyers, *A Life*, p. 186.

11. R. Maugham, *Conversations with Willie*, p. 51.

12. R. Maugham, *Conversations with Willie*, p. 19.

13 R. Maugham, *Conversations with Willie*, p. 19.

14. Bryan Connon, *Beverley Nichols: A Life.* London: Constable, 1991, p. 171.

15. R. Maugham, *Conversations with Willie*, p. 50.

16. R. Maugham, *Escape from the Shadows*, p. 105.

17. Meyers, *A Life*, p. 102.

18. Beverley Nichols, *A Case of Human Bondage.* London: Secker & Warburg, 1966.

19. Nichols, *A Case*, p. 15.

20. Some biographers believe that Syrie, through friends in high places, may have engineered the deportation order, which was delivered even though Haxton had been acquitted of the charges of gross indecency.

21. Noël Coward, *The Noël Coward Diaries.* Boston: Little Brown, 1982, p. 229.

22. R. Maugham, *Conversations with Willie*, p. 134.

23. Quoted in Robert Calder, *Willie: The Life of W. Somerset Maugham.* London: Heinemann, 1990, p. 142.

24. "According to Robin [Maugham], Maugham called *The Narrow Corner* his 'queer' novel and said, 'Thank heavens nobody's seen it'" (Calder, 234).

25. W. Somerset Maugham, *The Narrow Corner.* London: The Vanguard Library, 1952, p. 53. Further references are to this edition.

26. The review is reprinted in *W. Somerset Maugham: The Critical Heritage*, ed. Anthony Curtis and John Whitehead. London: Routledge and Kegan Paul, 1987, p. 200.

27. There were successful male-dominated plays in the 1920s; for example, *Journey's End.*

28. *Theatre* was adapted for the stage by Guy Bolton as *Larger than Life* and had a successful run in 1950 at the Duke of Yorks Theatre in London starring Jessie Royce Landis and Reginald Denny. A French translation, *L'Adorable Julia*, ran in Paris for over five hundred performances in 1955–1956 and in 1962 was turned into a film with Lilli Palmer and Charles Boyer. A French television version was produced in 1988. Another film version of *Theatre*, *Being Julia*, with Annette Bening and Jeremy Irons, was released in 2004.
29. W. Somerset Maugham, *Theatre*. London: Vintage, 2001, p. 110. Further references are to this edition.
30. W. Somerset Maugham, *Plays: Two*. London: Methuen, 1999, p. 107. Further references to *The Letter* are to this edition.
31. Quoted in Sean O'Connor, *Straight Acting: Popular Gay Drama from Wilde to Rattigan*. London: Cassell, 1998, p. 65.
32. Noël Coward, *The Letters of Noël Coward*. ed. Barry Day. London: Methuen, 2007, p. 227.
33. Garson Kanin, *Remembering Mr. Maugham*. London: Hamish Hamilton, 1966, p. 64.
34. Meyers, *A Life*, p. 59.
35. Quoted in Meyers, *A Life*, pp. 219–20.
36. "Looking Back was published in serial form in the London *Sunday Express* in September and October, 1962. Maugham wanted it published in book form, but his publisher, A. S. Frere, was "appalled" by the work: "It was quite clear to him that its central theme, a vitriolic account of the author's marriage, was the product of an unsound mind, that Maugham, in short, had taken leave of his senses, and that he must be protected from having his dotage exposed." (Selina Hastings, *The Secret Lives of Somerset Maugham*. London: John Murray, 2009, p. 530.)
37. Beverley Nichols, *The Unforgiving Minute*. London: W.H. Allen, 1978.
38. Connon, *Beverley Nichols*, p. 212.
39. Nichols, *A Case*, p. 7.
40. Quoted in Connon, *Beverley Nichols*, p. 269.
41. Huggett, *Binkie Beaumont*, p. 492.
42. R. Maugham, *Escape from the Shadows*, p. 9.

3 LOVE OR MARRIAGE: SIR NOËL COWARD AND SIR TERENCE RATTIGAN

1. Philip Hoare, *Noël Coward: A Biography*. Chicago: University of Chicago Press, 1998, p. 514.
2. Bryan Connon, *Beverley Nichols: A Life*. London: Constable, 1991, p. 270.
3. Connon, *A Life*, p. 270.
4. Richard Huggett, *Binkie Beaumont, Eminence Grise of the West End Theatre, 1933–1973*. London: Hodder and Stoughton, 1989, p. 79.

5. Huggett, *Binkie Beaumont*, p. 539.
6. Noël Coward, *Letters of Noël Coward*, ed. Barry Day. London: Methuen, 2007, p. 225.
7. Quoted in Coward, *Letters*, p. 227.
8. Noël Coward, "Introduction," to Garson Kanin, *Remembering Mr. Maugham*. London: Hamish Hamilton, 1966, n. pag.
9. Connon, *A Life*, p. 170.
10. Quoted in Huggett, *Binkie Beaumont*, p. 498.
11. Noël Coward, *Pointe Valaine*, in *Collected Plays: Six*. London: Methuen, 1988, p. 88. Further references are to this edition.
12. Directed by Nikolai Foster with Peter Egan in the leading role. Richmond Theatre, April 20-25, 2009.
13. Noël Coward, *A Song at Twilight*, in *Collected Plays: Five*. London: Methuen, 1988, p. 408. Further references are to this edition.
14. John Russell Taylor, *The Rise and Fall of the Well-Made Play*. London: Methuen, 1967, p. 126.
15. John Lahr, *Coward the Playwright*. London: Methuen, 1982, p. 159.
16. Huggett, *Binkie Beaumont*, p. 492.
17. *Easy Virtue* was adapted for the screen in 2008 and directed by Stephan Elliott. In the screen version, Larita is a champion race car driver. At the end of the play, she leaves with her young husband's handsome father (Colin Firth, who else), who is as disgusted with his family as she is.
18. Noël Coward, *Easy Virtue*, in *Plays: One*. London: Methuen, 1988, p. 195. Further references are to this edition.
19. Hoare, *Noël Coward*, p. 250.
20. Noël Coward, *Design for Living*, in *Plays: Three*. London: Methuen, 1988, p. 94. Further references are to this edition.
21. The 2010 London revival directed by Anthony Page, the most successful production of *Design for Living* that I have seen, makes clear that these three people cannot live without each other. Every couple is incomplete.
22. Lahr, *Coward*, p. 132.
23. Coward, *Still Life*, in *Plays: Three*. London: Methuen, 1988, p. 265. Further references are to this edition.
24. *Brief Encounter*, produced by Noël Coward, Anthony Havelock-Allan, Ronald Neame (also screenwriters), directed by David Lean (UK, 1945)
25. Coward, *Plays: Five*, p. 488. Further references to the plays in *Suite in Three Keys* are to this edition.
26. Quoted in O'Connor, *Straight Acting*, p. 174.
27. A term for realistic plays set in affluent homes. In one preface, Rattigan defines the term playfully: "In such plays French windows were extensively employed for entrances—usually for young couples in tennis clothes who after depositing their rackets, often went straight into a proposal scene on a sofa, seat facing

squarely to the audience and with its back to the fireplace; but it was also useful for the entrance, at the end of Act One, for characters, often pseudonymized in the programme as 'The Stranger', who would ultimately reveal themselves as the Devil or God or someone's long lost husband [a reference to the plays of T. S. Eliot]. French windows were often useful, too, for the heroine's frantic final exit to plunge herself into the mill-race [Ibsen's *Rosmersholm*]." (Terence Rattigan, *The Collected Plays of Terence Rattigan, Volume 2*. Cresskill, NJ: The Paper Tiger Press, 2001, p. 5.) "Kitchen sink plays" took place in working-class kitchens or bedsits (one-room apartments without kitchens or bathrooms).

28. Rattigan, *Collected Plays, Volume 2*. p. 15. Further references to Rattigan's work, except for *The Last Dance,* are to this edition.
29. Michael Darlow, *Terence Rattigan: The Man and His Work*. London: Quartet Books, 2000, p. 270.
30. Geoffrey Wansell, *Terence Rattigan: A Biography*. London: Fourth Estate, 1996, p. 235.
31. Nicholas Wright's play *Rattigan's Nijinsky* dramatizes Rattigan's cancelling of a production of his television drama about the great Russian dancer Vaslav Nijinsky, the only play he ever wrote about a gay affair. According to Wright's play, Rattigan cancelled the production when Nijinsky's widow, Romola, threatened to out him if the play was aired. Romola did not want the public to think her husband ever had an affair with impresario Serge Diaghilev (though the affair is common knowledge) and, even in 1973, in the era of gay liberation, Rattigan still wanted his sexual proclivities to be kept secret: "I won't be *categorized*. I refuse to be *this* kind of person or *that* kind of person. It would diminish me." (Nicholas Wright, *Rattigan's Nijinsky*. London: Nick Hern Books, 2011, p. 63)
32. Darlow, *Rattigan,* p. 349.
33. Rattigan, *Collected Plays, Volume 2*, p. 215.
34. Wansell, *A Biography*, p. 293.
35. Quoted in Wansell, *A Biography*, p. 296.
36. Darlow, *Rattigan,* p. 315.
37. Much has been written about the biographical origins of *The Deep Blue Sea* in the suicide of one of Rattigan's lovers, Kenneth Morgan. Morgan left Rattigan for another lover but shortly thereafter killed himself. The crucial issue is how Rattigan turned this sad event into a work of art that comments on heterosexual relations.
38. Taylor, *Rise and Fall*, p. 154.
39. Taylor, *Rise and Fall*, p. 155.
40. Terence Rattigan, *After the Dance*. London: Nick Hern Books, 1995, p. 55. Further references are to this edition.
41. Quoted in Hoare, *Noël Coward*, pp. 436–7.
42. Coward, *Letters*, p. 258.

4 EMLYN WILLIAMS: GROWING INTO MARRIAGE

1. Gielgud's arrest is the subject of Nicholas de Jongh's critically acclaimed 2008 play, *Plague Over England,* which had its premiere at the Finborough Theatre, a major fringe venue, and then moved to the West End in 2009.
2. In 1937, an American film with Robert Montgomery as the killer, and in 1964, directed by Karel Reiz with Albert Finney.
3. Emlyn Williams, *Emlyn, An Early Autobiography, 1927–1935.* London: The Bodley Head, 1973, p. 4. Further references are to this edition.
4. Emlyn Williams, *George: An Early Autobiography.* New York: Random House, 1961, p. 389.
5. James Harding, *Emlyn Williams: A Life.* Cardiff: Welsh Academic Press, 1993, p. 50.
6. Harding, *Emlyn Williams*, p. 53.
7. Harding, *Emlyn Williams*, pp. 80–1.
8. Harding, *Emlyn Williams*, p. 93.
9. Emlyn Williams, *The Collected Plays, Volume 1.* London: Heinemann, 1961, p. xvii.
10. Quoted in Harding, *Emlyn Williams*, p. 150.
11. Quoted in Harding, *Emlyn Williams*, p. 152.
12. Matt Houlbrook. *Queer London*, pp. 266–7.
13. Emlyn Williams, *Accolade*, London: Heinmann, 1950, p. 33. Further references are to this edition.
14. A 2011 revival of *Accolade* at the Finborough Theatre in London earned plaudits from the press and a sellout run.

5 CLYDE FITCH AND GEORGE KELLY: SPUNKY AMERICAN WIVES AND DOMESTIC MONSTERS

1. Quoted in William Lyon Phelps, *Essays on Modern Dramatists.* New York: Macmillan, 1926, pp. 146–7.
2. E. Anthony Rotundo, *American Manhood: Transformations in Masculinity from the Revolution to the Modern Era.* New York: Basic Books, 1993, p. 265.
3. Kim Marra, "Clyde Fitch's Too Wilde Love," in *Queer Readings of American Theater History*, ed. Kim Marra and Robert A. Schanke. Ann Arbor: University of Michigan Press, 2002, p. 25.
4. Clyde Fitch, *Plays by Clyde Fitch in Four Volumes, Volume 4*, ed. Montrose J. Moses and Virginia Gerson. Boston: Little Brown, 1915, p. xxvii. All quotes from Fitch's plays and prefaces are from this edition.
5. Montrose J. Moses, *The American Dramatist.* Boston: Little Brown, 1925, p. 310.

6. Moses, *The American Dramatist*, p. 313.
7. William Winter, *The Wallet of Time: Containing Personal, Biographical and Critical Reminiscence of the American Theater*. Freeport, NY: Books for Libraries Press, 1969, p. 313. First published 1913.
8. Moses, *The American Dramatist*, p. 314.
9. Montrose J. Moses and Virginia Gerson, *Clyde Fitch and His Letters*. Boston: Little Brown, 1914, p. 282.
10. Gary Schmidgall, *The Stranger Wilde: Interpreting Oscar*. New York: Dutton, 1994, p. 442.
11. Moses and Gerson, *Letters*, p. 313.
12. Archie Bell, *The Clyde Fitch I Knew*. New York: Broadway, 1909, p. 94.
13. Moses and Gerson, *Letters*, p. 281.
14. Schmidgall, *The Stranger Wilde*, p. 442.
15. Bell, *The Clyde Fitch I Knew*, p. 2.
16. George Chauncey, *Gay New York: Gender, Urban Culture, and the Making of the Gay Male World, 1890–1940*. New York: Basic Books, 1994, p. 6.
17. Marra, "Too Wilde Love," p. 26.
18. Martin Birnbaum, *Oscar Wilde: Fragments and Memories*. London: Elkin Mathews, 1920, p.30.
19. Birnbaum is interestingly neutral on other gay figures. In his memoir, he writes of being entertained in Taormina by Baron von Gloeden, who was famous for his photography of nude Sicilian peasant boys. Birnbaum describes him as "the German photographer who posed his models in pseudo-Hellenistic settings" (Martin Birnbaum, *The Last Romantic: The Story of More Than A Half-Century in the World of Art*. New York: Twayne, 1960, p. 28).
20. Birnbaum, *The Last Romantic*, p. 23.
21. Birnbaum, *The Last Romantic*, p. 24.
22. Birnbaum, *Oscar Wilde*. New York: James F. Drake, 1914, p. 1.
23. Birnbaum, *Oscar Wilde*, p. 8.
24. Birnbaum, *Oscar Wilde*, pp. 8–9.
25. Birnbaum, *Oscar Wilde*, p. 10.
26. Oscar Wilde, *Oscar Wilde: A Life in Letters*, ed. Merlin Holland. New York: Carroll and Graf, 2007, p. 276.
27. Quoted in Bell, *The Clyde Fitch I Knew*, p. 25.
28. Quoted in Phelps, *Essays on Modern Dramatists*, p. 149.
29. Melissa Knox, *Oscar Wilde: A Long and Lovely Suicide*. New Haven: Yale University Press, 1994, p. 152.
30. Knox, *Long and Lovely Suicide*, p. 151.
31. Moses and Gerson, *Letters*, pp. 46–7.
32. Moses and Gerson, *Letters*, p. 47
33. Chauncey, *Gay New York*, p. 115.
34. Rotundo, *American Manhood*, p. 273.
35. Phelps, *Essays on Modern Dramatists*, p. 162.
36. Phelps, *Essays on Modern Dramatists*, p. 175.

37. Phelps, *Essays on Modern Dramatists*, pp. 142–3.
38. Phelps, *Essays on Modern Dramatists*, p. 145.
39. Phelps, *Essays on Modern Dramatists*, p. 146.
40. Phelps, *Essays on Modern Dramatists*, p. 147.
41. Moses and Gerson, *Letters*, p. 20.
42. Moses and Gerson, *Letters*, p. 19.
43. Marra, "Too Wilde Love," pp. 42–3.
44. George Kelly, *The Flattering Word and Other One Act Plays*. Boston: Little Brown & Co., 1930, pp. 17–8.
45. Billy J. Harbin, "George Kelly, American Playwright: Characters in the Hands of an Angry God," in *Staging Desire: Queer Readings of American Theater History*, ed. Kim Marra and Robert A Schanke. Ann Arbor: University of Michigan Press, 2002, p. 136.
46. For a discussion of the Joan Crawford vehicle, *Harriet Craig*, the last film adaptation of *Craig's Wife*, see my book *He's All Man: Learning Masculinity, Gayness and Love from American Movies* (New York: Palgrave, 2002). The best film version was directed by Dorothy Arzner and stars Rosalind Russell.
47. William Lynch, "George Kelly, the Man," in *Three Plays by George Kelly*. New York: Limelight Editions, 1999, p. 2.
48. Arthur Lewis, *Those Philadelphia Kellys: With a Touch of Grace*. New York: William Morrow, 1977, p. 94.
49. Lewis, *Those Philadelphia Kellys*, pp. 91–2.
50. George Kelly, *Daisy Mayme*. Boston: Little, Brown and Company, 1927, pp. 83–4.
51. Lewis, *Those Philadelphia Kellys*, pp. 30–1.
52. Harbin, "Characters in the Hands of an Angry God," p. 135.
53. Lewis, *Those Philadelphia Kellys*, p. 125.
54. Lewis, *Those Philadelphia Kellys*, p. 126.
55. Lewis, *Those Philadelphia Kellys*, p. 129.
56. George Kelly, *The Deep Mrs. Sykes*. New York: Samuel French, 1946, p. 100. Further references are to this edition.
57. George Kelly, *Philip Goes Forth*. New York: Samuel French, 1931, p. 112.
58. George Kelly, *Three Plays by George Kelly* (*The Torch-Bearers*, *The Show-Off*, *Craig's Wife*). New York: Limelight Editions, 1999, p. 393.
59. A note on Kelly's use of italics: Many playwrights use italics or capital letters to indicate words the actor should emphasize. I cannot for the life of me see the logic in Kelly's italics. Speeches would sound very mannered if actors emphasized his italicized words. We do know that, like Clyde Fitch, Kelly was very much a control freak about his plays. He directed and designed their Broadway productions. The acting scripts of his plays are full of very specific stage directions so amateur theaters can reproduce the plays as he intended them to be seen and heard.
60. George Kelly, *The Fatal Weakness*. New York: Samuel French, 1947, p. 19.

61. Mary McCarthy, *Mary McCarthy's Theatre Chronicles*. New York: iUniverse, 2000, p. 101.
62. McCarthy, *Theatre Chronicles*, p. 98.
63. McCarthy, *Theatre Chronicles*, p. 97.

6 1950S MARRIAGES SWEET AND SOUR: TENNESSEE WILLIAMS AND WILLIAM INGE

1. Tennessee Williams, *Memoirs*. New York: Doubleday, 1983, p. 90.
2. Tennessee Williams, *The Selected Letters of Tennessee Williams, Volume 2*, ed. Albert J. Devlin, coedited by Nancy M. Tischler. New York: New Directions, 2004, p. 536.
3. Ralph F. Voss, *A Life of William Inge: The Strains of Triumph*. Lawrence, KA: University Press of Kansas, 1989, p. 176.
4. Williams, *Memoirs*, p. 165.
5. Donald Spoto, *The Kindness of Strangers: The Life of Tennessee Williams*. Boston: Little Brown, 1985, p. 229.
6. Tennessee Williams, *The Glass Menagerie*, in *The Theatre of Tennessee Williams, Volume 1*. New York: New Directions, 1971, p. 156.
7. Tennessee Williams, *Spring Storm*. Edited and with an introduction by Dan Isaac. New York: New Directions, 1999, pp. 14–5. Further references are to this edition.
8. This exchange shows that the young Williams had been reading his Eugene O'Neill. The symbolism has the labored quality it has in O'Neill's plays.
9. Tennessee Williams, *Orpheus Descending*, in *The Theatre of Tennessee Williams, Volume 3*. New York: New Directions, 1971, p. 230.
10. *The Rose Tattoo* had a reasonable run on Broadway directed by Daniel Mann, who had also directed Inge's first success, *Come Back, Little Sheba* (Williams had wanted Elia Kazan, but he was not available), and it won a number of awards for the play and its star, Maureen Stapleton. It was made into a successful film (1955, also directed by Mann) with Anna Magnani (whom Williams had wanted for the play), who won an Oscar for her performance, her first in an American film. Burt Lancaster, who certainly does not fit Williams's physical description of Alvaro, was her costar. There have been two major revivals in London in the past twenty years, one with Julie Walters, the other with Zoe Wanamaker.
11. Williams, *Memoirs*, p. 194.
12. Quoted in Spoto, *Kindness*, pp. 258–9.
13. Tennessee Williams, *Notebooks*, ed. Margaret Bradham Thornton. New Haven: Yale University Press, 2006, pp. 234–5.
14. Tennessee Williams, *The Rose Tattoo*, in *The Theatre of Tennessee Williams, Volume 2*. New York: New Directions, 1971, p. 274.

15. Onstage, Alvaro and, later, Vacarro in the film *Baby Doll,* were played by Eli Wallach, who was neither Italian American nor particularly good-looking. But neither was Maureen Stapleton, the original Serafina, Italian American. I have never understood how a production can reconcile Alvaro being good-looking but having a clownish face.

16. Philip C. Kolin, "The Family of Mitch: (Un)suitable Suitors in Tennessee Williams," in *Bloom's Modern Critical Views: Tennessee Williams.* New York: Infobase, 2007, p. 166.

17. Lyle Leverich, *Tom: The Unknown Tennessee Williams.* New York: Crown, 1995, pp. 47–8.

18. Leverich, *Unknown,* p. 42.

19. Leverich, *Unknown,* pp. 47–8.

20. Tennessee Williams, *Period of Adjustment,* in *The Theatre of Tennessee Williams, Volume 4.* New York: New Directions, 1972, p. 32. Further references to the play are to this edition.

21. Produced by the Almeida Theatre, London, February–March, 2006, directed by Michael Attenborough.

22. Tennessee Williams, *The Night of the Iguana,* in *The Theatre of Tennessee Williams, Volume 4.* New York: New Directions, 1972, p. 365. Further references are to this edition.

23. Voss, *A Life,* p. 83.

24. Burt Lancaster, William Holden, Marilyn Monroe, and Teresa Wright, respectively.

25. I chronicle the nasty antigay articles by *New York Times* drama critic Howard Taubman addressing the homosexual themes in the work of Inge, Williams, and Albee (though never mentioning them by name) in my book *Acting Gay: Male Homosexuality in Modern Drama* (New York: Columbia, 1992), also published in a revised, expanded version as *Still Acting Gay* (New York: St. Martins, 2000). There, I also discuss Inge's one-acts about homosexuality and *Where's Daddy?*

26. William Inge, *Where's Daddy?* New York: Random House, 1966, p. 95.

27. Voss, *A Life,* p. 254.

28. It wasn't until 1974, the year after Inge's suicide, that the American Psychiatric Association took homosexuality off of its list of mental illnesses.

29. William Inge, *Four Plays* (*Come Back, Little Sheba, Picnic, Bus Stop, The Dark at the Top of the Stairs*). New York: Grove Press, 1958. Further references are to this edition.

30. R. Baird Shuman. *William Inge: Revised Edition.* New York: Twayne, 1989, p. 39.

31. Voss, *A Life,* p. 133.

32. William Inge, *Summer Brave and Eleven Short Plays.* New York: Random House, 1962, p. 90. Further references are to this edition.

33. Johnson, Jeff. *William Inge and the Subversion of Gender.* Jefferson, NC: McFarland and Company, 2005, p. 83.

34. *The Dark at the Top of the Stairs*, screenplay by Harriet Frank, Jr., and Irving Ravetch, directed by Delbert Mann.

7 EDWARD ALBEE: MARRIAGE AS VAUDEVILLE

1. Mel Gussow, *Edward Albee: A Singular Journey*. New York: Simon & Shuster, 1999. Albee's reaction to biographical readings of his work: "But all biographers do this. They feel it's their responsibility to find the connective tissue, which may be valid, but if the work doesn't transcend the experience that produced it, then it's not worth the trouble in the first place." (Edward Albee, *Stretching My Mind*. New York: Carroll and Graf, 2005, p. 281.)
2. Albee, *Stretching My Mind*, p. 280.
3. Albee, *Stretching My Mind*, p. 283.
4. Edward Albee, interview with Randy Shulman. *Metro Weekly*, March 11, 2011.
5. Albee, *Stretching My Mind*, p. 281.
6. Quoted athttp://johnshaplin.blogspot.com/2010-06/whos-afraif-of-edward -albee-by-mel.html
7. I have written on Albee's work previously in my book, *Acting Gay: Male Homosexuality in Modern Drama*. One section of this chapter is a revision of my essay, "Withered age and stale custom: Marriage, diminution, and sex in *Tiny Alice, A Delicate Balance*, and *Finding the Sun*," in *The Cambridge Companion to Edward Albee* (New York: Cambridge University Press, 2005, pp. 59–74).
8. Edward Albee, *The Goat, or Who Is Sylvia*, in *The Collected Plays of Edward Albee: Volume 3, 1978–2003*. New York: Overlook Duckworth, 2008, p. 614. A brief word here on Albee's ellipses that are sprinkled through his dialogue. As much as Albee loves long, self-dramatizing speeches like this one, characters often stop momentarily to find the right word. Here Billy is sobbing, fighting to get the words out, but ellipses also happen in less emotional moments. It is another sign of the self-consciousness of the speech of Albee's characters. Nothing is just blurted out. Characters are deciding what word to use or not use.
9. As playwright and as director of his work (he has directed many productions of his work), Albee is always concerned with realistic character portrayal. In his study of Albee's work as a director, Rakeesh H. Solomon observes that "many of his instructions [to actors] stemmed from his conviction that actors must '"become" rather than "indicate" their characters.'...In this directorial emphasis, remarkable for a playwright with a considerable body of non-naturalistic work, Edward Albee has shown himself firmly linked to the mainstream of postwar American directing and acting, as represented by Elia Kazan and Lee Strasberg, especially at the Actors Studio." (Rakeesh H. Solomon, *Albee in Performance*. Bloomington: Indiana University Press, 2010, pp. 192–3.)

10. Edward Albee, *At Home At the Zoo*. New York: Dramatists Play Service, 2008, p. 4. Further references are to this edition.
11. Albee is a great admirer of Noël Coward's work.
12. Edward Albee, *Marriage Play*, in *Volume 3*, p. 303. Further references are to this edition.
13. Edward Albee, *A Delicate Balance*, in *The Collected Plays of Edward Albee: Volume 2, 1966–1977*. New York: Overlook Duckworth, 2008, p. 46.
14. Albee, *Stretching My Mind*, p. 99.
15. Albee, *Stretching My Mind*, p. 114.
16. Albee, *Stretching My Mind*, p. 282.
17. Edward Albee, *Counting the Ways*, in *Volume 2*, p. 526. Further references are to this edition.
18. Edward Albee, *Finding the Sun*, in *Volume 3*, p. 201. Further references are to this edition.
19. Albee, *Stretching My Mind*, 262.
20. Edward Albee, *The Goat or, Who Is Sylvia*, in *Volume 3*, p. 542. Further references are to this edition.
21. J. Ellen Gainor, "Albee's *The Goat*: Rethinking Tragedy for the 21st Century," in *The Cambridge Companion to Edward Albee*, ed. Stephen Bottoms. New York: Cambridge University Press, 2005, p. 214.

8 GAY PLAYWRIGHTS, GAY HUSBANDS, GAY HISTORY

1. Written by Richard Levinson and William Link, directed by Lamont Johnson. Aired on ABC, which over the years, has been the most gay-friendly network in terms of programming. The son's crisis over the discovery of his father's homosexuality is the focus of the teleplay. You can see the complete telefilm on YouTube.
2. A J. Arthur Rank production. Janet Green and John McCormick (screenplay), Basil Dearden (director).
3. As I write this, a musical about the scandal, *Cleveland Street* (book and lyrics by Glenn Chandler, music Matt Devereaux), is being performed at London's Above the Stag Theatre.
4. Quoted in John Coldstream, *Dirk Bogarde: The Authorised Biography*. London: Phoenix, 2005, p. 360.
5. Drew Pautz, *Love the Sinner*. London: Nick Hern Books, 2010, p. 115. Further references are to this edition. *Love the Sinner* was first performed in the National Theatre Cottesloe Theatre on May 4, 2010, in a production directed by Matthew Dunster. Jonathan Cullen and Charlotte Randle were Michael and Shelly.
6. John M. Clum, *Still Acting Gay: Male Homosexuality in Modern Drama*. New York: St. Martin's, 2000. p. xiii.
7. Clum, *Still Acting Gay*, p. xiii.

8. I don't treat *Angels in America* at length here since I have done so in *Still Acting Gay*.

9. Alexi Kaye Campbell, *The Pride*. London: Nick Hern Books, 2008, p. 5. Further references are to this edition. *The Pride* had its premiere at the Royal Court Jerwood Theatre Upstairs on November 21, 2008. The production was directed by Jamie Lloyd and featured Bertie Carvel, J. J. Feild, and Lyndsey Marshal as Oliver, Philip, and Sylvia. The play had its New York premiere on January 28, 2010, at the Lucille Lortel Theatre with Ben Whishaw, Hugh Dancy, and Andrea Riseborough and directed by Joe Mantello.

10. *Victim* star Dirk Bogarde's biographer, John Coldstream, repeats unsubstantiated rumors that the star regularly checked himself into University College Hospital for aversion therapy to curb his homosexual desire: "Dirk, if the account is correct, would spend a week on the ward, where he would be shown erotic pictures of men while being administered drugs to make him vomit." This dreadful treatment was not uncommon at the time. (John Coldstream, *Dirk Bogarde*, p. 355.)

11. Tony Kushner, "Notes Toward a Theater of the Fabulous," in *Staging Gay Lives: An Anthology of Contemporary Gay Theater*, ed, John M. Clum. Boulder, CO: Westview, 1996, p. viii.

12. Kushner, "Notes," p. vii.

13. Jonathan Harvey, *Canary*. London: Methuen, 2010, p. 19. Further references are to this edition. *Canary* was first performed on April 23, 2010, at the Liverpool Playhouse in a production directed by Hettie MacDonald. The production subsequently moved to the Hampstead Theatre in London.

14. Samuel Adamson, *Southwark Fair*. London: Faber and Faber, 2006. Further references are to this edition. *Southwark Fair* was first performed in the National Theatre Cottesloe Theatre on February 10, 2006, in a production directed by Nicholas Hytner. Con O'Neill was the wayward husband, Patrick, and Michael Legge was the hopeful waiter, Aurek.

15. See my discussion of McNally's plays in *Still Acting Gay: Male Homosexuality in Modern Drama*, and in *Terrence McNally: A Casebook*, ed. Toby Zinman (New York: Garland, 1997), pp. 95–116.

16. Terrence McNally, *Some Men*, in *Some Men and Deuce*. New York: Grove Press, 2007, p. 15. *Some Men* had its New York premiere at Second Stage Theatre and was directed by Trip Cullman.

17. David Leavitt, "Notes Toward an Opinion of Gay Marriage," *The M Word: Writers on Same-Sex Marriage*, ed. Kathy Pories. Chapel Hill, NC: Algonquin Books, 2004, pp. 41–2.

Index ✑

Rattigan, Terence, 2, 10, 12, 13, 14, 15, 41, 69–70, 85–100, 101, 111, 115, 193, 214–15n
Rattigan's Nijinsky (Wright), 215n
Rebel without a Cause (film), 172
Rebellato, Dan, 100
Ritz, The (McNally), 204
Rose Tattoo, The (T. Williams), 143, 147, 148–52, 157, 220n
Rotundo, E. Anthony, 123
Rowbotham, Sheila, 18

Sacred Flame The (Maugham), 58, 59
Salome (Wilde), 27, 28
Sardou, Victorien, 115
Savage, Dan, 6–7
Scarlet Letter, The (Hawthorne), 32
Schmidgall, Gary, 116, 117, 118, 120, 125
Scribe, Augustin, 115
Searle, Alan, 47, 62, 64, 66, 67
Second Mrs. Tanqueray, The (Pinero), 76
Secret Fall of Constance Wilde, The (Kilroy), 210–11n
Selfridge, Gordon, 47, 55
Separate Tables (Rattigan), 86, 87, 91–3, 94
Servant, The (R. Maugham), 67, 211n
Sexual Inversion (Ellis), 23
Shadows of the Evening (Coward), 83, 84–5
Shaw, Bernard, 43, 123
Sheldon, Edward, 131
Show-Off, The (Kelly), 130, 140
Solomon, Rakeesh H., 221n
Some Men (McNally), 189, 203, 205–6
Somerset and All the Maughams (R. Maugham), 67
Sondheim, Stephen, 10–11
Song at Twilight, A (Noël Coward), 70, 71, 73–6, 83, 84

Southern Baptist Convention, 5
Southwark Fair (Adamson), 203–4
Splendor in the Grass (screenplay, Inge), 157, 158, 169, 171–2
Spring Storm (T. Williams), 145–7
Still Acting Gay (Clum), 195–6
Still Life (Coward), 81–2
Strauss, Richard, 27
Streetcar Named Desire, A (T. Williams), 145, 147, 149, 167, 169
Stubbornness of Geraldine, The (Fitch), 115, 126–7
Suite in Three Keys (Coward), 73, 85
Sullivan, Andrew, 6, 7
Summer and Smoke (T. Williams), 147
Summer Brave (Inge), 167–8
Sweet Bird of Youth (T. Williams), 143, 145
Sweet Charity (Coleman/Fields/ Simon), 2
Symonds, John Addington, 23
Syms, Sylvia, 192, 197

Taradash, Daniel, 165
Taylor, John Russell, 43, 74, 96
That Certain Summer (television drama), 189–90, 195
Theatre (Maugham), 51–3, 213n
Thoreau, Henry David, 218, 219
Three Tall Women (Albee), 173
Tonight at 8:30 (Coward), 81
Torch-Bearers, The (Kelly), 130, 135
Traviata, La (Verdi), 88
Truth, The (Fitch), 115, 126, 127–9

Unforgiving Minute, The (Nichols), 63

Variations on a Theme (Rattigan), 88–91
Victim (film), 190–4, 195, 206
View from the Bridge, A (Miller), 143
V.I.P.s, The (Rattigan screenplay), 87
Voss, Ralph, 158